Oxford History of Art

Medieval Architecture

Nicola Coldstream

OXFORD
UNIVERSITY PRESS

OXFORD
UNIVERSITY PRESS

Great Clarendon Street, Oxford OX2 6DP

Oxford New York

Athens Auckland Bangkok Bogotá Buenos Aires Cape Town
Chennai Dar es Salaam Delhi Florence Hong Kong Istanbul Karachi
Kolkata Kuala Lumpur Madrid Melbourne Mexico City Mumbai
Nairobi Paris São Paulo Shanghai Singapore Taipei Tokyo Toronto Warsaw
and associated companies in Berlin Ibadan

Oxford is a registered trade mark of Oxford University Press
in the UK and in certain other countries

ISBN-13: 978-0-19-284276-3
ISBN-10: 0-19-284276-5

10 9 8 7 6 5 4 3

British Library Cataloguing in Publication Data
Data available

Library of Congress Cataloguing in Publication Data
Data available

Picture research by Elisabeth Agate
Typesetting and production management by
The Running Head Limited, Cambridge, www.therunninghead.com
Printed in Hong Kong on acid-free paper by C&C Offset Printing Co. Ltd

*The websites referred to in the list on pages 239–41 of this book are in the public domain and
the addresses are provided by Oxford University Press in good faith and for information
only. Oxford University Press disclaims any responsibility for their content.*

Contents

To the Eeles family

Acknowledgements

This book is a brief overview of an enormous subject studied by many medievalists and architectural historians. My mother, the late Marian Carr, and my first teacher, Peter Kidson, introduced me to medieval architecture, and I have benefited from the writings of many scholars, and from listening and talking to them. In the preparation of the book my greatest thanks are due to Simon Mason, who commissioned it and encouraged its early stages, and to Michael T. Davis and Peter Draper, both of whom found time in busy workloads to read the entire text and offer valuable insights, suggestions, and corrections. Any remaining errors are mine, not theirs. Other kinds of help—intellectual, practical, hospitable—for which I am very grateful, were given by Anthony Beckles Willson, Hana and Jan Bouzek in Prague, Lynn Courtenay, Paul Davies, Jean Givens, Nina and Jocelyn Hillgarth in Mallorca, George Huxley, Virginia Jansen, Sister Jane Livesey IBVM, Marie-Louise and Franz-Georg Maier in Switzerland and Germany, Helen and Robert Merrillees in Burgundy, Julian Munby, Marion Roberts, Gavin Simpson, and Mary Whiteley. I thank Katharine Reeve, Ali Chivers, and Annie Jackson and David Williams of The Running Head, for seeing the book through the press; Lisa Agate, for her supportive and undaunted picture research, Phil Longford, for making the line drawings, and Nicolas Coldstream, who read the book in proof.

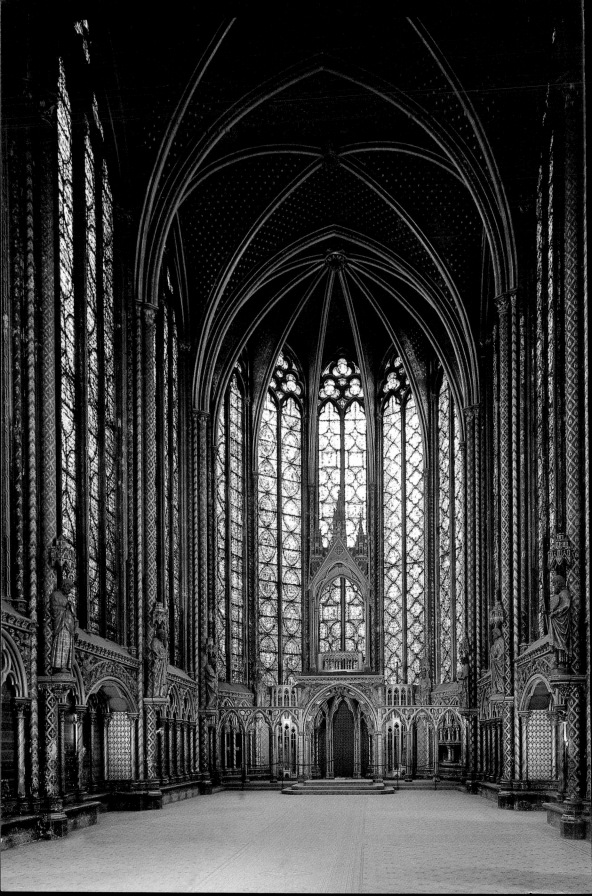

Introduction

The late thirteenth-century hospital at Tonnerre in Burgundy [2] is an immense, undivided space, lit by traceried windows and covered by a massive timber roof; it opens at one end into three vaulted chapels. The hospital was founded in 1293 by Margaret of Burgundy, countess of Tonnerre and widow of Charles of Anjou, who had been king of Sicily and claimed the crown of Jerusalem. Margaret herself was buried in the hospital, where her tomb survived until the French Revolution.

This little narrative of the hospital and its founder encapsulates many of the themes in the greater narrative of European architecture in the later Middle Ages, between the twelfth and sixteenth centuries, and of the people who built it: monumental buildings, made of wood and stone, decorated with architectural ornament; the fusion of the sacred and the secular, in thought, in motives, and in architectural space; and the late medieval world view. For here is a building erected with the quality of construction and materials that might be expected of a cathedral. Its chapel, as significant as the sick ward, was for prayers for the founder, and for the sick to confess their sins as part of their cure. The founder was sister-in-law to King Louis IX of France, and titular Queen of Jerusalem, a city then back in Muslim hands but to Christian Europe the physical and spiritual centre of the world.

European architecture was the architecture of Christendom and of Christians where they settled overseas. Before the fourteenth century the concept of Europe was nebulous. Its peoples inhabited Christendom, or more precisely the region that converted to Roman Catholic— or Latin—Christianity, as opposed to the Greek Orthodox areas further east [Map 1]. Except for very small minority populations of Jews and Muslims, European peoples were Christian, and Europe was identified with Christendom, expanding only as Christendom expanded: around the Baltic Sea—Lithuania was converted only in 1386—and in Spain, where the Christians pushed southwards throughout the period, finally expelling the last Muslim rulers in 1492. At the same time, though, trade, politics, and war took Christian merchants and crusaders to Africa, the eastern Mediterranean, the Black Sea, and Asia: the great trading cities of Venice and Genoa built up rival sea empires with settlements on the Adriatic coast, on Aegean

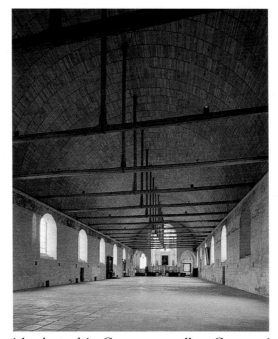

Hospital of Notre-Dame de
Fontenilles, Tonnerre, France,
interior, looking east

The building typifies the acts
of piety made by wealthy
medieval patrons to ensure
their own salvation through
charitable works. The founder,
Margaret of Burgundy, was
buried here, and prayers were
said for her soul in the eastern
chapel. Built from 1293, the
huge hall was the sick ward.
The wooden beams and posts
support a curved ceiling and
steeply pitched, tiled roof.

islands, and in Cyprus, as well as Constantinople and Kaffa in the Crimea. Merchants traded in Aleppo, Damascus, and further east. The crusaders had already established and begun to lose their precarious holdings in the Holy Land; and in the late twelfth century a branch of the western French Lusignan family took over rule of Cyprus. Wherever they settled, the Latins built churches, warehouses, barracks, and castles, with farms and villages. While their utilitarian buildings were more local in appearance, castles and places of worship were in the familiar style of home. Medieval European architecture existed, and still exists, outside Western Europe [**3**].

The culture was defined by Christianity. It was authoritative, exclusive, and focused on a single vision, in ways not easily imagined among the relative and uncertain values of today. The Church taught that life on earth was a mere prelude to the eternal life to come, and that Christ had died, been resurrected, and ascended to Heaven to redeem the sins of mankind and lead people to Paradise. Values were absolute, and the Second Coming of Christ, which would herald the end of the world and the Last Judgment, was a future reality; if not constantly remembered, it was ever present at not too deep a level of consciousness. As the keeper of the path to salvation, the Church was immensely powerful. Non-Christian or pre-Christian cultures were rationalized into the Christian outlook; except when convenient, non-Christians were excluded from political and business life. Everyone acted, as it were, under the authority of Rome. All rulers owed allegiance to the Pope, an allegiance that was by no means always nominal and was responsible for most of the main political upheavals of the time. Christendom was

Former Cathedral (now Lala Mustafa Mosque) of Famagusta, Cyprus, from the west

During Famagusta's wealthiest period, in the fourteenth century, much building was done, in styles familiar to the west European rulers and merchants who lived there. The Latin cathedral, built from c.1300, has a 'harmonized' façade, with three doors, and towers over the aisles. Tracery-filled, openwork gables project above the parapets. The decoration owes much to French thirteenth-century styles mediated through buildings in the Rhineland.

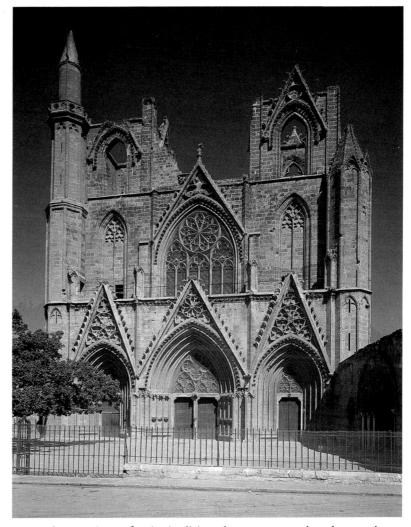

a conglomeration of principalities that grew or shrank as princes gained or lost power through war, marriage alliances, or dynastic weakness. By the late fifteenth century the political map was much altered [**Map 2**]. The greatest changes since the twelfth century had occurred in the German and Slav lands and the Italian peninsula; but in the Mediterranean empires had come and gone, just as they had in northern Europe with the loss of English lands in France, the decline of Danish power in Scandinavia, and the rise and fall of the great Duchy of Burgundy, which had accrued in Burgundy and the Netherlands in the fourteenth and fifteenth centuries. While the kingdom of Portugal had emerged through undisturbed occupation of the territory, those of France, Spain, Scotland, and England were still settling their frontiers by military or diplomatic means.

In the twelfth century what are now the nation states of Germany and Italy had nominally been subject to the emperors, self-proclaimed

Map 1 Western Christendom *c.*1200

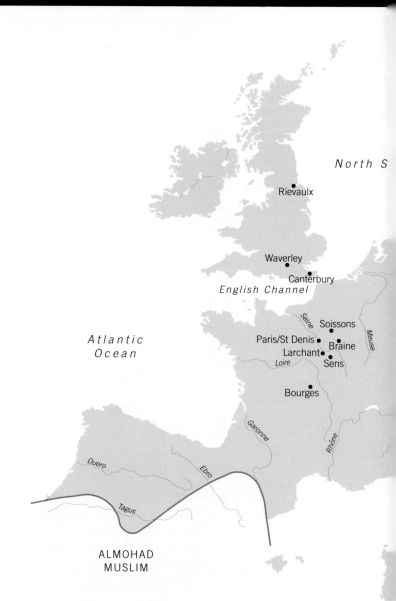

North S

Rievaulx

Waverley

Canterbury

English Channel

Atlantic Ocean

Seine

Soissons

Paris/St Denis

Braine

Larchant

Meuse

Loire

Sens

Bourges

Garonne

Rhône

Duero

Ebro

Tagus

ALMOHAD
MUSLIM

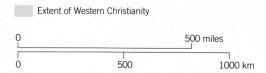

Extent of Western Christianity

| 0 | | 500 miles |
| 0 | 500 | 1000 km |

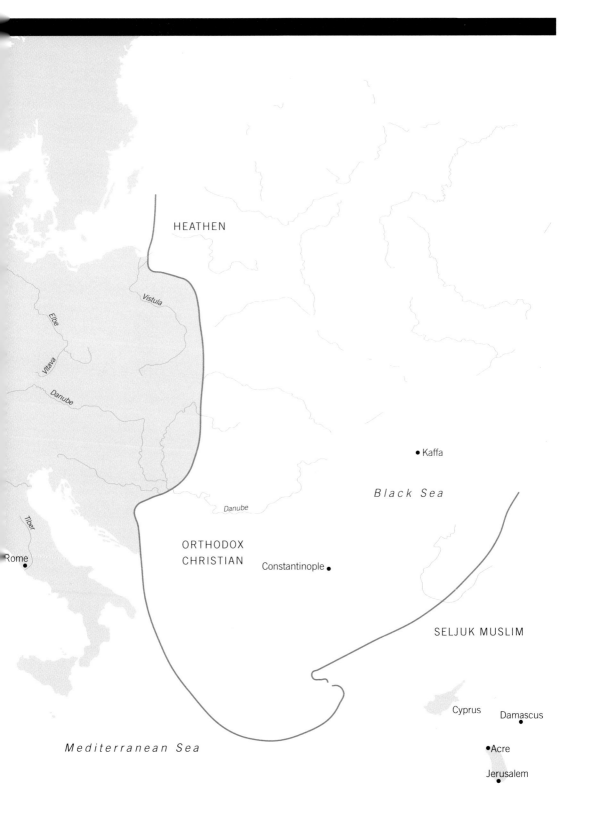

HEATHEN

Vistula

Elbe

Vltava

Danube

Tiber

Rome

ORTHODOX
CHRISTIAN

Danube

Constantinople

• Kaffa

Black Sea

SELJUK MUSLIM

Cyprus

Damascus

•Acre

Jerusalem

Mediterranean Sea

Map 2 Western Christendom *c.*1450

SCOTLAND

Melrose

Sweetheart

*North
Sea*

Tyne

*Lake
District*

*Irish
Sea*

Rievaulx Abbey

DEN

York

•Muckross

Caernarfon•

ENGLAND

Lincoln

Tattershall

Humber

WALES

St Davids

Abbey Dore

Peterborough

Bristol Channel

•Gloucester •Ely

Bath •Great Coxwell

Wells• •Westminster •Cressing Temple

Exeter• Salisbury London Canterbury

Middelburg

Herstmonceux

Bruges•Ghent

Soest

English Channel

Oudenaarde •Antwerp

Mechelen

Cologne

Amiens

Aachen

Caen•

Rouen

Louviers• •Ecouis Laon

Trier

Rhine

Gaillon• •La Ferté-Milon

Oppenheim•

Dir

Mantes St Denis

•Reims

No

Chartres Paris•Vincennes

Meuse

•Toul Maulbronn

*Atlantic
Ocean*

•Troyes

Schwäbis

Seine

Parçay-Meslay

Sens

Strasbourg• Gmü

Loire

Blaubeur

Tonnerre•

Freiburg

Bourges• Mehum Sur Yèvre

Im Breisgau

Marne

BURGUNDY *Lake Constance*

FRANCE

Clermont
Ferrand

Brou

Bern SWISS
CONFED

Ste Foy-La-Grande

Dordogne

Geneva

Alps

*Massif
Central*

Garonne

•Monpazier

La Chaise Dieu

Milan

Bay of Biscay

•Cahors

Lombardy

Piedmont

Pavia

León•

Toulouse

•Albi

Rhone

Avignon

Emilia

Liguria

Burgos•

Carcassonne

Genoa

Valladolid•

Narbonne•

Pyrenees

Ebro

So
Pis

La Mota Castle•

•Coca

Volt

Aljubarotta •Batalha

Salamanca•

Lleida

•Tomar

Segovia

Tagus

SPAIN

Barcelona

•Belém

Toledo•

•Teruel

La Mancha

Guadalquivir

Palma di Mallorca
and Bellver

•Seville

Granada •Murcia

GRANADA
MUSLIM

- - - - boundaries of Western Christendom

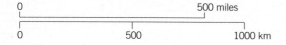

0		500 miles
0	500	1000 km

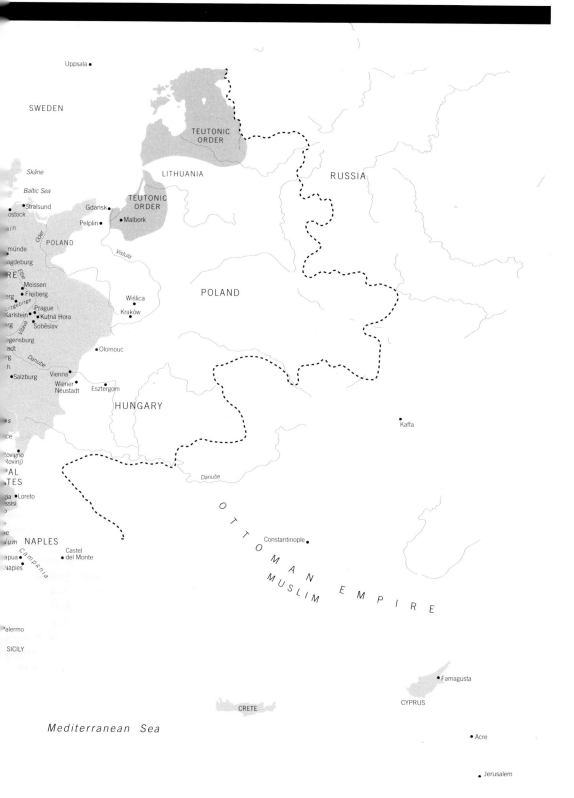

Uppsala •

SWEDEN

TEUTONIC
ORDER

Skåne

Baltic Sea

•Stralsund
ostock
•in
•münde
•agdeburg
RE

LITHUANIA

TEUTONIC
ORDER

Gdańsk•
Pelplin• •Malbork

POLAND

Oder

Vistula

RUSSIA

POLAND

•Meissen
•erg •Freiberg
erzgebirge
•Karlstein •Prague
•rg •Kutná Hora
•Soběslav
•egensburg
•adt
•g •h
•Salzburg

Elbe

Vltava

Wiślica

Kraków

•Olomouc

Danube

Vienna•
Wiener •
Neustadt • Esztergom

HUNGARY

Kaffa •

•s
•ce

•ovigno
Rovinj)

•AL
•TES

•ia •Loreto
•ssisi

•e
•um NAPLES

•apua

•Naples

•alermo

SICILY

Castel
• del Monte

Campania

Danube

O
T
T
O
M
A
N

Constantinople •

MUSLIM

EMPIRE

Mediterranean Sea

CRETE

•Famagusta

CYPRUS

• Acre

• Jerusalem

heirs to Charlemagne, whose legitimacy was conferred through coronation by the Pope. But the Italian peninsula was effectively partitioned into the south, under the Norman kings of Sicily, the directly ruled papal states in the middle, and the cities of the north, which acknowledged the emperor. As the imperial Hohenstaufen power weakened and collapsed in the thirteenth century, various interests, including powerful families (among them the Luxembourgs and the Habsburgs), the Teutonic Knights crusading to the Baltic peoples, and countless free imperial cities moved to consolidate territories for themselves. To protect their commerce, the cities joined into leagues, of which the north German Hanse, based in Lübeck and extending round the Baltic and to Britain, is the best known; the wealth of such organizations brought them considerable influence. As the Hohenstaufen weakened, so did the papacy; factional fighting brought it under the influence of the emerging power of the French kings, and between 1309 and 1377 the Popes were forced into exile at Avignon (see **54**); even after its final return to Rome the Papacy never recovered its former prestige. Southern Italy and Sicily passed to the French house of Anjou, thence to the kings of Aragon, whose empire eventually included Catalonia, the Balearic islands, and interests in mainland Greece and Cyprus.

Dynastic connections were deliberately wide and complex. The Angevins who kept power in Naples also involved themselves in east European politics by marrying into the ruling Arpád family in Hungary. Hungary's fate was, however, closely involved with the emergence in the fourteenth century of Poland under the Piasts and Bohemia under the Luxembourgs. The imperial crown, now an entirely Germanic emblem, was assumed by the Luxembourgs with Charles IV in 1346; they held it for most of the following century before it passed finally to the Habsburgs from 1438. The Habsburgs, having consolidated their lands in what is now Austria, changed the map of European power when, in 1477, the heir, Maximilian, married Mary, heiress to the Duchy of Burgundy, and united the Netherlands with Austria.

In the south many of the independent Italian communes had been taken over by absolutist dynastic rulers, presiding over their own courts reflecting those of the north. The next large bloc to be united was the Iberian peninsula, with the marriage of Ferdinand of Aragon to Isabella of Castile, the Catholic Monarchs who drove the Muslims out of Granada; and it was another dynastic marriage with the Habsburgs that was to bring Spain, the Netherlands, Austria, and Bohemia under one single ruler, the Habsburg emperor Charles V. By this time the politico-religious map was to undergo new radical change, caused by the Reformation within Christendom and the threat of the Ottoman Turks on its eastern frontiers. Although, with the discovery of America and the French conquests in north Italy, these events conventionally

mark the transition to the modern world, the fundamental issues were the same as ever: threats to the established religious order.

Within the wider picture of shifting political alliances were the myriad localities that actually composed Christendom—cities, villages, and manors, which registered the greater events only by changes in lordship or law codes. Among the rulers and princes who have occupied the last few paragraphs must be placed the smaller landowners and urban patriciates, the merchants, bankers, and tradesmen, whose growing wealth and confidence gave them increasing material visibility, marked in every town by the parish churches and city halls built by the newly powerful urban élites. To map European geography and politics is to map European architecture: the complex of castle, cathedral, and new town at Prague were built only when the Luxembourgs decided to make that city their principal base; the flowering of architecture in fourteenth-century Lesser Poland was motivated by the political energy of King Kasimir the Great. Building often reflects specific political events, especially conquest, as reflected in Malbork (see **107** and Box) and the other castles of the Teutonic Knights, or Edward I's ring of castles in north Wales (see **108**). The papal palace at Avignon owes its existence to the exile of the popes. The great brick churches of the Hanse towns, the cloth and market halls in Germany and the Low Countries all reflect the wealth and prestige of successful merchants.

Yet, as the hospital at Tonnerre demonstrates, motives were not always political or commercial, nor were such motives the most significant. The far greater proportion of churches among surviving medieval buildings cannot wholly be explained by the more transient nature of domestic architecture, although houses were built of less durable materials and were more easily sacrificed to changing fashion and greater physical comfort. The pursuit of salvation and the centrality of the Christian message ensured that much economic and artistic energy would be dedicated to building and furnishing churches. It was in churches that most designs were initiated, and only secular buildings of the highest status were as lavishly adorned with architectural ornament. Furnishing could cost as much as, or even more than, the structure: Notre-Dame at Ecouis in Normandy, built 1310–13 as the burial church of Enguerran de Marigny, chamberlain to King Philip IV of France, is now a plain, barn-like shell, and the only reminders of its original interior fittings are the superb monumental sculptures of saints displaced from their former positions in the choir.[1] Ecouis, like Tonnerre hospital, was at once a private and a public space, where prayers were invited for the founder. Many ecclesiastical foundations, from monastic churches to domestic chapels, had this dual function, while others—cathedrals, parish churches, friars' churches—were public. But all of them served the imperative need to prepare for death with sins forgiven and the hope of everlasting life.

This book presents medieval architecture as a force that maintained its creative power well into the sixteenth century, from Italy to Poland, Scandinavia, and Britain, and from Portugal to Cyprus. Construction embraced brick and timber as well as stone, houses and barns as well as churches and castles. Some were ornate, others austere, but the appearance of each was the result of deliberate choice. The text is in two parts. The first looks at the changing appearance of late medieval buildings, their structure, and how they were designed and built. The opening chapter provides a chronological framework for the thematic subject-matter of the chapters that follow. Part II is about the meaning of buildings: how space was used, architectural symbolism, and how buildings reinforced both religious and political messages. The two parts should, however, be read as one. In a world that represented its God as Architect of the universe, the building process was as much metaphysical as material.

Part I

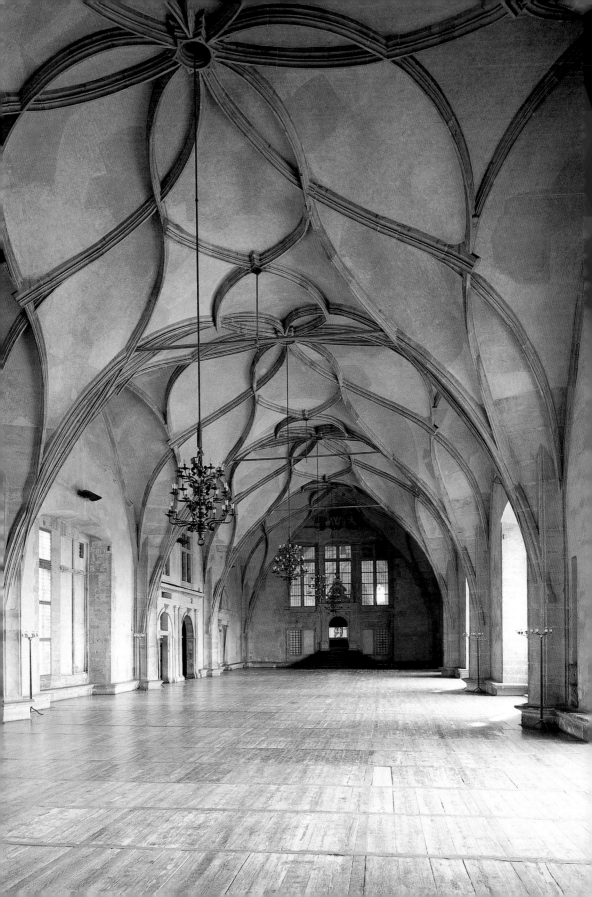

'What we now vulgarly call the Gothic'

1

Late medieval architecture is traditionally synonymous with Gothic, the style of the soaring cathedrals that dominate the skylines of European cities even today. Chartres Cathedral (see **124**) can be seen from many miles away; only the grain silos that stud the arable lands in which the city lies can rival the cathedral's silhouette. Built of fine, creamy-grey limestone, Chartres is an immense aisled basilica [**5**], three storeys high and roofed with a cross-ribbed vault. Above the pointed arcade is a narrow passage in the thickness of the wall, and tall clerestory windows which reach high into the vault space. The piers carry capitals decorated with the bunched, stylized leaves known as crockets, and have colonnettes attached to each axial face. The colonnettes towards the central vessel continue up the wall to meet the transverse arches of the vault and mark the division into bays. Lines of colonnettes and vault ribs link the two sides and emphasize the thinness already apparent in the masonry of the clerestory. It seems a miracle that such a structure can support a heavy stone vault. Less a miracle than sleight of hand, the superstructure and the pressures of the vault are carried on a scaffolding of arched flying buttresses placed around the building's exterior.

Chartres, however, is not typical of medieval architecture. While other cathedrals may have shared its gigantic size and superb stone-work, most other buildings did not. Even though this period is still characterized in all seriousness as the age of cathedrals,[1] the most characteristic building of the Middle Ages was not the cathedral, or even the castle, but the hall. The hall was the basis of domestic dwellings, barns, hospitals, shops, and markets. It was an essential element in more complex assemblies of buildings such as castles, colleges, or monasteries. The hall of Tonnerre hospital is stone-built, but timber and varieties of fired or mud brick were more common materials: in many parts of eastern Europe churches were made of wood. The Wheat Barn built by the Knights Templar c.1260 at Cressing Temple in Essex represents the everyday experience of architecture more closely than Chartres. Although it is based on a masonry sill, this large, aisled hall of seven bays [**6**] is constructed wholly of wooden trusses with linking timbers. There is not a rib or arch in sight. It was built when the

4

Vladislav Hall in Prague Castle, Czech Republic, interior, looking east

Vladislav II's reconstruction of the castle included the adaptation between 1492 and 1502 of three third-floor rooms into a single throne room and jousting hall, with the largest vaulted span—16 m—in Europe. To create the decorative curving vault, with its complex interlocking design and cut-off ribs, the master mason, Benedikt Ried, built massive cones against the existing walls, sinking their supports into the floors beneath.

5

Chartres Cathedral, France, interior, looking east

Chartres was rebuilt after a fire in 1194 destroyed all the superstructure except the western block. Constructed probably outwards from the crossing, the church was the first where the possibilities created by flying buttresses were exploited to lengthen the clerestory windows below the springing point of the vault. In this style of *c.*1200 piers, mouldings, and vaults are delineated to suggest their structural interdependence.

6

Cressing Temple, England, the Wheat Barn, interior

The Knights Templar were a monastic military order, founded in Jerusalem *c.*1119 to protect pilgrims to the Holy Land, eventually establishing houses throughout Christendom. This barn was built *c.*1260. It was originally entirely of oak, on a stone sill. The seven aisled bays are of post-and-beam construction, self-supporting and braced to prevent deformation. About 470 trees were needed, more than half small ones from managed (coppiced) woodland.

Gothic style was supposedly at its zenith, yet there is nothing Gothic at Cressing Temple. Nor does every church building share the Gothic of Chartres. Orvieto Cathedral [**7**] in central Italy, founded in 1290, is a light, two-storey structure. It has thin walls, but they are flat, without mouldings, and they support a timber roof. The arcade, on columns with foliage capitals, has round arches, and is separated from the small, plain clerestory windows by a jutting cornice. Round arches also frame the semi-circular chapels opening from the aisle walls, chapels that are not symmetrically related to the bay divisions created by the arcade. The windows are narrow, round-headed in the chapels, pointed in the main walls. The whole interior is clad in stripes of black and white marble. The only feature that Orvieto and Chartres possess in common is the pointed windows. Yet to contemporaries the elevation of Orvieto had great historical validity: directly descended from the early Christian basilica, it recalled the very beginnings of Christianity. The design was prevalent in Romanesque churches in both the Italian

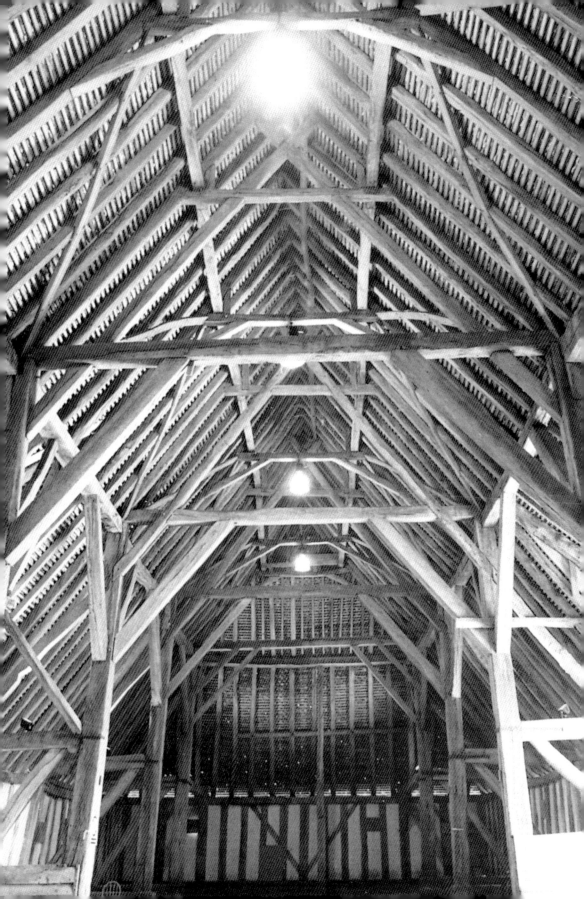

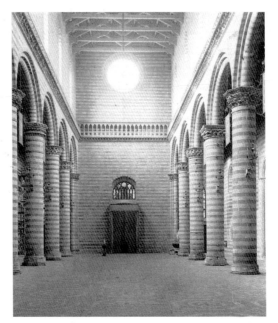

Orvieto Cathedral, Italy, interior, looking west
Founded in 1290 at the highest point of the hill town, the cathedral dominates the local landscape. Its interior does not conform to accepted ideas about Gothic. Only the capitals and bases of the piers, the more refined arch mouldings, and some pointed windows show acceptance of north European modes. The open rafter roof, the striped marble cladding, and the big oculus in the end wall are characteristic of central Italian architecture.

peninsula and Germany, and with modifications to mouldings and windows it continued into the late Middle Ages, the lightweight, austere but spacious structure being especially well suited to the smaller building that is not a great church or basilica. Yet, because Orvieto and other churches in Italy were built in the so-called Gothic period, and have decorative details that are recognizably 'Gothic', they are invariably included in books on Gothic architecture, even though scholars are uneasy about what 'Italian Gothic' actually means.[2]

Why, then, does church architecture of the Chartres type dominate our perception of late medieval building? It owes something to the priority given to churches at the time, but more to historiography, the scholarly tradition that has accumulated in layers ever since architectural writers in fifteenth-century Italy, in pursuit of classical principles, declared that the *maniera tedesca* (German manner) of contemporary building was a barbaric, or Gothic, subversion of those principles. The quotation from Sir Christopher Wren at the head of this chapter shows that by the seventeenth century the term Gothic was widely used, but that in England at least it had become a neutral epithet.[3] From the late eighteenth century and particularly the nineteenth, when antiquaries became seriously interested in medieval architecture, a combination of accurate scholarship, religious revival, and the need to express national identities across Europe endowed medieval—Gothic—architecture with a new legitimacy and moral force, which not only rescued from neglect many buildings that would otherwise have collapsed, but also gave rise to one of the great historicist styles of the nineteenth century. Principles of Gothic structure were defined and promulgated by the nineteenth-century French architect Viollet-le-Duc, drawing on his

experience restoring (and effectively rebuilding) such large cathedrals as those of Amiens [8] and Notre-Dame, Paris. Gothic has been explained as a structural system; as a way of organizing space; as an expression of a monarchy, of nationhood, even of a civilization. Except for the early notion that rib vaulting was inspired by groves of trees, or the interpretation of Gothic as an expression of national identity or metaphysical imperative (which now cause some embarrassment), most of the historic explanations have contributed to current thinking on the subject.[4] Each generation has added its own layer of interpretation. Every era writes history in the light of contemporary experience, and our own is no exception. The medieval period is recoverable only through centuries of distortion. The problem is particularly acute for architecture since what we are looking at is scarcely medieval in its present state. Buildings were subject to constant alteration and renewal in their own day, and have been rescued from total destruction only by comprehensive interference and reinterpretation by restorers.

The earliest attempts to place stone vaults safely over high, thin walls were made in Paris and its surrounding area in the 1130s, about 60 years before Chartres was begun. The established narrative states that these buildings—Sens Cathedral and abbey churches in Paris, including Saint-Denis—represent the beginnings of Gothic. A sense of spaciousness created by a thin structure and visual co-ordination supplanted the more solid forms of Romanesque architecture and, after a number of experiments, achieved perfection with the 'classic' cathedrals of Chartres, Soissons, Amiens, and Reims. The notion of 'classic' Gothic is based on two presumptions. The first embodies a biological view of architectural development that parallels the life cycle: youth in the twelfth century, maturity from the early thirteenth, and old age, with concomitant decay, setting in from about 1300.

The second is that in Chartres and its fellow cathedrals Gothic architecture achieved an ideal, a canon against which all other buildings should be measured. This idea is implicit in much writing on the subject. We find references to 'classic High Gothic', 'crazy vaults', and 'capriciousness': the first establishes the canon of Gothic, the other two imply that the canon has been subverted.[5] But this canon was imposed by scholars who had been trained in the classical tradition and expected architecture to follow rules. Medieval architecture took over from its Roman past a structure of arches and piers or columnar supports; but it has no equivalent to the classical orders. No rule or convention dictated which type of capital should adorn which design of column. Medieval architects did apply certain systems of proportion, but these concerned setting out and construction rather than aesthetics. Architecture has to obey certain precepts to remain standing, and the precepts followed in the medieval period were all structural and geometric; they were aesthetic only in so far as geometry and proportion overlapped in the

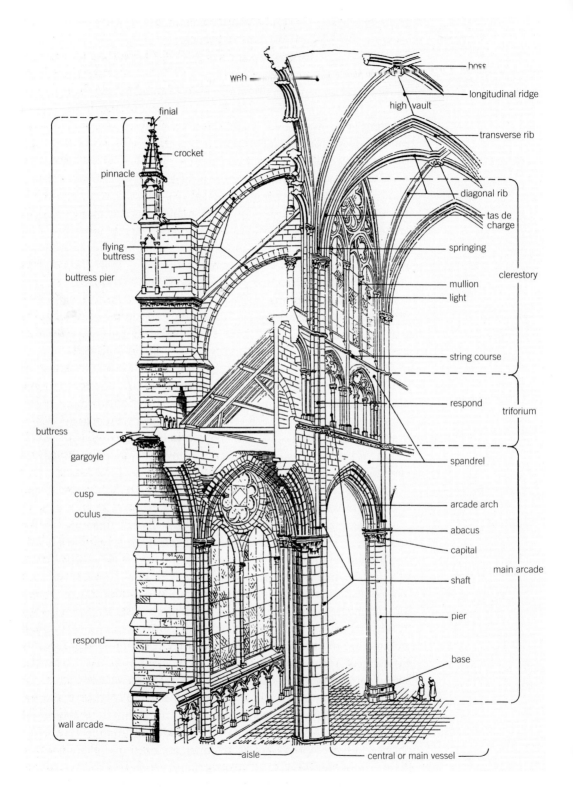

web

hoss

longitudinal ridge

high vault

transverse rib

finial

crocket

diagonal rib

pinnacle

tas de charge

springing

flying buttress

clerestory

buttress pier

mullion

light

string course

respond

triforium

buttress

spandrel

gargoyle

arcade arch

cusp

abacus

oculus

capital

shaft

main arcade

pier

respond

base

wall arcade

aisle

central or main vessel

E. CURLAUMOT

8

Section of the nave of Amiens
Cathedral, with architectural
features identified (after
Viollet-le-Duc)

designers' minds. Beyond rare references to 'the right measure', there is no contemporary record of an aesthetic rule.

Nor were such rules as they acknowledged confined to churches. One of the main impediments to a more balanced view of medieval architecture is the tradition of treating secular buildings separately from churches, with dedicated, specialist journals, which concentrate on structure and function at the expense of style. Castles are mostly considered less as architectural designs than as feats of military engineering. Timber-framed structures like Cressing Temple barn are treated in yet another category, the vernacular, which broadly encompasses local building traditions using local materials on forms not recognized as 'high style'. The exclusion of secular buildings has strongly affected the historiography of late medieval architecture. This is unfortunate, as the masons and carpenters did not specialize in particular building types, but were equally responsible for all of them. The timber frame of a barn is no less complicated than a timber roof above the stone vault of a cathedral (see **28**). The same methods were used to set out castles and churches, with the same care for planning, shaping interior space, and outward show. High style was not reserved either for churches or for Gothic, nor were all churches in high style.

Recently, the contribution that different approaches can make has been better appreciated. Study of the ritual and social functions of a church and the style of a castle can yield new information that emphasizes the common concerns of all architecture. Architecture was about ritual and display, a backdrop for ceremonial, from taking dinner to celebrating church festivals or the display of power. Since the sacred and the profane were two sides of the same mirror, and the religious was inextricably fused with the secular, public and private, ecclesiastical and lay activities were hierarchic, rich in ritual, and ordered by ceremony. The hierarchy of Heaven naturally reflected that of earth, for the unknown could be visualized only through existing experience. The very structure of a church building seems to express the hierarchies. It has often been noted that a carefully devised spatial design can seem unrelated to the necessary arrangements and furnishings on the ground, which interrupt the lines and block the spaces: the choir stalls often ran through the very crossing that the masons were at pains to stress, and piers were obscured by altars and altarpieces. The apparent dichotomy can be interpreted as a horizontal division, between the interests of the human congregation at floor level and of the realms of Heaven in the pure, uncluttered levels above.[6] But space was multi-directional: the figure of a saint to whom an altar was dedicated could be carved in the keystone of the vault overhead, creating a link through association.

An architectural setting had to be appropriate and signify the nature of the building. Style was therefore extremely important. Aesthetic taste was dictated by propriety, or *decorum*, a concept derived from the

Roman architectural writer Vitruvius. Many monastic libraries north of the Alps possessed copies of Vitruvius' treatise on architecture, and while there is little evidence that Vitruvius influenced medieval builders, there was awareness of his general precepts, although *decorum* was manifest not, as Vitruvius advised, in the correct deployment of the classical orders, but in a structure suited to the building's function and status.[7] Barns, such as Great Coxwell or Parçay-Meslay, are invariably plain, and plainer forms of vaulting were chosen for undercrofts and other storage areas in buildings that were decorated elsewhere. The quantity of decoration does not necessarily indicate status: its absence from leading Cistercian and Premonstratensian churches, for example, reflects the belief in those orders that ornament distracted a contemplative monk from achieving mystical union with God. Taste for decoration certainly changed between the thirteenth century and the sixteenth, when many buildings were encrusted with it (see **136**); but this did not mean that the later buildings were less functional. Functionalism is a modern concept that has no relation to the Middle Ages, when ornament was not superfluous to a building's function but could indicate what the function was. Buildings were assertive. They punctured the skyline with towers and gables, and at ground level the design and decoration of portals and thresholds indicated purpose and the patron's interests. Inside, the spatial disposition controlled access and movement. Decorative elements were used precisely, to convey the building's intention, its meaning, and its symbolism. The decorative language—mouldings of arches, piers, capitals, and bases, varieties of tracery and foliage—appears on many buildings that are not otherwise 'Gothic' and defines late medieval architecture more comprehensively than does any structural system. Therein lies the paradox that, although Gothic is an inadequate descriptive term for late medieval architecture, the grammar that we call Gothic defines the period. But by bringing together many kinds of building, we can begin to overcome our problems of perception.

The language of medieval architecture

Language has been used as a metaphor for architecture since the very first writers on the subject tried to characterize it, with parallels of grammar and vocabulary for structure and ornament.[8] The language concerns high style, and since the development of high style shows up most clearly in church buildings until the very end of the period, churches will provide most of the examples in the rest of this chapter; but it should not be forgotten that the same decorative repertory was used simultaneously in secular buildings of similar status (see **4**). The changes in architecture embodied new structural expression and ideas about what was appropriate. These naturally occurred in conjunction

with the builders' increasing technical skill. The unanswerable question whether skills were developed in response to demand, or whether new skills provoked new demands arises already in the 1140s with the new choir of the abbey church of Saint-Denis [**9**]. The account of the rebuilding written by the patron, Abbot Suger, makes clear what he wanted: a splendid setting for the shrine of the patron saint; adequate space for pilgrims to circulate; the whole to be encircled by a crown of light reflected through large stained glass windows.[9] The architect adapted the established plan of a semi-circular apse with seven chapels radiating from an ambulatory or walkway [**10**].

In Romanesque buildings there were intervals between the chapels, but at Saint-Denis they were pulled in to form a continuous rippling line (see **53**). The walls were reduced down to buttresses and strips of dividing masonry. The chapels, each with two windows, give an almost unbroken circuit of glass and enhance the spaciousness achieved by the clever use of rib vaulting over the chapels and ambulatory, and light, monolithic columns. The superstructure was rebuilt in the thirteenth century, but it is agreed to have been vaulted yet lightweight, with slender columns and ribs. The master mason provided Suger with what he wanted, and created a building that inspired others to emulate it. But the principles on which he worked had been adumbrated during the previous decade in local buildings. In producing a design that is now seen to mark a turning point in architectural history, the designer manipulated existing technology.

In a group of cathedrals and collegiate and abbey churches that were built or rebuilt in north and east France over the next half century, masons were concerned with vaulting structures that were becoming ever higher and wider. They had to reconcile the necessary support with the call for large windows that reduced the mass of masonry. It was in these years that techniques of buttressing were developed, leading to the arched flying buttress that typifies the great church exterior (see **31**). By carrying the thrusts exerted by the vault away from the upper wall, the flying buttress allowed the clerestory windows to be made much longer. The designers of Soissons Cathedral in the 1180s and Chartres in the 1190s were the first to exploit this, and the effect can be seen by comparing the elevation of Chartres (see **5**) with that of the earlier church of Mantes-la-Jolie (see **32**), where the clerestory windows come down only to the level from which the vault springs.

What makes these churches so significant in the history of architecture is that the principles of their designs had such an extraordinary effect. Romanesque architecture had spread across Christendom, but it had strong regional characteristics that remained local. Late medieval architecture also had a strong regional character: it takes very little practice to distinguish fourteenth-century churches in different areas. But between the 1170s and the late thirteenth century church architecture

9 (overleaf)
Saint-Denis, former abbey church, interior, looking east
In the distance are the columns and vault of the surviving ambulatory, built 1140–4 by Abbot Suger. The enormous, flat elevation of the choir and nave begun in 1231 has a four-part rib vault, moulded piers, a triforium pierced for glazing, and huge, four-light clerestory windows filled with bar tracery. The design emphasizes structural clarity and the visual linkage of different members that typify great churches in mid-thirteenth-century France.

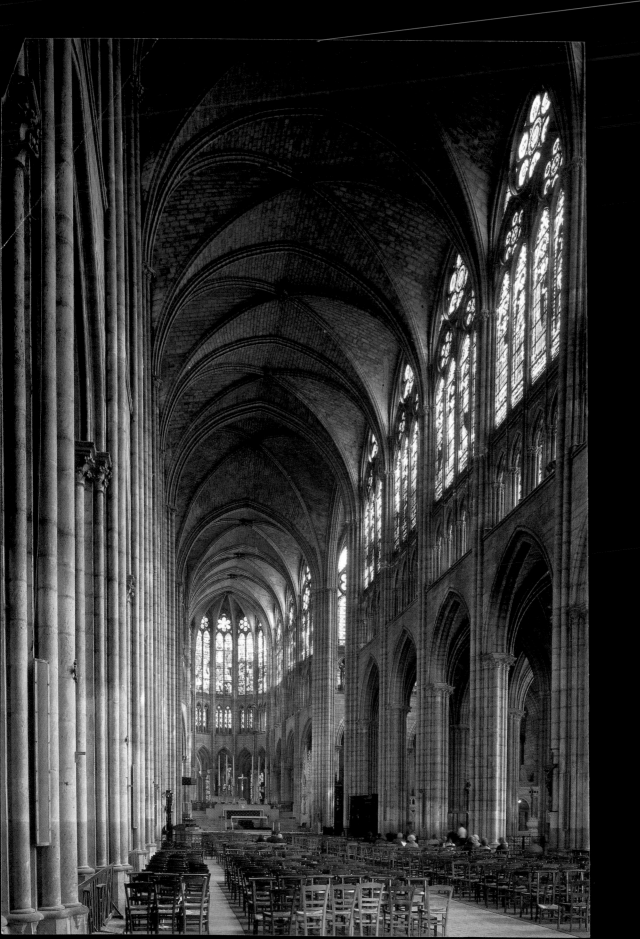

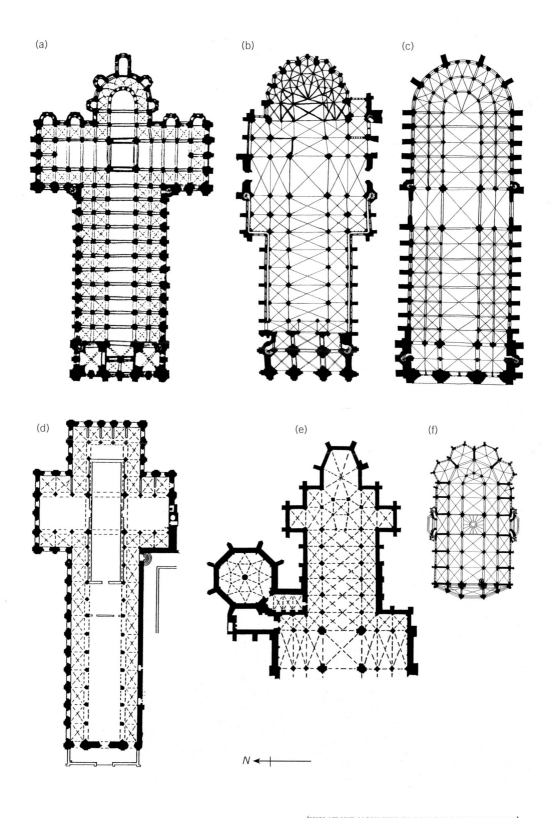

10 (previous page)

Church plans

The Romanesque plan of
Saint-Sernin, Toulouse (a)
shows the eastern radiating
chapels distinct and projecting
from the perimeter. Saint-
Denis (b) was one of several
Parisian churches from the
1130s in which the chapels
were drawn inwards to create a
more integrated space, taken
to extremes in the smooth
outline of Notre-Dame, Paris,
1160s (c). Alternatives to the
semi-circular chevet were
various rectangular plans (d)
(Byland Abbey). From the
thirteenth century masons
created complex plans that
opened oblique spatial views
(e) (Wells Cathedral) and (f)
(Saint-Maclou, Rouen).

was designed on French terms. If other regions did not wholly adopt the tall, thin structure, they took on with enthusiasm the cross-ribbed vault and the surface adornment of moulded arches and shafts. The north French milieu produced what was to become the language of late medieval architecture. Why it happened is debated. One reason is the sheer number of great churches that were built in what had been a poor and politically weak region but was now wealthy and in the hands of the increasingly powerful French monarchy allied to the growing prestige of the Church. It was also an area with good building stone. Architects were offered numerous opportunities to practise their craft, and the incentive to build on a grand scale. Initially, the style was diffused by masons and others who had worked with it: south-eastwards to the Holy Land and then Cyprus, after the establishment of a French ruling dynasty and Church dominated by French clergy; into central Europe, taken to Hungary by Francophile royal patrons; and north, to England, where the Cistercian monastic order was partly responsible for intro-ducing it to Yorkshire in the 1170s, at the same time that the choir of Canterbury Cathedral in the south-east was being rebuilt by a French master mason. Since many of the structural experiments had been derived from Anglo-Norman buildings, and the English had an innate preference for surface ornament, they were already halfway to accepting it.

The most striking features of Canterbury (see **121**) are French-

11

Dore Abbey, England, choir
interior, looking east

The church of Dore on the
Welsh borders was extended
by its ambitious abbot c.1200.
Although the piers and lancet
windows are richly moulded,
many with continuous
mouldings—lacking capitals
and bases—which appear in
several monuments in the
south and west, other
ornament is confined to simple
foliage, and the two-storey
elevation is characteristic of
the Cistercian desire for
simplicity.

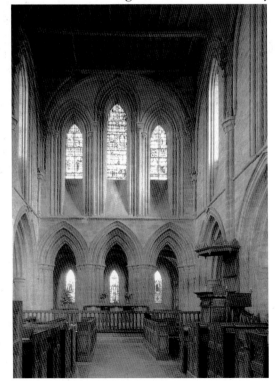

Magdeburg Cathedral,
Germany, interior, looking east
Magdeburg on the river Elbe in
Saxony had an illustrious
history as an early
ecclesiastical foundation in the
German drive eastwards
against the Slavs. The new
cathedral, begun 1209,
incorporated materials and
elements from its predecessor
to maintain memory and
continuity. It has one of the first
plans in Germany with an apse
and ambulatory on French
lines, but despite the three-
storey elevation and ribbed
vaults it is smaller than a
French equivalent.

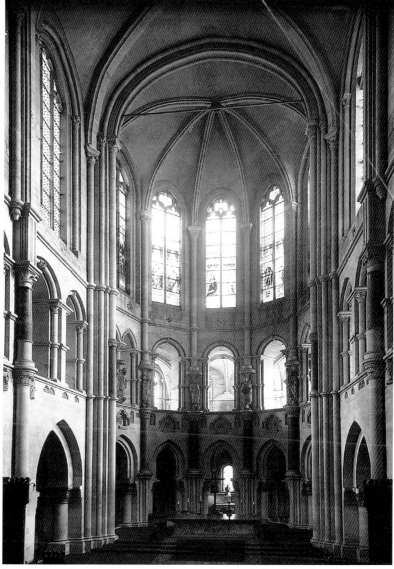

inspired: columnar piers, the sexpartite vault (a ribbed vault with six
compartments stretched over two bays of arcading—see **32**), the large,
acanthus-leaf capitals, and the colonnettes and shafts in contrasting
Purbeck stone. The passage through the clerestory represents a differ-
ent trend from the flatness of Chartres, a type of design that appeared
in several churches in this generation, including Geneva Cathedral. In
England mural depth and copious fine mouldings had more appeal
than high, thin walls [**11**]. In Germany, too, the initial response was to
graft these features on to traditional structures, whether the lighter
type, as at Bonn Minster or the heavy, bulky architecture of Magde-
burg Cathedral [**12**]. Builders in Spain also chose the same kind of
hybrid style until the 1220s, when the cathedrals of Burgos and Toledo

were based on a specific French model—the design of Bourges Cathedral, where the upper storeys are pushed high into the vault space by huge, tall columnar piers. In the meantime, however, masons at Reims had perfected a new device: window tracery [13].

Decorating the window opening with delicate stone circlets was the first hint of what was to become one of the most significant elements in late medieval architecture. Considering its later effect, tracery was slow to penetrate, appearing in England tentatively at Lincoln c.1230 and more positively at Westminster a decade later. Tracery was used from c.1227 in the church of Our Lady at Trier in Germany (see 99). It was only in the late thirteenth century that tracery designs became independent of their French models, and, together with patterned vaulting, wrested architectural initiative from French hands. Builders in Britain had experimented with vault designs from the late twelfth century, when in St Hugh's choir at Lincoln they introduced 'split' ribs that met at a longitudinal ridge rib rather than crossing each other [14]. This design destroyed the implicit suggestion that a vault was a regular structural canopy, substituting the idea that it was simply another surface to be decorated, an idea next developed in the nave of Lincoln, where multiple ribs springing from each pier met at equal intervals along the ridge [15].

In the mid-thirteenth century, however, French designs were still innovatory and influential, partly owing to the immense prestige of the king, Louis IX, whose piety, diplomatic skills, and conquests deep into the regions south of the royal nucleus around Paris made him the leading monarch of Christendom. It was again in the Paris area that various ideas were brought together in a coherent architectural scheme. The elevation of the nave and upper choir of Saint-Denis (see 9) has the same disposition as Chartres, with an arcade, triforium passage, and tall clerestory. But here the masonry is reduced to a thin membrane: the clerestory glass fills the width of the bay and the outer wall of the triforium is pierced for glazing, making the stonework seem more than ever like a cage for glass. The mouldings have proliferated, on piers, in more complex tracery patterns, and in the vault supports. The style takes its name—Rayonnant—from the radiating, wheel-like patterns of the rose windows that filled the flat end walls of naves and transepts. The thin, febrile effect of interiors was carried over to exteriors, where buttresses lost their bulk beneath coverings of tracery and canopy work, and silhouettes were broken by pinnacles and gables, which were set over doors and windows, and often pierced with tracery for extra fragility (see 3 and 128).

Although Saint-Denis is a large basilica, Rayonnant was well suited to smaller churches. It was in these years that the aspiration towards great height and immense, shadowy spaces began to wane, although it never wholly died, as the huge cathedrals of Milan, begun in 1389, and

13

Tracery patterns

Tracery composed of thin bars of stone appeared from *c*.1210, first at Reims Cathedral. Patterns were geometric, based on circles and foiled shapes (a); but elongations and intersecting lines were soon introduced (b). About 1310 the ogee—reversed—curve allowed sinuous shapes to be devised (c) to (e); but late medieval forms were stiffer, often rectilinear (f).

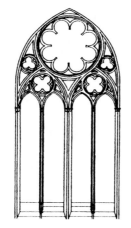

(a) Geometric – Amiens Cathedral

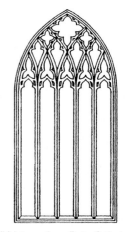

(b) Intersecting – Exeter Cathedral

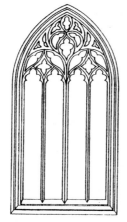

(c) Curvilinear flowing, Boston, Lincs.

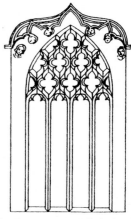

(d) Curvilinear reticulated, Faringdon, Berks.

14 (overleaf)

Vault patterns

Alongside regular quadripartite rib vaults over square or rectangular bays, asymmetrical vaults were introduced for the main vessel (a) and for difficult corners (b). Patterns based on the tri-radial (b) were popular in the Empire (c), (d), (e), and (f); and the tierceron vault devised for the nave of Lincoln Cathedral influenced buildings along the Baltic (g). From the fourteenth century onwards patterned vaulting was used in designs of nets (h), curves (i), fans (j), and stars for main vessels, porches (k), and staircases (l).

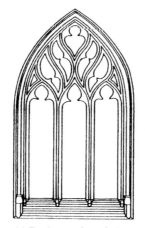

(e) Flamboyant, Caen, St Jean

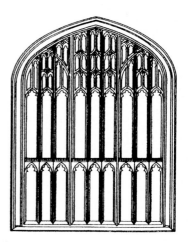

(f) Rectilinear, King's College Chapel, Cambridge

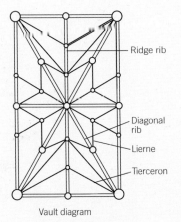

Ridge rib

Diagonal rib

Lierne

Tierceron

Vault diagram

(a) Lincoln, St Hugh's Choir

(b) Tri-radial vault

(c) Eberbach, chapter house

(d) Lübeck, St Mary

(e) Maulbronn, chapter house

(f) Prague Cathedral Sacristy

(g) Pelplin Abbey

(h) Schwäbisch Gmund, Holy Cross

(i) Annaberg, St Anne Curving vault

(j) Westminster Abbey, Henry VII Chapel, Fan vault

(k) Frankfurt: parish church: north porch, west tower

(l) New College, Oxford staircase to hall Star vault

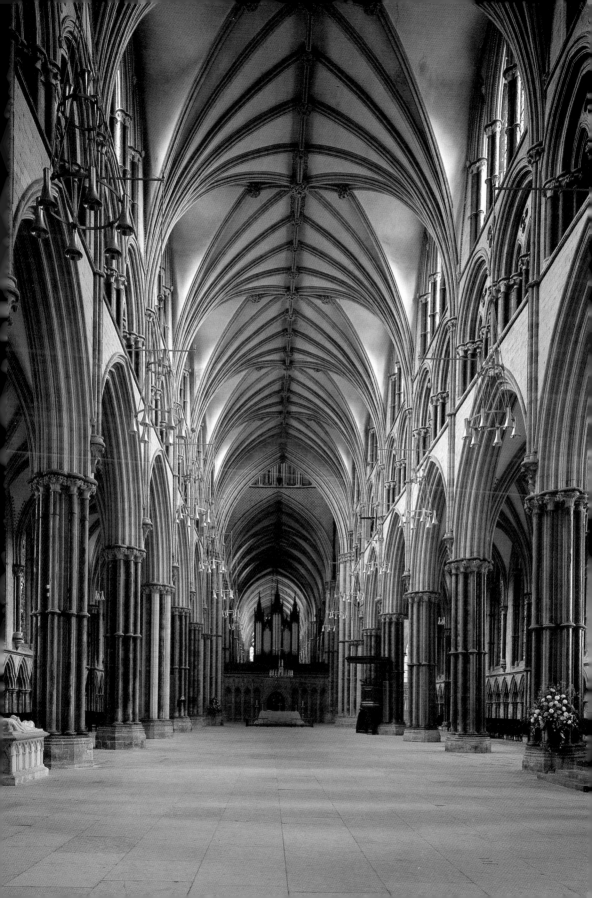

Begun in the 1220s, the
solidity of the three-storey
elevation is concealed under
copious moulded decoration
in the arches and shaftwork.
Colour and texture are
provided by Purbeck marble at
all levels. Capitals and corbels
supporting the vault shafts
have windblown, stiff-leaf
foliage carving. The vault,
composed of multiple
tierceron ribs rising to a
longitudinal ridge rib, is an
early form of decorative vault.

Gothic styles

Gothic architecture was classified into several substyles from the early nineteenth century. The categories contain just enough truth to keep the terms in use, although usage tends to ossify attitudes towards both stylistic change and stylistic content. The following brief descriptions explain the terms most frequently encountered in the literature:

Backsteingotik The brick architecture of north Germany and the lands around the Baltic.

Decorated English architecture between *c*.1250 and *c*.1350, using tracery, much sculptured ornament, and, in its later phase, the ogee arch.

Early Gothic Architecture in the Ile-de-France *c*.1130–*c*.1190; the initial phases of Gothic in any other country.

Early English Architecture in Britain between *c*.1170 and *c*.1250, using rib vaults, pointed arches, and copious architectural ornament, particularly shaft work. Can be austere or highly ornamented.

Flamboyant Last phase of French Gothic, from the fifteenth century, using ogees in flame-like tracery patterns, and thin, faceted mouldings.

High Gothic The so-called classic phase in France, including Chartres, Reims, and Amiens Cathedrals: tall, thin structures, with long clerestories and flying buttresses.

Hispano-Flemish Highly decorative style from the reign of Isabella I of Castile (1474–1504), combining Netherlandish and local Islamic-inspired *Mudéjar* forms.

Late Gothic Used loosely of architecture after *c*.1350, but essentially applicable to the Empire, characterized by variety in pier forms, tracery, and vault patterns; exemplified in hall churches.

Manueline Architecture in Portugal associated with Manuel I (1495–1521), highly sculptured, with many marine motifs celebrating Portugal's maritime discoveries.

Perpendicular English architecture from the late fourteenth century, characterized by rectilinear surface panelling, flattish, four-centred arches, and multi-ribbed or fan vaulting.

Transitional Styles around 1200 that seem to combine Romanesque and Gothic forms, and interpreted as evolving from one to the other. Term used especially for buildings in the Empire and Britain.

Rayonnant French architecture from *c*.1230, after the invention of window tracery: light, moulded, with mural passages and much surface decoration.

Reduktionsgotik 'Reduced Gothic' describes the preaching churches built in the Empire by the mendicant orders, with plain, simple structure and little ornament.

the early sixteenth-century cathedrals of Segovia and Salamanca would testify. It was not that masons had reached the limits of what was technically possible, but that the cultural emphasis was moving away from great churches to more modest parish churches, churches for the mendicant orders of friars, and chapels. The Sainte Chapelle, built in the 1240s by Louis IX in the palace in Paris, was the most influential building of the thirteenth century (see **1**). Although it is set high upon an undercroft and is itself quite lofty (see **72**), the Sainte Chapelle gives an impression of great splendour contained within a small space. The chapel was built to house relics of Christ's Passion, which Louis had acquired in the dispersal of relics after the Sack of

Constantinople in 1204, and its resemblance to a reliquary casket was deliberate: it was noted at the time. The upper chapel is a single cell with a seven-sided apse, the walls consisting of huge windows set above a dado. The west wall has a large rose window (replaced in the fifteenth century). Moulded piers, fronted by statues of the apostles, rise to the vault. The interior was articulated with paint, sculpture, gilding, and stained glass, and the exterior with tracery, mouldings, and gables. Not everything was innovatory. Interiors were routinely painted, and increasing numbers of original colour schemes are being revealed by conservation work. In Chartres the finer mouldings were picked out in white against yellow ochre walls, which emphasized the linear connections of piers and vaults; in St Mary's, Lübeck, in the fourteenth century, the masonry was lined out with red on a white ground, then embellished with foliate and geometrical motifs to offset the flat surfaces.[10] The metallic quality evident in the masonry of the Sainte Chapelle had been anticipated in the sharply faceted mouldings and foliage sculpture of such English buildings as the cathedrals of Lincoln [15] and Ely. But the chapel set a new standard of splendour, which, combined with its symbolic and political associations, made it a model for chapels and church choirs throughout Christendom. Rayonnant introduced a characteristic that was to change the appearance of architecture more profoundly even than the new vaults and tracery, which were subsumed within it: the concept of micro-architecture, in which such elements as gables, pinnacles, and tracery were used in miniature, borrowing back from metal reliquaries the architectural forms that they had adopted from monumental buildings and transformed into sacred imagery (see **105**).

Three monumental buildings outside France—Cologne Cathedral [**16**], León Cathedral in Castile [**17**], and Westminster Abbey—were all begun shortly after the Sainte Chapelle, and the two former in particular faithfully reproduced the Rayonnant style for great churches. Rayonnant remained the basis for such churches, however varied their details: Strasbourg Cathedral and York Minster in the late thirteenth century, the cathedrals of Prague, Vienna, and Milan, and Ulm parish church in the fourteenth, then Seville, Segovia, and Salamanca. What was understood to be the French style was widely admired. As late as 1280 the chronicler Burchard of Halle recorded that the church at Wimpfen-im-Thal in Swabia was being built in 'the French manner' (*opus francigenum*).[11] Judging by its simple structure, the French manner could be achieved very superficially with rib vaults and tracery, as also happened to an extent at Uppsala in Sweden, where the Rayonnant piers and vaulting were allegedly introduced by a French mason, Etienne de Bonneuil. Yet for all the aspirations of some patrons, architecture was becoming increasingly independent of France. There were changes to the political balance of Europe, and to both the

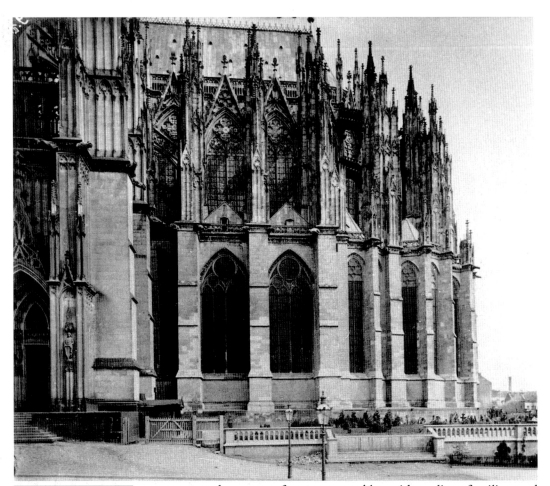

16

Cologne Cathedral, Germany, exterior of choir

The great exemplar of mid-thirteenth-century architecture in French style in the north Rhine area, the cathedral was rebuilt from 1248 by Archbishop Conrad von Hochstaden. The plan with ambulatory and radiating chapels is derived from Amiens Cathedral, the source also of the tracery patterns and the miniaturist, metallic ornament in gables, pinnacles, and buttresses. The building was not completed, the west front being built, following the medieval drawings, only in the nineteenth century.

patterns and nature of patronage. Alongside ruling families and princely courts the urban patriciate was becoming a powerful force, endowing parish churches, burial chapels, and mendicant churches, and erecting public buildings. Few new monasteries were founded; new patrons were more likely to found a church served by a college of secular priests to pray for their souls. Existing monasteries were refurbished or occasionally rebuilt, as at Blaubeuren, near Ulm, which was reformed and given new buildings in the fifteenth century (see **103**). The vocabulary of mouldings, tracery, and vaulting was effectively infinite, since patterns could be devised by any master mason and freely imitated by others. How this influenced the relation between patrons and architects is uncertain. Some scholars believe that this was the period when master masons transformed themselves into a profession more approximate to the modern architect—one who designs buildings but does not construct them.[12] It is more likely, however, that a greater number of master masons, armed with sheets of patterns and designs, were now in a position to direct the choices made by their employers.

The surge of creativity that broke the Parisian hegemony was

León Cathedral, Spain, north elevation of choir

León Cathedral was begun in 1255 after the union of the kingdoms of León and Castile. Like Burgos, its Castilian counterpart, León is based on French prototypes, here the Rayonnant style of such churches as Saint-Denis (compare **9**). It is characterized by the apparently thin, logical structure, with traceried clerestory windows filling the width of the bay, and a second tier of windows in the triforium passage below.

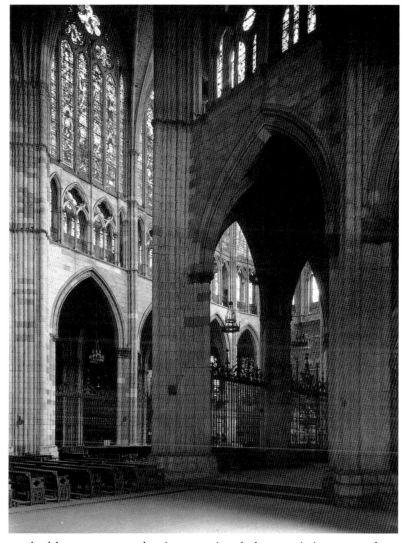

marked by a return to dominant regional characteristics, even where Parisian influence was still traceable: the choir of Aachen Cathedral, for instance (see **90**), is modelled on the Sainte Chapelle, but is not a replica. In Italy a flirtation with French forms in S. Francesco at Assisi (see **112**), the mother church of the Franciscan order of friars, which was begun in 1228, was not pursued by other orders. They favoured the light structure we have already noted at Orvieto (see **7**). In the Dominican church of S. Maria Novella (see **33**) and other churches in Florence the vaults were high and domical, a format that generally prevailed until Milan Cathedral was designed in the 1390s. Alternative types of elevation were explored particularly in Catalonia and the Empire. S. Maria del Mar in Barcelona [**18**], begun in 1324, has an immensely tall arcade which pushes up into the vault space, allowing only small, circular windows for the clerestory. The aisles are commensurately high,

Barcelona, Spain, interior of S. Maria del Mar

Like several Catalan churches, S. Maria del Mar, begun in 1328, has very high side aisles opening into chapels divided by buttresses that have been pulled within the perimeter wall. The main walls of the interior have been reduced effectively to nothing, by tall, slender, octagonal piers that rise to a clerestory of small oculi. Most of the lighting comes through the aisle windows.

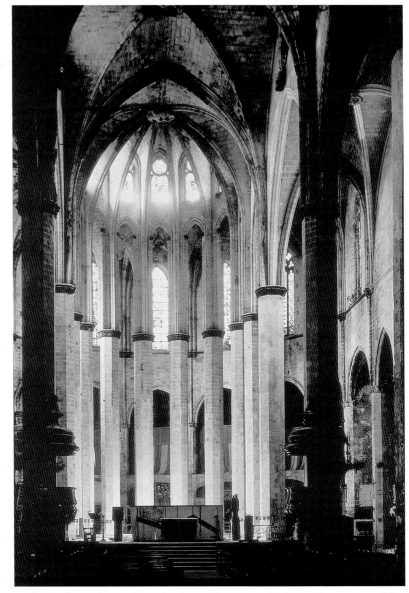

Nuremberg, Germany, interior of the choir of St Lorenz

In 1356 Emperor Charles IV stipulated that each newly-elected emperor must hold the Imperial Diet—meeting of the estates of the realm—at Nuremberg, which became the focus of lavish patronage. The townspeople established a series of altars in the choir, begun 1439 (for plan, see **36**). The uninterrupted vault pattern and apparent spatial fusion of the main vessel and aisles deny the structural logic displayed in earlier architecture.

with windows above chapels created between the lateral buttresses. The comparative darkness in contrast to the greater radiance of the choir only emphasizes the slender piers and lofty spaciousness. This parish church was based, probably deliberately, on the cathedral of Barcelona; the gigantic cathedral of Palma de Mallorca, which dominates the city's port, has a similar disposition. The German alternative to the basilica was the hall church, in which all three aisles are normally the same height, and the building is lit only through the tall side windows. From the early fourteenth century this type was developed for urban parish churches [19] and those attached to hospitals and other institutions. Tall, slender piers rise with little or no interruption to the arches and

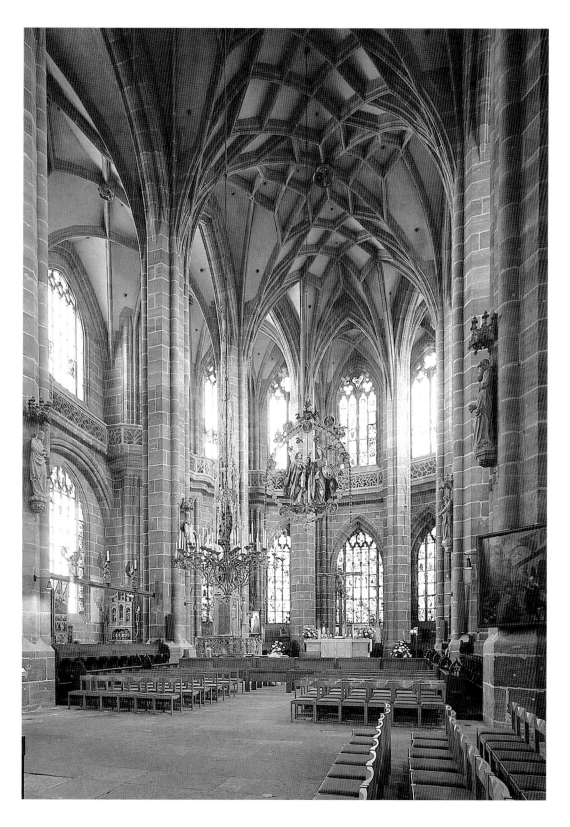

Toledo, Spain, *artesonado*
ceiling of El Tránsito
synagogue

The synagogue was founded
*c.*1357 by Shmuel ben Meïr
Ha-Levi Abulafia, Treasurer to
Pedro the Cruel, King of
Castile. It was later converted
into the chapel of the
Dormition of the Virgin, hence
its hybrid name—in full, Ermita
del Transito de Nuestra
Señora. Decorative
artesonado woodwork
featured in Muslim buildings in
north Africa and Spain, where,
as the local style, it was used
also in Jewish and Christian
architecture.

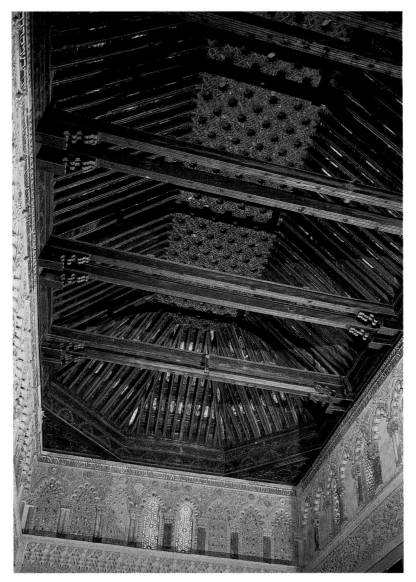

vault. Since there are no transepts, the distinction between the sanctuary and nave is often marked only by steps or a change in the vault pattern, which gives the spacious interiors a feeling of great unity.

The expanses of even vaulting fields inspired a wide variety of patterns. From the late thirteenth century to the fifteenth England and Germany were the leaders in designs of both vaults and tracery. This, and the exploration of architectural space (see **91**), was another reason for the architectural focus to shift decisively to Britain and central Europe. The English taste for extra ribs and ridge ribs spread to the Baltic, where the late thirteenth-century abbey church of Pelplin was the first in a sequence of designs that rapidly developed in patterns of nets and stars (see **14**). The need to vault corners led to the invention of

tri-radials—three ribs converging in a triangular field—which were used in such square or rectangular buildings as the chapter houses of Eberbach and Maulbronn and the sacristy of Prague Cathedral, before being combined with other patterns. But a different attitude to vaults and space was developing, which released the vault from defining the bay, so that it could be thought of, not as converging from the corners, but expanding outwards from the centre. In the polygonal chapter houses of the British Isles (see **96**) ribs radiate from a central column out to the corners. The same effect was achieved in the square chapter house

21

Oppenheim, Germany, south façade of St Catherine

In 1317 St Catherine became a collegiate church and new chapels for the priests were built along the south side of the nave. At this time churches along the Rhine reflected the styles of the local great churches. Here the vertical, linear forms, the 'blind' tracery on wall surfaces, and such patterns as propellers were chosen eclectically from Cologne, Strasbourg, and Freiburg-im-Breisgau.

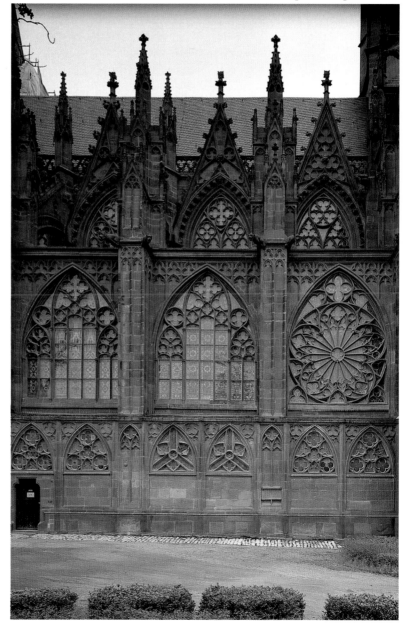

Peter Parler, who became
master mason in 1356,
developed patterns of vaults
and tracery that were to
influence central European
architecture for several
generations. The upper south
transept, above the
ceremonial entrance to the
cathedral, is clothed in
swooping, intersecting tracery.
The openwork staircase on a
corner buttress is stepped
back at intervals on the lines of
its support, and the mouldings
follow the angle of the stairs.

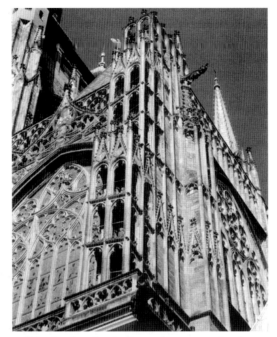

Brick was a common building
material around the Baltic; it
produced great variety of
pattern, colour, and texture.
The show façade, typical of
late medieval town halls in
northern Europe, has moulded
brick doorways, windows, and
tracery on the high gables. The
latter closely resemble Hinrich
Brunsberg's church of St
Katherine at Brandenburg;
Tangermünde town hall, built
in the 1430s, is probably by
one of his assistants.

at Eberbach, where the vaults are received on corbels, thus stressing the importance of the centre. A similar idea can be seen in such two-aisled churches as Wiślica (see **56**) and the former Dominican chapel, now Jacobin church, in Toulouse in south-west France (see **59**), although in the latter the vaults are received on slim wall shafts. Some of the most striking vaults and ceilings of this sort were fashioned from timber. The great lantern built *c*.1330 over the octagonal crossing of Ely Cathedral (see **97**) seems to hover in the air, supported on cantilevered timber vault webs. In parts of Spain such as Toledo, where Islamic craftsmanship continued in the so-called *Mudéjar* tradition, *artesonado* work interlaced rafters to create three-dimensional geometric patterns [**20**].

Net vaults at Bristol, Gloucester, and other buildings in the south-west of England were tracery in all but name. St Catherine at Oppenheim in the Rhineland [**21**] shows how tracery was no longer confined to windows and buttresses but decorated both interior and exterior walls in the form of elaborate arcading. Freiburg-im-Breisgau (see **73**) started a tradition of spires constructed like cages of openwork tracery. New shapes were introduced—trefoils, quatrefoils, curved triangles, and propellers. The ogee, or reversed curve, which appeared on metalwork and then in tracery from the late thirteenth century, transformed the geometric shapes into daggers and reticulations (see **13**). The tracery at Oppenheim is contained within a rigid frame, a format derived from Strasbourg Cathedral (see **64**), where the façade had been dressed with a facing of harpstring tracery that stands forward of the wall. Curvilinear or flowing tracery, as at Exeter Cathedral (see **65**), although just as symmetrical, denied the framework. It could,

however, be rigid, as in the fishscale motifs of the Lady chapel at Wells (see **91**). In central Europe the work of Peter Parler at Prague Cathedral from the 1350s [**22**] proved equal to the Sainte Chapelle in the extent and nature of its influence. The tracery and vaulting of later buildings are ultimately indebted to the variety and inventiveness of Parler's designs for Prague. The hall churches in the south— Nördlingen (see **135**), Dinkelsbühl, the choir of the Franciscan church at Salzburg—developed ideas adumbrated by Parler. In the north, gables on the brick buildings (*Backsteingotik*) of the Baltic region became surfaces for the display of ornate tracery patterns [**23**].

The clarity that had characterized architecture down to the late

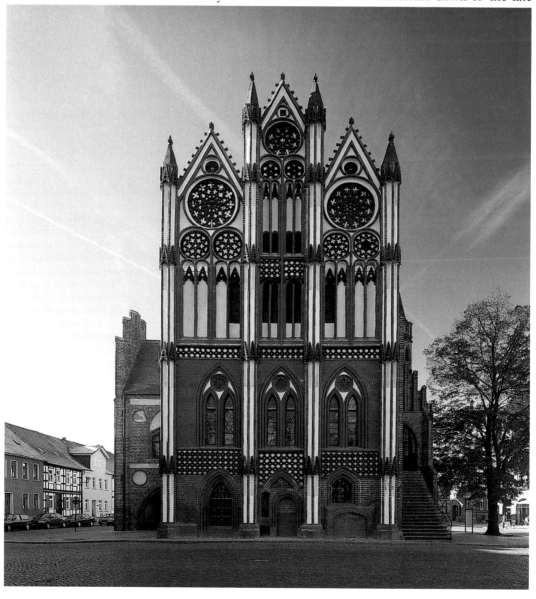

thirteenth century was increasingly rejected in favour of textured surfaces, softened edges, and play of light and illusionism. Capitals were often dispensed with as pier mouldings rose seamlessly into vaulting ribs, or else the ribs 'died' into the pier or wall. Brick, used in such regions as Scandinavia, the north Netherlands, and East Anglia, for want of good building stone, was favoured also for its decorative qualities. Spanish *Mudéjar* buildings in Teruel, Toledo, and elsewhere developed the possibilities of mouldings and tracery in brick, and by the fifteenth century, in such castles as La Mota and Coca (see **110**), the intricate, faceted packing of the bricks seems to dissolve the wall surface. At Tangermünde the mouldings cover the wall in a film of tracery, and also project forward as polygonal turrets. In late thirteenth-century England, rippling canopies created ambiguous depths above the wall niches of York chapter house and in the destroyed chapel of St Stephen in the Palace of Westminster. At Malbork Castle in Poland (see **107** and Box) high containing arches articulate the walls and windows of the Grand Master's palace so as to conceal their boundaries. Avoidance of obvious clarity was expressed also in angles and polygons. The mouldings on the south façade of St Catherine at Oppenheim are prismatic, presenting an angle to the spectator rather than the flat face. By the fifteenth century, pier bases were composed of numerous prismatic sub-bases; sharply angled, spiralling mouldings added a twist to the columnar piers of the Llotja (mercantile exchange) in Palma de Mallorca (see **81**). Masons based their design techniques on manipulating polygons: among the few surviving medieval writings on methods of design are texts devoted to designing pinnacles in this way (see page 68). Polygons were expressed overtly, as the end rather than the means. Some—the octagon at Ely (see **97**) or many castle towers, such as Caernarfon (see **108**)—were on the grand scale. Others were parts of a larger whole: the elegant oriel window on the corner of Ghent Town Hall (see **71**) or the polygonal spires of Ulm Minster (see **47**) and Strasbourg Cathedral (see **64**), which are attended by polygonal turrets and staircases. Miniature polygons carried over into the micro-structure of tombs and church furnishings.

The coverage of surfaces, enhancing plain walls with minutely precise, repetitive ornament to suggest precious metals and the jewel-like forms of reliquaries, was not to everyone's taste. In 1448 Henry VI, one of several medieval English kings who were active, knowledgeable patrons, stipulated 'that the edificacion of my said College of Eton procede in large fourme, clene and substancial, wel replenysshed with goodely windowes and vautes leyng a parte superfluite of to grete curi-ouse werkes of entaille and besy moldynge'.[13] After about 1400 two distinct aesthetic trends emerged from the superfluity. One empha-sized movement, the other arrested it. The former category developed

the implications of the fourteenth-century English Decorated style, in which ogee arches were bent forwards through space—the so-called nodding ogee—to create three-dimensional movement. The canopy over the portal of the St Lawrence chapel of Strasbourg Cathedral, made *c*.1500, is supported on three intersecting arches that swoop outwards. By the late fifteenth century the divorce between the vault and structural logic had led architects in Bohemia and the Empire to invent the twisting, petal-like curving and jumping vaults seen in, for example, the Vladislav hall in Prague Castle (see **4**), St Barbara, Kutná Hora, Annaberg (see **134**), and St-Maria-am-Gestade in Vienna. But it was not only vaults that turned and twisted. The tracery of Milan Cathedral (see **104**) was designed in swirling patterns. The columns of La Llotja at Palma are not unique: twisted piers were built at Braunschweig Cathedral in 1469, and the axis of Saint-Severin, Paris, was marked by a column with applied spiral mouldings. French conversion to curvilinear forms was late but fervent. Façades, windows, doorways, and porches were carved with flame-like tracery, tall ogee gables, intricate canopies, and deep, openwork parapets. Beauvais Cathedral was among several where transept façades were dressed in this way. A series of polygonal porches adorned churches at Falaise, Louviers, and other towns in Normandy. Figure sculpture emphasized the active, fleeting spirit of the style: in the house of Jacques Coeur (built 1443–51) in Bourges, sculptured figures lean over the balconies to survey the scene in the street below. One of the most memorable manifestations of the style, however, is the so-called Manueline work in early sixteenth-century Portugal. In the monastery of the Knights of Christ at Tomar (see **136**), door and window openings are almost literally alive with carved sea creatures, plants, cables, and political emblems.

24

Soběslav church, Czech Republic, detail of cell vault

The cell—or folded—vault is composed of prismatic cells sunk between the lines of ribs, which can themselves have no applied mouldings, as here. It was devised by Arnold von Westfalen, a master mason working in the later fifteenth century, mostly in Saxony, who was also responsible for the Albrechtsburg at Meissen (see **102**). Cell vaults became popular in Saxony and Bohemia, particularly for secular buildings.

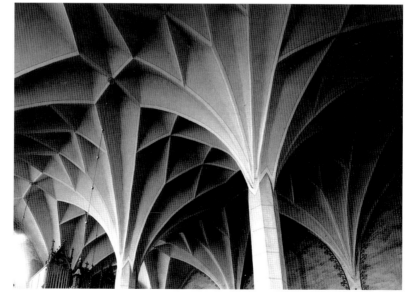

The taste for severe restraint, even if richly expressed, existed alongside the exuberance. In Portugal itself, tight ornament that is essentially static decorated the Capellas Imperfeitas of Batalha Abbey (see **100**). In England the fan-vaulted interiors of King's College Chapel, Cambridge, and the retrochoir of Peterborough Cathedral (see **34**) and the prismatic cell vaults of Germany and Bohemia [**24**] share this impression of stasis, as do the tightly packed, repetitive ornamental motifs that typify architecture in the Low Countries (see **70**) and Iberia. The political and artistic connections between these areas ensured that many craftsmen went to Spain from the north, which accounts for many similarities, but the tendency was already essential to *Mudéjar* work, as in the synagogue of El Tránsito at Toledo (see **20**). The quality of decoration in, for example the Condestable chapel at Burgos (see **101**) and even the looser, more open designs of S. Juan de los Reyes in Toledo [**25**], reflects its appeal to Spanish masons.

In many places, however, stillness was combined with movement, especially in France, where the Rayonnant tradition never quite died. Architects in the Norman capital at Rouen found a balance between them. The fifteenth-century parish church of Saint-Maclou [**26**] conceals a thin, flat, rectilinear interior behind a five-sided porch with huge openwork gables, which launches itself forward to the street (see **10f**). The sixteenth-century Palace of Justice has a façade covered in

25

Toledo, Spain, cloister of S. Juan de los Reyes

Originally intended as the burial church of the Catholic Monarchs (but see **132**), S. Juan was founded in 1476, and designed by the French master mason Juan Guas, one of the many craftsmen who came to Spain from northern Europe in the fifteenth century. They combined rich ornament and tracery with Islamic traditions in the style known as Hispano-Flemish.

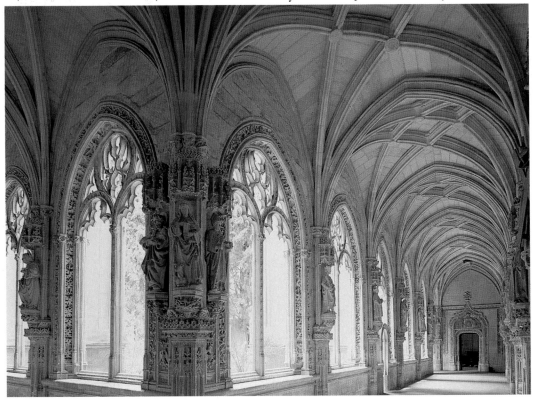

Rouen, France, Saint-Maclou, from the west

Saint-Maclou, which was planned from 1432, was one of the most important parish churches in the capital of Normandy. Situated east of the cathedral and the archbishop's palace, it lay on the processional routes for ceremonial Entries to the city made by royalty and leading churchmen, processions pausing in front of the church. The projecting west screen is decorated with an openwork parapet and gables filled with curvilinear tracery.

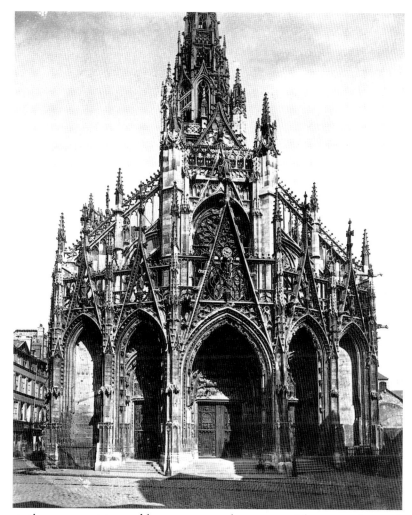

static ornament topped by an openwork parapet with ogee arches and small flying buttresses supporting gables over the dormer windows in the roof: a fantastical conceit similar in spirit to contemporary work in Bohemia, and like it, too, in that Bohemia and Normandy were among the parts of northern Europe that were the first to adopt the new classicizing motifs that were being brought from Italy. But the adoption of antique designs and architectural values represented something different from the imaginative creativity of the preceding centuries. Although masons of the fifteenth and sixteenth centuries had reversed the earlier taste for clarity, their changes were not radical: they used a similar architectural language. Why, during the sixteenth century, the first radical change in architecture for many centuries should ever have come about will be discussed in Chapter 7.

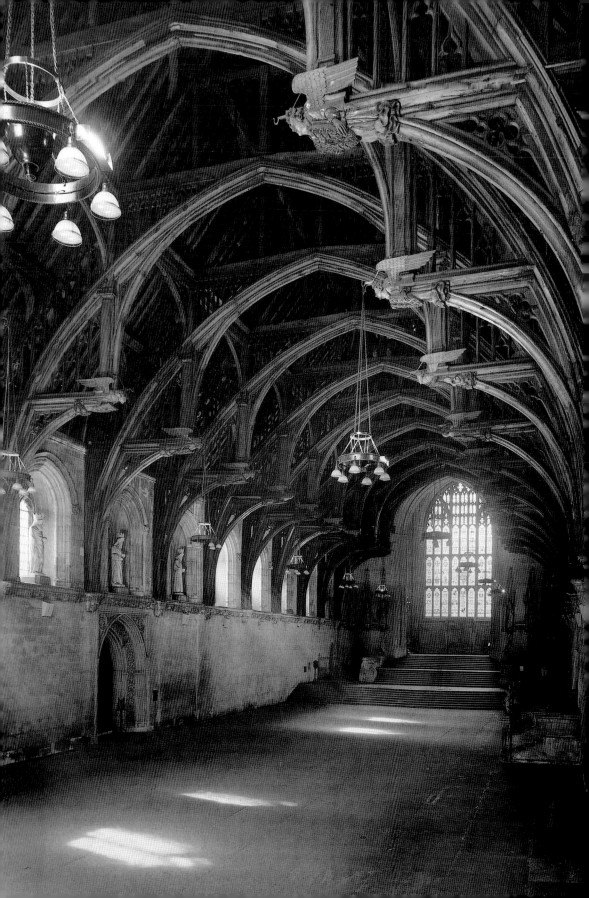

Structure and Design

'An honourable work glorifies its master, if it stands up': so wrote the German master mason Lorenz Lechler in his *Instructions*, a booklet on design that he composed for his son, Moritz, in 1516.[1] If *decorum*—a demeanour appropriate to the building's function and status—was one of the main principles of design, structural integrity was the other. Placing vaults securely on high, thin walls was a challenge to which twelfth-century masons brought experience and techniques, especially in buttressing, that they could develop in anticipation of new structural problems. But without modern theories of statics or the science of calculating building stresses, medieval architects could never be wholly certain that a particular solution would work. Even at the end of our period the leading masters of the day regularly foregathered to discuss a building project on the site—a process known as an Expertise. A typical figure was Jörg von Halsbach, architect to the city of Munich in the late fifteenth century. Among his responsibilities was rebuilding the parish church of Our Lady; but although he designed it, a number of masons were called from other cities to advise on the construction of the vault. In his turn, Jörg assessed the work of others in Ulm, Augsburg, and Hall in the Tyrol.

Vaults, however, were only part of the problem, since walls had to bear the additional weight of the lead-covered timber roof. Unlike some synthetic building materials, natural ones are essentially stable, but they act in different ways. Where masonry—brick and stone—is strong in compression, timber is strong in both compression and tension, and roofs were designed to move against the pressures of wind loading. This action affected the stiffer substructure. The upper walls of most great churches had to withstand the combined loads of the stone, the timber roof, and wind—only in the drier climate of the Mediterranean did builders avoid pitched roofs, giving Gothic cathedrals from Mallorca to Cyprus a flattened profile unfamiliar to a northern eye.

Stone structure and timber roof

If masons were unsure how their buildings would behave, they were not alone. The question is as alive now as it was in the Middle Ages. The

27

Westminster Hall, England, interior, looking south

The great timber roof was designed in the 1390s by the master carpenter Hugh Herland. Masonry walls 2 m thick, dating from the late eleventh century, were reinforced to take the weight. The rafters take thrusts to the outer edge of the wall. Triangulated with the projecting hammer beam and vertical hammer post, they help to keep the structure rigid.

locus classicus of Gothic structure is Viollet-le-Duc's analysis of Amiens Cathedral, and the argument is still conducted largely as a debate with his views (see **8**).[2] Vaulted in stone over high, thin walls rising more than 42 m to the vault, Amiens poses the problem of stability in an acute form. Viollet saw the system as a rigid, compressive structure. The walls, opened by passages and windows, were braced by the transverse arches and propped by the aisles. The vault ribs supported the webs. But enormous thrust was exerted on the upper wall by both the vault and the timber roof. Where the downward and outward pressure was greatest, just above the springing of the vault, stone arches—the flying buttresses—were placed against the wall to carry the forces out over the aisles to the huge vertical buttresses built against the outer aisle walls and through them to the ground. The higher rank of flyers absorbs the lateral forces exerted by the timber roof. In Viollet's reading, each architectural member has a precise function, interacting with the others to maintain equilibrium. Viollet saw a rigid, compressive system of balance and counter-balance, each masonry element designed to act in support of the others so that all were necessary to the whole.

The timber roof over such a structure needs more than flying buttresses to keep it braced, and by the thirteenth century carpenters had devised two principles of timber structure that lasted throughout the period and beyond. Both can be seen in the wooden roof over the nave of Notre-Dame, Paris, which was assembled in the 1220s, when the nave was remodelled [**28**]. The first introduced the tie beam, a horizontal beam spanning the building at intervals (here every fifth rafter), connected to the longitudinal wooden wall plates on which the rafter ends rest. This beam acts in tension, resisting the tendency of the coupled rafters to spread outwards. The second device is the important

28

Model of the timber frame above the nave vaults of Notre-Dame, Paris

The model, made in 1916 by H. Deneux, is of the timber roof built originally in the 1220s when the nave was remodelled. Novel features, introduced to increase structural stability, include longitudinal bracing timbers, the use of horizontal tie beams at the wall head, and triangulation: the right-angled triangles provide compression to the lower rafters.

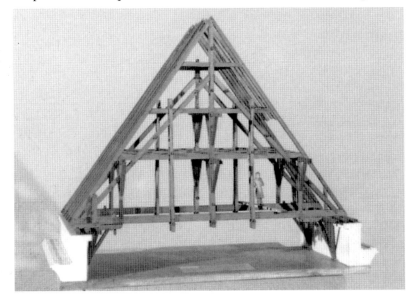

principle of triangulation. Compression is introduced near the base of each rafter by creating a right-angled triangle using a small vertical strut. This compressive triangle creates structural rigidity at the foot of each rafter, with a secure fixing to the longitudinal wall plate. The carpenters of Notre-Dame, however, introduced a third element: timbers supported on the struts and running the length of the roof to brace it longitudinally as well as across the span.[3] The rafters descend to the wall plate and transverse sole pieces resting on the top of the masonry wall, which at this point (35 m above the ground) is only 760 mm wide. The tie beams are in fact braced into the masonry parapet wall above the vault; both these braces and the rafters convey the loadings down through the masonry to the flyers and vertical buttresses.

Yet at Notre-Dame, owing to the presence of the stone vault, you cannot appreciate the co-operation needed between the master mason and the master carpenter to ensure the structure's integrity. Even such magnificent works of carpentry as the roof of York chapter house (1280s) or the lantern over the octagonal crossing at Ely (see **97**) are concealed by vault webs (which, ironically, are made of wood). But even in secular halls, where the meeting point of stone and timber is open to view, the true workings may not always be obvious. The eleventh-century great hall in the palace of Westminster [**27**] was refurbished in the 1390s by the master mason Henry Yevele and the master carpenter Hugh Herland. Yevele strengthened its masonry walls to carry Herland's enormous new hammer-beam roof, more than 72 m long with a span of nearly 21 m. The hammer beams, which jut horizontally from the wall head, their ends augmented by figures of angels, enable a wide space to be roofed in a single span, without floor posts. Westminster Hall is the culmination of the development of a technique that stretched back to the early thirteenth century. It manages to look both spectacular and logical. The structural behaviour of the timbers is debated,[4] but two interlocking systems seem to be at work. As at Notre-Dame the rafter couples are triangulated, both at the foot, and halfway up, and are braced longitudinally by the heavy purlins and the ridge piece at the apex, axial timbers that carry most of the weight of the rafters. The purlins are, however, tenoned into the second system, the great wooden arches that rise from heraldic stone corbels set halfway down the masonry wall, and are tenoned into the hammer beam and the vertical hammer post. While the hammer beam acts in tension to constrain any outward thrust from the rafters, the hammer post and the great arch convey vertical dead load and horizontal thrusts down to the corbels. It is at this level, not at the wall head, that the masonry absorbs the weight of the timber roof. The interstices of this great structure are filled by openwork panels of slender timbers. Exemplifying the medieval taste for visual deception Hugh Herland deflected attention away from the working elements with displays of

heraldry, angels, and delicate panels of tracery, in a manner that we have already observed in masonry structure.

The continued use of the rigid triangle and longitudinal bracing in roofs of differing designs suggests caution and pragmatism. Yet all these buildings experienced structural difficulties: by the late fifteenth century iron chains were run through the triforia of Amiens to prevent the crossing piers from buckling, and as we shall see in the next chapter, patrons worried perpetually about stability. Does this indicate that builders did not know what they were doing?

The medieval mason and the modern engineer

In Milan from about 1390, local masons called in a succession of northern masters to advise on the design of a new cathedral. Like its contemporary, S. Petronio in Bologna (see **143**), this building was to be on a large scale. But the patron, Duke Gean Galeazzo Visconti, wanted it to be modelled on the type of a French great church, which was not popular in Italy, and by this time was built only rarely in northern Europe. The meetings were decidedly fractious, but in the course of the exchanges the French master, Jean Mignot, asserted that pointed arches exerted less lateral thrust than round-headed ones.[5] Contributions by structural engineers to the debate begun by Viollet have not only modified the latter's view of a rigid structure but also confirmed that comprehension was not the master mason's problem: his difficulty lay in finding the correct solution.

The first person seriously to question Viollet's analysis was Pol Abraham, who asserted that the ribs did not act in support of the vault web.[6] Abbot Suger himself had illustrated the independence of the ribs and webs when he described how, during construction, the skeletal arches of the unfinished superstructure at Saint-Denis survived a violent storm,[7] and we can see at Ourscamp Abbey, near Noyon [**29**], that some of the vault webs have fallen, leaving the ribs intact. But at, for example, Waverley Abbey in Surrey [**30**] the reverse has happened: the ribs have fallen, but the webs are holding strongly. The curvature of the vault web forms a shell structure, which can support itself independently when the mortar has dried, so that while the ribs may be useful in construction, their supportive role ceases when the vault has set. The rib is now seen also as an aesthetic device to conceal the rough joins at the creases of the vault webs, and possibly to provide stiffening where the shell is at its weakest; but here structural engineers disagree, for experiments have produced different assessments of weakness in the shell. Photo-elastic modelling, which simulates loading on scaled and weighted models, and finite element analysis, which studies stress on discrete parts of a structure, give only approximations and averages that do not seem to apply closely enough to existing buildings. The extreme

29

Exposed vault ribs at Ourscamp Abbey, France

In the choir aisles of this ruined Cistercian church the vault webs above the *tas-de-charge*—through stones above the springing level—have fallen, leaving the ribs exposed. The ribs would have helped to support the vault while in construction, but afterwards their function was mainly decorative. Ourscamp is near Noyon, whose bishop founded the abbey in the twelfth century. The choir was rebuilt in the 1240s and 1250s, under stylistic influence from the new work at Saint-Denis.

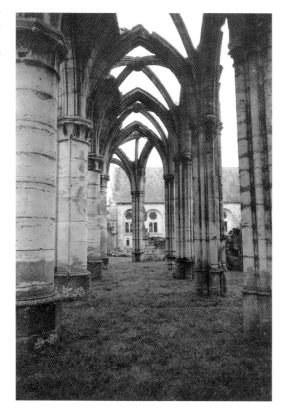

30

Vault webs at Waverley Abbey, England

In this rib-vaulted room the ribs have fallen, leaving the shell structure of the webs intact. This is the opposite to what happened at Ourscamp (see **29**) and demonstrates the independence of the ribs and the webs.

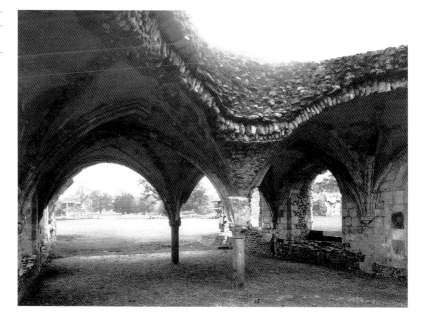

folding of the crease in cell vaults, although on a small scale, suggests that the crease is not dangerously weak. Yet all now agree that Viollet's notion of balance and equilibrium was too limited. Heyman has shown that arched masonry structures crack as they settle, and that this is both natural and safe, the separated parts standing on their own as a series of independent arches. Mark's model experiments have identified the causes and areas of tensile failure in masonry. Atop each wall buttress of Amiens Cathedral and countless other churches stands a handsome pinnacle, which completes the design and adds to the decorative quality of the exterior. But it has a precise function, helping to pin the wall buttress in its vertical position and counteract the tensile forces present in the masonry when the buttresses are under pressure.[8]

The pinnacle, then, was used for a structural purpose. Moreover, the development of patterned vaults, with nets, stars, and lozenges of ribs spread over the surface, suggests that shell structure and the behaviour of ribs were already fully understood at least by the late twelfth century. Most of the solutions were found in these early years, for it was then that patrons were commissioning the high buildings that produced most of the difficulties. With flying buttresses we can see genuine evolution as the masons both anticipated their requirements and modified the designs according to what seemed to work. The huge wall buttresses in Notre-Dame, Paris, for example, were built to support the complex flyers that would not be needed for many years, but which had to be anticipated in the initial planning; and the changes to a flatter arch for the flyers themselves, which can be traced through the second half of the twelfth century, were as much structural as aesthetic [31].[9] Masons were generally concerned with maintaining the stability of the

31

Flying buttresses of Bourges Cathedral, France

Bourges has double aisles flanking the main vessel giving five storeys; hence two sets of buttress piers and two double ranks of flyers. The chevet buttresses were in place by 1214. They are notably lean and elegant, the arch a shallow arc beneath the straight, thin extrados.

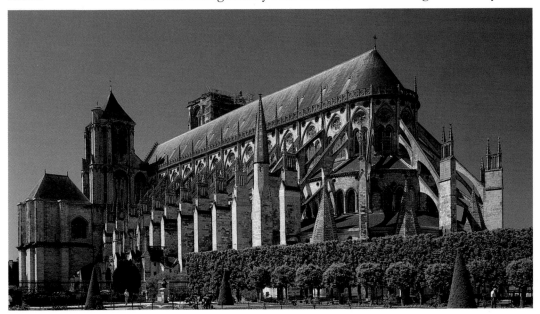

building and preventing spread. The weak, dangerous area between the clerestory windows where the vault met the wall was strengthened by the device known as the *tas-de-charge*, a set of through stones that combined the wall itself with the springing levels of the vault (see **8**), and the pockets between the webs were filled with rubble to absorb some of the stresses. The buttresses were positioned in exact relation to the *tas-de-charge*, and they failed if they were wrongly placed. At Amiens and Bourges Cathedrals, with variants at Canterbury and Lincoln, the triforium passage has semi-circular relieving arches built into the upper main wall of each bay. These disperse the vertical loading from above and help to tie the longitudinal axis of the building. To prevent the piers from spreading the masons inserted wood or iron tie bars above the capitals of the ground storey. Ties survive in many buildings from the Baltic coast to Venice (see **57**). In S. Fortunato at Todi in Umbria the piers are braced by stone struts across the aisles. The tops of spires were loaded with rubble to keep them stable. Yet not all the devices found in medieval buildings were built in anticipation of problems. We have already seen that the crossing piers at Amiens had to be rescued with iron chains; and the upper rank of flyers along the nave of Chartres Cathedral were built only in the fourteenth century when the thrust of the timber roof threatened the upper wall.

But although the masons' efforts look rational enough and certainly work, the scant records give a less reassuring picture. No written structural theory survives from the Middle Ages; the little notebooks produced by German and Spanish masons in the late fifteenth century and the mid-sixteenth are not theoretical but prescriptive in nature, instructing how to do something rather than the theory of doing it. The sources all indicate that the masons identified stability with aesthetics: that if the proportions (or 'measure') were right—*decorum* again—the building would remain standing. What is disconcerting is that they could not agree on the right proportions. This was the core of the debate in Milan. In total disagreement on the way forward, the two sides resorted to a mixture of empirical observation—that marble is stronger than limestone—and local aesthetic traditions, notably the ideal size of buttresses relative to piers. The latter figures had nothing to do with the requirements of the particular structure, but were derived from habit and were produced under the pressure of argument rather than for practical application.

We have, then, a mixture of the pragmatic and the folkloric, in which pragmatism predominates. In the early years, for example, the masons developed buttresses and other stabilizing techniques while staying close to tradition in other respects. This is why the break with Romanesque architecture was not sudden. In the twelfth and thirteenth centuries thin-walled, vaulted structures were built over plans of piers and bays that had been devised for earlier systems. The

32

Mantes-la-Jolie, France,
interior of Notre-Dame, looking
east

32

Mantes-la-Jolie, France,
interior of Notre-Dame, looking
east

Mantes, one of the new great
churches of the Ile-de-France,
was vaulted in the 1180s. It
has the alternating system of
'strong' compound piers,
which carry the transverse
arches and main ribs, and
'weak' columns, which carry
an intermediate transverse rib.
This creates a single vault in six
parts over two main bays. The
alternating system and
resulting square vault bay
continues an earlier tradition.

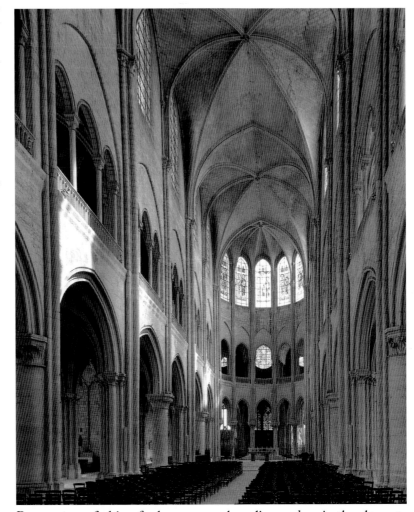

33

Florence, Italy, interior of S.
Maria Novella, looking east

In this Dominican church
begun by 1279 the bays of the
main vessel are square, with
rectangular aisle bays. The rib
vaults are domed, in marked
contrast to the flatter vaults of
northern Europe. A domical
vault needs little or no
centering in its lower courses
and exerts less diagonal
thrust, so buttressing can be
unobtrusive.

Romanesque fashion for large square bays lingered on in the alternat-
ing system of piers, whereby cruciform or compound piers alternated
with simple columns: the 'strong' compound piers carried the trans-
verse arches over the main vessel and the diagonal ribs; the 'weak'
columns carried transverse ribs that created a vault in six parts, based
on the square formed by the strong piers [**32**]. In most north
European churches the sexpartite vault did not survive the adoption
of rectangular bays by the mid-thirteenth century; but it lingered on
in the Baltic region and in Italy, where the square bay remained fash-
ionable. In S. Francesco, Bologna, founded in 1236, there are
sexpartite vaults over an alternating system; S. Maria Novella in
Florence [**33**], begun by 1279, has a quadripartite vault over single,
square bays. These have a high, domical profile quite different from
their northern counterparts. As so often in Italian building there is a
practical reason for this: all arches had to be shaped over wooden cen-
tering until their keystones were in place, but the lower courses of

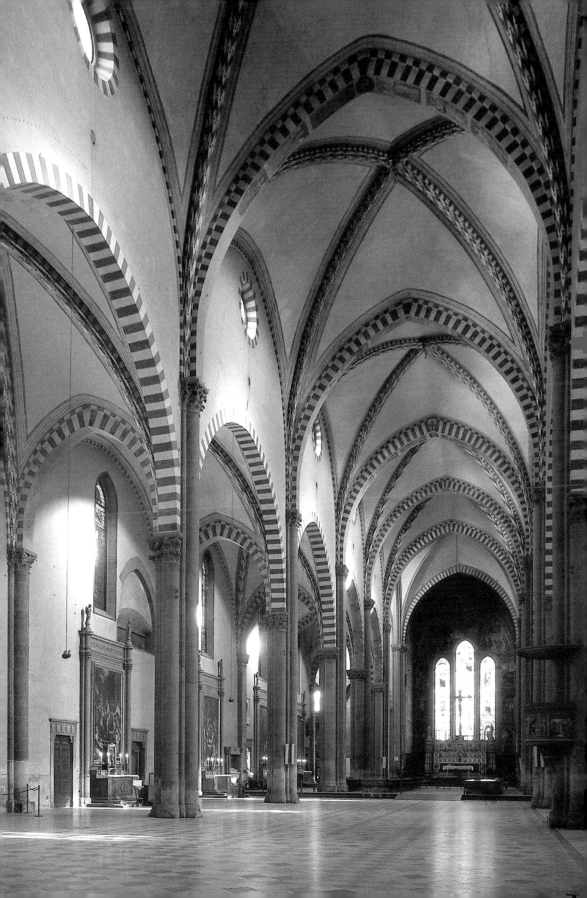

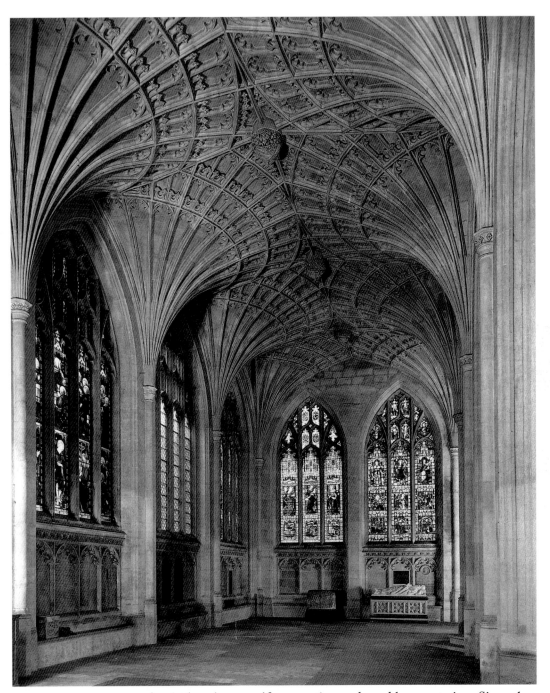

domical vaults are self-supporting and need less centering. Since they also exert less diagonal thrust buttressing can be reduced.

In England, too, buttressing was reduced, but for different reasons. There the fondness for squat, thick walling had survived centuries of influence from across the Channel, so that the walls continued to absorb much of the vault thrust, as in Romanesque architecture. By the

Peterborough Cathedral, England, retrochoir, looking south

The late medieval fan vault, exclusive to England, is a series of inverted conoids held by their upper compression rings and the flat, lozenge-shaped interstices. Ribs of identical curvatures rise from the springing to divide and sub-divide into blind panels. In this interior, built *c*.1518, the further tracery panels on walls and in windows give a rich, static effect.

end of the period greater confidence in the relation of the vault to the wall gave rise to a revolutionary kind of vault: the fan vault [**34**]. Fan vaults are conoid in shape and covered in rectilinear panels of blind tracery that subdivide across the surface from the base. The effect is rich but also static, since the underlying cone shape gives all the ribs the same curvature; and the cone itself is enhanced by the angle of the ribs, which are carved at right angles to the vault surface.[10] The cone is the ultimate shell structure, held by vertical and horizontal forces at the springing level, and by a compressive ring of masonry around the top edge. The flat lozenges with large sculptured bosses in the spaces between the fans give the rings their compressive strength. The fan vault in the New Building or eastern retrochoir of Peterborough Cathedral, which was built *c*.1518, shows how, as with pinnacles, structural necessity was inseparable from visual effect: the compressive ring at the outer edge of each fan is incorporated in a design of three horizontal ribs encasing delicately ornamented panels of tracery. The pockets of the Peterborough vault are half filled with rubble to distribute the forces over the backing wall. Like other fan vaults, it is made up of many separate pieces of stone. The lower sections, where the ribs are plain, are of rib-and-panel construction; that is, the ribs are cut from the same piece of stone as the backing panel. This helps to stiffen the vault near the *tas-de-charge*. As soon as the horizontal ribs are introduced, however, the method changes to jointed masonry, the joints carefully worked out to respect the decoration. Setting out the different curvatures of such stones required great professional skill, and was done by methods quite different from those in use today.

Constructive geometry

The Expertise at Milan was called initially to discuss the proposed transverse section of the cathedral, which was to be accommodated in a notional triangle within a square. The debate concerned the shape of the triangle, and which proportions would give the greatest stability. Medieval design is based on proportion. Architects identified structural integrity with correct proportion, and all aspects of design—stability, appearance, shapes of worked stones—followed the same method.

The master mason thought essentially in three dimensions. One of his principal tasks was to produce templates for every worked stone in the building, patterns for the top, bottom, sides, front, and rear of each one according to its position. He envisaged the structure, from the space frame to individual mouldings, in totality, and he drew up the design by relating the parts to the whole. Several sources give hints to the working method; although they are late medieval they evidently draw upon a long tradition. The Regensburg Ordinances, a set of regulations drawn up in that city in 1459, created a Brotherhood of

Masons who agreed to obey certain precepts. Whether the Brotherhood lasted any length of time, or even effectively existed, is debatable. What concerns us is one of the articles the masons swore to uphold: 'If someone wants to undertake stonework with Measure [*Mass*] or an extrapolation device [*Auszug*], which he does not know how to take out of the base plan [*Grund*], and he has not served a workman or enjoyed lodge promotion, then he should not in any way undertake the task.'[11] What is described here is the ability to take the elevation from the ground plan, that is, to create the proportions and measurements of the elevation from those of the plan. Lorenz Lechler's *Instructions*, quoted at the beginning of this chapter, show how this should be done. In designing a church the width of the choir was to be the module that should generate all the other main measurements—lengths, heights, and widths. The outside walls should be one-tenth the width of the choir, and this wall thickness should generate the smaller measurements of buttresses, windows, mullions, and transverse ribs. Proportional ratios were used to determine the cross ribs. Lechler was concerned with contemporary German hall churches with aisleless choirs, but his precepts, or others very similar, were applicable to earlier and more complicated buildings. Taking the measure of the ground plan was a matter of using the key dimensions in the plan to generate the main divisions of the elevation. It was a modular principle that established a set of proportions that could be reproduced horizontally and vertically throughout the building. A group of drawings seems to demonstrate how to achieve the curvatures of patterned vaults from a ground plan, by projecting arcs [**35**]. They all use the same method, which has been tested on a small-scale model and shown to work: the lengths of the different ribs were marked along a continuous line, and produced to meet the curve of the principal arch. The curved section between the vertical lines gives the curvatures of the particular ribs.

The proportions were fixed and the building set out by a process now known as constructive geometry. Using his drawing instruments—the mason's square, compasses, and straightedge—the craftsman established the main dimensions by manipulating geometric figures: circles and polygons. Polygons produced the triangle within a square that was the basis for the transverse section of Milan Cathedral. The choir of St Lorenz, Nuremberg, begun in 1439, was set out on a triangle and a circle: the three straight bays were set out on an equilateral triangle with its baseline at the east end of the thirteenth-century nave; the apex of the triangle is the centre of a circle on which are drawn the seven sides of the ambulatory [**36**].[12] There is evidence that the apse chapels of Saint-Denis were set out on a 13-sided polygon, and that for the east ends of Sens and Canterbury Cathedrals the architects used a nine-sided figure (see p. 187).

35

The technique of vault projection

A master mason had to know how to obtain the elevation, including the vault, from the dimensions of the ground plan. This is one of several late medieval drawings that indicate how curvatures were fixed. Two arcs were drawn and the ribs numbered off along a continuous line. The curve between two numbers was that of the relevant section of rib.

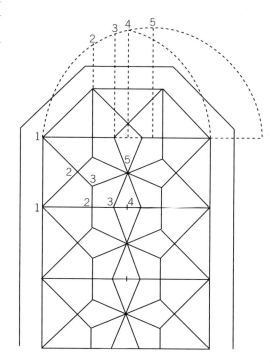

36

Setting out the choir of St Lorenz, Nuremberg

Constructive geometry used circles and polygons to set out full-scale plans. Here the church choir is set out on an equilateral triangle and a circle with its centre at the apex of the triangle. All the principal points of the plan are contained within these figures. Altar 1 is that of St John the Evangelist, 2 the high altar, and 3 the St Bartholomew altar with the Krell altarpiece (see **93**). A line (AB) through the centre of the circle marks the position of other important altars.

Key to altars

1 St John the Evangelist
2 High Altar
3 St Bartholomew, with Krell altarpiece

37

The derivation of some proportional ratios from polygons using constructive geometry

(a) √2 is derived from the diagonal of a square, and if the diagonal is produced to the baseline the result is a √2 rectangle.

(b) The Golden Section, related to √5, is obtained from the diagonal of half a square.

(c) The height of an equilateral triangle is √3 x half the baseline.

Polygons are also the source of proportional ratios based on irrational numbers, and it was these that established the lesser dimensions within the building—widths of aisles, window sizes, mullions, and so on. Once the basic measure was decided, all other dimensions in the building could be established by use of such ratios. There was no need to work them out afresh for each usage; their numerical equivalents were well known, as was the method of obtaining them, which was based on formulae involving simple additions. The ratios most commonly found in medieval buildings are the sequences based on √2, √3, and √5 with the Golden Section. The √2 ratio, formed from the side and diagonal of a square, was exceptionally easy to construct without calculation, and the rectangle derived from producing the diagonal to the baseline is found often in both ground plans and details [**37**]. Squares were rotated at 45° to produce a series of √2 proportions that could be used in any number of ways, as in Mathes Roriczer's *Booklet on Pinnacles*, published in 1486, which shows how to establish the

38

Mathes Roriczer's prescription for designing a pinnacle by rotated squares

Successive stages are based on dimensions derived from turning a square within a square by 45° stages. Many pinnacles and similar elements were designed in this way, the turned squares overt in the profile. The Roriczer family of masons was responsible for building the west façade of Regensburg Cathedral in the fifteenth century.

1 The cloister inner square
2 The square is rotated to obtain the width of the cloister walks
3 $\sqrt{2}$ rectangles generated from the diagonal of the larger square

obtain the east, north, and south ranges
4 and 5 $\sqrt{2}$ rectangles generated from the cloister and east range produce the width and length of the friary church

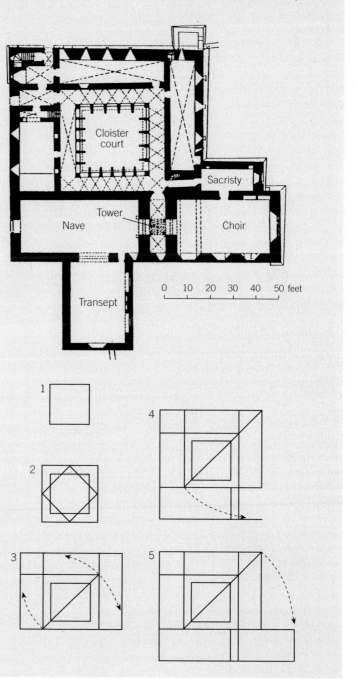

Rotated squares from the Notebook of Master W. G.

This drawing, dated 1572 and initialled WG, shows the outline of a chamfered window mullion drawn within rotated squares. The squares were drawn from larger dimensions in the building, relating the size of the mullions proportionally to other features of the design.

41
Allegory of Geometry from the *Hortus Deliciarum*

Destroyed in 1870, this encyclopaedia of biblical, moral, and theological material was compiled by Abbess Herrad of Landsberg in the late twelfth century. The figure representing Geometry holds giant compasses and a straightedge to indicate the association of geometry with architecture, a link made in treatises on the liberal and mechanical arts going back to antiquity. It was architects, carpenters, and land surveyors, who needed measuring skills, who kept alive the metrological traditions of antiquity.

successive storeys of a pinnacle by rotated squares [38]. The same principle was used for spires. The layout of the fifteenth-century friary at Muckross in Ireland was based on the square of the cloister garth: the cloister was established by rotating the square, and from there compasses made √2 rectangles to form the buildings ranged around it [39]. From these further √2 rectangles established the dimensions of the friary church. At the other end of the scale, the notebook of Master W. G. demonstrates how a moulding profile was designed within rotated squares [40].

Constructive geometry was not invented in the Middle Ages. The manipulation of geometric figures and the deployment of ratios derived from irrational numbers were ultimately descended from ancient mathematics. The link between geometry and architecture was recognized in philosophical writings, which were recycled in medieval treatises: in the twelfth-century *Hortus Deliciarum* (Garden of Delights), by Abbess Herrad of Landsberg, the allegorical figure of Geometry holds compasses and a straightedge [41]. In about 1250 Robert Kilwardby, the Dominican Archbishop of Canterbury, wrote *De Ortu Scientiarum*, a treatise on branches of knowledge in which, concerning the liberal and mechanical arts, he observed, 'Does not geometry teach how to measure every dimension, through which carpenters and stoneworkers work?'[13] This was more than mere inherited convention, for it was above all the building craftsmen, together with the surveyors (*agrimensores*), who measured land surfaces, who needed to know how to make and quantify exact measurements: they kept alive a metrological tradition that few other people required. Nevertheless, the constructive geometry used by building craftsmen had long lost its connections to ancient mathematics, and the rediscovery of Greek philosophers through Arabic translations from the twelfth century had

no effect on them. Circles and polygons were useful devices that did not require mathematical exactitude. Masons needed to know how to use geometric figures, but they did not need to know the theoretical basis of their actions. Their training path was through practice on the building site, not the classroom: there is no evidence that educated clerics tried to teach mathematics to craftsmen; and if they did, they were ignored. When the Milanese called in a university mathematician, Gabriele Stornaloco, to help them with their geometry, they rejected his proposals because they compromised their own, craft-based methods. Lechler's *Instructions* and Roriczer's *Booklet on Pinnacles* may well have been composed in reply to the sophisticated new mathematics emanating from humanist Florence, in particular *De Re Aedificatoria*, the architectural treatise by Leon Battista Alberti, which was published in 1485, but had been written thirty years before.[14]

Architectural drawing

If architects' drawing instruments were important in allegory, so they were in metaphor. To medieval scholars the great architect was God, who in His role as creator of the universe was depicted encircling the globe with giant compasses [**42**]. One of the earliest references to a genuine architect at work is Gervase of Canterbury's description of William of Sens making 'moulds' for the restoration work at the cathedral. Moulds were templates; and the ability to draw up designs is what distinguishes a master mason from his journeyman colleagues. In the thirteenth century one version of the *Dictionarius* of John of Garland could use *pourtrere* as a synonym for *architectrari*, apparently to mean the entire practice of building, from design to execution.[15] During the later Middle Ages architects produced drawings of not only templates but detailed studies of parts of buildings; mouldings had become more complex and patrons demanded drawings of what was proposed. There is more tangible evidence of masons' talent for drawing, as in, for example, the *Leaf-Pattern Book* produced by Hans von Böblingen in 1435. This has ten pages of designs for sculptures of leaves and fruit to be used for decorative work [**43**] which are finished drawings in their own right. Some scholars see in the emphasis on drawing a trend away from the mason as builder towards the architect as designer. Later medieval masters had such large practices that they were often not present at the building site: in the 1430s Pierre Robin, a master mason from Paris, provided a 'complete drawing' of the church of Saint-Maclou in Rouen, but the church itself was built by others.[16] Yet neither Pierre Robin nor his successful colleagues was an architect in the modern sense that this implies. Unlike his modern counterpart, Pierre Robin knew how to build. His training on the building site gave him the knowledge of the curvatures that would produce strong arches,

God as Architect of the Universe

In this thirteenth-century moralized bible (an illustrated biblical commentary) the enthroned God holds a globe in his left hand and giant compasses in his right. Since he was the supreme Architect, the term was little used in the west to denote human architects. The architect was the master mason, and different types of mason were described by the work they did in the building and quarrying crafts in which they were trained.

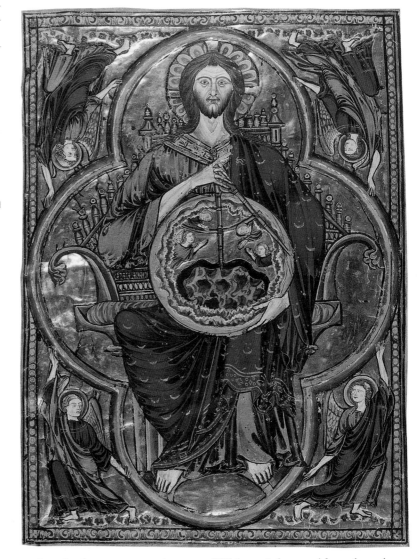

vault webs, buttresses, and towers. Without it he would not have been able to design the templates for the stones to be worked. Drawing, however sophisticated it became, was the product of practical craft skills, not a substitute for them. Craftsmen other than professional masons may well have contributed designs for a building's appearance, as in the 1330s, when Jean d'Autheuil, who was apparently a painter, made an expensive 'pictura' for Notre-Dame of Paris. But Jean would not have been able to work out the structural implications of his design, which was actually built by the master mason, Jean Ravy;[17] and it is the identification of the design with the structure that characterizes the practice of architecture in the medieval period. Even fifteenth-century architects practised the mechanical rather than the liberal arts.

By the fifteenth century a master mason was expected to produce intricate drawings. Head of a dynasty of masons working in Strasbourg, Ulm, and Esslingen, Hans compiled ten pages of studies of fruit and foliage in 1435. The ribbed, spiky foliage, with sharp, metallic edges and indications of deep undercutting, is typical of contemporary work in sculpture [**44**] and metal.

Pierre Robin's 'complete portrait' does not survive, and it is difficult to know its exact nature. He certainly made templates for all the mouldings in the church, for Saint-Maclou is strikingly consistent on both proportion and style throughout. The implication is that he drew a plan or elevational sketch to show the clients what they were getting, a procedure that is attested by contracts and drawings from other sites. The drawings of vault projections that were considered above are among the surprising variety of medieval architectural drawings, on parchment, in manuscripts, and in illustrated notebooks like those of Lechler and Roriczer; drawings were also incised on the stone surfaces of the buildings themselves. The latter are unequivocally working drawings; but many of the former were only loosely connected with the building process. Their survival is patchy and accidental. The earliest known, the so-called Reims Palimpsest of the 1230s, was preserved only because the material was scraped and reused in a collection of obituaries and ceremonials of the diocese of Reims. The majority of the others were kept in the offices of such long-established building works as Strasbourg, Vienna, and Ulm. Parchment drawings like these can be huge. The great drawing F for the west façade of Cologne Cathedral, including the towers, is 4 m high, made on eleven membranes joined together; and many of the drawings at Strasbourg and Ulm are 2 or 3 m, again on several membranes. They are usually drawn in ink, with metal-point; if there is no trace of metal-point the drawing

Foliage sculpture was used extensively for decoration, as background to monumental figures, or inhabited by human figures, animals, or grotesques. It adorned capitals, keystones, corbels, door- and window-jambs, walls, and liturgical furnishings. Its prominence depended on contemporary taste, from relative austerity in the late twelfth century to lush exoticism in the fifteenth and sixteenth. Foliate capitals continued a tradition that survived from antiquity. In the twelfth century they were still recognizably derived from the Composite order, with layers of stylized acanthus leaves and coiled volutes at the upper corners, but designs then moved away from their remote prototypes. New foliage designs spread fast and uniformly, with regular changes of fashion that make them a reliable guide for dating a building. Examples (c) and (d) here are from successive phases of construction at the same church, indicating that the transept was built before the nave. Despite variations within foliage types, however, it is not possible to isolate the work of individual craftsmen since many hands worked on the same pieces: at Exeter Cathedral, for example, a visiting mason was paid to finish a keystone that had been started by someone else.

Crockets (a) evolved in late twelfth-century France, whence they spread with other French characteristics as far afield as the Holy Land (Jerusalem, Room of the Last Supper, before 1187). Still just reminiscent of the Composite capital, the flat, broad leaf with a prominent central stem bends over into tightly curled volutes.

Stiff leaf (b) is a thirteenth-century English form, in which swirls of deeply undercut leaves curl in windswept bunches. It can also be inhabited.

From the later thirteenth century there was a brief fashion for carving leaves, flowers, and fruit with great attention to naturalism (c). Many fruits and flowers were symbolic: here the grape vine represents Christ and the Eucharistic wine. By the fourteenth century naturalistic leaves had been elongated into stylized, undulating, and bubbly seaweed (d), which later developed into spikier, less bulbous forms.

Astwerk or branch ornament (e), here a vine stem with pruned shoots, appeared in late fifteenth-century Germany.

44
(a) Crocket, south transept of Laon Cathedral, France, 1170s
(b) Stiff leaf, nave of West Walton parish church, Norfolk, c.1240
(c) Naturalistic, transept of former cathedral of Toul, France, 1280s
(d) Seaweed, nave of former cathedral of Toul, France, late fourteenth century
(e) *Astwerk*, west chapel of Ingolstadt parish church, Swabia, c.1520

(a)

(b)

(c)

(d)

(e)

45

Drawing of the buttresses and a plan for a tower at Prague Cathedral

Drawn in the late fourteenth century in black ink on parchment, the plan at the top of the sheet, probably of the unexecuted north tower, shows how successive storeys were depicted in a single image. Inside the piers at the base is the square upper storey enclosing the octagonal spire, with four octagonal turrets.

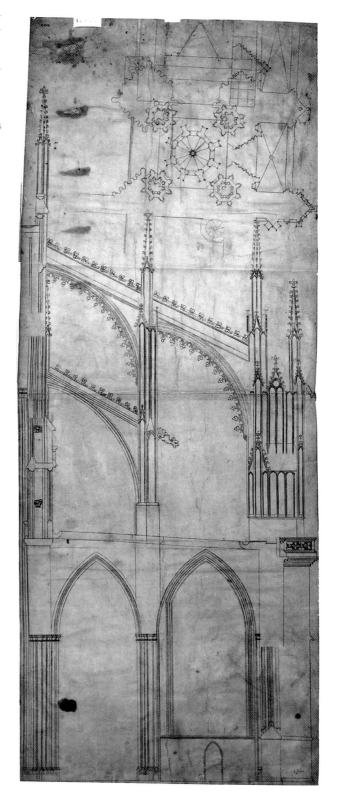

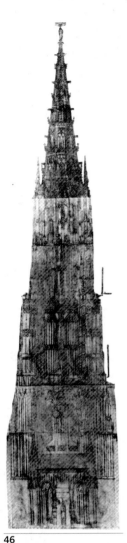

46

Drawing for the west tower of Ulm Minster, Germany

Matthäus Böblinger produced this drawing c.1477 (see **47**). He continued the original design but suggested refinements to the transition to the octagon. The spire was completed only in 1890.

47

Ulm Minster from the south-west

The immense tower was begun in 1392 by Ulrich von Ensingen. In the late fifteenth century, when the tower had reached the lower stages of the octagon, structural failure forced modifications to the west end and interior of the church.

is probably a copy from the original. Such drawings as the detail of the façade of Strasbourg Cathedral made c.1360 are beautifully coloured and detailed, and must be classed as study drawings or those made for presentations to clients.

The consistent character of these drawing collections suggests that they are a representative sample. They are nearly all of façades, layering of towers and staircases, and small components; few show the main space frame and none is scaled. In other words, they concern the relation of parts to each other and details of two-dimensional appearance, not three-dimensional space. A late fourteenth-century drawing in Prague [**45**], however, does show, if not the space frame, the double-rank buttresses of the cathedral. Differences in detail from the building itself suggest that this is another study drawing; but the small plan at the top of the sheet is typical of the way towers were shown as a series of superimposed levels. Probably a plan of the north tower that was never built, the great piers at the base have complete profiles of their mouldings and spiral staircases in the angles; the bays of the adjoining porch are drawn alongside. In the centre are the details of the top of the tower: a central octagonal spire with buttresses and eight windows, and four flanking turrets of similar shape. A mason would have been able to envisage the tower's structure at a glance.

Some drawings similar to the Prague design seem to have been made after the structure was built; but the drawings of the west tower of Ulm Minster are interpreted as designs produced by successive masters who worked on its construction [**47**]. The tower has five stages: the porch level, the first upper level with the St Martin window, the second upper level, the octagon and the openwork spire. Ulrich von Ensingen, who began the tower, produced a complete drawing, but by 1419 had built only up to the eaves of the porch; the St Martin window and the triple arches in front were constructed by the next three masters; then Ulrich's grandson, Moritz Ensinger, produced a new design for completing the tower in about 1470, although he managed to build only the second upper level and lower part of the octagon. Moritz's successor, Matthäus Böblinger, made a third drawing for the tower [**46**], which improved the transition between the rectangular and octagonal storeys. He added the rows of intersecting nodding ogees that decorate the spire like a papal tiara. Owing to Ulrich von Ensingen's inadequate preparation the structure then began to fail, and it was completed only in the 1880s, following Matthäus' designs, just as the west front of Cologne had been finished according to drawing F.

If drawings on parchment still defy analysis to some extent, those incised on stone do seem to be genuine working drawings, from which shapes and curvatures could be taken. These survive in two forms: on a convenient flat surface in the building itself, as on the ambulatory roofs

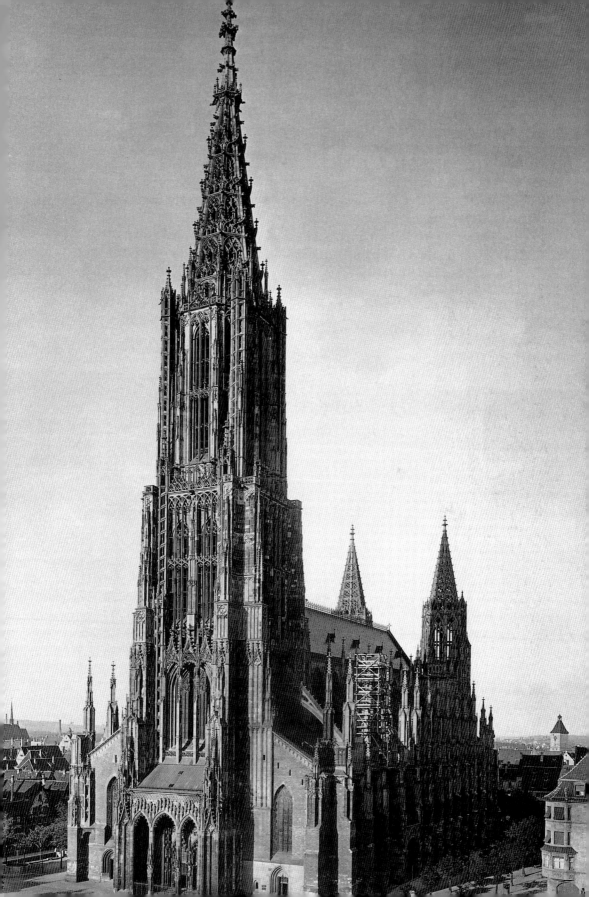

48

Incised drawing at Clermont-
Ferrand Cathedral, France

Working drawings from which
patterns could be taken were
made full-size on a convenient
surface. This was often the
stonework of the building itself.
The ambulatory roof at
Clermont, built at an early
stage, provided a surface for
working out curvatures and
details in later parts of the
building.

of Clermont-Ferrand and Narbonne Cathedrals [48], or on a specially
prepared plaster tracing table or floor, as at York Minster [49]. The
incised designs include arches, moulding profiles, and patterns for
windows. They are all drawn full-scale, so that wooden patterns could
be made from them, or the worked stones laid against them to check
for accuracy. A large proportion of the surviving designs are for
window tracery, from the cusped oculus for the centre of the western
rose at Byland Abbey to complete designs in Cambridge, Gengen-
bach, York, and elsewhere.[18] Although it gives no profiles, the outline
drawing on the plaster floor at York can be matched line for line with
the general characteristics of the windows in the choir [50] for which it
was a guide. It also demonstrates the proportional system of setting out
according to standard numerical ratios, for, expressed in feet, the
radius of the arch is 17 feet 10½ inches and its width is 12 feet 7 inches,
near enough one of the most familiar approximations of $1:\sqrt{2}$.

49

The tracing floor of York
Minster

The plaster floor was laid down
in the masons' workroom
above the vestibule leading to
the chapter house. Among the
incised lines can be seen a
sketch for Y-tracery and the
outline of the pattern for the
choir aisle windows of the
Minster (see **50**) The profile of
a moulding that also appears is
not related to this.

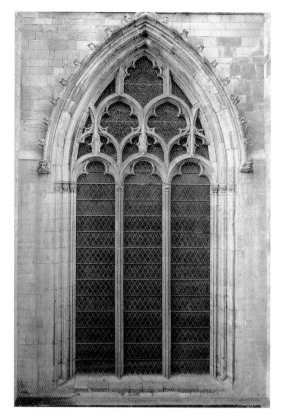

Architectural models

In the Arena chapel in Padua the patron, Enrico Scrovegni, is shown
dedicating a model of his building to Christ at the Last Judgment.
This is one of the many votive models that survive in paintings, sculp-
ture, and metalwork (see **126**). Models as part of the design process are
attested in Italy from the fourteenth century, but there is no sign of
them in northern Europe before the late fifteenth, when they were
introduced probably under Italian influence. Alberti refers to them in
De Re Aedificatoria, and it may be no accident that they first appeared
across the Alps in south Germany, close to Eichstätt, seat of Roriczer's
patron, the humanist bishop William of Reichenau. But models seem
to have been intended less for working out problems in structure and
design than for mediating with the patron, just as they do today. We
can easily imagine the authorities of the hospital of the Holy Spirit at
Nuremberg understanding the layout of the new extension and bridge
through the wooden model provided by Sebald Schreyer in 1487; or,
twenty years later, those of Bern Cathedral pondering Burkhard
Engelberg's model for the projected new tower. Craftsmen with a par-
ticular affinity to models were goldsmiths, who had long used them;
and with the highly decorative micro-architectural detail shared by

buildings and goldsmiths' work, masons and metalworkers worked closely together. Hans von Böblingen's drawings of leaf patterns have the sharpness of metal, and a goldsmith, Hanns Schmuttermayer, produced at roughly the same time as Mathes Roriczer an illustrated booklet on designing pinnacles. Engelberg worked with a goldsmith; but craftsmen such as Alart Duhamel in the Netherlands, like Filippo Brunelleschi before them, practised both crafts. Models, then, were used for information and decoration, and as votives, but not as aids to construction.

Transmission

Owing to their rarity, models could not have been primary transmitters of ideas; but what of drawings? Those incised on buildings or tracing floors are by definition not portable; but drawings on parchment or in notebooks could be carried about quite easily, and could in theory have transmitted designs from place to place, along with the draughtsman's personal style. In practice, however, the process of transmission is less easy to discern. For one thing it was often centripetal rather than centrifugal, since, far from designs being dispatched to other centres, if a mason wanted to study a particular design it was he who moved, travelling to the building concerned to study it on the spot. Contracts and regulations often stipulate that a master mason is not to take drawings away, and the collections at Ulm, Vienna, and Strasbourg show how they could accumulate over decades. As best they could, the authorities guarded their designs, but since no mason could be prevented from reproducing a design elsewhere, they had little control. The craft regulations and references to established masons' lodges have given the medieval building trade an institutional air that is somewhat misleading. It has been reinforced by a generation of scholars who interpreted masons' notebooks as lodgebooks, that is, books of craft secrets belonging to a specific masons' lodge. As we shall see in the next chapter, the craft organization was much looser than the regulations suggest. Indeed, it was the absence of tight institutional control that called for the regulations. In so far as the notebooks can be interpreted, they were the property of the individuals who composed them, of their dedicatees and, in Roriczer's case, the buying public. What they contained was not secret—the secret, if such really existed, was in the practice of constructive geometry; as Schmuttermayer's booklet on pinnacles demonstrates, this was known to other craftsmen. The earliest survivor, the portfolio of drawings on parchment sheets assembled by Villard de Honnecourt around 1230, has been shown not to be a lodgebook, but the idiosyncratic jottings of a man who could draw designs for metalwork, copy out moulding profiles, geometric constructions, and designs of machinery, but who was incapable of

accurately recording an architectural detail even if it was in front of his eyes.[19]

Designs could have been transmitted through canvas templates, but more likely they spread through constructive geometry itself, allowing as it did any design to be reproduced from a few verbal indicators. Attributions to individuals have been made on the basis of identical moulding profiles or tracery motifs, but since masons could and did copy each other's work, and altered their own styles as directed, such attributions may not always be sound. What we do not possess are the studies that Villard's works ought to be but are not: a mason's drawings of designs that interested him for use in his own work. The buildings themselves demonstrate different kinds of influence, from the vast, general spread of French Rayonnant ideas to the local but strong influence of individual architects. Perhaps the most pervasive was that of Peter Parler in south Germany and Prague from the late fourteenth century. His style was spread in the work of his own family, from Vienna to Strasbourg; in the south it influenced Hans von Burg-hausen, and the work of Peter von Pusica and Hans Puchspaum in Vienna. It inspired Hans Kun, the son-in-law of Ulrich von Ensingen, and the Eselers, father and son, at Dinkelsbühl, Rothenburg, and Schwäbisch Hall. In the north it found expression in the distinctive brick building of Hinrich Brunsberg near the Baltic (see **23**). Parler inspired not so much direct copying as an approach to design, in precocious and varied patterns of vaults and tracery. Yet masons were not the only people interested in how a building should look; the process of design is intimately connected to patronage and construction.

Patron and Builder

3

A building site [**51**] was a noisy place. Permeated with the dust of lime mortar and the residues of cutting stone and wood, it rang to the sound of hammers, chisels, axes, and saws, as well as the shouts of the work-force as they manoeuvred materials and machines into position. The simultaneous performance of so many different tasks gave an air of barely controlled chaos. Any large-scale operation, involving so many different craftsmen, the regular supply of the right materials at the right time, and the means to pay for them and for the wages bill, required careful control. If architecture was about artistic inspiration, it was also about thoroughly mundane administrative matters. Buildings like these were a joint effort by the patron, the administrators, and the builders through to the plumbers, tilers, painters, and glaziers who completed the decoration. At the heart of it were the complicated,

51

A building site in the fifteenth century

This miniature from the *Chronicles of Hainault* shows some regular building activities and stresses the close relation between carpenters and masons. The carpenters, bottom right, are trimming timbers for scaffolding, ladders, and other equipment as well as roof beams and rafters. Masons used chisels, hammers, and axes, checked accuracy with squares and plumblines, and lifted materials with hoists and cranes.

often fraught, relationships between the patrons, the building works, and the master craftsmen.

While the prevalent belief that medieval buildings are anonymous is misleading, since the name of the master mason is often recorded, it is true that the evidence gives us little idea of the builders' thoughts and attitudes. We may find patrons giving specific directions, but such glimpses do not make up the linear narrative of aesthetic preference that can be written for more recent architecture. It was only during the Renaissance that aesthetes and commentators devised or revived a vocabulary for describing buildings, and therefore only from that time that the latter could be discussed as coherent, three-dimensional artefacts. Medieval literary sources used time-honoured conventions—*topoi*—for dealing with architecture, which bore little relation to the buildings themselves. Many non-literary sources, such as building accounts, concerned only the minutiae of wages and materials. But some others, Expertises and the deliberations of some works organizations in Italy, do give us insights to the processes of both construction and the negotiations between patrons or their advisers and the masons.

The rebuilding of Florence Cathedral lasted from 1296 to 1467, when the lantern was put in place over the dome designed by Filippo Brunelleschi [**52**]. As in other Italian communes, responsibility was in the hands of the laity rather than the Church, and the master masons were appointed by the republican government. From 1332 the Wool Guild of the city was put in charge of the works, electing four of their members to account for the use of public funds.[1] In the early days these men—the Operai—had little control: they were apparently powerless when in 1334 Giotto, the newly appointed supervisor of civic building in Florence, seems to have redirected money from the cathedral to the bell-tower, which was rising steadily while the cathedral languished. Later on, however, the Operai devised ways of keeping the master masons under closer surveillance. It was not until the 1360s that the design of the building, particularly the great octagonal crossing, was finally decided. For the first time the Operai included the masters Ghini and Talenti at their meetings, and demanded a series of models and plans for their inspection. They also invited successive Expertises of visiting masters to comment on the proposed changes. If opinions were not unanimous, the different proposals were put on public display, and sub-committees formed to represent public opinion. The stated aim was to achieve consensus; a useful side effect for the Operai was that responsibility was seen to be collective. No single master was allowed to claim personal glory for his designs: even during the construction of the dome the Operai maintained the pretence of consulting masters other than Brunelleschi, even though his solutions were always accepted.

The master's technical skill did something to maintain the balance

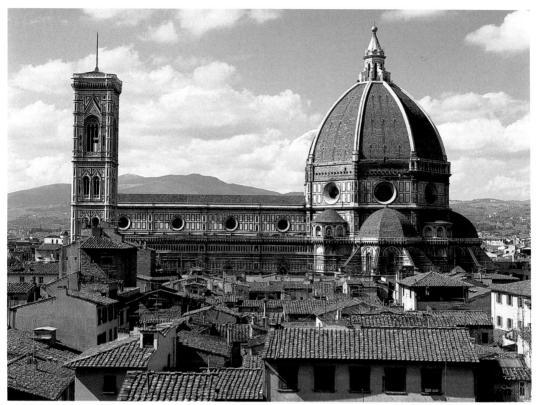

52

Florence, Italy, Cathedral and bell tower from the south

Both buildings are clad in pink, white, and green marble. Dominating its surroundings, the dome, built by Filippo Brunelleschi 1418–36, symbolizes the city itself. The cathedral, S. Maria del Fiore, was begun in 1296 and completed only in 1467, with the lantern. The dome is the exterior expression of the octagonal interior crossing. The bell tower, the responsibility of Giotto in 1333, is set apart to emphasize the importance of bells in marking the passage of time.

of power, since the patrons were dependent upon it: the Florentine Opera del Duomo was much preoccupied with the building's strength and stability. One intriguing example of the relationship between the two sides, intriguing because, unlike in Florence, the discussions were not recorded, is the innovatory manner in which the choir of Saint-Denis abbey church was set out. In the most significant area, the uninterrupted circuit of windows around the ambulatory, the master mason set out the geometry on two different interlocking curvatures that pushed the three easternmost chapels very slightly outwards [**53** and **10b**]. Suger's account does not comment on this: perhaps he lacked the necessary architectural vocabulary. But it leaves us to speculate either that he never noticed it, or that the master mason was a skilful diplomat in pushing a revolutionary solution past an essentially conservative patron.[2]

Patrons and design

It was not the master mason's job to dictate a building's appearance. This was the patrons' responsibility, but the extent of their personal knowledge and interest is hard to assess. Two buildings funded by Clement VI, Pope in Avignon 1342–52, are instructive. Clement was a professed Benedictine monk but a man of grandiose tastes who

The view shows four of the seven chapels that lie in a continuous, shallow ring around the ambulatory. Their axes all converge on the same point in the choir, displaying the stained glass to full effect. The three easternmost chapels contain the most important altars after those in the main vessel. They are set out on a different curvature, projected slightly outwards to make them deeper. The superstructure was rebuilt in the thirteenth century.

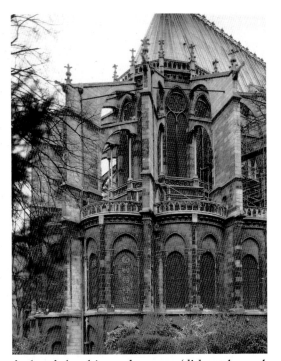

declared that his predecessors 'did not know how to be Pope'. During his pontificate he rebuilt the abbey church of La Chaise-Dieu in the remote, wooded hills of the Velay region north of Le Puy, and added rooms to the new palace in Avignon, attached to the papal palace built by Benedict XII. Clement closely supervised the designs.[3] At Avignon he built audience halls suited to the dignity of his papal office [**54**], high, vaulted, airy buildings with delicate rib vaults and carved and painted decoration. Thick walls, hefty towers and solid crenellations give a militaristic air that is belied by large windows and generally weak defences. Clement's burial church of La Chaise-Dieu [**55**] replaces a Romanesque building. It is also grand, but it has a massive simplicity expressed in ample proportions and clean lines. Here the windows are tall, to allow in enough light: the aisles are vaulted at the same height as the main vessel, creating an impression of spaciousness that is enhanced by the slender piers. But members of the public were, and still are, confronted on entering by the huge masonry screen that conceals the monks' choir and high altar from profane eyes. It was beyond the screen that Clement placed his tomb, before the high altar under which lay the relics of Robert, founder of the abbey. Magnificent in death as in life—his funeral cortège was a month on the road—Clement nevertheless awaited the Last Judgment in a sacred space he had created amid the privacy and seclusion of his fellow monks.[4]

Here we are seeing Clement's personal taste mediated through his sense of *decorum*. While the stylistic expression of ideas about *decorum* or symbolic ornament changed over the years, reliable signs of

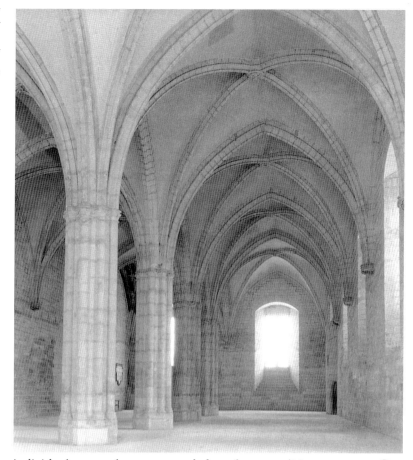

Pope Benedict XII
(*reg.*1334–42) built a massive,
fortified papal palace in
Avignon. His successor,
Clement VI, added a 'new
palace', a sequence of large,
airy, vaulted rooms
appropriate to the dignity of
the papal office. Works of
masonry were supervised by
Pons Sernin, with the master
mason Jean de Loubières,
while the carpentry and joinery
were directed by Rostan Berc.
Piers and vaults are finely
moulded with careful attention
to detail.

individual taste that transcended such generalities are rare. One
example is Ca' d'Oro in Venice, the house built by Marin Contarini,
which is discussed in more detail on p. 107. Here the surviving accounts
make it clear that Contarini, like Clement, was the sole arbiter of all
aesthetic matters, but while many elements were symbolic and
emblematic, others were purely decorative and represent his visual
preferences. There may be a parallel in works commissioned by Henry
III of England (*reg.* 1215–72), another patron who took a close interest
in his buildings: an unusual design for doors, with flattish arches rising
from vertical springers, recurs often enough to suggest that it was
Henry's choice. Yet considerations of personal taste can easily shade off
into religious, political, or cultural choices. The appearance of
conspicuously 'French' forms in buildings outside the French kingdom,
particularly after the mid-thirteenth century, when French influence
was less pervasive, is invariably interpreted in this way. In the mid-
thirteenth century Cologne Cathedral and Westminster Abbey, shrine
churches that wished to promote the importance of their relics, had
drawn inspiration from the Sainte Chapelle. The nave of York Minster,
begun in 1291, has a thin, flat internal elevation that is evidently based

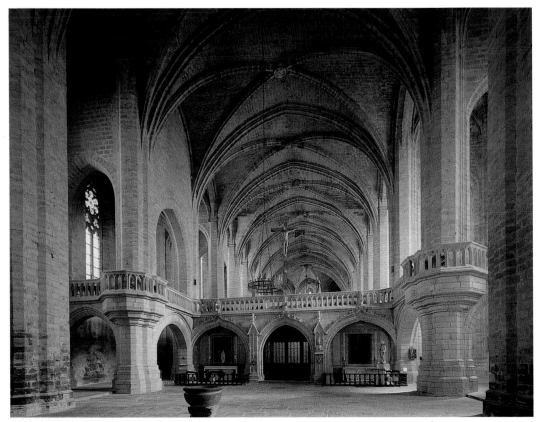

55

Benedictine abbey church of La Chaise-Dieu, France, nave, looking east

Pope Clement VI (*reg.* 1342–53), a monk of La Chaise-Dieu, chose to be buried there, funding the rebuilding of the church. The nave is twice as wide as the aisles, and detail is minimal, mouldings dying into piers without capitals. The masonry walls spanning the aisles create diaphragm arches, which form an internal buttressing system. The screen ensures privacy for the monks' choir further east.

on Rayonnant basilicas, and the Parisian connections of the archbishop, John le Romeyn, have often been noted. Whether he simply preferred the style or was making some sort of cultural statement is not clear. The York chapter may have wanted a building that was the greatest possible contrast to the rival metropolitan at Canterbury (see **121**). What is clear, however, is that despite modern insistence on the cultural supremacy of Paris, the models chosen for York and other buildings were not Parisian: they were more recent works in the south—the cathedrals of Clermont-Ferrand and Narbonne, and Saint-Nazaire at Carcassonne—which had been built in the wake of the French royal conquests. There the Rayonnant, although hybrid, was a political gesture, but even political gestures did not necessarily produce whole buildings in French style: when Charles of Anjou, who conquered the kingdom of Sicily in 1269, brought in French masons for his new buildings in the Naples region and ordered that the Castel Nuovo be built '*ad modo Francesco*' he was referring to roof tiles.[5] By the fourteenth century Paris was no longer the model. In Cyprus, Famagusta Cathedral (see **3**) and Bellapais Abbey, built by rulers who were still nominally French, owe their Rayonnant details to recent architecture in the Rhineland. The most surprising case of all is Prague Cathedral. Although Charles IV was remodelling the castle and city as

an evocation of Paris, his first architect, Matthew of Arras, used south French design sources. Even without Peter Parler's later transformations, Prague Cathedral would never have looked Parisian.

Whether a patron can be associated with a style or building type is also debated. Evidence of this sort comes primarily from royal patrons, who were much wealthier, built more, and were better recorded. But there is a danger of seeing a pattern of intention that may not exist. The patronage of Louis IX of France, for instance, has for long been associated with a 'court' style linked to the emergence of Rayonnant. The new Rayonnant buildings in the south seem to bear it out. But closer study of Louis' buildings suggests that the claim is exaggerated.[6] Churches built in the 1350s and 1360s under the auspices of the Polish king Kasimir III show an association of a building type and style with a particular patron that is more persuasive. Typical among this group is the collegiate church of Wiślica [**56**]: a single-cell

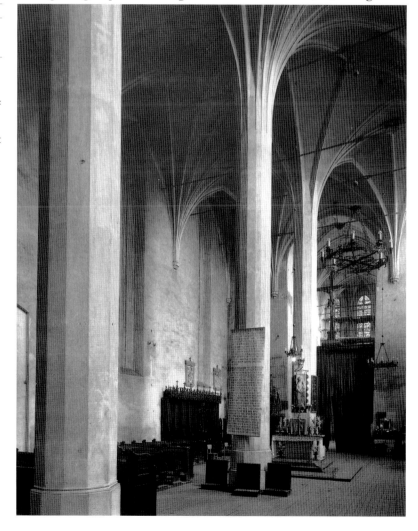

56

Wiślica, Poland. Collegiate church of St Mary, interior, looking east

Built in the 1350s, this is an example of the 'axial-pillar' church type favoured by the patron, King Kasimir the Great: the nave is divided into two aisles by three columns on the axis. The vaults seem to sprout from the piers in star patterns, supported on the outer walls by small corbels, while the corner bays have tri-radial rib patterns. Such patterns deny the 'structural logic' of earlier buildings.

Venice, Italy, SS Giovanni e
Paolo, interior, looking east

This Dominican church, begun
in 1333, introduced the
longitudinal, aisled basilica to
Venice. The main eastern apse
is flanked by four smaller ones.
The crossing dome was added
later. The plan and elevation
have close Florentine parallels,
but the suffusing colour is
entirely Venetian and flouts
Dominican principles of
restraint. Two levels of wooden
tie beams pull the walls and
piers together, to help increase
resistance to earthquakes and
unstable foundations.

choir with a polygonal apse is attached to a hall nave with two aisles,
divided down the axis by three columns. Vault ribs radiate in star
bursts from the columns, meeting tri-radial ribs at the corners of the
hall. The ribs are supported at the walls by small corbels, which deny
any sense of a rhythm of bays. Apart from the vault the building is
almost unadorned, with tall, plain windows. These churches, unusu-
ally for this date in a region of brick building, are constructed in
limestone. Circumstantial evidence suggests that Kasimir was closely
involved in the project, itself a small part of his prolific building activ-
ity. Both the plans and some formal elements may have been chosen
for symbolic reasons (see page 120), but it was Kasimir's influence that
produced the stylistic consistency.[7]

The religious orders, too, influenced styles in certain circumstances,
although claims that the Cistercians contributed significantly to the
spread of early Gothic styles may be exaggerated. Beginning with their
mother church of S. Francesco at Assisi (see **112**), the Franciscans in
Italy consistently favoured French architectural elements, possibly
owing to the support their order had received from the French royal
family. In northern Europe, the light, open, rectangular designs of
mendicant churches were to affect parish church architecture. The
Dominicans, however, even caused a stylistic change. In 1333 they began
the church of SS Giovanni e Paolo in Venice [**57**]. Although it is built in
the standard Venetian materials of brick, stone, and timber, its plan
ignores the Venetian tradition of small, centralized churches built under
Byzantine influence; it has a longitudinal ground plan of five bays with
aisles, the square bays and polygonal apse inviting comparison with the
Dominican church of S. Maria Novella in Florence (see **33**). By intro-
ducing their own traditions to Venice, the Dominicans, with the other
mendicant orders, transformed church architecture in the city.[8]

The Dominicans were among various institutional patrons—
religious orders, civic authorities—who tried to affect buildings by
imposing constraints, although their success was limited. In 1297 the
city government of Siena forbade balconies on the windows of build-
ings around the new Campo, the square in front of the Palazzo
Pubblico (see **111**). But the religious orders imposed much vaguer con-
ditions. The Cistercians and the mendicants developed ideas about
appropriate modesty in architecture, the Cistercians because they
believed that ornament distracted the contemplative monk from
perfect union with God, the mendicants because they espoused holy
poverty. Yet the Cistercians never officially promulgated a type or style
of architecture, even in the twelfth century, their period of greatest
expansion, when their church plans were remarkably similar from
Scandinavia to Spain. Their written policy amounted to prohibitions
against specific houses for infringements of an undefined desire for
simplicity. The only 'rules' were that bell-towers should not be built of

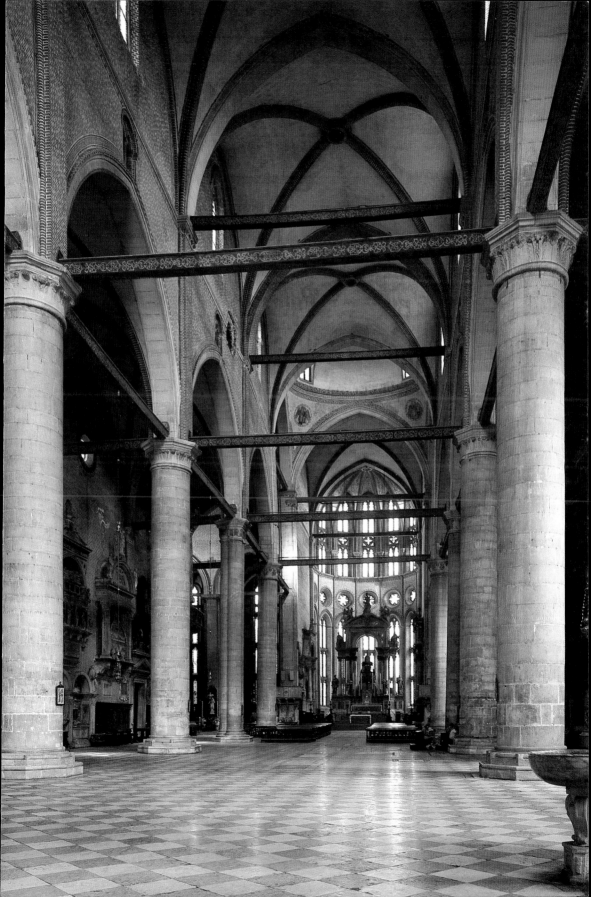

Since medieval women left fewer written records than men, they can be hard to trace in the records, unless they were rich widows, independent of attempts by feudal overlords to subsume their wealth and identity in new marriages. They were, however, patrons of architecture in their own right. The Lady Devorgilla of Galloway was the wife of John Balliol (d. 1269), sometime regent of Scotland and founder of Balliol College, Oxford. In 1273 Devorgilla founded the 'New Abbey' in south-west Scotland in his memory. The story goes that she encased his heart in a special casket and kept it beside her until her death in 1290, when she was buried, with the heart, in her new foundation—hence the name, Sweetheart.

Devorgilla was herself related to the Scottish royal house and her foundation of a Cistercian monastery, the last in Scotland, followed family tradition. Built of red sandstone, the church has a modest, two-storey elevation enlivened by window tracery. Note the roof lines on the crossing tower, which show that the tower conformed to the Cistercian principle that it should rise no more than one storey above the roof.

stone, and that crossing towers should not rise more than one storey above the main vessel. Otherwise, Cistercian churches were built in the styles of their contemporaries, holding to the principles of simplicity by reducing ornament and detail (see **113**). The mendicant orders, however, did incorporate architectural custom into their constitutions.[9]

The Dominicans had been founded to preach against heresy, in particular the Cathars of southern France who pursued purity and self-denial, and if the Dominicans were seen to enjoy lavish surroundings they would lose moral authority. From the beginning in 1220 they decreed that their houses should be 'moderate and humble [*mediocres ... et humiles*]'; through the thirteenth century they decided that buildings should not be more than 30 *pedes* (*c.*10 m) high, and only choirs and sacristies should be vaulted. In the 1260s both the Dominicans and the Franciscans forbade 'notably superfluous' decoration. Provincial chapters tried hard to enforce the legislation, but by 1300 it was being violated routinely. Many churches, such as the Dominican chapel in Toulouse [**59**], were vaulted in stone throughout and exceeded the rules on height. In Venice, the Dominicans may have imposed a church type upon the city, but the coloured interior of SS Giovanni e Paolo is wholly Venetian in spirit.

The foregoing kinds of stylistic choice are only to be expected. More controversial is the precise level at which patrons or advisers interfered with designs. Some, like Clement VI, took tight control. Patrons

certainly took practical action: Abbot Suger, although a representative of the monastic community of which he was head, behaved like a private patron, giving detailed directions and taking an active lead if he felt the masons were becoming discouraged. Edward I of England (*reg.* 1272–1307) brought in Flemish hydraulics experts to advise on waterworks for his castles, and specified details of fortifications. But whether patrons actually designed buildings is another matter. There is occasional evidence of patrons supplying masons or carpenters with designs, but the concern here is whether a patron could ever accurately be described as a building's architect. A building at the centre of this debate is Salisbury Cathedral [**60**]. Its clear layout, deceptive consistency, and rich but austere decoration have been interpreted as representing new ideals of *decorum* inspired by the reforms adumbrated by the Fourth Lateran council of 1215, which were enthusiastically supported by the founder, Bishop Poore. The man in charge of the project and its finances was Elias of Dereham, a cleric who seems to have

59

Former Dominican chapel (now Jacobin church), Toulouse, France, interior, looking east

Begun as a modest chapel suited to the Dominican fight against the Cathar heresy, the church was soon transformed into a high, vaulted space. It is lit through tall, traceried windows and the plain columns dividing the nave support great cones of vault ribs, as many as 22 ribs springing from the eastern pier. There the vault becomes more complex as it spreads into the apse (1280s).

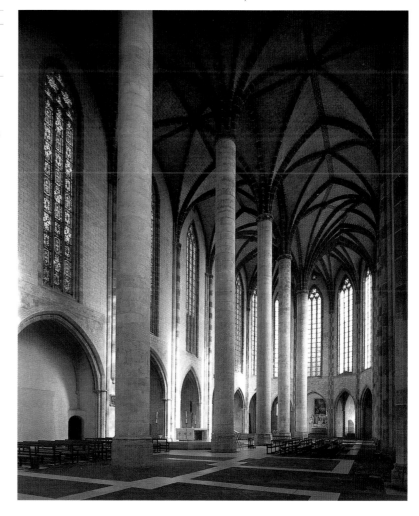

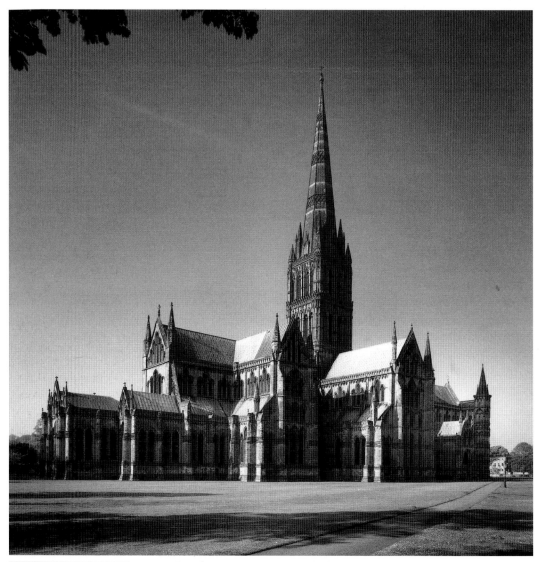

60

Salisbury Cathedral, England, exterior from the north-east

The earlier cathedral had been built on the former Iron Age hill fort at nearby Old Sarum. Lack of room for expansion forced a move that received papal approval in 1218. Laid out on the new site, the profile is exceptionally regular, with an easily 'read' sequence of windows and buttresses. Liturgical areas are clearly defined. The smaller, eastern transept marks processional entrances to the choir.

specialized in extracting bishops from political or other difficulties, but is also recorded as a '*mirabilis artifex*'. This has been enough to confer on Elias the distinction of being the architect of Salisbury Cathedral. But in a life that is exceptionally well documented by medieval standards, there is no evidence that Elias had the practical experience of the masons' craft.[10] He is more likely to have been the clerk of the works, an official who was not a mason but a clerk in holy orders, literate in Latin and able to do accounts. He acted as liaison between the master mason and the patron; he was responsible for supplying materials and tools, hiring the craftsmen that were not brought in by the master mason, and paying the wages. Since craftsmen, even the masters, came and went, often working to task or on day rates as required, the clerk of the works provided essential continuity. He also probably issued the banker

marks, the signs inscribed by masons on ashlar blocks that they cut, for purposes of payment.[11] The confusion between the clerk and the mason arises because both can be referred to as *magister operis*, master of the works, and where other information is lacking it can be difficult to decide which is meant. In a large works organization their duties might overlap to some extent. This was certainly the case in late thirteenth-century England, where the mason Robert of Beverley, Master of the King's Works, was responsible for maintaining buildings across a wide area, including handling building accounts. He brought specialist knowledge of how a building site actually functioned to the business of organizing complicated campaigns. When Edward I soon afterwards built his castles in north Wales (see **108**), and turned Snowdonia into an enormous construction site, he brought from Savoy one Master James of St George, who had wide experience of organizing the construction of towns and fortifications on many sites simultaneously. In Wales Master James ran the entire operation in conjunction with the administrative clerks. Whether he also designed any buildings is not clear.

Yet none of these administrative activities involved knowledge of structural engineering, selecting stone, and, above all, constructive geometry. Constructive geometry is the key to the argument. It was useful only in the building craft, and no one unconnected with the trade would have reason to know it. As we saw in Chapter 2, its links to the rediscovered ancient mathematics studied in the universities and schools that produced men like Elias of Dereham were tenuous in the extreme. A drawing by the twelfth-century theologian, Richard of Saint-Victor, that attempts to reconstruct Solomon's Temple in Jerusalem, as described by Ezekiel in the Old Testament (Ezekiel 40–2), which has been claimed as a serious architectural drawing, shows no comprehension either of ground plans or their relation to the elevation.[12] Without constructive geometry Elias could not have designed templates and vault curvatures, and he cannot therefore be described as an architect. What he very likely did was advise closely on the visual aspects of Salisbury and other buildings, and since he was well travelled he could pass on ideas about design that he had seen elsewhere. But the realization of his dreams depended on a competent master mason.

The master mason

'Master mason' is not quite synonymous with 'architect'. Carpenters also designed buildings; and in Italy, for example, a mason became a master automatically upon entering the craft guild: a master mason was a carver in stone as distinct from a bricklayer. As we shall see at Ca' d'Oro, the men in charge at the site were the bricklayers who built the

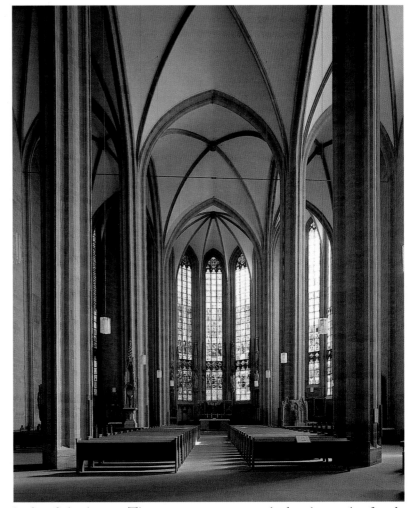

61

Soest, Germany, St Maria-zur-Wiese, interior, looking east

Three square bays lead to a polygonal eastern chapel flanked by smaller chapels opening from the aisles, which have oblong bays. The fusion created by the large windows and piers with continuous mouldings, which present an oblique aspect that reduces bulk, led earlier scholars to see in this church the beginnings of a 'unified' hall type. Yet Soest took so long to build that the design may have been modified.

body of the house. The master masons worked only on the façade under the master bricklayer's supervision. In northern Europe, however, the master mason did run the building site. But he was not necessarily the original architect. Most building campaigns lasted many years: La Chaise-Dieu was built in ten years from 1342, thanks to regular payments from Clement VI. Yet at the church of St Maria zur Wiese in Soest, north Germany [**61**], the foundation stone was laid in 1313; by 1376 they were still working on the eastern chapels; and the main structure was completed only around 1529. The west front was not finished until the nineteenth century. At Amiens Cathedral and one or two other very large projects the administrators found more cost-effective methods of assembling the masonry: stones for the piers were cut to identical, interlocking shapes, involving fewer templates and faster construction.[13] But regular financing and the will to complete the building counted for much more. These local forces were far more powerful than such events as war and plague, which were both

endemic and subject to sudden upsurges: in the fourteenth century, for example, the visitations of plague, known as the Black Death, had little serious effect on the rhythms of long building campaigns. The protracted nature of the works meant that changes of master mason were inevitable; sometimes the incoming master changed the design, at others he did not. The successive masters of the works at Saint-Maclou in Rouen (see **26**) during the fifteenth century continued faithfully to build to Pierre Robin's original specifications. Thus, both terms, master mason and architect, are slightly problematic for this period. But whatever the medieval architect is called, the differences between him and his modern counterpart are clear.

Unlike a modern architect, whose main job is to provide drawings, the master mason was also the structural engineer and building contractor. He organized supplies of stone, sub-contracted his team of masons, and, as we have seen, sometimes administered the finances. He became a master, not through academic study, but by training within the building industry. Some master masons were prosperous businessmen, and many, especially towards the end of the period, had so many simultaneous commissions that work at different sites had to be entrusted to undermasters, known as wardens or *Parliers* (whence, perhaps, the name Parler). At La Chaise-Dieu Hugues Morel acted as undermaster to Pierre de Cébazat, who visited occasionally from Clermont-Ferrand. A common *topos* in contemporary texts was the master mason's superior role as a director, a man of science, rather than a craftsman; it was thus that he was characterized in the much-quoted sermon of the Dominican Nicolas de Biard: 'Observe: in these large buildings there is wont to be one chief master who orders matters only by word, rarely or never putting his hand to the task.'[14] Much the same spirit informs the inscription on the tombstone of the master Pierre de Montreuil, which describes him as *doctor lathomorum*, a doctor of stonecutting. But these are literary conceits, claiming architecture as a liberal art, the work of the mind. In reality science, or knowledge, went hand-in-hand with practical skill. This was the basis of the outburst at Milan (as recorded by the secretaries) in which the French adviser, Jean Mignot, exasperatedly told his Italian opponents: '*Ars sine scientia nihil est* [craft is nothing without knowledge].'[15] These texts seem to confirm the idea that from the mid-thirteenth century at least some leading masters formed an élite group above the master masons rooted in the building industry, the medieval equivalent of the later master builder.[16] This is a misconception. If a master was not present at one site, he was travelling to or working at another, and when there he supervised construction. Although some masons were more successful than others, they were all based in the quarry and the site rather than an office. Mignot's implication that science was necessary to craft recognizes that the master mason rose from a craft background. The

building industry in general was low grade, concerned mostly with repairs to houses and workshops, done by carpenters and tilers working with such materials as timber, earth, rubble, and rushes rather than ashlar masonry. If dressed stone appeared in such repair work it was as *spolia*, stone recycled for convenience from earlier buildings, occasionally for symbolic purposes.

Although a master mason's connection to the intellect in the form of geometry might theoretically raise his status, his necessary association with the work of the hand, his ability to measure and cut stone to order, kept his status below that of even his humbler ecclesiastical or mercantile patrons. Even by the end of the period master masons' names were not necessarily preserved and their reputations were of little interest. The sixteenth-century Netherlandish mason Rombout Keldermans was knighted by Emperor Charles V, but such honours were highly unusual. Buildings were associated with their patrons rather than the masons. We know the names of most master masons not from written appraisals of their work but from wages lists, contracts, tombstones, chronicles, and occasional inscriptions. Within the craft itself the only master whose memory survived was Peter Parler, the master mason of Prague Cathedral, who died in 1399: his workshop was recalled nearly two centuries later in the legendary 'Junker von Prag' mentioned in the writings of Mathes Roriczer and Hanns Schmuttermayer. A building was not seen as a showcase of individual talent. The Florentines played down Brunelleschi's authorship of the dome only partly for reasons of consensus. Such long-lasting, large-scale administrative bodies as the English royal works, the Œuvre Notre-Dame at Strasbourg, or the Opera del Duomo in Florence had the master masons in their power. Building works claimed ownership of their drawings; at Ghent Town Hall (see p. 110) Rombout Keldermans had to ensure that his rights to his drawings were written into the contract. Brunelleschi's reputation survived because the cultural climate in Tuscany was changing; earlier, he would have lost his identity as surely as Suger's master mason has lost his.

The guild, the lodge, and the family

Although there is much talk of guilds, brotherhoods of masons, and lodges, the memory of the Junker von Prag is significant evidence of the true base of the profession: the family. Craft guilds existed in the twelfth century but did not emerge fully before the late thirteenth. They were charitable as well as craft organizations, but their secular purpose was to protect the interests of their members and regulate employment, with additional responsibility in Italy for administering building works. Masonry was a less settled occupation than some others, since stonemasons were obliged to travel to where the work was

offered; but from the late fourteenth century even masons were settling more permanently in cities, becoming powerful members of the city government in such towns as Bruges, and more anxious to protect their interests. Guild regulations tried to ensure that immigrant craftsmen would work to an agreed standard. This might be a genuine concern in, for instance, fifteenth-century Venice, where the building boom arising from renewed prosperity attracted craftsmen from Milan and all over north Italy.

The training path is still obscure: the procedure laid down in the Regensburg Ordinances could only have been normative, since masons' personal and familial connections could always override any systems of control. By this later period, however, an apprenticeship of five or seven years led to qualification as a journeyman. To become a master the journeyman had to be able to draw templates; but no known test pieces survive, so the process of qualification is not clear. Promotion did not depend on the so-called *Wanderjahr*, the wandering year, when a newly qualified journeyman allegedly set out to travel between building sites, gaining experience and studying the work of others, in a sort of masonic rite of passage. As far as the medieval period is concerned the wandering year is a factoid, born of later practice and the undoubted fact that masons did move about; but such a concept was never formally instituted, nor was it a prerequisite to a successful career.

The lodge was the masons' headquarters on the building site, often a temporary wooden structure built for the purpose [**62**]. Setting it up was among the craftsmen's first tasks. The lodge was the storage depot, the rest house, and the workshop, where the masons could finish the fine carving that could not be done at the quarry or in the master mason's own shop. Yet, for reasons that lie deep in German historiography, the lodge has been elevated far above its actual significance. The meaning of the term has been transferred from the humble building to those who occupied it; and it is in this sense, of a group of masons working at a particular site or for a particular patron, that it is most commonly used today. It has additional connotations of a site identity, so that mention of the Prague lodge or the Vienna lodge, for example, is intended to convey institutional permanence and an associated style or habit of design. This notion goes back to the nineteenth-century writer and architect August von Reichensperger, who followed what he believed to be medieval practice and established lodges to train masons to restore the great German cathedrals. To him, the lodges of Vienna, Prague, Strasbourg, and Cologne had been the main training centres of their day.[17] The collections of drawings guarded so jealously by the building works seemed to confirm the existence of a lodge establishment. But this is to conflate the lodge with the building works. As we have seen, it was with the works that any permanence lay; and at Strasbourg, for instance, it was not the lodge that claimed ownership of

drawings but the Œuvre Notre Dame. Few masons remained at a site for any length of time, and although the talented Anton Pilgram (d. 1515), who came from a family of masons in Moravia, almost certainly trained in Vienna, most apprentices were trained by their fathers or uncles. It was only from the fourteenth century, when their training and qualification were put on a more formal footing, that they were ratified through the guild.

All over Europe the backbone of the craft was the family business, often involving quarry work and stone contracting. The most famous dynasty is the Parlers, beginning with Heinrich in the mid-fourteenth century at Schwäbisch Gmünd in south Germany; but there were many others. From about 1450 the architecture of Burgos in Castile was dominated by the Colonia family, brought apparently from the Rhineland by the bishop, Alonso de Cartagena, to work on his burial

62

A masons' lodge

This illustration in a manuscript of 1354 shows the kind of temporary structure that often constituted the masons' lodge. The lodge was essentially their workshop, and was built of timber and thatch. Inside, masons are cutting stone—the man on the right is carving a shaped piece. The masons on the tower are raising ashlar blocks with a hoist and giant metal pincers.

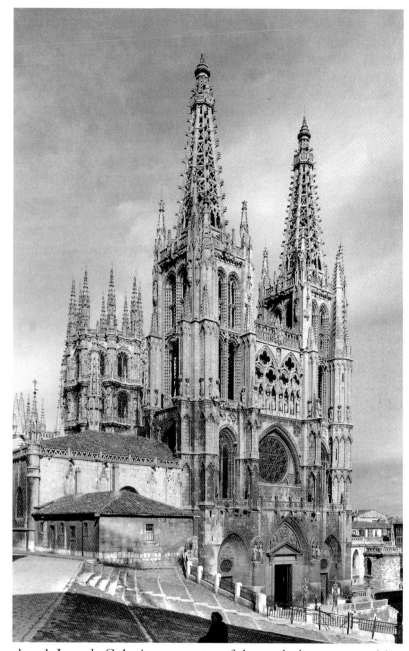

Burgos Cathedral, Spain, exterior from the north-west

Three generations of the Colonia family filled the post of master mason at Burgos from the 1440s. Juan de Colonia added the openwork spires to the west towers from 1442, modelling them on such Rhenish examples as Freiburg-im-Breisgau, which were known to the patron, Alonso de Cartagena. This strongly accented and decorative exterior is unusual for Spain, where exteriors are often hidden by encroaching buildings and decoration is concentrated on the interior.

chapel. Juan de Colonia was master of the works by 1454, a position taken over successively by his son, Simón, and his grandson, Francisco. They also completed the west towers [63] and the crossing tower (rebuilt in the sixteenth century) of the cathedral, with other works there and elsewhere. Simón attended at least one Expertise, at S. Juan de los Reyes in Toledo.

When we can follow their activities these dynasties give a vivid picture of the craftsmen's professional networks. The Ensinger family,

who worked mostly in south Germany and Switzerland in the late fourteenth century and the fifteenth, illustrate them very clearly. It was the founder of the dynasty, Ulrich von Ensingen, who became master of the works at Ulm Minster in 1392 and inaugurated the great west tower (see **47**). Yet he had already opened negotiations with the cathedral authorities in Milan, who paid much higher salaries, and in 1394 he went to Milan to work on the windows and the capitals of the main arcade. Dismissed after six months, he returned to Ulm, to be made master mason for life in 1397. But in 1399 he acquired a senior post in the works at Strasbourg Cathedral, and between then and his death in 1419 he returned only once to Ulm. He also began the west tower of the hall church of Our Lady in Esslingen. He almost certainly arranged for the work at Ulm and Esslingen to be done by a *Parlier*. Ulrich seems to have been valued as a tower specialist, for at Strasbourg he was employed to design the upper stages of the north tower of the west façade [**64**], two octagonal storeys with corner stair turrets, which rise clear of the main block. This elegant structure inspired the authorities at Basel to request a similar design.

Ulrich's assistant at both Ulm and Strasbourg was his son-in-law, Hans Kun. Kun supervised the work at Strasbourg for two years before Ulrich's death, and became master mason at Ulm, with his own son, Kaspar, as *Parlier*. For some decades Ulm became effectively an Ensinger family fiefdom—much like Burgos under the Colonias—for the works were taken over by Matthäus Ensinger, Ulrich's son and Kun's brother-in-law. Matthäus (d. 1463) is the best documented of Ulrich's three sons. He trained under his father at Strasbourg, and by Ulrich's death he was already working with Johannes Hültz, who added the extraordinary openwork spire to Ulrich's octagonal tower. Matthäus took over the works at Esslingen, and also became master mason at Bern Minster, building the choir and beginning the nave. In Ulm he vaulted the choir, and also the aisles, which had had to be rebuilt owing to the crushing weight of the west tower, which Ulrich had miscalculated. In 1449 Matthäus tried to negotiate a post as absentee master mason at Strasbourg, but the cathedral authorities would not allow him to remain living in Ulm.

Matthäus had two sons, Vincenz and Moritz. Vincenz acted for his father in Bern, accompanying him also to Ulm and Strasbourg before being appointed master mason to Konstanz Cathedral, where he did extensive works on the ancillary buildings. After 36 years he was dismissed, but he was kept on as a consultant until his death in the 1490s. Like Simón de Colonia and others, Vincenz attended Expertises; and he was also present at the meeting of masons in Regensburg in 1459 that devised the masons' Ordinances. Moritz had a similar career, assisting his father in Ulm, where he eventually became master mason for life, although he was also a house owner and citizen

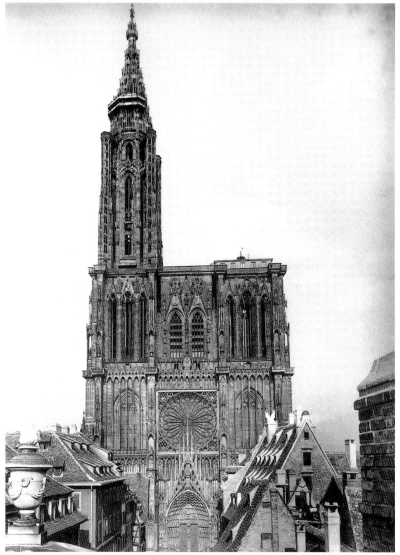

Strasbourg Cathedral, France, west façade

By the time Ulrich von Ensingen and Johannes Hültz constructed the fourth level of the north-west tower and the spire of small turrets, the façade design had been through several modifications. Surviving late thirteenth-century drawings show schemes with and without the free-standing harpstring tracery that modulates the main block, reducing the mass and throwing shadows. Despite the long-established building works, the Œuvre Notre-Dame, the façade was never finished.

of Konstanz. In 1478 he left Konstanz to become master mason at Bern. Moritz, too, took part in Expertises, often with Vincenz; and he was among those who advised on the vault of the church of Our Lady in Munich (see page 55). Moritz was also involved to some degree on the works of the nave vault and tower of St Georg, Nördlingen, where he recommended a design for the tower and sent a plan, now lost, for a horse-driven lifting device.

Marriage within the craft created wide networks. Hans Kun married his boss's daughter. Parler's first wife, Gertrud, was the daughter of a Cologne mason, and another Cologne mason married one of Peter's daughters. This was a world of family concerns, some small, some large, that underlay the more public world of guilds and lodges. But the best illustration of how all the interests discussed in this

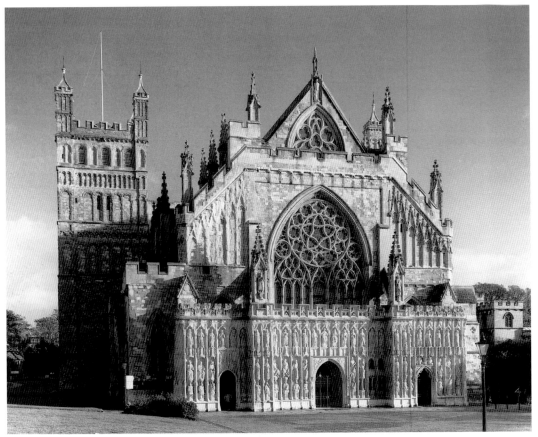

65

Exeter Cathedral, England, exterior from the west

The choir and nave were rebuilt from *c.*1270, and all that remains visible of the Romanesque cathedral is the transept towers (the north seen here) and masonry in the nave walls. The earlier building, however, dictated the height and width of the present one. The building process was recorded in detail in the fabric accounts, although the earliest years are missing and the name of the first architect is unknown.

chapter worked to produce the buildings is the process itself. Three examples that have left detailed records—Exeter Cathedral, Ca' d'Oro in Venice, and Ghent Town Hall—give a vivid picture of craftsmen and administrators at work.

Exeter Cathedral

Rebuilding the Romanesque cathedral of Exeter in Devon lasted from *c.*1270 to the end of the fourteenth century [**65**]. From 1299 there survives a remarkable run of fabric rolls (building accounts on parchment rolls), which lasts with a few gaps until 1353.[18] They show, not the grand design, but the myriad practical details that brought the architecture into being: as well as buying in all the building materials down to pegs and nails, the works had to pay smiths to maintain the metal building tools, and run a team of cart horses, which pulled loads of stone and timber to the building site, and needed fodder and horseshoes (bought in bulk). The masons, most of whom came from south-west England, were housed in a hostel in Kalendarhay, a street close to the cathedral, by the masons' yard and the tracing house where designs were drawn up. The craftsmen were paid weekly, or for piece

work; only the master mason and the warden, here the clerk of the works, were paid a quarterly salary.

Like Florence, Exeter received a steady income for more than 25 years, thanks to the generosity of successive bishops, who gave an annual fee out of their incomes and persuaded the dean and chapter to do the same. Stapeldon (*reg.* 1307–25), one of the wealthier bishops, gave additional sums, and on one occasion he helped the works by buying timber for them in London. All this support enabled the wardens to plan ahead, even to the extent of buying quantities of stone in prosperous years and storing it, an astute move since, when Bishop Grandisson arrived in 1327, he stopped the annual payments on grounds of poverty; but by drawing on the stockpile they were able to continue building. Even Grandisson, though, gave timbers for the nave roof.

Exeter is built mainly of sandstone shipped from Salcombe, a short distance along the coast; limestone from Caen in Normandy; and Purbeck stone from Dorset. This dark 'marble' was bought from William Canon, a member of a stone-contracting family in Corfe that also had a business in London. He supplied pieces for piers and whole colonnettes, carved ready for use to templates provided by the master mason. Building began to the east of and around the Romanesque church, which was taken down as work progressed. Some existing masonry was left standing, including the transept towers, the lower walls of the nave and west front, and parts of the superstructure in the choir. The design of the main elevation was changed once in the course of construction: the easternmost bays had two storeys, with a deeply sloping window-sill; but from the choir westwards the sill was replaced by a wall passage fronted by an arcade [**66**]. This second design survived several changes of master mason. Thomas of Witney, who took over in 1316 and remained in charge until 1342, built most of the nave, changing only patterns of door mouldings and window tracery. One significant alteration in detail was, however, made soon after his arrival. Carefully recorded in the fabric account for 1318 is the expenditure of £10 8s on marble 'for the galleries between the great altar and the choir with capitals and bases for the same': this relates to the east bays, where the sloping sill was filled in and fronted by a blind arcade, to make it resemble the later work more closely. Concerned only with materials and payments, the fabric rolls reveal no conversations between Thomas of Witney, the warden, John of Sherford, and the clergy, so we can only infer that it was the clergy who wanted to maintain the second elevation design throughout the building, but that the change to the east bays was perhaps suggested by Master Thomas.

Although the cathedral retained a master carpenter to make the roofs, Thomas of Witney was also involved in timber construction. He was originally summoned in 1313 to advise on the wood to be used in

66 (overleaf)

Exeter Cathedral, choir interior, looking south-east

The choir is dominated by the bishop's throne, a canopied, wooden structure that was probably designed by the master mason, Thomas of Witney, but built by a carpenter, Richard de Galmeton. The clerestory of the four eastern bays originally had a sloping window-sill, but an arcaded passage was introduced in the fifth bay (behind the throne) and in 1318 the earlier bays were built up and fronted by a similar arcade.

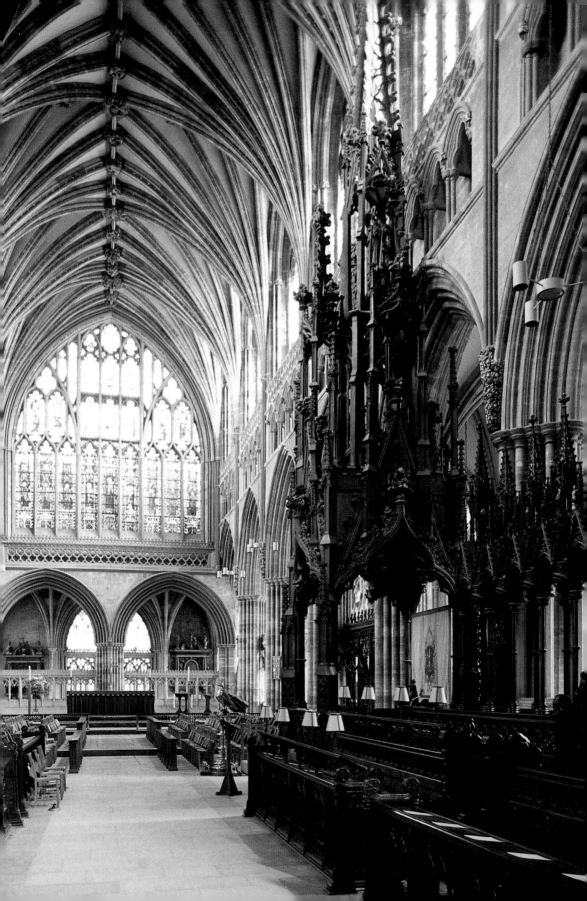

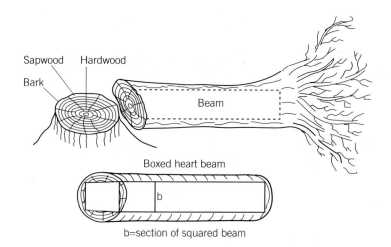

Sapwood Hardwood

Bark

Beam

Boxed heart beam

b

b=section of squared beam

the new bishop's throne [**67**]. In the 1320s, under Thomas's mastership, the wooden vaults were made for the Romanesque transept towers. The records mention only work on the south tower, and neither Thomas nor the master carpenter feature in the accounts; but since Thomas was paid a salary, his work is rarely specified. The vault and masonry are so closely tailored that it is inconceivable that Thomas was not present when the prepared timber frame was lifted and fixed in place. A series of position marks—Roman numerals—on the timbers corresponds to those on the slots into which they fit.[19] The surviving metal ties and wooden bosses that complete the vault are mentioned in the accounts.

The Exeter rolls are richly informative about all aspects of the building process in England, amplifying scantier sources elsewhere and revealing aspects of an architect's work, such as involvement in carpentry, that we would otherwise have not known. The records of the second example, Ca' d'Oro, show different organizational structures, and a unique glimpse into the mind and methods of an active patron.

Ca' d'Oro

Between 1422 and the late 1430s the Venetian aristocrat, Marin Contarini, built himself a new palace beside the Grand Canal [**68**], replacing a house belonging to the Zeno family into which he had married.[20] Its coloured and gilded façade—from which comes its name, the House of Gold—represented the wealth and lineage of the Contarini and Zeno families. Contarini's own records of the building work reveal his close personal interest: the contract for the decoration of the façade goes into minute detail, including the extraordinary design of the crenellations. Contarini acted as his own clerk of the works, and dealt, not with an ordered hierarchy under one master mason, but with several independent craftsmen.

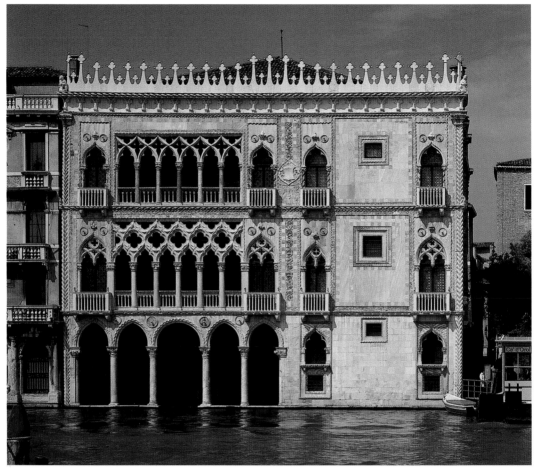

68

Ca' d'Oro, Venice, main façade
The House of Gold, built from
1422, is named from the
gilding that adorns the exotic
crenellations and other details,
some of which are from Islamic
sources. The façade displays
Contarini family emblems and
materials re-used from the
former house on the site to
perpetuate memory. The ogee
arches and red and white
colouring resemble the
Palazzo Ducale, and the
unusual asymmetry reflects
the interior disposition of
rooms. Ca' d'Oro was restored
in the nineteenth century.

Ca' d'Oro was built of brick with timber foundations and ties, and a stone façade applied to the brick structure. Each material was the responsibility of a different, autonomous group of craftsmen. The bricklayers also prepared foundations and roofs, and were distinct from the stonemasons, who worked in limestone and marble. Only where two materials met—on the staircase or the façade—did the builder of the brick walls co-ordinate the work; but he was not *capomaestro* to the whole workforce. Marin Contarini employed both local men and immigrants, the latter mostly from Milan and Como in association with one of the master masons, Matteo Raverti, a Milanese who set up a workshop in Venice. Among the locals were father-and-son businesses: the stonemasons, Zane and Bartolomeo Bon, and the carpenters, Zane and Antonio Rosso. The only surviving contracts are with Zane Bon; but since Bon was absent for months at a time, by making a formal contract with him Contarini was perhaps vainly trying to keep his master craftsman's undivided attention. Bon and Raverti were both extremely important in Contarini's eyes, creating between them the new work for the façade and incorporating decorative material from the old Zeno

house. Raverti designed and carved the two arcaded loggie that front the main rooms; Bon made the arcade to the quay, the window traceries, and the gilded crenellations.

Building materials were drawn from many different places: bricks mostly from kilns at Mestre on the mainland and larchwood from the Friuli region in the north-east. The white limestone was shipped from the port of Rovigno (Rovinj) in Istria across the Adriatic. Masons regularly went over to select the stone, some arranging delivery through agents, others, like Raverti, acting as stone contractors themselves. The red polished marble that patterns the façade is Veronese *broccatello*, the thin sheets of white marble round the windows are from Carrara in Tuscany. Since the site was so restricted, much of the stone- and wood-carving was done in the masters' own workshops, where they also stored details of timbers, cornices, fireplaces, and mouldings for doors and windows, which customers could buy ready made.

The brick structure went up in three main campaigns [**69**]. Since the ground was unstable and earthquakes frequent, the carpenters

69

Building phases of Ca' d'Oro, Venice

The ground floor housed commercial activities, with the quay (*riva*) on the Grand Canal and the large hall, the *androne*, behind. Secure rooms were in the mezzanine, with a small window on the façade (see **68**). Above were two floors of living rooms flanking the long *porteghi* behind the arcaded balconies. Access was via an open stairway in the courtyard and an internal stair.

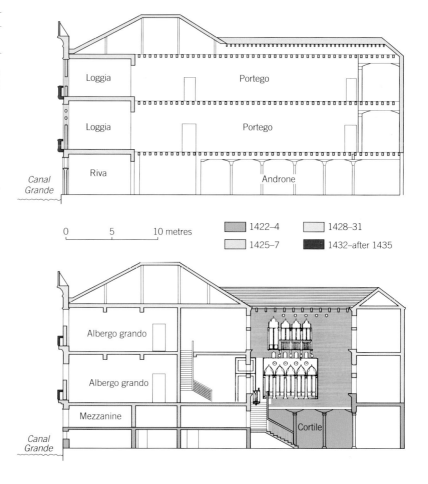

Late medieval Netherlandish towns celebrated their civic pride in magnificent city and market halls. Equally fine halls were built at, for example, Antwerp, Ypres, Oudenaarde, and Bruges. Only a part of Ghent Town Hall—the Stadhuis—was ever built. Four out of 17 planned bays were constructed on this side, and 15 out of 22 on the Hoogport side. Drawings for the complete project survive.

rapidly stabilized the upper storeys with tie beams and floor planks. Based as the house was on its predecessor, new foundations were needed only for the façade and the quay: a quantity of wooden piles was hammered in, with a raft of planks laid on top to support the stone platform. The builder was on hand when the façade was installed, to manage the temporary jetty and hoists, and ensure that the stone front was properly tied in to the brick structure behind. Other craftsmen came in as required, to put in iron ties, glaze the windows, and decorate and polish the woodwork and tiled floors.

As seems to have been the rule throughout medieval Europe the patron, Contarini, co-ordinated the supplies himself, delegating only the purchase of stone to the master mason. Unlike the warden at Exeter he could not act as a full-time clerk of the works, and this may partly explain why the façade design in particular seems to have evolved from year to year, with such details as some balconies added as afterthoughts. It may also explain the vivid little entry in his notebook for 1428, when he paid Zane Bon for making a window 'by hand in the Piazza [of S. Marco] where the vegetable market is held.'[21] His notebooks take us closer to the mind of a particular patron than do the public works represented by the last example, Ghent Town Hall.

Ghent Town Hall

Ghent Town Hall—the Stadhuis—was built by an institutional patron, the city aldermen, who decided in 1517 that they needed a new building [70].[22] They approached the two leading Netherlandish architects of the day, Rombout Keldermans—knighted by Charles V—and Domien de Waghemakere, who designed and began a large structure in the style now known as Brabantine Gothic, richly ornamented with sculptured stonework, typical of Flanders and Brabant in the fifteenth century and the early sixteenth. Full records survive from 1516/17 and 1521/22, with partial accounts for the following years while construction continued, never to be finished: only a quarter of the original design was ever realized. These accounts, like those for Exeter and Ca' d'Oro, concern building materials and payment for work done; but we also have the architects' contract and other information about the workforce.

The aldermen chose Rombout and Domien because, they said, of their ability and knowledge of all the necessary tasks and their technical knowledge. The masters' principal job was to provide drawings and oral and written instructions for the building work. In return they were offered reasonably generous terms: they need not join the Ghent masons' guild; their presence in Ghent was required only three times a year—at the beginning of the building season, once during it, and lastly to give the masons their instructions for the winter. If they were

needed at other times they would be given three or four weeks' notice. The two architects did not always visit the site together, and they sometimes sent substitutes, as when Rombout's nephew, Laureys Keldermans, replaced Domien in 1528/9, even taking Domien's salary. Work was supervised by a number of undermasters, but it cannot always have proceeded smoothly, since on at least one occasion the undermaster went to Mechelen to consult Rombout and to Antwerp to consult Domien.

Rombout and Domien represent the type of late medieval master mason who did little actual building himself. But since they were trained builders, they cannot be equated with modern architects. Domien (d. 1542) had been trained by his father, working with him in Lier; Rombout (d. 1531) came from an extensive family of architects and sculptors, known especially for their carved choir screens, who were based in Mechelen and worked widely in the Netherlands, notably at Leuven, Middelburg, and Bergen op Zoom. Although the two masters tried to prevent their designs from being copied by stipulating that, while they lived, the drawings should remain in their keeping, espionage was difficult to counter: when in 1526 the aldermen of Oudenaarde wanted an equally splendid town hall for themselves, they consulted the masons Jan Stassius and Laurens de Vaddere, who just happened to be the current undermasters at Ghent.

Initially, building in Ghent went ahead rapidly, with stone of varying types and quality being ordered—not only ashlar blocks, but details that were fully or partly finished, including cornices, balustrades, parts of windows, staircase treads, roofing materials, and decorative sculptures. Specialist window-makers arrived in 1518/19,

71

Corner turret, Ghent Town Hall
The turret that marks the junction of Hoogport and Botermarkt was built from 1520. Although the aldermen employed a regular workforce they called in specialists for various details, including *cleenskekers* to carve the capitals of the consoles that support the statues. The architects, Rombout Keldermans and Domien de Waghemakere, provided a design full of intricate ornament—mouldings, openwork tracery, naturalistic and stylized foliage—in the style known as Brabantine Gothic.

when the staircase in the angle turret was also done; and from 1520 more specialists, such as the carvers of the consoles supporting the statues on the turret [71], were called in. In winter, the unskilled labourers, who had covered exposed surfaces with protective straw, were turned off. Their skilled companions were kept on, cutting stone in the workshops set up in houses opposite the site, which had been bought for the purpose.

The documents from these three building sites—in England, Venice, and Flanders—give an idea of the immense human and material resources that were needed for successful building. They show that there was no fixed pattern of organization; circumstances varied according to the time and the place. Yet together they give a picture of the works organizations in action, planning ahead and reacting to sudden crises; ordering supplies, sometimes from a great distance; and negotiating with the master craftsmen. This enormous effort was, however, but a means to an end: the chapters that follow will examine the reasons for it.

Part II

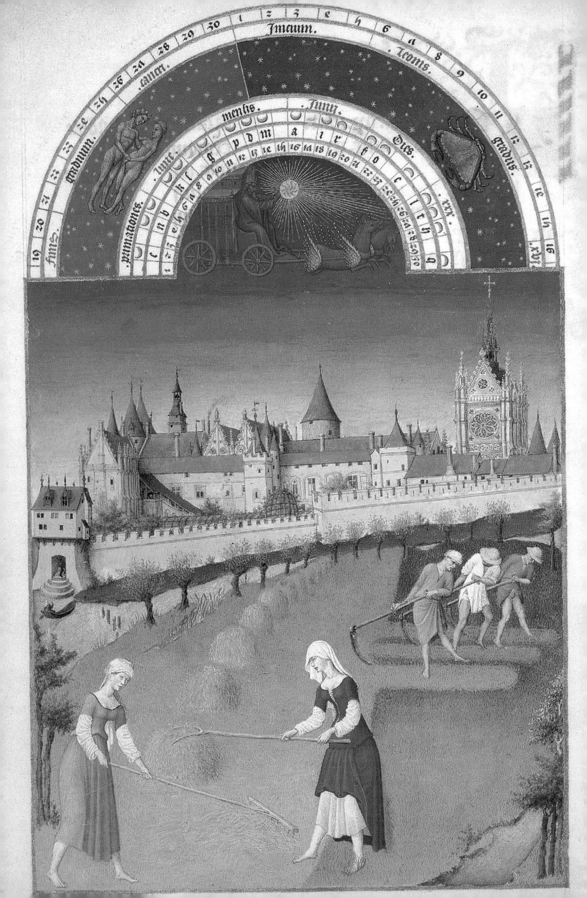

Introduction

The Sainte Chapelle in Paris (see **1**) was the most influential building of the thirteenth century, and its influence remained long after its builder, Louis IX, was dead. Many other buildings adopted its general design (see **90**) and its decorative details. The reason for the chapel's continuing hold on the imagination was its many layers of meaning. The metallic quality of the ornament, the elaborate, lacy exterior with pinnacles, gables, and tracery, and above all the monumental figures of apostles on the piers, reminded contemporaries of a reliquary (see **105**): the building not only housed a reliquary but was a reliquary in itself. But the imagery in the stained glass and the dado, as well as the monumental and relief sculpture, encompassed a religious and political programme that drew on Old and New Testament parallels to give a visual representation of Louis' belief in redemption and Christian rule. Like other rulers, Louis claimed, through the sacring ceremony at his coronation, to be the temporal representative of God's divine order. Layered within the imagery are references to the Incarnation of Christ, to Solomon as the archetypal wise ruler, and the Crown of Thorns itself. The focus of the programme was the arcaded screen that supported the reliquary in the apse, a symbolic recreation of Solomon's throne, here equated with the Virgin as *sedes sapientiae*, the seat of wisdom.[1]

The first part of this book examined the practical aspects of financing and constructing a building. Part II considers the meaning and symbolism that were the heart of medieval architecture. In medieval terms, the first part concerns the material, the second the symbolic, or, to put it another way, the precise and the imprecise. Architecture may have needed accurate measurements and construction in order to stand up, but once standing, it was infused by a different set of values. For much of the period the Christian emphasis on the transience of human life and on the world beyond Earth created an outlook opposite to our own. Since the greater reality was outside time and space, there was no need to measure the latter in physical terms. Our temporal and spatial existence is measurable, at the practical if not the philosophical level, but before the fourteenth century time was marked not in hours of equal length chimed out by clocks, but in the

72

The Palace of Paris

This early fifteenth-century view shows the buildings from the west, the most secluded area. Beyond the garden, from the left, are Louis IX's Salle sur l'Eau, overlooking the river Seine, and the Logis du Roi, renovated by Philip IV. Behind them rise the roofs of Philip's Grand' Chambre and Grand' Salle, the latter's twin gables showing how the room was divided by a central row of piers. The Sainte Chapelle stands at the right.

Market square and former
parish church, Freiburg-im-
Breisgau, Germany
Churches and markets were
the focal points of medieval
town planning, and were
closely associated, the annual
town fair often being held on
the feast day of the church's
patron saint. Freiburg, a
planned town, was founded in
1120 by the Zähringer dukes,
and, as its name suggests,
received significant freedoms.
The single west tower of the
church (now cathedral) is the
earliest of this type, the
openwork spire probably by
Strasbourg masons.

hours of the Christian liturgy, rung by bells. The liturgical hours were of different duration both in themselves and at different seasons, according to the length of daylight. Maps did not record accurate topography—sea charts first appeared in the thirteenth century—but the accumulated history of Christendom and Christian experience. Geography was sacred rather than physical. The world was centred on the source and engine of Christianity: Jerusalem, the site of Christ's crucifixion, and Rome. These and countless lesser shrines were the goal of pilgrimage, that journey of the body and soul that was a metaphor of humankind's journey towards God. Although in the later Middle Ages merchants, lawyers, and other professional bodies did develop clocks and number skills for the realities of commerce, the Church remained a powerful influence on experience of the natural world. Thus, the modern era has reversed the absolute and relative values of the Middle Ages.

To philosophers and artists physical manifestations reflected inner states of being: buildings existed in the mind as well as on the ground, and their spiritual significance dictated interpretation. Since earthly life was governed by the prospect of the life hereafter, people sought connection to the eternal world in prayers to saints, who would inter-cede on behalf of the living and dead, as naturally as they breathed. A tour of the altars in a church was also a spiritual journey, marked by meditations on relics and imagery, a journey directed by the disposition of the surrounding building. The physical was not separated from the metaphysical, as witness the placing of altars that we have already noted in St Lorenz, Nuremberg, and Saint-Denis, where geometry was used to enhance the liturgy. The division of this book into two parts, therefore, does not oppose the material to the symbolic but is adopted for the sake of clarity.

Similarly, although function, symbolism, and memory are treated in separate chapters, they are essentially indivisible. Most medieval buildings were settings for ritual activity, be it that of the church or the secular hierarchies. Where we tend to consider the sum of a building's parts or the architect's handling of space, medieval builders were less interested in framing or dividing space for its own sake than in controlling it through attention to thresholds and internal divisions, and signalling the building's significance with towers and gables. Dec-orated doorways marked social divisions. The vaulted ceiling was not merely an exercise in artistic ingenuity but represented the canopy of Heaven, suitably adorned, or a canopy of honour over the head of a secular lord. The fusion of sacred and profane was a fact of life, sym-bolized every day in market-places established beside the main church [73]. It was represented in the claims of kings and emperors to be the temporal representatives of God's eternal, divine order. In practice this was expressed most clearly in the dispensation of justice. Vested with

divine authority, the ruler was the source of earthly justice, delegated through him to his judicial officers down to the local level that touched everybody's life. As if to emphasize this, judicial ceremonies took place in the open air: in town squares, or most spectacularly in the Cour du Mai, the public open space before the palace in Paris. Buildings in which justice was dispensed, such as Italian city halls, had both sacred and profane functions and meaning. Both churches and halls could be seats of justice: Wiślica and other churches built by Kasimir the Great in Poland had a judicial role that was expressed in their twin-aisled form;[2] the great halls in the palaces of Paris and Westminster (see **27**) were the senior law courts of the English and French kingdoms respectively.

The great palaces were not only judicial centres. They were also administrative, residential, and commercial, with merchants jostling clerks and judges, and all competing for space with royal ceremonial. Since such buildings arose piecemeal over many centuries, ground plans rambled. The space where audiences were held was also used for dining and sleeping. Flexibility also characterized individual building elements, which may have functional, representational, and symbolic purposes, all of which should be remembered when thinking about any one of them. Such elements, separate aspects of a single entity, take their meaning from what they are and what they represent in their immediate context. The meaning of a tower, for example, may have modified emphasis according to its position. A tower generally represented seigneurial authority and protection. In a German castle, the prominent tower rising above hilly terrain 'nailed the valley', signalling the lord's power over and protection of the surrounding landscape.[3] But a church tower, although also a symbol of power, was a stronger symbol of protection. Crossing towers, with apses and domes, defined the sanctity of the space beneath. This symbolic function was accorded to similar elements throughout the building, from the vaults to altar canopies, niches, and tabernacles, each with the same sacred connotations as the major architectural features.

The shared purpose of the large and small scale is a significant theme in medieval architectural space, for the ritual setting might be a corner of a church, a town square, or a whole city. Jerusalem and Rome were symbolic cities, existing in the mind as well as in reality. Memory of events in the life of Christ was affirmed in symbolic acts performed in alternative spaces: the eastern altars of St Lorenz, Nuremberg (see **19**) contained relics of the Passion and the apostles that, together with the church imagery, provided a form of proxy pilgrimage to the Holy Places themselves.

In considering the way medieval people constructed and used space, and the meanings they gave it, the spiritual dimension can be lost amid analysis of territorial demarcation and conflicts over rights. But the

temporal–eternal continuum was always before those whose brief, toil-some existence was merely a prelude to the everlasting life that would come after death, and it informed architecture as much as it was the basis of religion. Organization and order were perceived as much through the mind's eye as in the architecture itself.

Architectural Space

Shaping urban space

Medieval urban space was partly an accidental development, reflecting a town's long history, and partly the result of random evolution or conscious shaping. Existing castles and ecclesiastical precincts affected the topography by dictating the direction in which a town developed. Many towns grew up as markets next to earlier castles. A typical example is Olomouc in Moravia, where the castle dates back to the eighth century. The first settlement grew up at the foot of the castle hill, eventually developing into an important bishopric and attracting a colony of German merchants and craftsmen. This was a common pattern of development throughout central Europe. The main castle gate normally faced the town, although since castles had their own jurisdictions they were separated from it by a visible boundary such as a ditch. In a few places, notably Caernarfon in north Wales (see **108**), the main gate gave directly on to the town and a single circuit of walls encompassed both.

Castles, cathedrals, and municipal buildings all represented authority, and changes to urban topography have been interpreted as reflections of the balance of power. The placing of public buildings could depend on relations between the different city authorities. In north Italy, where a bishop and commune shared power successfully, the communal palace was built close to the bishop's palace; but a powerful commune would distance its palace from the bishop.[1] At Olomouc the church ultimately predominated over the castle, and the castle hill was covered by ecclesiastical buildings. In England, as castles declined in significance, houses and shops encroached unchallenged on castle ditches. Interesting in this connection is the effect of building the huge new cathedrals in north France in the twelfth and thirteenth centuries. Traditionally seen as symbols of the Church triumphant, they occupied far more space than their predecessors, yet experience differed from one city to another. At Amiens the church of Saint-Firmin was demolished and the hospital of the Hôtel-Dieu was moved to the suburbs; but at Bourges the cathedral was partly extended eastwards disturbing fewer properties in its vicinity by breaching the town wall.[2] Negotiation between numerous interested parties undoubtedly

involved conflict, sometimes violent; but these possibilities were anticipated and efforts made to contain them. Regulations for parish fraternities stressed the importance of the annual feast that encouraged members to 'live at peace'.[3]

Many towns show their Roman origins in street layouts and standing remains. But nearly 1,000 towns were founded in the medieval period, primarily for economic reasons, to create wealth for local lords and the burghers through trade and taxation. Although contemporary paintings of towns show buildings tightly packed within a circuit of walls and towers [74], towns were not necessarily walled. Walls and gates were not primarily defensive, but were built to control the movement and taxation of people and goods. They did not isolate a town from its surroundings, with which it was integrated economically, politically, and psychologically. Far from being packed, a town was full of open spaces, unoccupied building lots and the precincts and gardens of urban religious houses. Its physical limits were often obscured by suburban settlements and hospitals, mendicant convents, and Cistercian abbeys, which wished to associate themselves with the town but to be apart. Town and country were closely linked by ties of family and household, and the far-flung property interests that were the basis of medieval society. The urban patriciate often held land with dependent communities in the vicinity. Each burgher in the new towns—*bastides*—of south-west France was allotted land outside the town as well as a tenement and garden within it. Architectural space extended itself beyond the interiors of buildings into courtyards, streets, and squares. It went below ground, in cellars and in such engineering works as the *bottini*, the great brick tunnels that channelled the water system of Siena.[4] It crossed bridges [75], linking districts of towns on opposing river banks, and connecting towns to

74

Fifteenth-century view of Kraków, Poland

Kraków, the capital of Lesser Poland, is shown with houses packed inside tight circuits of walls and towers. On the right is the Wawel hill, with the royal castle and cathedral, within their own fortification. On the left, linked by bridges over the river Vistula, is the district of Kazimierz, founded in 1335. Kazimierz has a regular layout of rectangular lots round a central market-place.

75

The Pont Valentré, Cahors, France

Bridges were essential across unfordable rivers. Even such large cities as Paris and London had wooden bridges, but in the later Middle Ages stone was increasingly used. This bridge is the only survivor of three stone bridges in Cahors, all over 300 m in span and fortified with gate towers, each fully defensible. The prominent cut-waters rise to the level of the parapet; the passages through them may have been linked by galleries.

the outside world. Towns could enlarge their spheres of influence by trading across great distances, and through political activity, which could give them autonomy over a wide area. But there were other influences, abstract, perhaps, but no less real, governed by ideas and associations. In the thirteenth century a traveller on business with the Pope went to Rome: but 'Rome' might in practice mean any of the half-dozen papal capitals in Rome's hinterland, which the Pope regularly visited, cities as near as Viterbo, Orvieto, or Anagni, but also Perugia, well to the north in Umbria. Thus at an abstract level Rome became elastic, encompassing other cities that were in effect an extension of Rome itself.[5] While Rome might be a special case, similar ties are detectable elsewhere: in Cyprus, for instance, the Benedictine monks who had taken over Stavrovouni Monastery in the mountains south of Nicosia established a spiritual link with the city by encouraging a pilgrimage to the monastery's relics of the Crucifixion.[6]

The focal points of towns were traditionally the market squares and the main church. Depending on their historical development, towns

could have several autonomous districts. The German immigrants to Olomouc had their own settlement. Nuremberg had two cities, based on the churches of St Sebaldus and St Lorenz, either side of the river Pegnitz. The parishioners of St Sebaldus were administrative officials associated with the town castle, while in St Lorenz lived merchants and craftsmen. It was not until the fourteenth century that the cities were unified by an encompassing circuit of walls, and a main market founded near the Pegnitz, together with the 'neutral' church of Our Lady, the Frauenkirche. Kraków, the capital of Lesser Poland, had its own township, with additional commercial centres in Kleparz to the north, and Kazimierz to the south. Kraków and Kazimierz both had rectangular street plans—parallel streets crossed by others at right angles—with a central market square, and other market spaces were established in the numerous suburbs, including Garbery, the craftsmens' quarter, and Stradom, the merchant settlement.

New towns and urban design

Over almost the whole of Europe planners and surveyors of new towns favoured symmetry and the rectangular layout, except in Spain, where the symmetrical plan of Ciudad Real, founded in 1255 by Alfonso X of Castile, is exceptional. But medieval symmetry was a subtle modification of the Roman grid. Where a true grid has building lots and street blocks of uniform size, medieval layouts focused on prominent buildings and spaces, magnifying the significant features in a manner analogous to the figurative arts, where important characters are depicted larger size. This tendency is particularly clear in two groups of towns founded in the thirteenth and fourteenth centuries in France and Italy. The French *bastides* were founded by rival lords, including King Louis IX of France, his brother, Alphonse of Poitiers, and Edward I of England, to create trade in new areas and extend their spheres of economic influence. Ste-Foy-la-Grande and Monpazier typify the layout of rectangular plan around a market square [**76**]. The main church was usually on the square, although it could be in its own space adjacent to it. Straight streets cut the town into blocks for tenements, and the main axial streets met and intersected at the market

76

Plan of Monpazier, France

Monpazier is one of the *bastides*, the new towns founded in south-west France in the thirteenth and fourteenth centuries. The plan shows the open, unwalled layout that allowed for future expansion. There is no regular Roman grid, but a more flexible, although still rectangular, pattern, which can emphasize important locations: the main square and the church square that opens off one corner. Access from only a few streets enabled the spaces to be controlled.

square. In these towns the blocks were of regular size, but the market square, with the streets meeting under its arcades, was the focus. It was in the square that the foundation ceremony was held, with the planting of the *pal*, a tall post bearing the founder's insignia. The square was the juridical as well as the market centre, and its autonomy was underscored by the geometry of the town plan: the square was the basis of $\sqrt{2}$ rectangles that determined the street pattern.[7]

The new towns founded on Florentine territory in the early fourteenth century had a more defensive and administrative role than the *bastides*. Unlike the latter, which allowed for expansion, these towns were planned to a finite size, apparently laid out on trigonometric rather than geometric principles, and surrounded by walls and gates.[8] But within the walls each had a rectangular plan with a central public square bisected by the main street. In Giglio Fiorentino the main street was the focus of the town plan. The widest street in the town, it was lined by the grandest houses, which had to conform to strict regulations concerning uniform heights and building materials. Behind the main street building lots were smaller and the houses more humble. Flanking the main square itself were the public buildings: the palace of the Florentine official, the town hall, the main churches. As time passed, the commercial element of the square faded in favour of public ceremonial, but this trend reflected the anxiety of the mother city to maintain a Florentine identity. Meanwhile, what would become the next phase of urban spatial design has been identified in Florence itself: a main square developed for ceremonial and aesthetic reasons, with no market functions. When the Palazzo dei Priori (now the Palazzo Vecchio) was altered and embellished in a manner appropriate to the commune, the Piazza della Signoria on which it stands was systematically enlarged and its edges straightened, to create a space around two sides of the Palazzo and align it with the cathedral area to the north. The layout of the latter area reflects the former Roman grid. Illustrating the disruptive effects of work on large public buildings in established towns, the orientation of the Palazzo Vecchio had been turned towards this regular, rectangular plan rather than to the irregular streets between it and the river Arno.[9]

Public and private space

The idea that urban spaces should be public grew only slowly during the Middle Ages, earlier in Italy than the north. Public and private are not necessarily easy to distinguish, since a structure built for private use may have a public function. In Tuscania in central Italy a number of private towers were built in the district of Poggio, itself laid out on a regular plan in the thirteenth century. The largest tower [77] is free-standing, carefully positioned at the end of the main street and

Towers like this were built in many Italian cities in the strife between the Guelphs and Ghibellines—respectively supporters of the Papacy and Empire—that dominated politics in the peninsula. Towers controlled streets and sectors of the town. Many were attached to residential palaces, and, although habitable, were themselves refuges of last resort. The Torre di Lavello was associated with the tyrant Tartaglia, who usurped power 1414–21. Its height was later reduced.

able to control several other streets—useful to the owners in times of civil strife but helpful to the whole town if the threat was from without.[10] Public access was easier to achieve in new developments or under strong governments. Otherwise, landholders clung to their rights. In Genoa the Doria family created a towered compound around the church of S. Matteo, in which the family, the household, and its rural dependents could take refuge, and assert their claim and identity by holding important family ceremonies in the square, which could be closed off and defended if need be. Churchmen also restricted access to their precincts, though for different reasons. The cathedral close of Lichfield in Staffordshire was an enclave within the city, inhabited by about a hundred clergy, choristers, cathedral officials, and servants and protected by a stone wall and moat. It had two huge gatehouses and its own water supply. The gates were shut at night, to keep the clergy in and women out.[11] On the whole, though, even ecclesiastical space was graduated, from the inner, private areas to outer courts where there could be contact with the laity. The Cistercians kept strictly to the rules of monastic seclusion, even fitting all their necessary buildings, including kitchens, around the cloister, so that no monk would have a pretext for leaving it. The modern landscape of Rievaulx Abbey still has traces of its medieval disposition [**78**]: immediately west of the tight group of conventual buildings was the inner court, reached from outside through the great gatehouse;

north and west of the monastic complex was the outer court, where some animals were kept and sheep-shearing took place; beyond, but still within the walled area and outer gatehouse, was the precinct, with its meadows and mill stream. Four home granges, for managing supplies of wheat, stood just outside the precinct. Each activity was placed according to its need for access to the outside world. The inner court was open only to important visitors, servants, and the lay brothers, who worked the farms. Inside the claustral area, deepest space was reserved for the novices, to help them to make the transition from secular life. The novices' house stood in the Infirmary cloister, behind the great cloister and further from the monastic courts and gateways. At meals they sat furthest from the refectory door. In church they were placed nearest the altar. Professed religious sat in order of seniority, the longest-professed and most senior in the westernmost stalls, that is, closer to the nave, the secular end of the church. The novices thus lived, physically and spiritually, deep inside the monastic space, sheltered from the world by their professed brothers or sisters.[12]

Yet a dichotomy between public and private is palpable, certainly

78

Rievaulx Abbey, Yorkshire, schematic plan of the precinct

The monastic precinct was surrounded by walls and gates, and areas within it—the outer and inner courts— marked the transition from the outside world to the enclosed spaces of the conventual buildings. The ground was landscaped into platforms to support the church and cloister. The course of the river Rye was altered to increase the size of the precinct and exploit the water power for mills and other works.

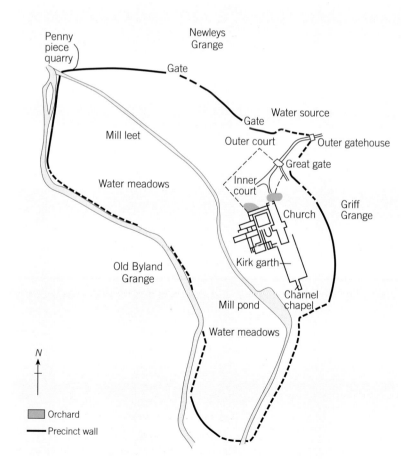

outside the cloister. One of the most secluded spaces in Europe was at
Karlstein, the private retreat and imperial treasury built south-west of
Prague by Emperor Charles IV from 1348 [**79**]. The castle has three
main buildings, which ascend the hill in increasing privacy and intensi-
fying iconography that concentrates on Charles, his imperial sanctity,
and his collection of relics. The series of chapels and galleries culmi-
nates in the Great Tower at the summit, in which a narrow staircase
leads to the chapel of the Holy Cross near the top. Here, closely
guarded in the deepest space of the castle, were kept the imperial
regalia and the relics of the Passion. Had these relics been wholly
secluded, however, much of their function would have been lost. Since
they both symbolized and legitimized imperial power, complete seclu-
sion was not an option, and they were displayed once a year in the
Charles church in the New Town of Prague. Such conflicting demands
occurred in far lower ranks of society than royalty, but because they
were felt more acutely at the upper levels, how space was organized to
meet them can best be studied in a royal milieu.

The Palace of Paris

The French royal palace on the Ile de la Cité [**72**] on the river Seine in
Paris was the administrative and judicial centre of the kingdom, and,
until the late fourteenth century, the most important royal residence in

the city. It shared space on the island with the cathedral of Notre-Dame. Both buildings were ancient foundations, going back to Merovingian times, and thus central to the self-belief of the French monarchy. The main entrance to the palace was on its east side [**80**]. A donjon (tower-keep) and the king's rooms, or Logis du Roi, were added to the ancient core of the palace in the twelfth century. In the thirteenth, Louis IX built the Sainte Chapelle, the Galerie des Merciers and the hall known as the Salle sur l'Eau, with its attached Bonbec tower, on the north edge of the island. The new buildings put up by Philip IV from the 1290s made the palace the unequivocal centre of justice and administration for the realm. He built new state rooms, a new exchequer, the Chambre des Comptes, added walls and towers, and remodelled the Logis du Roi, connecting the rooms with galleries and corridors. West of the Logis he made a private garden.

The Sainte Chapelle is the only building of the medieval palace to survive, and much of the detailed evidence of the way rooms were used is uncertain. But the general picture is clear enough and it shows how logical movement and demarcation were imposed on buildings that rambled too much to be the outward sign of inner order. On the east side were the public areas, the great entrance courtyard of the Cour du Mai and the Galerie des Merciers, where traders set up their stalls. North of these were the new Grand' Salle—the audience chamber and seat of justice—and Grand' Chambre, where the Parlement met. South of the Galerie des Merciers were the Sainte Chapelle and the exchequer. Behind these buildings, withdrawn from the public side, were the royal apartments, with their private garden. Yet in opposition

80

Plan of the Palace of Paris in the early fourteenth century

The palace was built on the north side of the Ile de la Cité in the river Seine, with Notre-Dame cathedral to the south-east. The plan shows the relation of the main buildings to one another, and the notional line east-west from the Logis du Roi through the Galerie des Merciers and the *grands degrés* or staircase to the great gate.

Not all medieval castles were strongly fortified and some palaces were not wholly residential. The distinction between them in the medieval period is complicated by both subtleties of meaning in different languages and an overlay of post-medieval usage, whereby Palace-Palazzo-Schloss-Château has been reduced to mean a grand aristocratic residence. In the Middle Ages matters were less clearly defined. At Windsor Edward III built one of the most magnificent palaces in Europe within the castle bailey, and the structure as a whole continued to be known as a castle.

Castle Although fortified with keeps (donjon or *tour maitresse*), towers and gatehouses, castles were also centres of administration and local government, lightly garrisoned and with residential accommodation. After about 1300 when local conditions rendered such fortifications obsolete, buildings known as castles continued to be erected, but they

were increasingly grandiose houses with castellated trimmings. In Spain, however, in the series of magnificent late medieval castles—e.g. Coca (see **110**), La Mota—the fortifications, although beautifully ornamented, were also massive.

Palace A palace was an aristocratic residence; but the house of the bishops of St Davids was referred to as a *palatium*, and in Italy a *palazzo* was a building for urban administration until the later Middle Ages, when important families built them as residences. The German *Palas* was the residential building in a fortified castle. Individual palaces changed their function over time, as in Paris: by the late fourteenth century the lightly fortified Cité palace had ceased to be residential and was given over to administration, while the Louvre, with its *tour maitresse* and stout walls and towers, was also known as a palace and had become an important royal residence.

to the westward movement towards privacy was the imperative of access and display, which was essential to successful kingship. The great entrance gate lay in a straight line east–west to the Logis du Roi, through the staircase leading up to the Galerie des Merciers. On royal festivals all commercial activity was cleared out of the Galerie, which became an impressive corridor leading to both the Grand' Salle and the Logis, and to the person of the monarch. The staircase itself anticipated the grandeur of the king's rooms, and signalled a dual message, of privacy and openness.[13]

The palace illustrates medieval spatial organization in all its subtlety. We have already seen how the different interests—judicial, administrative, residential, and commercial—all crowded one another, spatial functions changing continuously. In such a building, although access to the Logis and the garden was severely restricted, nowhere was wholly private, owing to the monarch's need to maintain ties with his household and people. These ties were maintained in two highly characteristic areas of the palace: the halls and the courtyard.

Hall and courtyard

It was in the hall and courtyard that much medieval life was conducted. Both essentially public areas, the hall as building and the courtyard as

open space were not opposites or alternatives; their development and that of their ancillary buildings were intimately linked.

The halls at Tonnerre (see **2**), Prague (see **4**), Westminster (see **27**), and Avignon (see **54**), which have already been illustrated, reveal the hall as an all-purpose structure, suitable for a hospital, an audience hall, and a law court. The list includes universities and colleges, fraternity and guild halls, houses, shops, barns, commercial buildings, and warehouses [**81**]. Many survive overtly as halls or hall-houses [**82**] and shops.[14] A great number are hidden behind later façades, particularly in towns, where early modern frontages conceal rows of medieval halls placed end-on to the street [**83**]. A hall could be constructed with or without aisles, of any building material, and have a vault or a timber roof. Unlike a castle or great church, it took its status entirely from its context rather than its size or position, so that while one might be a

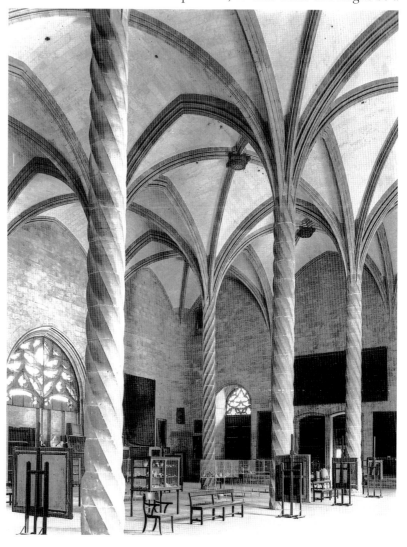

81

The Llotja, Palma de Mallorca, interior

Market halls and exchanges, buildings for trading such commodities as cloth, butter, and corn, existed in every port, surviving best in the Netherlands, the Venetian *fondachi*, and in Catalonia. The Llotja (exchange) of Barcelona (1380–92) and that of Palma (begun 1425) have aisles and arcades. Here Guillem Sagrera, master mason at Palma Cathedral, designed twisted columns rising to deep vault cones, curvilinear window tracery, and the merchants' angel emblem sculpted over the main door.

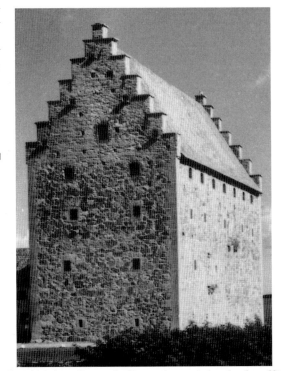

The hall was the basis of
innumerable types of medieval
building all over Europe,
including most houses, the
rooms of which were
subdivided halls.
Glimmingehus was built
c.1500 by a member of the
Danish nobility. It had a vaulted
basement with kitchens and
storage rooms, supporting
three upper floors. The
rectangular shape and
stepped gables clearly show
the building's hall structure.

palatial audience hall another might shade off into peasant vernacular
building. The questions of type and status—social differences between
first-floor halls and ground-floor, aisled halls, for instance—are much
debated, as are regional preferences in design and materials. Of more
immediate concern here is the relation of the hall to the building as a
whole.

In origin, the early medieval hall was the place where the lord dined
with his household, and where members of the household slept at
night. As the only large space, it developed its other functions fairly
quickly; but even outside the residential context the hall maintained its
primary role as a dining-room, as in guild and fraternity buildings
which had—as they still do—prominent halls for the annual feast.
The position of the hall depended on the nature of the building. In
unfortified building complexes it stood in an open court, and in
Germany even in fortified buildings the hall had been separated from
the defensive tower or other strong point. In some thirteenth-century
French and English castles, however, a hall was still incorporated in the
donjon, notably the huge cylindrical towers built by Philip II Augustus
at the Louvre in Paris and elsewhere, and by Enguerrand, Lord of
Coucy, at his castle near Laon. But even in France and England other
castle-builders were abandoning donjons in favour of strengthened
gatehouses, which did not contain halls. In such castles the hall was
built against the curtain wall in the bailey or courtyard, becoming inte-
grated with the courtyard just as in unfortified dwellings.

This detail of a painting by a
follower of Robert Campin
shows a town with walls and
gates. (The full picture is
shown below.) The church
looms over the other buildings,
but here its dominance is also
symbolic. There are spacious
streets and squares, with
houses either parallel or at
right angles to the frontage.
Building materials include
brick, stone, and wood.
Houses have plain or stepped
gables and projecting upper
storeys.

The hall remained the focus of communal household life, but in the
meantime separate living quarters grew up beside it. The reason for
this must be sought in the structure of the medieval household. The
household rarely consisted of a single family. Not even extended fami-
lies actually lived in the same set of rooms. The household was
structured around several nuclear families living on the same property.
This is true even of peasant families, which built separate quarters
within the compound for siblings and different generations.[15] In noble
households the officers and retainers had households of their own, and
by the late thirteenth century these retinues had moved out of the hall

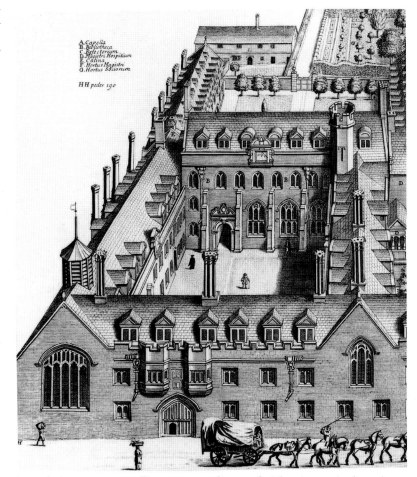

Old Court, Pembroke College, Cambridge

Marie de Valence, Countess of Pembroke, founded the 'scholars house', later 'college of the hall of Valense Marie', in 1347. Early university colleges were among the first buildings to combine hall and courtyard in coherent schemes. In this print of *c.*1688, showing renovated buildings, the chapel with its large window is lower left, the hall across the courtyard. The remaining ranges were filled by sets of chambers, each with a fireplace and chimney.

into their own rooms. Rooms were disposed either in vertical stacks or horizontally. Ca' d'Oro in Venice is a good example of a patrician town house with a vertical arrangement of living space (see **69**). The main feature of each floor is a long hall, with ancillary rooms: above the ground-floor commercial area, the middle storey was for communal living and the top floor was partitioned into discrete units for several family groups. Similarly, domestic chamber blocks built next to halls contained up to three storeys above a storage basement, each storey with a separate lodging. The same disposition is found in city towers, as in Tuscania, or the tower houses built in Ireland and on the Scottish borders into early modern times.

Lodgings spread horizontally around courtyards, giving rise to integrated designs of halls and chambers focused on the courtyard. A large, aristocratic establishment might have several halls, for the lord, the household, visitors, and servants. The layout was highly successful in many kinds of domestic planning. Such communal residences as almshouses and colleges had individual lodgings with a hall and chapel in common [**84**]. Carthusian monks lived separately, each in

his own cell, the cells built around a series of cloisters. Benedictine refectory and infirmary halls were approached through cloister courts. The courtyard became the central space, sometimes literally so: a number of polygonal or circular castles were built around central courtyards, among them Castel del Monte in south Italy (c.1240), Bellver near Palma de Mallorca (1309–14), and Old Wardour, Wiltshire (1390s). Usually, however, the space was the metaphorical centre, the hub of arriving and dispersing traffic, the most public space in the property, giving controlled access to the private areas. Yet, separate lodgings notwithstanding, how was privacy achieved? Most rooms interconnected and were often accessible from several directions. Room use is another much-debated topic: the main inferences are that outer spaces were more public than inner ones, and that in, for instance, a chamber block, the least accessible room was probably occupied by the lord. In large spaces such as halls, rooms were created by screens.

Screens

For the modern spectator one of the main difficulties in 'reading' a medieval building and trying to see it through contemporary eyes is that many of the open vistas that now reveal the whole design as the sum of its parts were then interrupted by liturgical furnishings and obscured by screens. Many screens have disappeared. They are represented at best by modern replacements and at worst by slots in piers and floors, and it is easy to underestimate their effect on an interior. But any enquiry into architectural space must take them into account, for the small, private spaces they created were as significant as the larger areas of hall, courtyard, and street. A choir screen in particular could create a building within the building [85]. Made of stone, metal, or wood, gilded and painted, and adorned with the latest motifs of micro-architecture, screens were two-dimensional reductions of the structures around them.

The advantage of the screen was that it could mark out a space that was not designed into the architectural structure. The rectangular, box-like, eastern arms of many great churches in Britain (see 113) were infinitely adaptable precisely because the liturgical spaces of the choir, shrine chapel, and eastern chapels were not dictated by immovable stone apses, but were arranged with screens to suit the requirements of each building. The passage at the lower—that is, the service—end of the great hall that separated the hall from the pantry and buttery was formed by a wooden screen with doors in it (and is known as the screens passage). In hospital and infirmary halls screens placed at right angles in the aisles between the wall and the piers formed cubicles for beds or consulting rooms. Monastic dormitories had similar cubicles

85

Albi Cathedral, France, choir
screen, looking west

The imposing late fifteenth-
century screen completely
surrounds the choir, creating a
discrete space within the
cavernous, aisleless interior.
The screen is composed of
micro-architectural motifs to
emphasize the sacred space it
encloses. Albi Cathedral is a
thirteenth-century brick
building; its exterior is
'fortified', as if against the local
Cathar heresy. The buttresses
are pulled back into the
interior, forming lateral
chapels.

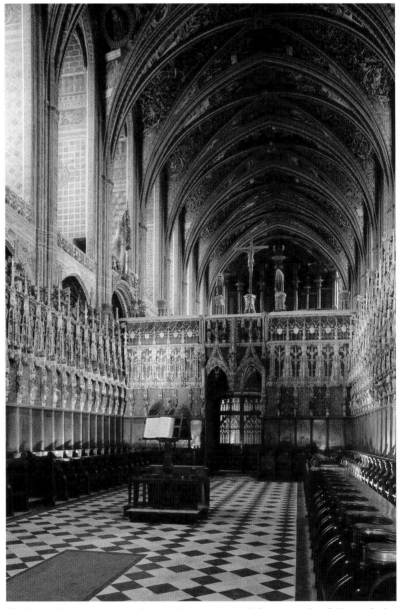

fairly early, the screens becoming more solid as monks followed the
laity in their desire for more privacy. By the fifteenth century most
dormitories had been converted to sets of private rooms.

Screens were essentially partitions, but they are not necessarily to be
interpreted as impenetrable barriers, even when, as at Albi or La
Chaise-Dieu (see **55**), they might appear to be solid constructions.
Earlier screens had been low or transparent, but as the centuries passed
height was increased and transparency reduced. This is particularly
true of screens that separated the choir and sanctuary from the choir
aisles and, for different reasons, the shrine area behind the high altar. A

high shrine in that position had been visible over the high altar, at least to the celebrating priest; but with the late medieval emphasis on the body of Christ, the shrine was screened out to focus on its symbolic presence as the Eucharistic wafer, or host, on the high altar. In a great church the choir screen was a deep, vaulted structure supporting a platform, above which stood the Rood—figures of the crucified Christ, the Virgin and St John. Against it stood the altar of the Holy Cross, which honoured Christ and was the secondary high altar, serving the laity, who normally remained in the nave. The screen defined the clerical and lay areas of the church, but it linked them literally by its central doorway and metaphorically through the sermons, readings, and masses that were delivered from the platform.[16]

Other screens were more transparent, often openwork above solid lower panels. Zane Bon's traceried screen dividing the quay and the main hall of Ca' d'Oro was not a barrier; it invited people to look through it. The same impulse governed lesser screens in churches. Choir screens of smaller churches allowed the congregation to view the host. Screens partitioned aisle bays into separate chapels for fraternities and private family burials, but the founders of fraternities and chantries invited outsiders to pray for their dead associates and relatives, crossing into the chapel space spiritually while remaining physically outside it. Chantry chapels [**86**], even more than choirs, became buildings in miniature, since they could have vaulted roofs as well as walls (see **120**). Chantry chapels were the epitome of the controlled space that was at once public and private.

86

Chantry chapel screen, Cirencester church, England

The mid-fifteenth-century carved wooden screen separates the eastern bay of the south aisle of the parish church into a burial chapel for the Garstang family, wool merchants in the town. The family renewed the windows and built the tomb recess that is visible through the screen. The chapel was served by its own priest, who said masses for the souls of family members, but prayers were also invited from outsiders, who could see through the architectural panelling.

Ritual and procession

Architectural space was a ritual setting. Medieval ritual, sacred or secular, was raised to the level of an art form. The contrivances of ritual were absorbed into the fabric of everyday life, so that while some settings were designed specifically for ritual, others could become ritual spaces when needed. A typical example of a controlled open space of this kind is the main square of Scarperia, one of the Florentine new towns [**87**]. Its apparent accessibility is belied by the small number of streets that lead to it; and its character is defined by the important buildings that line it. It is a square and a main urban thoroughfare, but it could also become a ritual auditorium. In 1353 the confraternity of the Nativity of the Virgin in the town built an oratory on the square, a single-storey, vaulted loggia, which contained an altar surmounted by a tabernacle with a painted image of the Virgin. The square was now the auditorium for spectators. Square and loggia together formed a space that was partly religious and, since the loggia was also probably used by the city governor, partly political.[17]

Rites of various kinds were the reason for the continuous spatial flow between interiors and exteriors, and the concomitant significance of thresholds and approaches. Much may be learned from doorways: the amount of decoration, whether it is on the inside or the outside of the door, in which direction the door leaves opened, and associated vestibules, waiting rooms, or guard rooms. There may be a simple step or a whole flight of stairs. That such matters were essential for display and status is shown in the bishop's palace at St Davids in west Wales, built by Bishop Gower in the 1330s. The see of St Davids was not rich, and Gower hardly visited his episcopal seat, but the new residence had halls on two sides of a courtyard, each approached by a staircase and elaborate entrance. The entrance to the smaller hall has a polygonal arch to the door at the top of the steps, which opens into a small, square, vaulted vestibule, thence into the hall. The vestibule led also to the kitchen passage: its vault canopy distinguished the visitor's route from kitchen activities. The entrance to the great hall is a two-storey,

87

Oratory of the Compagnia di Piazza, Scarperia, Italy. Reconstruction as in 1353

The Augustinian friars of S. Barnaba, whose church stood on the main square, sponsored a confraternity of the Nativity of the Virgin, known as the Compagnia di Piazza from its association with the square. The oratory was originally a loggia, open to the square and sheltering an image in a tabernacle embellished with micro-architectural motifs. The loggia became a stage for ritual enacted before the congregation out in the square.

The porch provides a ceremonial entrance to the hall on the first floor. The stair rises through the porch, slightly skewed to avoid a passage from the kitchen to the left. The moulded doorway is surmounted by an ogee arch and the remains of seated figures in niches, too damaged for certain identification. The arcaded parapet with a chequered pattern and large projecting corbels runs around all the main palace buildings.

battlemented porch, ornamented with carved, seated figures in niches and a large, moulded ogee arch over the door [**88**]. A broad flight of steps mounts through the door and the porch, up to the hall. The decorative door treatments and other details show the builder, Bishop Gower, adopting high-class connotations for these thresholds. The most surprising one is the angle of the two staircases. It was still common to position stairs flanking the building, but these are set perpendicular to it. Gower's source for what was a relatively recent development seems to have been very exalted indeed: the Palace in Paris.

In Paris two staircases led out of the public square, the Cour du Mai: one gave access to the low end of the Grand' Salle, the other—*les grands degrés*—opened to the Galerie des Merciers. Both were set perpendicular to the buildings. The *grands degrés*, situated at the centre of the gallery, led up to a double door with a tracery tympanum [**89**] and, as at St Davids, carved figures, here statues of Philip IV and two

The great ceremonial staircase was destroyed in the eighteenth century, but is shown here in a mid-fifteenth-century painting. The stairs, of tripartite design, were set near the centre of the façade, and perpendicular to it, unlike stairs to halls of lower status, which were at one end and often flanked the building. The doorway design was based on church portals.

others, one his chief minister, Enguerran de Marigny. The ensemble, the most magnificent of its kind yet built, was the focus of public ceremonies enacted in the Cour du Mai and the king's rooms. Proclamations were read from it, and it was used for the ceremonial entries of royal visitors. Its tripartite design probably reflected hierarchy and rank among members of the households who would be assembled there on such occasions. The stair gave access to the king's rooms when he made himself visible to his subjects, but when he was absent or inaccessible his carved image on the portal 'stood in' for his presence.[18]

The loggia and square at Scarperia and the staircases of Paris and St Davids were intended for outdoor ceremonies; but, as with planting the *pal* at the foundation of a *bastide*, such squares and steps reverted to normal use once the ceremony was over. The question of how far buildings were designed for specific rituals is still unresolved. Rites and ceremonies changed and developed. New ones were introduced. These could not always be performed in purpose-built structures, but had to adapt to the layout of existing buildings. Nevertheless, there is evidence of ritual consideration in architectural planning. Since it illustrates both conscious planning and adaptation, we may return once more to the Palace in Paris. The Sainte Chapelle was built by Louis IX to act as a collegiate church to house the relics of the Passion, and as a monument to the Capetian kings and their ideology of kingship. The king and queen may well have been focal points of the iconographical programme, for they sat in specially ornate alcoves

halfway along the walls, living figures among those evoked in sculpture and paint.[19] Yet the palace in which the chapel stood had been built without architectural focus, until Philip IV, wishing to extend and clarify the meanings and functions introduced by his grandfather, linked it all by the galleries and staircases that imposed a visual pattern on the ideology. Visual patterns of this kind existed at far inferior levels. A hall, for instance, with its dais (often lit by a special window), and the separation of the chamber block from the service area, was designed to accommodate the hierarchies and seating patterns of the household's dinner. But where we find both adaptation and deliberate intention expressed most clearly is in buildings for the church.

There is disagreement over the extent to which churches were planned with the liturgy specifically in mind, and the evidence supports a variety of conflicting opinions. The matter concerns ground plans rather than elevations, since by our period, although some rites involved the use of upper levels, as we shall see, the routine use of chapels in upper galleries had been abandoned. At the simplest level conduct of the liturgy needed only an altar. A baptismal font was necessary in parish churches, and extra altars and shrines were in a sense optional. But the liturgy expanded with the addition of new feasts and processions, as well as the refinement of long-established rites. Clergy serving existing buildings that were not altered were forced to adapt liturgical procedures to suit their floor plans. The plan with an ambulatory—in its many forms—emerged as the most satisfactory answer to the needs of processions and pilgrims, but ambulatories were by no means universal. Aachen Cathedral [90] has a chapel-like choir, one of many such across German territories that were clearly influenced by the Sainte Chapelle. Though spacious on a large scale, these choirs are often small, and the needs of the clergy were subordinated to the connotations of the building type. Nor did a new ambulatory necessarily herald liturgical change: at Cologne the desire for a huge new cathedral with a chevet and radiating chapels in thirteenth-century French style seems to have transcended loyalty to the old liturgy, which had to be adapted to the new spaces.[20]

Yet there is unequivocal evidence that some churches were planned to suit practical needs rather than symbolic references—or that the latter were incorporated in the former. One specifically late medieval building type is the mendicant church, an open structure with wide arcading and slender piers, in which preachers might have a better chance of making themselves heard. The so-called Sarum rite—the ritual customs devised for Salisbury Cathedral that were widely adopted in southern English great churches—has been associated with newly extended eastern arms, planned to allow ease of movement through a logical layout. At Wells Cathedral the late twelfth-century eastern arm was partly demolished and replaced by an extension that

Choir of Aachen Cathedral, Germany, exterior from the south

This structure replaced the earlier choir of the former palatine chapel of Aachen between 1355 and 1414. Its design, a single vaulted space with immense, tall windows, was based on that of the Sainte Chapelle in Paris, an appropriate model since both housed relics of canonized rulers. The eastern bays were widened to give the windows even more effect. Many central European churches (e.g Wiślica **56**) adopted the design on a more modest scale.

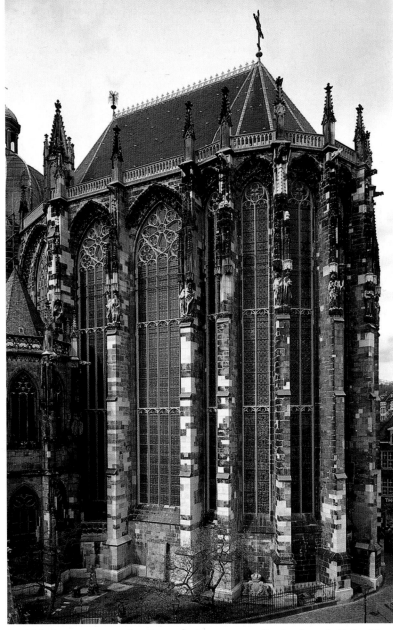

91

Wells Cathedral, England, interior of Lady chapel and retrochoir, looking north-east

The choir was extended eastwards c.1320 to accommodate the expanded liturgy of the fourteenth century, providing positions for extra altars on the east walls. The Lady chapel—an irregular octagon—merges with the ambulatory, or retrochoir, the design of fused spaces typical of English architecture at this time. Richly patterned tracery and vaulting, intricate mouldings using contrasting stones, and stylized foliage add to the decorative effects.

included more space for altars and an eastern Lady chapel, linked by a broad vestibule or retrochoir [**91** and **10e**]. This beautiful, fluid design allowed the Sunday procession around the altars to follow an orderly path with no doubling back or awkward squeezing through narrow spaces. At the same time it gave architectural prominence to the Lady chapel. Lady chapels, dedicated to the Virgin Mary, were built for the increasingly elaborated liturgy of the Virgin, with its own feasts and hours running parallel to the general daily offices. The Lady chapel

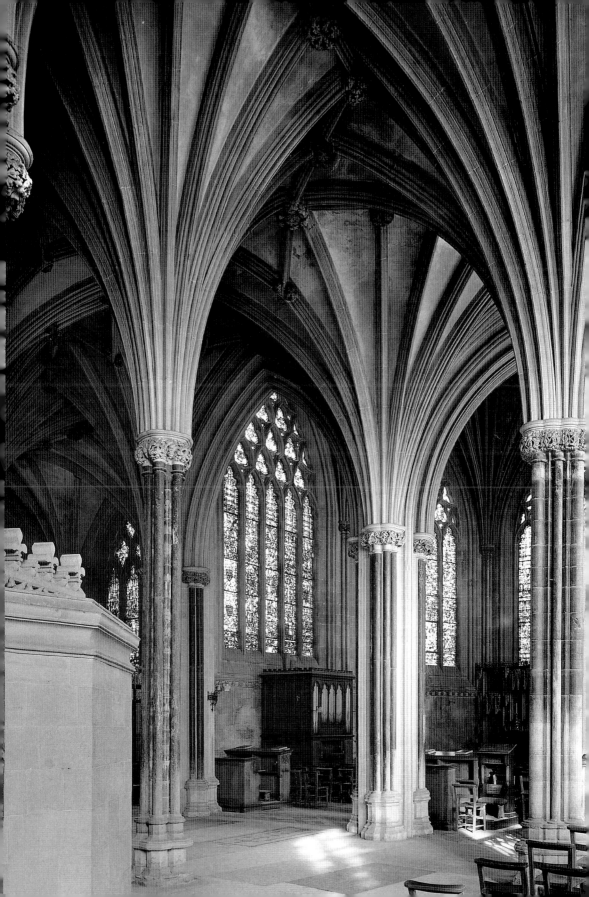

was often positioned at the extreme east, beyond the high altar. In some places, as at Wells, it was expressed in architectural form; in others it was differentiated by screens. Late medieval devotion concentrated on both Christ and His mother, and introduced along with new feasts of Christ, such as the Five Wounds and the Crown of Thorns, those of the Visitation and the Name of Jesus, which shared devotion between them. These feasts were a manifestation of the late medieval emphasis on corporate spirituality and collective devotion.[21] Another manifestation of this was the corporate procession.

Above all other medieval rituals, processions brought together interior and exterior space. They reached into towns and to village boundaries, defining limits and jurisdictions, and uniting different interests. They connected areas or specific buildings, as in the procession that followed the Pope's coronation in St Peter's. This led from the Vatican across the city to the papal residence and cathedral at the Lateran, a procession that linked the two founder churches of Roman Christianity and bound them together with the districts through which it passed. As the liturgy expanded, so did the number of processions. Some, like the Palm Sunday procession the week before Easter, had their origins at least in the tenth century. The feast of Corpus Christi, on the other hand, was instituted only in the thirteenth century, the procession fully developing from the fourteenth. While Palm Sunday was essentially a procession of the clergy, the Corpus Christi procession came to be shared with the laity, especially the craft guilds, who staged the cycles of Corpus Christi plays. Corpus Christi processional routes varied from town to town, reflecting local preoccupations and the relative power of the clergy and lay people.[22] Demarcating areas of influence, they also honoured the parishes, so that at Verona, for instance, the procession began at the cathedral, visited all seven parishes in the city, and returned to the cathedral via the main public open spaces of the Piazza dei Signori and the Piazza Erbe. At Durham the route included the shrine of St Cuthbert behind the high altar of the cathedral. In Lleida in Catalonia the procession followed royal and episcopal ceremonial routes.

But it was in the Palm Sunday and Easter rituals that architecture played a practical as well as symbolic part. The Palm Sunday procession, taking place after the distribution of palms and before Mass, toured both inside and outside the church as well as far beyond it. It culminated in front of the west door, where boy singers accompanied with praise the symbolic re-enactment of Christ's Entry to Jerusalem. The choir could stand on a temporary stage, but at several English great churches, including Salisbury, Wells, and Exeter (see **65**), the choristers stood up in a gallery built within the fabric of the west front. At the former two cathedrals special holes in the west wall allowed the voices of invisible angels to be heard below. At Exeter during the

Easter procession the choristers also stood in the minstrels' gallery halfway down the nave, fronted by sculptures of musical angels. Thus the architecture underscored the ritual, was itself the setting for an emotional, dramatic presentation, and became imbued with the symbolism of the earthly and heavenly Jerusalem.[23]

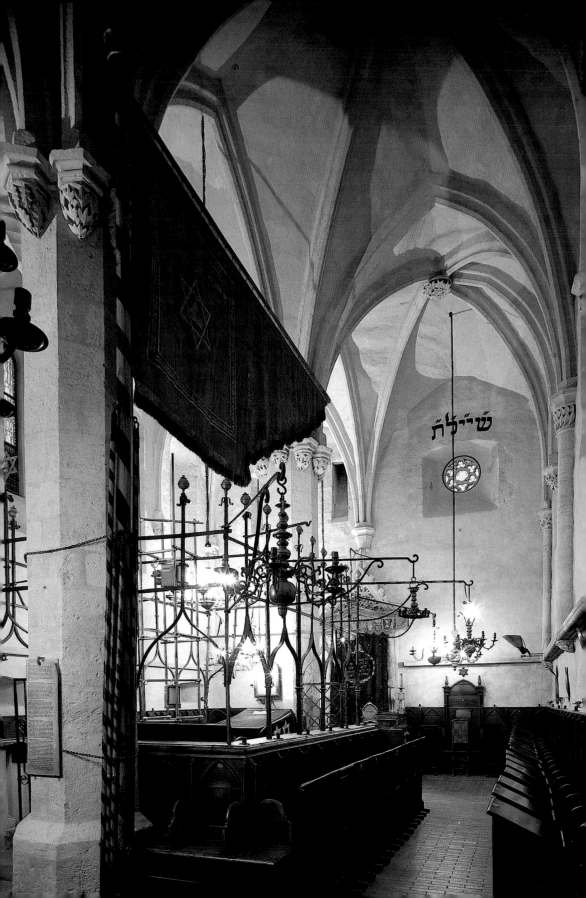

Symbolic Architecture: Representation and Association

5

'All thy walls are precious stones and the towers of Jerusalem shall be built of gems.' This quotation from the medieval service for the dedication of a church identifies the church building with the Heavenly Jerusalem, an image derived from John's vision of the eternal city in the New Testament book of Revelation, 21: 19–21. It is unequivocal evidence that architecture was interpreted symbolically. The topic of symbolism in medieval buildings can be elusive. That decoration and imagery are symbolic goes without saying. Church imagery symbolizes all aspects of Christian experience and hope, just as the decoration on the façade of Ca' d'Oro perpetuates the memory and aspirations of the Contarini family (see **68**). But symbolism in the structure itself is another matter. The subject is kept alive in the popular mind by those who seek to show that churches were laid out according to systems of symbolic numbers, but in academic circles it goes in and out of fashion. Medieval symbolism was discussed energetically in the decades around the 1840s, when such enthusiasts for the Gothic Revival as A. W. N. Pugin and the group known as the Ecclesiologists dedicated themselves to its rediscovery. A key text was part of a treatise on the Divine Office written by William Durandus, a thirteenth-century bishop of Mende in southern France, which was translated in 1843 as *The Symbolism of Churches and Church Ornaments*.[1] This work supplied all the necessary justification for Ecclesiological beliefs, and was the basis of later work on church symbolism, which extended the study to other medieval scholarly texts. Influential works by Hans Sedlmayr and Otto von Simson developed the theme of the Gothic cathedral as a representation of the Heavenly Jerusalem.[2] But simply accepting that architecture was imbued with symbolism does not consider how far symbols were designed into a building and how far they were identified after the event. Some medieval writers, including Durandus, equated the monastic cloister with the portico of Solomon's temple in Jerusalem; but although cloisters are traceable back to the early eighth century, the comparison was devised only in

92

Prague, Old-New Synagogue, interior, looking east

The rectangular hall is divided into six bays by two axial piers. These are octagonal, with plain bases but more elaborate, foliate capitals, some stylized but others naturalistic, and with varied profiles. The finely cut rib mouldings are characteristic of such contemporary buildings in Prague as the churches in St Agnes Convent. The extra rib in each bay descends to a console, anticipating the vaulting of later churches in Lesser Poland.

the twelfth.[3] Durandus goes into detail on the symbolism of parts of buildings:

The Piers of the church are Bishops and Doctors: who specially sustain the Church of God by their doctrine . . . The bases of the columns are the Apostolic Bishops, who support the frame of the whole Church. The capitals of the Piers are the opinions of the Bishops and Doctors. For as the members are directed and moved by the head, so are our words and works governed by their mind.[4]

Yet these words are not evidence that patrons or builders selected particular elements for their symbolic significance. Too many buildings fail to conform: continuous mouldings have no capitals, and few ambulatories are marked out by exactly twelve apostolic columns. Durandus was, in fact, providing his fellow clergy with material for sermons, offering parts of buildings as metaphorical exemplars within the congregation's line of vision.

Architectural symbolism was expressed in decorative elements, like the maritime motifs on Portuguese Manueline buildings and in the deliberate use of *spolia*, as at Ca' d'Oro. Yet it should not be reduced only to details. As Sedlmayr and von Simson both recognized, symbolism was concerned with a larger picture, the representation of divine truth and association with holy objects. Their interpretations have been questioned on various grounds. Both they and the Ecclesiologists reconstructed a period of ideal Christianity and worship that certainly never existed, and their vision is incompatible with the piecemeal nature of construction and decoration. A large cathedral of the kind those scholars had in mind could take many years to build, be modified along the way, and involve different interest groups; changing ideas and fashions, with destruction and restoration, make it impossible to know whether the original patrons had such an integrated vision.[5] Yet, while there is some truth in these criticisms, the groups that contributed to a church building did so with common objectives: their association with the divine order and their desire for salvation. Their political or commercial concerns were secondary to the primary purpose, however long that took to fulfil. Symbolism was implicit in their efforts to unite the material and the spiritual.

One way of testing the presence of symbolic association is to look for evidence of its rejection. This can be found in the late thirteenth century Old-New Synagogue in Prague [**92**]. The synagogue has all the characteristics of a smart Gothic building of its day, with foliage capitals and cross-ribbed vaults. But each bay of vaulting has five ribs rather than four. Jews avoided the cruciform, and it has been suggested that the fifth rib, which has no structural purpose, was inserted to deny any association with the cross. That they did so demonstrates its symbolic power.[6]

The Heavenly Jerusalem

Central to the Christian faith, the cross and the crucifixion were the strongest visual and literary images in the experience of medieval Christendom. Only a little less powerful was the Heavenly Jerusalem. John's description in Revelation and the Old Testament prophet Ezekiel's vision of the rebuilt Temple of Jerusalem gave it both biblical authority and a form that could be visualized, as we saw in the work of Richard of St Victor. Durandus's interpretation of the eternal city at several levels is typical of medieval writing on the subject; 'In like manner, Jerusalem is understood historically of the earthly city whither pilgrims journey; allegorically, of the Church militant; tropologically, of every faithful soul; anagogically, of the celestial Jerusalem, which is our Country.'[7] Durandus shows that the Heavenly Jerusalem was simultaneously physical and spiritual. The fourth element, the anagogical, whereby a material representation could raise the senses to a vision of the eternal ideal, was expounded also in Suger's description of Saint-Denis. But the eternal city's success as a metaphor depended less on its mystical associations than on the participation of the 'living stones' of the Church, which brought it into the personal sphere of every individual. Robert Grosseteste expounded the idea in detail in *Templum Dei*, his own little book of instruction for priests composing sermons. The Heavenly Jerusalem was both remote and intensely alive within each soul.

But as Durandus makes clear, the idea of a heavenly city implies its earthly counterpart. Jerusalem, the site of Christ's last days on earth, was far from western Europe and in Muslim hands. Although determined pilgrims travelled to Palestine, the holy places—and the events they represented—could be recreated in the west. There were two ways of evoking them, both surviving in St Lorenz, Nuremberg. The Krell altar in the eastern chapel of the ambulatory shows the Virgin and Child against a background depicting the town of Nuremberg [**93**], with its distinctive outline of castle and churches. It is one of several

93

Fifteenth-century view of Nuremberg

This altarpiece, which was given to St Lorenz, Nuremberg, by Jodocus Krell, a priest who died in 1483, shows the earliest known depiction of the town, with the castle and two main parish churches. The painting stands on the altar of St Bartholomew, one of several dedicated to apostles, forming part of a spiritual journey within the building, bringing events in the Holy Land into the heart of Nuremberg itself.

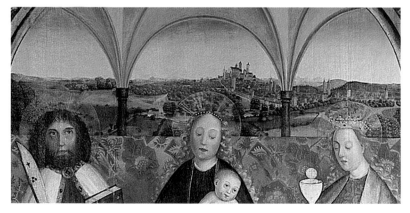

late medieval altarpieces (Konrad Witz's *Miraculous Draft of Fishes* for the high altar of Geneva Cathedral is another) that brought the reality of biblical events right into the personal sphere by showing them in the immediate locality. The Krell altar itself contained relics of the Passion. These, with other altars to the Virgin and apostles, offered a tour of meditations on holy events and places that amounted to an alternative method of making a pilgrimage to Jerusalem.[8] Jerusalem was thus evoked in the cities and buildings of western Christendom by a process of sacred geography. The essence of the city varied according to requirement. St Lorenz offered a spiritual pilgrimage. In the Sainte Chapelle in Paris, Jerusalem underscored Louis IX's image of himself as a Christian ruler: the Crown of Thorns (and the fragment of the True Cross, which was added later) affirmed the king's claim to inherit his authority directly from Christ, as implied by the Pope's charter of privileges, which stated, 'The Lord has crowned you with his crown of Thorns'.[9] The chapel became the Jerusalem, not only of Christ's Passion, but, owing to its Solomonic and redemptive iconography, the city of Solomon's temple and of eternity. Jerusalem could also spread out into the urban fabric, as at York, which became the New Jerusalem when the citizens acted out the Passion of Christ in their annual mystery plays. When Richard III visited York in 1483, he requested a performance of the Creed play, walking in procession to the Minster along streets that had become the Way of the Cross.[10]

94

Tomb of Christ in Konstanz Cathedral, Germany

This small structure conveys meaning through its centralized shape, which evokes the church of the Holy Sepulchre in Jerusalem, and its imagery. The figures flanking the upper register of windows on the left of the entrance represent the Three Maries visiting Christ's tomb, and those on the right the Three Magi at the Nativity of Christ. This juxtaposition draws a parallel between the two episodes, emphasizing the significance of Christ's birth and resurrection.

The church was part of a larger
charitable building attached to
the mansion of the Adornes
family, Genoese merchants of
whom one branch had settled
in Bruges to take advantage of
the trade flourishing between
the two cities. Built of brick like
many structures in Bruges, the
irregular octagon that recalls
the Holy Sepulchre stands
over the raised choir. The low,
rectangular nave is the burial
chapel of members of the
family.

Jerusalem was also recreated structurally, in symbols of the Holy
Sepulchre, which represented the city as a whole. Although the later
medieval period had no counterpart to the sequence of eleventh-
century buildings at S. Stefano, Bologna, which were interpreted as
Calvary and the Holy Sepulchre, versions of both the tomb of Christ
and the rotunda of the Anastasis (Resurrection) attached to the church
of the Holy Sepulchre continued to be made. The representations of
the tomb that were placed in a number of western churches were rea-
sonably accurate,[11] but the Anastasis structures sought to reproduce
only the essential characteristics of circularity. The so-called Tomb of
Christ in Konstanz Cathedral [94] is a small polygon that does not
resemble the tomb edicule but implies the centralized plan of the
rotunda complete with its conical roof. The tracery, gables, and sculp-
ture, however, are typical of its mid-thirteenth-century date. What
was required was not a replica, but a form that provoked meditation on
the meaning of the building represented. The Konstanz structure is a

liturgical object within the church, but in Bruges between 1427 and the 1450s the Adornes family built a Holy Sepulchre church—the Jerusalemkerk—next to the family mansion [**95**].[12] A rectangular nave leads up to a combined choir and bell-tower which takes the shape of a tall irregular octagon with corner turrets. Beneath the choir is a representation of the Holy Sepulchre. The resemblance to the Anastasis rotunda is again not exact; but the centralized form makes the connotations plain as do those of churches built by the Knights Templar, for example in London and Laon.

Centralized buildings

Buildings as diverse as kitchens and chapter houses [**96**] testify that centralized plans were not confined to churches. Among churches, those representing the Holy Sepulchre alone, without additional meanings, formed only a small proportion. More commonly they were associated with particular dedications to the Virgin (see **147**), with

96

Salisbury Cathedral, chapter house interior

Constructed *c*.1260 and based on the chapter house of Westminster Abbey, the building is an immense octagon, with huge traceried windows and benches under an arcade with figured sculpture in its spandrels. The vault appears to rise from the slender central column of Purbeck stone, with its detached shafts around a core. Eight iron tie-bars originally linked the column to the walls, but the last traces were removed in the nineteenth century.

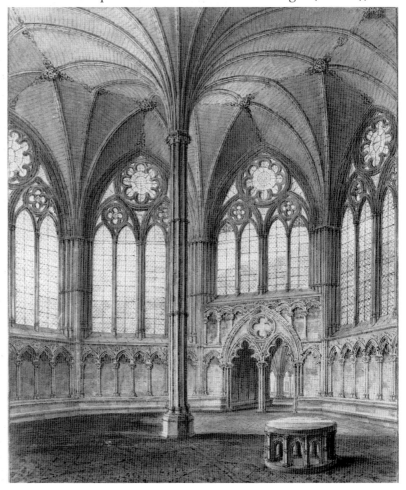

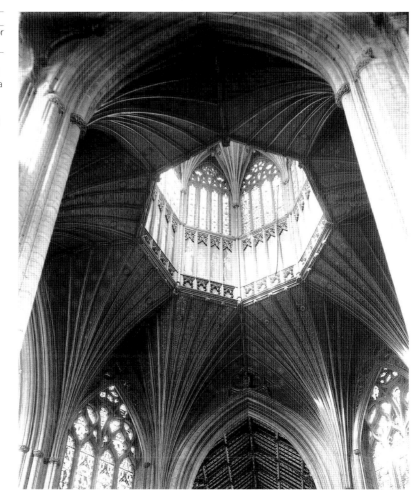

Ely Cathedral, England, interior of the octagon and lantern

When the Norman crossing tower fell in 1322 the crossing piers were removed to create a large octagonal space, which was defined in stone and vaulted in wood, with a central lantern. It is one of the most showy achievements of fourteenth-century English architecture, which tried out hitherto unexplored spatial configurations and boundaries. The carpenter, William Hurley, also provided the stalls for the new choir.

cults of saints and relics, and with other burials (as was the Jerusalem church in Bruges). All such uses implied the sepulchre but extended its associations. They continued traditions established as far back as the sixth century, which were developed particularly by the Carolingians and their successors. These traditions conflated various building types and functions. The association with burials and cults is traceable to the domed, circular built tombs and mausolea of late Roman times. From the sixth century a centralized building on the Mount of Olives outside Jerusalem was pointed out to pilgrims as the tomb of the Virgin, and it is likely that this is the reason why the circular, domed Pantheon in Rome, dating from the second century AD, was thought appropriate for rededication in 609 to the Virgin and Martyrs. The intermediate history of centralized buildings in the west cannot be given here, but by the later Middle Ages their specialist uses and associations were fully established. They vary considerably in plan, size, decoration, and character. Many are polygonal or cruciform rather than circular, and none has a dome. What distinguishes them is their central, as opposed

to longitudinal, focus. In these buildings the centripetal pattern of the vault is reflected by the arrangements on the ground, a contrast to similar vaults over crossings, which often presided over a line of choir stalls that denied the implications of the vault pattern [**97**].

One of the most remarkable churches of the Virgin is Our Lady at Trier, in the Mosel region of Germany. Trier is a Roman city, its past vividly present in the layout of the urban centre, in the great city gate and the basilica, the imperial audience hall. The cathedral, too, was originally founded in the fourth century, as a double basilica with two parallel halls. Remnants of the halls underlie the present cathedral and the church of Our Lady immediately to the south. Our Lady, built from *c.*1227, is the latest in a succession of churches on this site that performed the cathedral's parochial functions. The plan is cruciform with equal arms, the angles of which are filled by radiating chapels [**98**]. The eastern arm projects into an extra bay and a polygonal apse. The plan resembles a neat, compact flower; something of the exterior massing, rising to the central lantern, gives the same compact impression. But inside, the effect is different [**99**]. The building seems to radiate out from the crossing towards a crown of light diffused through the encircling windows, two levels at the ends of the main arms, with a short clerestory above the chapels. This is most emphatically not a hall church. It has a basilican structure, folded in like origami as a counter-focus to the pull exerted by the windows. The quadripartite vaults of the main vessel lead to the crossing vault set one storey up in the lantern. The crossing vault is composed of four compartments which together make up a pattern of intersecting ribs not unlike contemporary work in England. In general, though, Trier belongs to the generation of German buildings that took their inspiration from France. The stylistic affinities of this church are with buildings in the

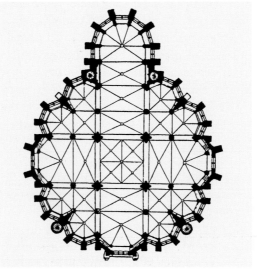

98

Trier, church of Our Lady, ground plan

The plan is essentially cruciform, with three arms of equal length, and an extended apse at the east. The chapels in the angles are set obliquely to the axis, to create a circular effect. The church is rib-vaulted throughout, with a pattern of intersecting ribs in the crossing. The entrance is at the west, and there are four spiral staircases, two flanking the bay before the apse.

Trier, Germany, church of Our
Lady, interior, looking north-
east

The Liebfrauenkirche dates
back to early Christian times.
The present building was one
of the first in the Empire to
reflect strong French stylistic
influence, particularly in its thin
structure, the columnar piers,
and the window tracery. The
oculus over two lights was first
presented at Reims Cathedral
not long before Trier was
begun. The crossing is
emphasized by the use of
piliers cantonnés.

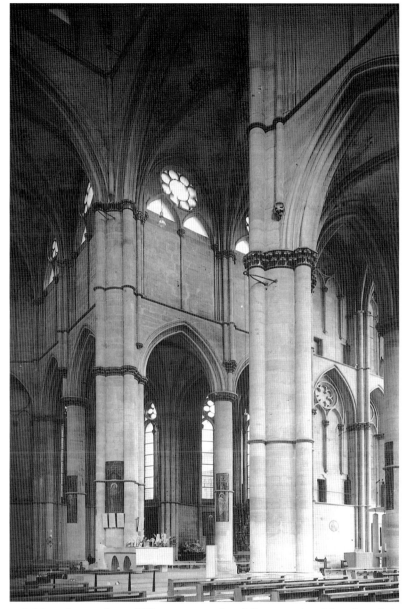

neighbouring region of Champagne: the oblique angle of the chapels is
derived from Saint-Yved at Braine, near Soissons, and the design of the
elevation—tall columnar piers, foliage capitals, the vault design, and
the huge two-light windows with oculi—depends on Reims Cathedral
and other related buildings. The projecting choir bay has wall passages
at two levels, a strongly Rémois feature that emphasizes Trier's origins.

Centralized buildings were also devoted to cults of saints and relics,
although by the end of our period the aristocracy had arrogated the
form to their own burial arrangements. Three eastern chapels begun in
the late twelfth century at the cathedrals of Canterbury, Trondheim in

Norway, and Lincoln, had much in common. The corona at Canterbury (see 121) seems to have been built in connection with the cult of the murdered archbishop Thomas Becket. Before the translation of the saint's main shrine to the Trinity chapel in 1220, the corona already housed a reliquary containing the saint's scalp. The rotunda at Trondheim was built over the grave of St Olaf; and the axial chapel of St Hugh's choir at Lincoln was almost certainly associated with attempts to canonize Remigius, an earlier bishop of Lincoln.[13] Of the three, only Canterbury survives in a reasonable condition. Trondheim has effectively been rebuilt, and the Lincoln chapel was destroyed within a few decades to make way for the new Angel choir. Trondheim was closely linked to Canterbury structurally as well as in iconography and style, but despite this the three buildings were different in character. Canterbury and Trondheim are circular, and Trondheim has an ambulatory. Both stand proud of the main building although attached to it. The axial chapel at Lincoln was hexagonal and apparently contained within the fabric of the east end. Like Our Lady at Trier, the corona of Canterbury is strongly influenced by contemporary architecture in France, albeit of an earlier generation. Its three storeys match those of the Trinity chapel in height, and whether it was intended to go higher is not clear. Two levels of broad lancet windows are divided by a triforium passage, and the vault springs from the base of the clerestory. Dark Purbeck stone was used for decorative colonnettes, the vault shafts, and the triforium arcade. Its sources were Parisian and north French, but even by French standards this is a precocious design for its date.

Despite its richness, the Purbeck articulation of the corona looks minimalist beside the burial chapels that were built in the Iberian peninsula in the fifteenth century. The decoration of the square or polygonal chapels ideally suited the trends towards opulent display. King João I of Portugal established his mausoleum at Batalha, the Dominican priory he founded after the Portuguese defeated a Castilian force at the battle of Aljubarotta in 1385. The Founder's chapel was built from 1402 off the south-west end of the nave by the second master mason, Huguet. Its outer shell is a square of three bays each side; but eight internal piers support a central octagonal lantern. The exterior has delicately traceried cornices and parapets, with foliate cusping on pinnacles and flying buttresses, and curvilinear window tracery. The inside is tall, solid, and rather sombre. The moulded piers are massive and the walls plain. But the solemnity is alleviated by decorative cusping beneath the arch mouldings, and by the weaving patterns of ribs in the ambulatory vault and the star vault in the lantern, above the tombs of João and his queen, Philippa of Lancaster.

At the east end of the church Huguet began a second mausoleum, for João's successor Duarte [100]. Both Duarte and Huguet died in 1438, and the building remained unfinished until Manuel I (*reg.*

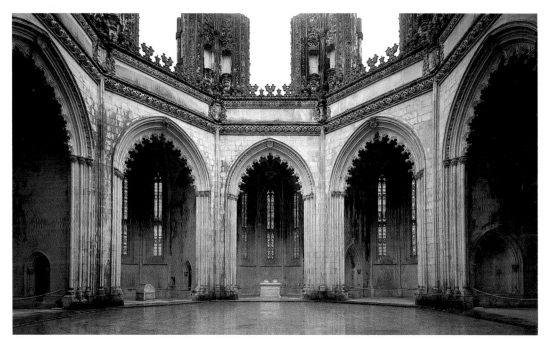

100

Batalha Abbey, Portugal, the Capellas Imperfeitas, interior, looking north

Although three successive master masons worked on the mausoleum of the Avis dynasty of Portuguese kings, the chapels remained unfinished. They were begun by Huguet, a poorly documented master who is thought to have come from Spain. Huguet had completed the abbey church, cloister, and Founder's chapel, and his rich but restrained decorative style can be distinguished from the later, more exuberant work in the upper parts and the entrance door.

1495–1521) took up the work, only to leave it incomplete, with the name Capellas Imperfeitas. The central octagon has seven radiating chapels. Details of the plan suggest that Huguet was familiar with the east end of Toledo cathedral: the closed triangular spaces between the chapels, which create a smoothly undulating exterior, resemble the solution adopted for Toledo; and the chapels have a plan similar to Toledo's chapel of S. Ildefonso, with a straight bay leading to a polygonal apse. As in the Founder's chapel, heavily moulded piers and plain walls offset intricate, undercut decoration on arches and cornices. Intersecting cusps define the doorway. Manuel's work on the upper storey introduced some classicizing motifs and forms among twisted vault shafts and intricate foliage on window jambs. The intended vault pattern can only be guessed at but was evidently to be some sort of star design.

From the 1440s bishops and high-ranking government officials added burial chapels round the edges of such Castilian cathedrals as Toledo, Burgos, and Murcia. Two—the Santiago chapel at Toledo and the Condestable chapel at Burgos—were set at the east end, probably reflecting the royal chapel in the apse of Toledo, and they have the plan of a straight bay and polygonal apse. Others were attached to transepts or aisles. In Burgos Juan de Colonia built the chapel of the Visitation for Bishop Alonso de Cartagena, patron of the west towers (see **63**); and from 1482 his son Simón built the spectacular Condestable chapel [**101**] for the Constable of Castile, Pedro Fernández de Velasco and his wife Dona Mencia de Mendoza. The shape and purpose of the chapel typically suited the opulent decorative style of the time: repeated ornament drawn from northern as well as *Mudéjar* traditions

Burgos Cathedral, Spain,
Capilla del Condestable,
interior, looking east

The chapel was founded by
Pedro Fernández de Velasco,
Conde de Haro and, from
1473, the Constable of Castile.
Leading masters of the day—
Gil de Siloe, Diego de Siloe,
and Simón de Colonia—all
worked on the building, which
continued long after Velasco's
death in 1492. Velasco also
built the Casa del Cordón, a
town house decorated with a
motif of knotted cords to
symbolize the girdle of St
Francis.

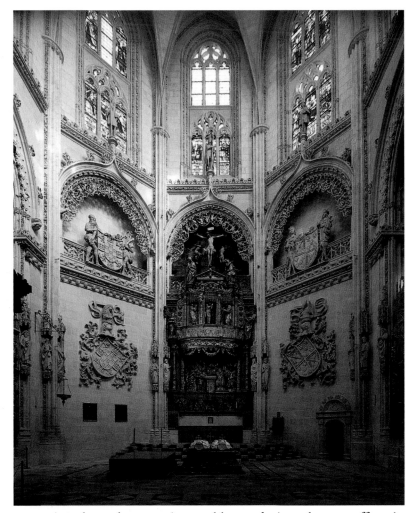

encrusting the arches, cornices, gables, and pinnacles, set off, as in
Portugal, by plain walling. Elaborately dressed wodewoses—wild men
and women—support huge shields of arms. The chapel is lit from the
side by large traceried windows and top lit through the vault. Owing to
the chapel's plan, an octagonal vault had to be created by structural
adaptation below the springing. The webs and ribs converge in the star
shape that is open at the crown. As in the rebuilt *cimborio* over the main
crossing of the cathedral, the centre of the vault is openwork tracery,
which complements the lace-like filigree of the decoration below.

Micro-architecture

Just as the Holy Sepulchre represented the city of Jerusalem, so did
other elements stand for a larger whole. The seigneurial symbolism of
the tower, for example, was expressed also in tower staircases. Where
staircases had been contained within the thickness of the wall, they

From 1471 the castle of
Meissen, known as
Albrechtsburg from 1676, was
converted to a residential
palace by the Electors Ernest
and Albrecht of Saxony. Cell
vaulting was used for the main
rooms as well as the staircase.
The finely carved, hollowed
mouldings are typical of this
period, when stone was
worked into twisted, flexible
forms that denied the solid
rigidity of the medium.

now began to project beyond it. The trend was initiated by Charles V
of France, who from 1364 converted the Louvre from a fortress into an
important residential palace in Paris. The work included a spiral stair-
case, the 'grande viz', in its own tower attached to the new range of
royal lodgings. The stair led directly from the court to the king's and
queen's apartments; set about with sculptured figures of the king, the
queen and the four royal dukes, it was used only when the king was
present, for ceremonial entrances and festive occasions. Charles's
brother, Louis of Anjou, immediately built a similar stair tower in his
castle at Saumur on the Loire, and other great men of the kingdom fol-
lowed, in Paris and at Coucy and elsewhere. By the late fifteenth

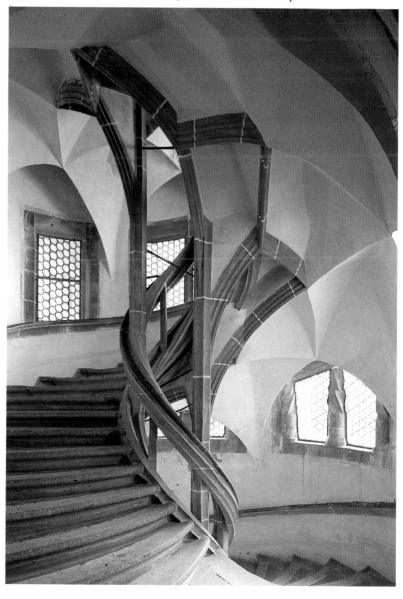

century such staircases were becoming decorative objects in their own right: the main spiral stair in the Albrechtsburg Palace at Meissen in Saxony, built in the 1470s [102], twines round slender, fluted newels, the moulded banister rail twisting around its own centre. The staircase is vaulted by cell vaults that are partly moulded around the newels.

Stair towers, though, while smaller than the seigneurial towers whose meanings they express, are not truly miniature. For that we have to look at the phenomenon that was, with tracery, the most characteristic late medieval decorative device: micro-architecture. When Blaubeuren Abbey in Swabia was reformed and rebuilt in the late fifteenth century the new church was fitted out with choir stalls and a high altar retable made by joiners and woodcarvers from nearby Ulm [103]. Jörg Syrlin's design for the choir stalls is a row of openwork canopies, their undulating lines derived from gables and pinnacles. The lofty tabernacles that punctuate the line display more conventional versions of the same motifs. In the canopies over the figures in Michael Erhart's altarpiece, foliate patterns contend with ogival gables. The centre is surmounted by more of the fantastical decoration of the choir stalls: architectural forms are metamorphosed into stems and branches—*Astwerk* (see **44e**)—that reach to the keystones of the vault above.

Blaubeuren was built towards the end of a tradition of reproducing or transforming architectural elements on a small scale that began in the late twelfth century and came to fruition from the mid-thirteenth. Micro-architecture emerged from a process of exchange between objects and media, in which the meaning and significance of one was

From 1387 the patron, Gean Galeazzo Visconti, transformed a design for a typically north Italian brick church to a tall, vaulted structure built of marble in what was intended to be the style of French Gothic. Many of the advisers to the project were from Germany and much of the elaborate micro-architectural detailing owes more to south German architecture than to contemporary work in France.

adopted by another, only to be reflected back to the source. Micro-architecture began by denoting the sacred, but by the end of the fourteenth century it had also become an indispensable part of lay aristocratic display. It appeared in all media from manuscripts to stained glass, sculpture, metalwork, and architecture itself. Its beginnings arose from the gradual conflation of various functions and associations: of canopies, tabernacles, and reliquaries.

Canopies and tabernacles sheltered and protected such sacred objects as altars and the reserved sacrament. They were essentially architectural in form, both variations on a framework with a gabled roof, but in practice they were far more elaborate. By the thirteenth century the canopy was becoming a substitute for the niche, conferring protection and sanctity on statues. What appeared on the west portals of Chartres Cathedral in the mid-twelfth century as a row of miniature buildings representing the Heavenly Jerusalem developed into towering structures of arches, gables, pinnacles, and vaults, scaled down in proportion [104]. These characteristics passed into tabernacles, which adorned altarpieces, screens, font covers, and sacrament houses, conveying their sacred purpose through intricate architectural detail (see 19). But these connotations arose also from a development that was

105

Reliquary of the Holy Sepulchre

Beneath the canopy of the miniature building the seated angel shows off Christ's empty tomb to the three Marys, while the soldiers sleep off the effects of drink. This late thirteenth-century silver-gilt reliquary in the north Spanish cathedral of Pamplona may have been a gift from King Philip IV of France. Standing 880 mm to the angel atop the spire, it was made by a Parisian workshop that produced several reliquaries with figured scenes in church-like settings.

happening simultaneously in another medium altogether: the reliquary casket. Metal reliquaries had long been made in the shapes of buildings, at first simple affairs of four walls with a pitched roof; but from the late twelfth century they were surrounded by figures and scenes in niches and roundels, before starting more overtly to take on such contemporary architectural elements as gables, buttresses, and pinnacles. The silver-gilt reliquary of the Holy Sepulchre [105], made in Paris in the late thirteenth century, is a fully realized example of the type. The scene of the women at the tomb is set under an open, roofed structure with cusped arches and gables. At the corners, buttresses have the offsets and gargoyles of their larger models, together with niches sheltering small figures of angels. The buttresses support tall pinnacles with miniature gables. Atop the roof an elegant tower with tracery windows and gables supports a spire crowned by the figure of an angel.

This architectural reliquary reflects the significance of the church building as guardian of the sacred. But by the time it was made, buildings themselves had begun to adopt the connotations of reliquaries. We have seen this at the Sainte Chapelle, where the large figures of apostles in the inside seem to be transposed from the exterior of a metal casket, and the exterior was enlivened by decorative gables and other details. The Sainte Chapelle was understood at the time to resemble a reliquary in stone, and although it was not the first building to be treated with highly metallic decoration, it was certainly the most influential. The intricate, spiky silhouette of Saint-Urbain at Troyes (1260s), for example (see **128**), owes much to the Sainte Chapelle. Once the idea of micro-architecture had passed back to buildings, it gave the monumental the miniaturist appearance of a reliquary. Heavy stone work was lightened and treated like filigree, as on the harpstring façade of Strasbourg Cathedral (see **64**) or the spire of Freiburg (see **73**). We are intended to read sacred meanings into decorative wall panelling and niche work in such English chapels as the destroyed St Stephen's, Westminster (begun 1292), or the Lady chapel at Ely (begun 1321). One of the most creative designers of micro-architecture was Peter Parler, whose gables, pinnacles, and tracery on the exterior of Prague Cathedral had immediate influence, particularly across south Germany, for instance at Ulm (see **47**). On the nave of St Stephen's, Vienna, which was founded by Rudolf IV of Habsburg in 1359, the gabled dormers over the tall windows are fronted by smaller gables, traceried windows, and pinnacles that reflect in miniature the monumental work around them [**106**].

The gabled dormers are traditionally believed to represent the crown of Rudolf of Habsburg. This would be a typically medieval extension of meaning, giving the lay ruler's crown the symbolism of a tabernacle. Perhaps a similar intention lay behind Philip IV's decision to adorn the windows of the Grand' Salle and Galerie des Merciers in

Vienna Cathedral, Austria, exterior from the south-west

The failed attempt by the founder, Rudolf IV of Habsburg, to raise the church to cathedral status explains the grandiose design of the nave, with its tall, traceried windows and buttresses, and the Ducal chapels at the west end. The south tower was influenced by work of the Parlers at Prague. Wenzel from Prague advised on its design c. 1400. Building was continued by Peter Prachatitz, who incorporated the gable motifs from the nave.

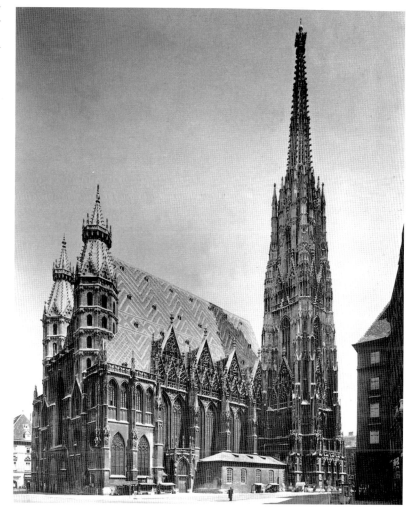

the palace in Paris with gables, the openwork designs of which seem to echo the earlier gables on the Sainte Chapelle.[14] Gables, however, are not the only devices that link the sacred to the profane, to the latter's advantage. Another favourite form was the miniature battlement, which appeared on tombs, buttresses, and pinnacles, reflecting its grander cousins on parapets and cornices. Representing strength and the power to protect, battlements enhanced a church's meaning as a bastion of faith and an embodiment of Jerusalem. It is in this guise that they adorn the west front of Exeter Cathedral (see **65**), itself a symbolic eternal city. But battlements were also a symbol of authority.

Power and authority

The image of a castle, its walls, towers, and battlements, was common-place in sermons and homilies, a universal metaphor for faith. It was an aristocratic image, evoking authority and power as well as strength. In

his description of the French queen Isabella of Bavaria's Entry to Paris in 1399 the chronicler Jean Froissart shows a ruler exploiting both aspects to identify his interests with those of the court of Heaven:

At the gate of St. Denis was a starry firmament, and within it were children dressed as angels... The upper part of this firmament was richly adorned with the arms of France and Bavaria, with a brilliant sun dispersing his rays throughout the heavens; and this sun was the king's device at the ensuing tournaments... Below the monastery of the Trinity a scaffold had been erected in the streets, and on it a castle, with a representation of the battle with King Saladin performed by living actors, the Christians on one side and the Saracens on the other. The procession then passed on to the second gate of St. Denis, which was adorned as the first; and as the queen was going through the gate two angels descended and gently placed on her head a rich golden crown.[15]

107 Malbork Castle

The huge brick fortress of Malbork (formerly Marienburg) consists of three castles, each separately fortified but enclosed, with the town, in a common circuit of walls. It lies about 30 miles from Gdańsk in Poland, one of the castles built by the Teutonic Knights as they subjugated the lands around the river Vistula and the Baltic coast. From 1309, when it became the headquarters of the Grand Master, Malbork was greatly expanded. To the late thirteenth-century Upper Castle (on the right), which housed the conventual buildings, was added the Middle Castle, with a refectory and audience rooms, and the Grand Master's palace (on the left). Outbuildings were located in the Lower Castle, beyond. Malbork was not only a fortress, but a centre of government, a palace, and a holy city. All of these functions are expressed in its architecture. Interiors are spacious and vaulted with intricate star and tri-radial vaults devised by masons from Germany and Bohemia. Except for the Grand Master's palace, with its tall containing arches and machicolated corner turrets, the exterior is plain, to express the order's claims to supremacy. It is alleviated by the varied roof heights, which symbolize a visionary Jerusalem.

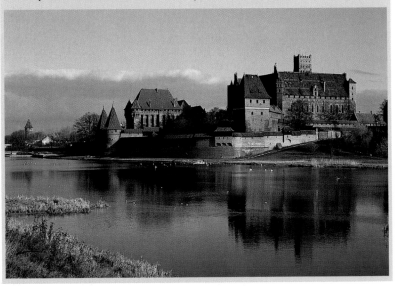

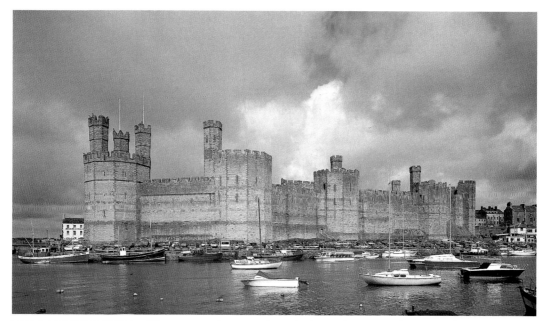

108

Caernarfon Castle, Wales, south curtain

Begun in 1283, Caernarfon symbolized the legitimacy of Edward I's rule in Wales. It was founded near the site of Roman Segontium, which was associated in Welsh legend with Emperor Magnus Maximus, the legendary father of Constantine. Red brick bands in stone walls are common in Roman architecture and may refer to the imperial past. The meaning of the stone eagles atop the Eagle tower (extreme left), added in 1317, is, however, uncertain.

The procession continued through streets hung with tapestries to Notre-Dame and the queen's official coronation. In this display the royal couple's arms appeared in Heaven, the sun symbolized the king, and Isabella was crowned by angels. A model castle represented the triumph of Christianity (see **148**).

The religious symbolism of the castle never superseded its essentially political nature. As centres of administration and local justice, castles were seldom purely military buildings, but it is in the context of military tactics that their design has traditionally been discussed. Several recent studies have, however, suggested that the symbolic content may be equally significant. The donjons built in the early thirteenth century by Philip II of France at the Louvre, Montlhéry, Dourdan, and Villeneuve-sur-Yonne were huge, imposing cylindrical towers, cylindrical not because the smooth, curved exterior offered fewer blind spots and deflected missiles more effectively, but to create a distinctive, consistent presence across the newly consolidated royal domains. The towers were an instantly recognizable sign of royal authority, so much so that it was many years before any but the most powerful magnates—Enguerrand de Coucy and Robert, Count of Dreux—built similar ones on their own territories.[16] A similar image of authority was created in the late thirteenth century for Edward I in north Wales. The designs of his six castles at Flint, Rhuddlan, Harlech, Conwy, Caernarfon [**108**], and Beaumaris vary to some extent—ideas were refined as building went along—but their main characteristics of geometrically based plans, strengthened gatehouses, and walls and towers are dressed with shared details that create a coherent group evidently intended to be read as a whole. The only other

castle in the area with the same features is Denbigh, which was built on royal licence. The concentric format with towered gatehouses used at Rhuddlan, Harlech, and Beaumaris was in no sense innovatory, even in these sophisticated versions; but it is hardly a coincidence that their closest forerunner is Caerfili, built in the marches of south Wales around 1270 to advance the interests of the powerful Clare earls and to contain perceived threats from the local princes. At Caernarfon, however, the symbolism may be more specific. A skeleton discovered while the foundations were being dug in 1283 was at once identified as that of Emperor Constantine's father, whom local tradition associated with the nearby Roman site of Segontium. The castle has certain characteristics—polygonal towers and walls banded with coloured brick—that the others do not share. These have been compared to the late fourth-century Theodosian walls of Constantinople. This imagery has been interpreted as 'imperial', but the imperial aspects may be less significant than an intention to show Edward as the new Constantine. Whatever the true explanation, it seems to indicate more than the general message of authority evinced by the others in the group.

By 1300, when these castles were mostly complete, the castle as a fortress was about to give way to less military, more palatial aristocratic residences. The change was slow, and not uniform across Europe, since it depended on local conditions. Owing to civil strife, fortified strongholds continued to be built in the Italian territories, as they were in France during the Hundred Years' War (1337–1453). But in the more peaceful British Isles and Spain, display and domestic comfort could be pursued more safely. Yet the symbolism of warfare lived on: still called castles, these buildings were decked out in the symbolic detail of towers, gatehouses, moats, and drawbridges (see **117**). Few were seriously defensible. Such buildings have been seen as castles of nostalgia, built by old soldiers dreaming of past glory, or castles of chivalry, in which aristocrats acted out a chivalric mythology rooted in the literary tradition of Arthur, Charlemagne, or the Nine Heroes—historical and legendary figures as moral exemplars from ancient and earlier medieval times—all of whose stories were well known and much illustrated.[17] There may be something in this. Owing to the tradition that traced Arthur's ancestry to Constantine, Caernarfon had Arthurian, as well as imperial, connotations, which were heavily exploited by Edward I. What these later castles undoubtedly represent, however, is a declaration of status. A licence to crenellate allowed a builder to add battlements to a precinct wall or a house: the act of crenellation showed everyone that, socially speaking, the owner of the house had arrived.

Castle-builders began to celebrate an idea of 'castleness' while tricking them out in ornament that defied bombardment. Already by the early fourteenth century Conwy had pinnacles atop its crenellations and Caernarfon had the famous sculptured eagles, as well as a carved

109

La Ferté-Milon, France, façade from the south

Built on an enormous artificial platform, the façade, the only part of the building to be even partly completed, is 104 m long. The two central towers flanking the entrance are D-shaped with beaks that project at an angle, a rare form that had no military purpose here. The angles draw attention to the programme of carved imagery—the Coronation of the Virgin above the door, and two Heroines in niches on the towers themselves.

image of the king above the main gate. The images of the French royal castles painted in the *Très Riches Heures* of the Duke of Berry in the early fifteenth century show such buildings as Mehun-sur-Yèvre near Bourges covered in gables, pinnacles, tracery, and statues. The standing remains of Mehun give little idea of it, but something can be gained from the surviving façade of La Ferté-Milon, in the Aisne valley north of Paris [109]. Together with Pierrefonds, La Ferté-Milon was begun in the late 1390s by Louis d'Orléans, brother of Charles VI. Only the front wall and stubs of interior walls were ever built. Relief sculpture was installed on the gate towers (which are integral with the façade), huge windows were inserted, and the beginnings of machicolation—the corbelled support for a parapet or wall-walk—still survive. For all its sturdy bulk, this building is clearly not a working castle but a palatial residence with castellated features. The machicolation here, at Mehun, and elsewhere changed the profile of a castle tower. The new shape brought French designs to the forefront of fashionable building. They were quickly influential, especially in such English castles of aspiration as Warwick, where the machicolated Guy's and Caesar's towers contrast with the earlier ones on the wall circuit.

In Britain a liking for overtly geometric plans showed not only in chapter houses but as early as the twelfth century in the polygonal tower at Orford in Suffolk.[18] Edward I's castles show a taste for geometric precision, although the contemporary triangular castle at Caerlaverock in south-west Scotland is not directly associated with

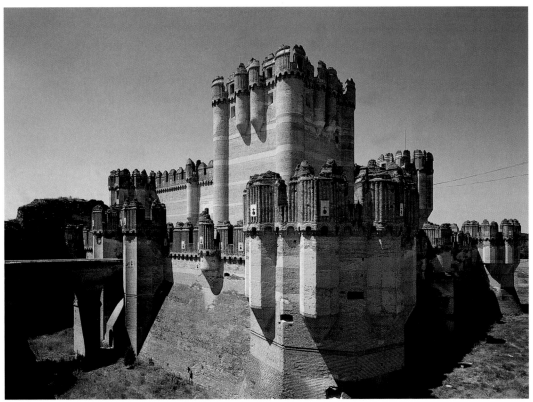

110

Coca Castle, Spain, exterior from the north-east

The castle is dominated by the keep, the Tower of Homage, in the inner court. There were three circuits of walls, the middle one having a deeply sloping talus into the ditch. Despite this, the castle was built essentially for show. The polygonal towers at the corners have polygonal turrets on each face, which add festivity and texture, as do the elaborate machicolations and crenellations, all fine examples of *Mudéjar* work.

him. Later castles planned to figures that owe more to art than defensibility include Old Wardour, a hexagon round a tiny courtyard, and Warkworth in Northumberland, which has a square central block with projecting wings. Old Wardour and Warkworth are both tower houses. Warkworth necessarily has extra defences against Scottish border raids. A lion carved in relief is the emblem of the Percy family and a symbol of their defiant presence. Donjon towers continued to be built to the end of the Middle Ages. The castle at Sirmione on Lake Garda, built by the della Scala family, was contemporary with Edward I's castles in Wales, but, like the later tower at Vincennes near Paris, was a refuge of last resort as well as a residence. Other donjon towers had the same symbolic function as battlements or gatehouses. Among these are Tattershall in Lincolnshire, built from the 1430s by the Treasurer of England, Ralph, Lord Cromwell, and Coca, north of Segovia in Castile. Coca [110] was begun in 1448 by Don Alonso de Fonseca, Archbishop of Seville. Like several other late medieval Spanish castles, it is built of *Mudéjar* brickwork. It has three concentric circuits of walls and a tall, square tower at one corner of the inner courtyard. The massive structure is arrayed in crenellations and turrets. But Coca was built at a relatively peaceful period in Spanish history: although the castellated detail was called into service in the sixteenth century, it was designed largely to impress.

The entrance to the outer courtyard of Coca is flanked by two projecting polygonal towers that suggest the gatehouse without which no northern castle of this date would be complete. By this time, though, the towered gatehouse had reached beyond the palatial residence. Towered gatehouses guarded the entrances to ecclesiastical precincts, clearly defining areas of jurisdiction. Monastic gatehouses, which had a long history without need of towers or turrets, began to acquire them in the late fourteenth century. Gatehouses of the earliest university colleges, with beginnings closely linked to monastic institutions, did not have turrets (see **84**), but from the fifteenth century Queens' College, Cambridge, set a fashion for turreted gatehouses that persisted from then on. Such reduced symbols embodied and implied the residential, administrative, and protective functions of their source: the castle of the thirteenth century.

Civic pride

City gates controlled comings and goings, and their hefty towers could be statements of power and of warning, as, for example, at Lübeck or Bruges. But, standing as they did at the city's threshold, the gate bore additional meanings. Some were highly personal: the gate at Capua near Naples, built in the 1230s by Emperor Frederick II but now dismantled, carried imagery that celebrated Frederick's vision of his supremacy and of universal peace. The tower of the Old Town bridge in Prague, which was both a bridge tower and a town gate, was decorated with a statue of Charles IV amid symbols of the city's patron saints. Imagery on other gates was more universal. Statues of the Virgin or of St Michael acted as guardians of the threshold and protectors of the city. Since travellers needed protection at points of transition, chapels often stood on or near both bridges and city gates.[19]

But if money and pride, as well as prudence, contributed to the provision of gates and thresholds, the most striking expressions of late medieval civic pride were reserved for government and commercial buildings. These halls and palaces survive in many Italian and Netherlandish cities [**111**]. They often have tall towers, which assert the presence of the city governors among the competing towers and spires of churches. In Italy they are often a perpetual reminder of what they have replaced: the residential towers of the nobility, razed by the victorious commune. The symbolic associations of the towers and crenellations are similar to those that we have already looked at, but in this instance they are not derived from castles of feudalism. The symbolism of these city buildings was self-generating, arising from civil strife that demanded strong fortification. Early civic palaces, fortified out of necessity, established an iconographic type that persisted into less troublous times. The early thirteenth-century Palazzo dei Priori in

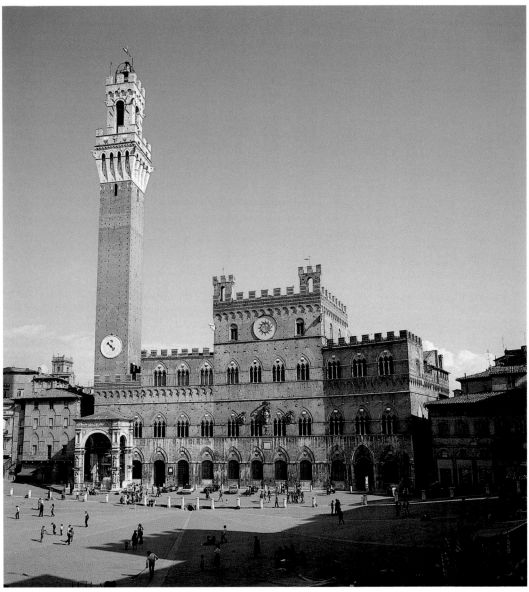

Volterra, an uncompromising block with a tower, seems to have inspired the Bargello in Florence, built from about 1255 with solid walls, small doors and windows, machicolated battlements, and a tall corner tower. A similar format was adopted for the Palazzo dei Priori—the Palazzo Vecchio—which was begun in 1299. In Siena, deep in rivalry with Florence in these years, the Palazzo Pubblico is in a similar spirit, with a tall central block, machicolated battlements, and the immense Torre della Mangia.

Yet the Siena design includes arcading along the ground floor, and rows of large three-light windows (*trifore*) above. These features are taken over from a different tradition of communal palaces. From the

The town hall was begun beside the great open Campo in 1297–8 to house the offices of the Customs, the Mint, and the Council, with a residence for the Podestà, equivalent of the Mayor. Built in brick, with stone facing on the ground floor and uniform windows, the design changed over the years, with the side wings added to the central block, angled slightly to respond to the configuration of the Campo.

early thirteenth century, communal palaces throughout north and central Italy, from Como to Perugia, Todi, and Orvieto, have an open arcade on the ground floor, a first-floor hall fronted by two- or three-light windows, and, inevitably, a tower. The design is derived from that of bishops' palaces, but on a much larger scale. In many of these towns the commune was also challenging the authority of the bishop and the image of authority established by the bishops was here taken over by the commune.[20]

The tendency to imitate was another significant aspect of civic pride, born of intensely competitive commercial as well as political rivalry. The desire of the citizens of Oudenaarde for a town hall to emulate Ghent, which was noted in Chapter 3, was not unique. In the north, the format was broadly similar to Italy, with only the decorative detail changing as the years passed. The brick cloth hall at Bruges, for example, which was begun in the late thirteenth century, is a plainer, more restrained building than the later town halls of Ghent and Arras, although the arcading and upper windows are not dissimilar. What distinguishes most, though not all, of the Netherlandish exchanges and town halls is the tower, disproportionately high and lavishly decorated. We find a subtler form of imitation in the churches of towns around the Baltic, churches built by the mercantile families who had formed the Hanseatic League. From the late thirteenth century, Lübeck, leader of the original group of Hansa towns, established a type of church with a hall nave and a basilican choir with radiating chapels and transepts, which had evolved almost by accident at the cathedral and was followed with some variation at the parish church of St Mary. St Mary was imitated at Rostock, Stralsund, and Lüneburg, with a curious hybrid in the enormous brick church of St Mary at Gdańsk. These churches represent more than simple rivalry between cities: it amounts to an expression of the League's identity.

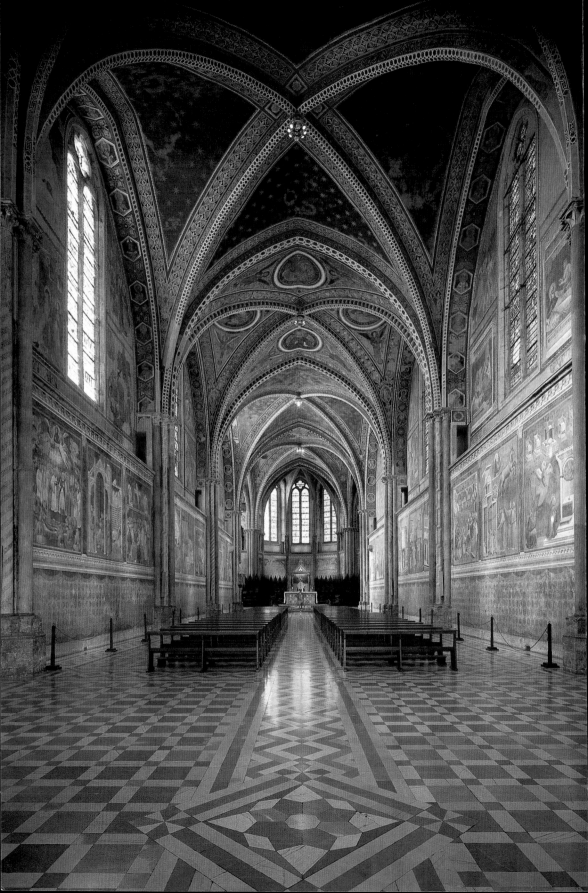

Innovation and Commemoration

To change the architectural metaphor from language to music, much late medieval building consists of variations on a theme. Once the general disposition of plans and elevations had been established, there were only superficial modulations to pier forms, mouldings, and architectural decoration. After about 1300 no new elements or approaches to building and design were introduced: the changes to architectural space evident in hall structures, flattened and decorated vault surfaces, and subtle, directional mouldings had been adumbrated in the preceding years. This does not betoken any lack of creative imagination, but illustrates the medieval desire to stay in touch with the past. Medieval buildings enshrined memory. Churches were founded for the purpose of commemoration, of Christ, the saints, and often of events: Kasimir the Great of Poland founded the church at Wiślica (see **56**) to honour the place whence his father, Ladislas Łokietek, had launched the recovery of his, and Poland's, fortunes in 1305. A reason often given for founding an abbey was to honour a vow made at a time of acute danger. Vale Royal Abbey in Cheshire owed its existence nominally to a vow made by the future Edward I at the prospect of imminent shipwreck. Memory guarded the core and focus of the church's interior. Once consecrated, the high altar was seldom, if ever, moved, even when the building was reconstructed on a larger scale, as happened more than once at churches with a very long history. In some instances the high altar marked the burial place of the saint commemorated in the church. In others it did not; but the act of consecration endowed that spot with particular holiness, which prevailed through subsequent change.

When architectural innovation did occur it did not break with the past so much as cloak tradition, and the dichotomy between the desire to innovate and the need to preserve memory may be acutely sensed. The conservative style of Parisian buildings in the early fourteenth century that are associated with Philip IV has been explained as a symptom of Philip's cult of his illustrious grandfather, Louis IX, and his wish to 'maintain a dialogue with the past'.[1] Yet a cult could produce an innovatory design, as at Rievaulx Abbey [113], where the lofty rectangular, aisled choir, an early thirteenth-century break with Cistercian tradition, was built probably to accommodate the shrine of the

112

Assisi, Italy, S. Francesco, interior of the upper church, looking east

The burial church of the founder of the Franciscan order is on two levels. St Francis's tomb is in the lower church. The wide, aisleless nave of the upper church, with frescoed scenes of the saint's life, leads to a transept and apsidal choir. The rib vault descending to clustered shafts, the wall passage, and the large, traceried windows are French characteristics, perhaps to acknowledge French support for the Franciscans.

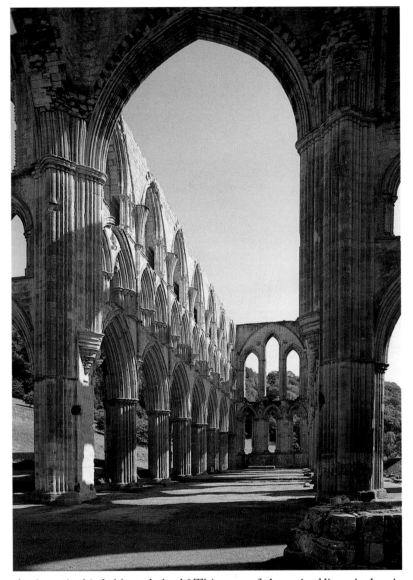

Rievaulx Abbey, England, choir interior, looking east

This is a slightly earlier contemporary of Assisi. The rectangular plan with a flat terminal wall was flexible enough to be used for both monastic and secular churches. Rievaulx choir is one of the few three-storey elevations in English Cistercian architecture. Its heavily moulded piers, arches, and gallery typify one current trend in English building. The discreet use of foliage ornament suited Cistercian tastes, but the ensemble is a break with their tradition.

charismatic third abbot, Aelred.[2] This type of plan suited liturgical variations so well that it became widespread in Britain, whether or not the church had a great shrine, and in a typically medieval modulation it was used both for a new cult at Lincoln and to redevelop an established one at Ely, Old St Paul's in London, and elsewhere. Architecturally, commemoration can be seen in buildings that overtly express a thread to the past, and in those where memory is preserved despite radical change.

The thread to the past

In the 1380s work started on rebuilding the Cistercian abbey church of Melrose in the Scottish borders [**114**], an undertaking that was never

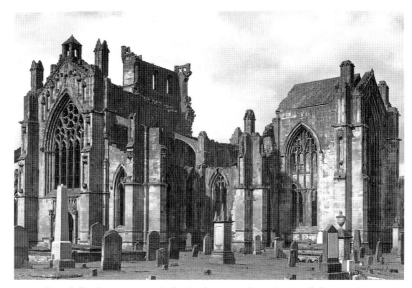

Melrose Abbey, Scotland,
presbytery and south transept
from the south-east

Melrose, a daughter-house of
Rievaulx (see **113**), was badly
damaged in the Anglo-Scottish
wars in 1385. It was rebuilt to
an historic Cistercian plan but
with an ornate elevation. The
presbytery was almost
certainly designed by an
English master mason, since
its net-like vaulting and the
Perpendicular tracery of its
large windows were of English
type. Later work was done by
one John Morow, who claimed
in an inscription to be Paris-
born.

completed. Its huge traceried windows and sculptured decoration were
more elaborate than one might expect from a Cistercian church, but in
one respect Melrose stayed close to tradition. The presbytery has a
squared east wall and no aisles, and it is flanked by two simple, square
chapels opening off the transept. This plan is closely related to those of
Cistercian churches built in the mid-twelfth century, when the order
was at the height of its development and prestige, but it was abandoned
in most of their later buildings, including Melrose's mother-house of
Rievaulx. Yet two centuries later, the monks of Melrose chose to
acknowledge the early history of their order in the plan of their new
presbytery.

Medieval society functioned by precedent and reference to tradi-
tion, and it could not divorce itself from the past since the past justified
the present: we see it in rulers who tended more to base their claims to
succession on inheritance rather than conquest. Literacy and keeping
of written records increased, particularly from the thirteenth century
onwards,[3] but more was conveyed by signs and images, and claims were
often expressed visually, as in the inclusion of ancestral quarterings on
coats of arms. The justification of the present by reference to the past is
exemplified in such secular decorative themes as displays of the Nine
Heroes and Heroines or scenes of biblical heroes with whose exploits
the patron wished to be identified. At Karlstein Charles IV had
painted a 'genealogy' of the House of Luxembourg, which included
suitably distinguished individuals through Roman times to the Old
Testament as far back as Noah. The Church and secular authorities
supported each other in this pursuit, as is most vividly illustrated by the
wall of shields at the castle of Wiener Neustadt in eastern Austria
[**115**]. As its name implies, Wiener Neustadt was a new town, founded
by Duke Leopold of Babenberg to defend part of his territory. It was

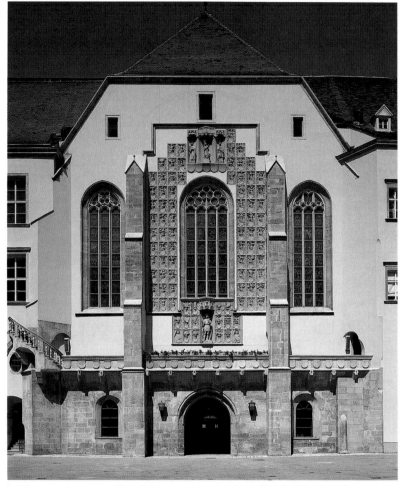

The *Wappenwand* of Wiener Neustadt is an extreme example of a kind of architectural adornment that was widespread in the later Middle Ages: the use of heraldry to assert identity, ancestry, political connections, or claims to property. Like many rulers and aristocrats the patron, Emperor Frederick III, also claimed association with the Virgin as a symbol of humility, placing a statue of himself in her company (see also **109**).

laid out as a rectangle with cross streets that divided it into four quarters, each named after its principal religious establishment. The castle is in the Trinity quarter, much altered over the centuries until, in the 1450s, the Habsburg Emperor Frederick III (*reg.* 1440–93) took it over as an imperial residence. He employed the master mason Peter von Pusica to build an entrance vestibule with above it the chapel of St George. The chapel, an aisled hall, was at once a consecrated chapel and the refectory of the chivalric order of St George, which Frederick had founded. The façade on to the courtyard is embellished with statues of the Emperor and the Virgin, with over one hundred shields of arms, some imaginary, which purport to be the titles claimed by Frederick. The Emperor seems to have indulged his sense of history with such retrospective architectural detailing as sexpartite vaults, and tracery reminiscent of the Parlers' buildings in Bohemia several decades before—elements that Pusica included in much of his other work in Wiener Neustadt.

One ruler who evoked history without the Church's mediation was

116

Castel del Monte, Italy, entrance door

Less a fortress than a hunting lodge, Castel del Monte is poorly documented. It was built *c.*1240 but Frederick II scarcely ever visited it. Nonetheless its great elegance—an octagonal structure with angle towers, constructed of creamy stone—proclaimed the Emperor's presence in Puglia, and the 'Roman' details of the entrance reinforced his claims to imperial rule. The frame, the triangular pediment, and fluted pilasters also appear on his castle at Prato in Tuscany.

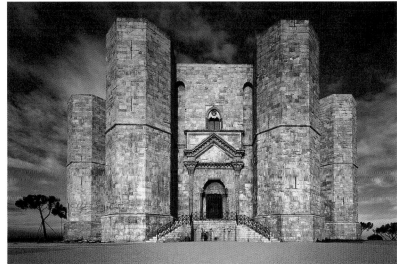

the Hohenstaufen emperor, Frederick II. On the *augustales*, the gold coin issue of 1231, he styled himself 'Imperator Romanorum Caesar Augustus', and some of his buildings have details of a consciously Roman character. Unlike Edward I's possible references to Constantinople at Caernarfon (see **108**), Frederick's Roman style has no Christian nuance. Historians debate how far Frederick deliberately identified himself with the Roman Empire, drawing attention both to his inconsistency as a patron and the classical tastes of his twelfth-century predecessors in Sicily.[4] He was not, in fact, a prolific builder, and his buildings also have such French elements as rib vaults and crocket capitals. This, however, suggests that when overtly Roman detailing was used, as on the Capua gate, where the statue of Frederick is shown dressed in a Roman toga, Rome represented something to both Frederick and his subjects. The most overt architectural references to Rome are the pedimented portals of the castle at Prato in Tuscany and Frederick's hunting lodge at Castel del Monte in Puglia [**116**]. At Castel del Monte the door itself, with a pointed arch, blank tympanum, and a lintel flanked by carved lions atop fluted columns, fits well enough into a local context; but it is surrounded by a rectangular frame with fluted pilasters and an emphatically moulded triangular pediment, with coffered rosettes and foliate corbels. Hybrid though the details are, the essential feature—the triangular pediment—is rare in medieval stone architecture. As such, its 'Roman' message could not be clearer. Frederick evoked ancient Rome to identify himself with those whom he saw as his imperial forerunners, an identification that was wholly political and without the hints of nostalgia that imbue the display of towers and gatehouses fronting late medieval castles [**117**]. But the underlying motives are not dissimilar. As was noted in Chapter 5, the latter symbolized an heroic past that conferred status on the builder,

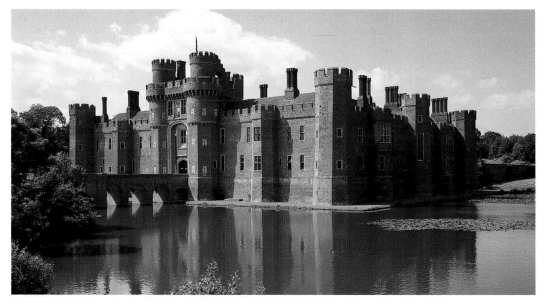

often a newly enriched individual with no ancestral claim to the baronial exploits that the castellations implied. Frederick's claims to Roman ancestry were equally weak, but conducted at a higher political level.

Commemorating the dead

The Church kept the Christian message alive and in touch with its origins through elaborate commemorative rituals. The congregation was composed of both the living and the dead. Commemoration of the dead began with the rite of the sacrifice of Christ on the cross, which was the focal point of the Mass. To this was added memorials of saints and martyrs, their written lives and their physical remains, and commemoration of the unsanctified dead, for whose souls the congregation prayed, themselves to be prayed for when the time came.[5] The disposition of altars and furnishings in the church reflected the hierarchy of Christ and the saints: the high altar at the east took precedence over the rood and the rood altar. A third principal focus could be the main shrine, a relic—usually the complete body of a saint—that was often elevated on a platform behind the high altar. Radiating from these focal points were the other altars, each with its holy relic—some of local saints, others, such as the Virgin and apostles, universal; some very ancient, others more recently deceased. Petitioners believed that the saints interceded with Christ on their behalf. They were also a constant reminder of the history of the Church, its struggles and its triumph. The Christian message was reinforced by the decoration and imagery in the stained glass, sculpture, painting, and wall hangings, which told the stories and displayed emblems that invited meditation.

Commemoration was central to the activities of the parish, the trade

guild, and the religious confraternity, all of which focused on devotion to their patron saint and memorials of deceased relatives or brethren. They, too, required an appropriate architectural setting, and their halls, hospitals, and chapels made a distinctive contribution to the urban fabric. In Venice by the late fifteenth century each of the six *sestieri* or districts of the city had a *scuola* or confraternity, which built a large hall for the annual feast and commemoration of the dead [**118**].[6] In Cambridge the guilds of Corpus Christi and St Mary founded a college in honour of the new feast in 1352. Individuals naturally made provision for their own deaths. The ideal was to be buried, like Emperor Constantine, 'among the saints', an ambition for all levels of society, whether in a monastery, mendicant convent, cathedral, or parish church. Although the mendicants had attracted many of the nobility away from monasteries, as late as 1513 Margaret of Austria, Habsburg Regent of the Netherlands, could rebuild the Augustinian priory of St Nicholas of Tolentino at Brou in Burgundy [**119**] for her own burial and that of her husband. Designed by the Netherlandish mason Loys van Bodeghem, the two-storey, aisled church is relatively plain, with strong, dominant mouldings. But the choir screen, stalls, and the tombs are heavily ornate, with the curvilinear, recurring motifs typical of architecture in Brabant (see **70**), motifs that appear also on the façade, relating the furnishings to the enveloping building.[7] Brou is an opulent statement, not of monastic principles, but of political and dynastic pride.

An alternative was a family burial church served by a college of priests and open for public prayer. Bishop Grandisson of Exeter founded a collegiate church to care for the souls of his family at Ottery

118

Venice, Scuola Vecchia della Misericordia, exterior

The *scuole grandi*, religious confraternities that became charitable institutions, were based on neither parishes nor professions. Each had a building with a chapel and meeting rooms for their administrative and communal activities. This, the most complete medieval example, dates from 1411–12. Its later façade had a sculpture of the Virgin of Pity (London, Victoria and Albert Museum) by the workshop of Bartolomeo Bon, who was also employed at Ca' d'Oro (see **68**): compare the pendent tracery windows.

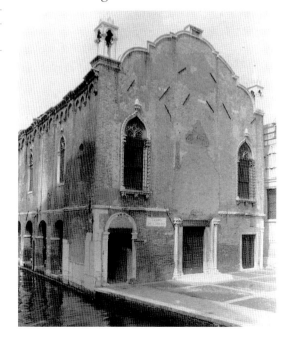

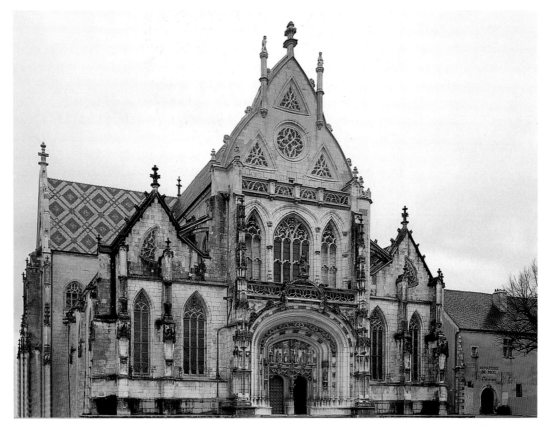

119

Bourg-en-Bresse, France, priory church of St Nicholas of Tolentino, Brou, west front

The ornament is by Netherlandish designers employed by Margaret of Austria, daughter of the Habsburg Emperor Maximilian I, who ruled the Netherlands from Mechelen but held Burgundy as part of her dowry. Margaret chose Brou for the burials of herself and her third husband, Philibert, Duke of Savoy. The bell motifs and trefoils in the tracery of the façade are repeated on their tombs.

St Mary, not far from his cathedral city. Grandisson himself chose to be buried in the cathedral, in a chapel specially constructed within the fabric of the west façade (see **65**). We have already seen burial chapels added to the perimeter of a building, at Batalha and Burgos (see **100** and **101**): they could also be created within the church by screens (see **86**). From the fifteenth century, however, leading prelates built stone chantry chapels inside the building, sometimes converting an existing chapel, but often creating a new structure. Like other burial chapels, chantries were served by their own priests, who prayed for the soul of the occupant and others whom he had specified in his will. Placed between two piers, or in the choir screen, such chapels were miniature buildings decorated with micro-architecture, with space enough for a sarcophagus and effigy, and an altar [**120**]. They were vaulted with exquisite miniature vaults, and the altar wall was fitted with niches for statues to act as the altar screen. Like other chantry chapels, they were open to view, to invite prayers from passers-by.

Commemorating the saints

'The martyr's protection and the church's beauty furnish us with a bond of unity': thus the abbot of Tynemouth in Northumberland,

From the fifteenth century
senior churchmen and some
lay people built personal
chantry chapels, tiny, ornate
buildings often inserted
between the piers of an
arcade, to house their tomb
and a chantry altar, with
appropriate sculpture and
painting. The chantry of Prior
Bird, begun in 1515, has large,
unglazed windows to display
his tomb and invite prayer. The
rectilinear tracery and
panelling, and the dense,
undercut foliage decoration
typify the art of these years.

reflecting on the essential link between the patron saint and the church, and the homage paid to the former in the latter.[8] In monastic churches especially, the main shrine was the object of intense veneration; but new saints were created throughout our period. Many cults were unofficial, prompted by popular feeling and promoted by local people of modest means, who could not afford a lavish building. Popular cults could attract larger numbers of pilgrims than those officially promoted by the clergy or the aristocracy, although there were fashions in shrines as in everything else, and a cult could lapse as rapidly as it grew. Margherita, a thirteenth-century holy woman who lived, much revered, at Cortona in southern Tuscany, became just such a local saint. Her cult church was originally small and plain, but her supporters could afford an elaborate cycle of narrative paintings to adorn its walls.[9] Official cults, however, were often orchestrated by leading prelates, sometimes in conjunction with the laity, and their architectural settings, especially if the cult were new, were often innovatory. Margherita of Cortona was a member of the Franciscan Third Order, affiliated to the Franciscans but remaining a lay person. St Francis himself was buried in the new church at Assisi [112], which was unlike any of its contemporary buildings in Italy. A double church, on two levels, with the saint's tomb in the lower church, it has a series of rib-vaulted bays without aisles. The great areas of plain wall, which were intended to display cycles of narrative painting, were not unusual; but the details of vaults and window tracery are in French mode, without being traceable to a specific source, possibly reflecting Franciscan gratitude for French support of their order.

Shrine churches vary enormously, owing to differences in the

Canterbury Cathedral, England, interior of choir and Trinity chapel, looking east

Becket's shrine stood in the Trinity chapel above and behind the high altar. The elevation of Canterbury was devised by William of Sens, a French mason who introduced sexpartite vaults on columnar piers, and foliage capitals closely based on French models. He exploited colour and surface texture by using contrasting stone, which was popular both sides of the Channel. The building's unusual shape arises from the adaptation and extension of the previous building.

origins and circumstances of the cults themselves. Old buildings could house new cults, and new buildings could be made for old cults as well as recent ones. A complicated example is Christ Church, Canterbury, an ancient cathedral built originally before 600. Filled with the relics of many sainted archbishops, the Romanesque cathedral was partly destroyed by fire in 1174, to be rebuilt with a new focus on the cult of the recently murdered archbishop Thomas Becket [121]. The whole history of the Canterbury cults can be read in its architecture, in which commemoration is strongly emphasized.

Christ Church, Canterbury

Since most medieval saints died in their beds Canterbury was distinguished by possessing a contemporary martyr who could unite the faithful with the martyrs of the early Church. The cathedral was, and is, redolent of martyrdom. Becket was murdered in 1170; the building had been desecrated by the attack on him, and the place where he was struck down became an important station on the pilgrim route around the cathedral's shrines. Becket's body was entombed in the projecting eastern chapel of the crypt [122].

After the 'glorious choir' had been built earlier in the twelfth century, the remains of Becket's predecessors had been buried in the numerous ancillary chapels, with the great Anglo-Saxon archbishops, saints Dunstan and Ælfheah, in the places of honour either side of the high altar. Largely owing to the political circumstances surrounding his death, Becket was canonized within three years. Whether his body was intended to remain in the crypt is unknown, but there was no room in the choir for a shrine behind the high altar, even had the monks wanted one; they may already have chosen to enshrine Becket's remains in the Trinity chapel directly above his tomb. The next year, however, one of the best attested events in architectural history damaged the 'glorious choir' so badly that it had to be rebuilt, and the reconstruction that followed took account of provision for such a shrine, a concept that became ever more grandiose as a decade of building proceeded. The new choir was built upon and within the renovated ruins of the old one, and the shrine was placed in the Trinity chapel. When complete, the chapel was the most magnificent setting for a shrine in any church in Britain. The choir broadly follows the lines of its predecessor, but the Trinity chapel, formerly a square structure of no great size, opens out at the east as an expansive, horseshoe-shaped apse, which leads in its turn to the corona, the eastern rotunda in which was displayed the relic of Becket's scalp. The two chapels shimmer with colour and reflective surfaces, not only in the large stained-glass windows on two levels, but in the contrasting marbles used for the main piers and for colonnettes in the aisles, the triforium and

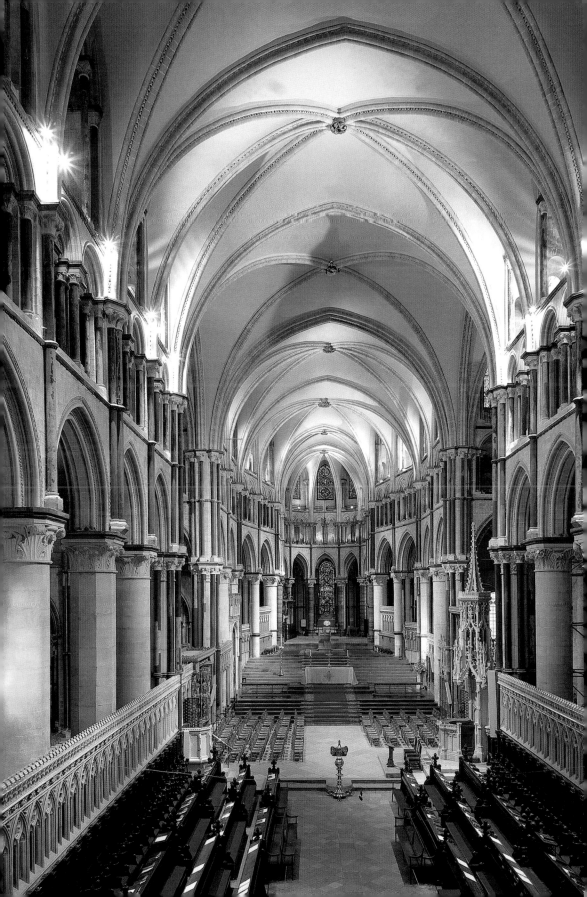

122

Canterbury Cathedral, comparative plans of the choir

Before the fire of 1174, the choir terminated in an ambulatory with a quadrangular eastern chapel. After 1174 the outer walls of the choir were retained, but the eastern—Trinity—chapel was extended to form an aisled, horseshoe-shaped apse leading to the eastern corona. The crypt was likewise extended. Becket's tomb remained in the crypt, his shrine being placed immediately above it.

A Shrine of St Ælfheah
B Shrine of St Dunstan
C Shrine of St Thomas Becket
X High Altar

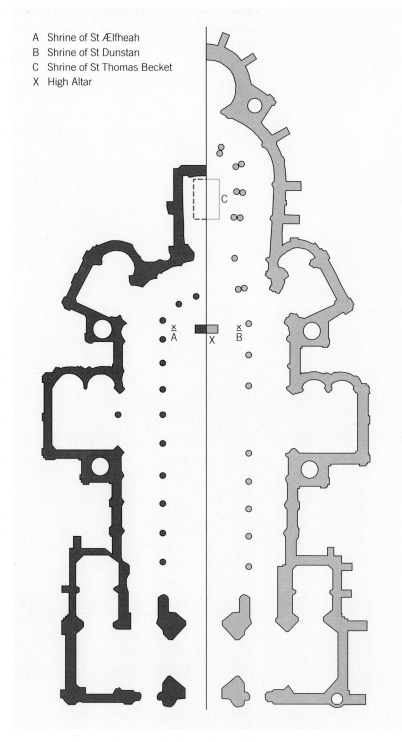

clerestory, and in the mosaic floor. The Trinity chapel is the culmina-
tion of a series of rising floor levels, which ascend by flights of steps
from the nave, through the choir to the eastern chapel. All the chapel
lacks today is the reliquary of St Thomas, which was completed in 1220
and raised on a tall base behind and above the high altar, gleaming with
gold and jewels.

But this Trinity chapel was the outcome of several changes of plan
and intention. These changes are detectable only in the fabric: the
account of the *Burning and Repair of the Church of Canterbury* written
by the monk Gervase, a unique medieval document in its careful
description and comparison of the church before and after the fire, is
the basis of all modern research into the structure, but it gives no hint
of what were evidently substantial changes of mind.[10] Gervase stresses
the monks' longing to return to their choir and their concern to rein-
state the burials that had been displaced by the fire and the rebuilding.
He pays little attention to the Trinity chapel, yet research shows that
the original idea was to place it on the same level as the choir, possibly
on a centralized plan, but polygonal in form. Its plan was to be an
enneagon—a nine-sided figure that, although unusual, could be set out
by constructive geometry, and is also the underlying figure for the
corona.[11] In 1179, when work had already begun on the Trinity chapel
site, its crypt was heightened, the main floor level raised, and the
enneagon plan opened out and extended to create a space that is at once
discrete, but open to the choir. These changes, which enhanced the
whole area of the shrine, are thought to reflect shifting attitudes among
the monks themselves. There is little sign of any particular enthusiasm
for a major cult of Becket until the appointment in 1179 of a new prior,
Alan of Tewkesbury, who was an enthusiast both for the principle of
ecclesiastical rights and for Becket, who had died for those rights. It
was only after Alan's arrival that the focus of devotion was substantially
changed. Becket's shrine now became the apex of a complex pattern of
veneration: it is set directly above the saint's tomb in the crypt, to
which it is linked by an invisible devotional thread that leads also round
the other sites devoted to Becket in the building. At the same time, the
shrine completed the layout of earlier archiepiscopal burials, each care-
fully reinstated in its former location, all of which led to Becket,
mediated by the shrines of Dunstan and Ælfheah, flanking the high
altar just below Becket himself. The impression is deliberately theatri-
cal and a highly effective assault on the emotions: perhaps a metaphor
for Becket's undoubted dramatic flair.

St Elisabeth's church, Marburg

About sixty years after Becket's death, Elisabeth, daughter of the king
of Hungary, died at Marburg, and became the subject of a cult as

highly orchestrated as the one at Canterbury.[12] Yet Marburg could scarcely be more different: it was not the seat of an important ecclesiastical province but a small north German town that came to prominence only by its association with Elisabeth. As the young widow of the Landgrave of Thuringia, Elisabeth retreated to Marburg to avoid her domineering brothers-in-law, devoting herself to religious work. Like Margherita of Cortona she was a Franciscan Tertiary; she founded a hospital in Marburg in 1228, and died there, ill from overwork and self-mortification, in 1231. A small, single-cell church was built over her grave, where miracles were already occurring; and in the next few years her cult was exploited by the Landgraves, the Teutonic Knights, and Emperor Frederick II. They combined their interests to gain control of the hospital, which was handed to the Teutonic Knights in 1234, and five years later Landgrave Konrad briefly became Grand Master of the order. As with Becket, Elisabeth's canonization was rapid, and its ratification in 1235 was followed immediately by the announcement of a new church—but first her remains were translated to a new tomb, during which ceremony Frederick II confirmed the political alliance and associated his office with the power of sanctity by placing his crown on Elisabeth's head. She became a patron saint of the Teutonic order, and although imperial interest faded, the order and the Landgraves maintained a significant presence in the church.

The new church was built with no serious changes of mind. It has a unique design, a hall nave with choir and transepts arranged as a triconch: three polygonal apses opening off the crossing [**123**]. The style of the elevation is drawn from the Reims-Soissons area and closely linked to Reims Cathedral itself. The north transept was built over and beside Elisabeth's grave, giving continuity with the previous building, albeit at a less intense level than the complex layers of reference at Canterbury. The Knights' choir was in the eastern apse, and from the 1270s the Landgraves began to use the south transept as their burial chapel. The Knights began a scheme to elevate Elisabeth's shrine behind the high altar in more conventional mode, but this came to nothing. Yet her position in the north transept did not detract from her influence within the church: the Landgraves also built a new mausoleum over her tomb, where her head reliquary was displayed on feast days, and she appears several times in the carved and painted imagery of the building. Her statue on the high altar screen ensured her presence in the Knights' part of the church. Like Frederick, the Knights and the Landgraves accrued benefit to themselves by their public association with her sanctity.

Elisabeth's influence may well also be felt in the style of the church, a claim that has been made less convincingly for Becket at Canterbury. Her Hungarian relatives had been responsible for

Marburg, Germany, St
Elisabeth's church, exterior
from the south-east

In some respects Marburg
resembles its contemporary,
Our Lady in Trier (see **99**), but
whether it is by the same
master mason is uncertain. At
both, such details as *piliers
cantonnés*, the foliage
designs, and the window
tracery—an oculus over two
lights—reflect the Reims area
of France. Marburg was
influential in central Europe,
where some buildings
deliberately adopted the
absence of cusping.

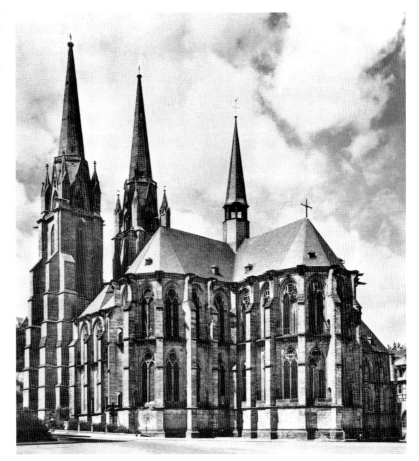

introducing French architectural forms to Hungary well before the
end of the twelfth century, and their interest in French styles contin-
ued. The contemporary French details of Marburg may well have
been chosen in Elisabeth's honour. Her cult was both aristocratic and
popular, commemorating her in a building that was personally hers in
a way that Canterbury was never Becket's, despite the immense power
of his memory down the centuries. Neither building changed much
after their shrines became established. It was with long-standing, leg-
endary cults of great antiquity that memory was maintained through
change.

Continuity through change

Cult settings were nearly always custom built, but a distinction should
be made between settings of new cults, like those of Thomas Becket
and Elisabeth of Hungary, and cults that already possessed a long
history, where the essential core survived while the building, and often
the cult itself, changed round it. The classic instance of a site where
substantial change occurred round an original core is the Tomb of

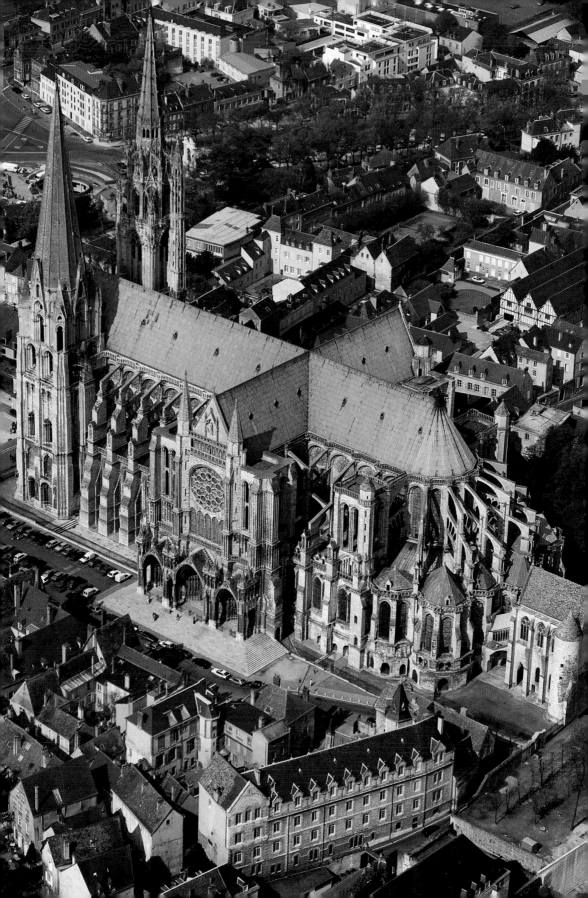

Christ in the Holy Sepulchre church in Jerusalem, where the first, rock-cut tomb survives within its surrounding edicule, which has been reconstructed several times.[13] Many cult places of medieval Europe extend back to pre-Christian times: continuity of cult is especially apparent at sites near water sources, the curative properties and constantly renewed energy of which invited offerings and ceremony. At such places there might be interruptions to the cult, but people seem to revive it, if to a new deity. Vezelay Abbey in Burgundy stands on a hill directly above a Gallo-Roman cult site centred on extensive springs, suggesting a cultic evolution that changed the deity but not the location. Many churches are built above or close to wells: the town of Wells in Somerset takes its name from the springs near which a succession of churches has been built, culminating in the present cathedral.

Chartres Cathedral

The existing, thirteenth-century cathedral building at Chartres [124] represents new architecture chosen for an established cult site, but it is unusual in that, while purporting to be a popular cult, it was essentially local and aristocratic. The huge, imposing structure in the latest style seems to have been built not to accommodate known numbers of pilgrims and celebrate the fame of the shrine, but purposely to try to draw the crowds. When the present cathedral was built Chartres was not a major pilgrimage centre, nor did large numbers visit in the ensuing years. The main attraction in the southern Ile-de-France was the modest church of Saint-Mathurin at Larchant, between Chartres and Sens on a road known, significantly, as the 'chemin de Saint-Mathurin'.[14] Larchant [125] was a possession of Notre-Dame in Paris, and its architecture reflects that distinguished connection in a manner appropriate to its size. But by comparison with Larchant the gigantic structure built at Chartres is out of all proportion to the importance of its cult. At Larchant the clergy managed a cult with a strong popular following. At Chartres they tried to promote interest in the cult by means of an imposing building and a fantastic legendary history.

The legend was devised around two constituent features: a well in the crypt of the cathedral and a relic of the Virgin Mary—the tunic that she had worn at the birth of Christ. Since by tradition the Virgin had been taken up bodily into Heaven, her physical relics were hard to find or justify, and it was possession of the tunic that led the clergy to claim Chartres as the leading shrine of the Virgin in Christendom. Stories of her miracles invariably cast the Virgin in an active role, going out to rescue people in trouble, and her tunic played a similar part at Chartres. Given to the cathedral c.876 by the Carolingian Emperor

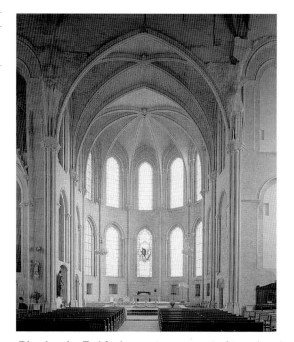

Larchant, France, church of
Saint-Mathurin, interior of
apse, looking east

The cult of St Mathurin was
established in the ninth
century, and Larchant was one
of the most popular pilgrimage
churches in north France. It
belonged to the chapter of
Notre-Dame, Paris, and
although of modest size it
shares much of that
cathedral's elegance. Built
perhaps from the 1170s, the
interior is articulated by slim,
detached monolithic shafts. In
the fourteenth century a
chapel of the Virgin was added
in the contemporary style of
Notre-Dame.

Charles the Bald, the tunic was carried into battle against the Normans in 911 and against Louis VI in 1119. It survived the fire of 1194 that destroyed most of the cathedral, and was the focus of fundraising efforts for the present building. But the tunic was only part of the story. By the eleventh century there was also a cult statue of the Virgin, almost certainly a black madonna, of which examples exist elsewhere, which was displayed in the crypt not far from the well (probably in the *confessio*, the crypt's inner sanctuary), thus combining the curative powers of water with those attributed to the Virgin.

The only evidence that the well is ancient is the fact that the Christian building was associated with it, a common enough device by which Christian missionaries hoped to suppress heathen practices. The *confessio*, which was originally dedicated to the sixth-century bishop, Lubin, is the oldest surviving fabric in the present church, dating probably from after a Danish raid in 858. It may have been Bishop Fulbert who, in the eleventh century, placed the statue of the Virgin in the *confessio*, thus changing the cult. Fulbert was devoted to the Virgin, writing meditations on her Nativity that were incorporated into the liturgy of the French Church. He rebuilt the cathedral, positioning it around and over the *confessio*, and creating three deep radiating chapels, which survive in the present plan, together with long aisles or galleries in the crypt that lead from the west end of the nave. All this implies efforts to accommodate pilgrims. The well, which stood in the north aisle of the crypt just outside the *confessio*, entered the written record around 1100, when monks from Sens and Saint-Père in Chartres wrote accounts of the Danish raids in which

Patrons were often depicted in paint, sculpture, or other media offering a model of their building. Here Jean Tissendier, Bishop of Rieux-Volvestre in France, holds a model of the Rieux chapel, now demolished, that he added to the Franciscan church in Toulouse. Tissendier was born in Cahors, but entered the Franciscan order in Toulouse, being made a bishop in 1324 before being employed at the papal curia in Avignon. He built his burial chapel between 1333 and 1344. Tissendier is shown in his Franciscan habit and bishop's mitre, which is decorated with architectural motifs.

Models could be formulaic, but were often fairly accurate portrayals. Eighteenth-century illustrations indicate that this one is a faithful depiction. It shows the massive but plain architecture of the mendicants in southern France: an aisleless building above a crypt, with a polygonal apse. Two-light windows with heavy mullions are deeply recessed between solid buttresses. The openwork parapet is the only ornament. Such models were in no sense aids for the builders, but were offered to place the building and its donor under the protection of God.

martyrs, including Saints Modeste, Savinien, and Potentien, had been thrown down the well, now named as the Saints-Forts and allegedly attracting pilgrims. In the twelfth century the bishops of Chartres systematically linked the cathedral with the protection of the Virgin, using her as a metaphor for themselves. The clergy were already being highly manipulative in the 1140s when, in an event known as the Cult of Carts, devout citizens pulled cartloads of stone to the site of the west towers, which were then under construction. It has now been shown that the Cult of Carts, which occurred with

apparent spontaneity at other sites, was in reality carefully organized by a small group of churchmen acting in collusion.

After the fire of 1194, the fundraising activity for the new cathedral included a treatise on the miracles of the Virgin, written c.1210, which opened with the miracle of the tunic's surviving the fire. Six of the 27 miracles stressed the earlier episode in 1145 of the Cult of Carts, and it may be significant that the twelfth-century west towers and façade with the sculptured Royal Portal were retained in the final design for the thirteenth-century building. Once the new cathedral was up, overt efforts were made to establish the priority of Chartres among sanctuaries of the Virgin. In 1259 a new reliquary of the tunic was being made, and in 1262 the power of the Virgin was finally brought together with that of the well: the *Livre des Miracles de Notre-Dame de Chartres* recounted that, in an early twelfth-century outbreak of the gangrenous disease known as ergotism, so many of the afflicted had crowded into the cathedral that the north aisle of the crypt became the hospital of the Saints-Lieux-Forts. A century later King Jean II declared that the cathedral had been built as early as the Virgin's lifetime; and in 1389 the *Vieille Chronique* mentioned a cult of a virgin at Chartres in pre-Christian times. Fifteenth-century French kings also noticed Chartres, but it was in the sixteenth that the cult statue was moved to an altar placed next to the well, in the chapel of Notre-Dame-sous-Terre, which led also to a *cave*, the prison of Saints Savinien and Potentien. Finally, in the seventeenth century, fifty years before the whole arrangement was destroyed, the pre-Christian virgin was associated with the Druids, and the legend of Chartres was complete.[15]

The Virgin's tunic and the Saints-Forts fitted plausibly into hagiographic traditions, which created saints' lives from legends and *topoi*. What is interesting at Chartres is the limited extent to which historical reference was allowed to dictate the architecture. The *confessio* remained; the projecting chapels around the east end preserve the plan of Fulbert's church, the Romanesque nave foundations were re-used for the new structure, and the twelfth-century western block defines its termination. But within these constraints the clergy built a cathedral that advertised the cult in the latest style, while confining references to the cult to the carved and painted imagery. In this Chartres differed markedly from Saint-Denis, where architectural change embodied and expressed a sense of the building's past.

Saint-Denis Abbey

The core of Saint-Denis Abbey church was the tomb of Dionysius (or St Denis), a missionary martyred supposedly in AD 258, although the first church was built only about 500. The seventh-century Mero-

vingian king Dagobert remodelled it and later legend recognized him as the abbey's founder. By the eleventh century another legend had Dagobert's church miraculously consecrated by Christ. In the meantime the Carolingian abbot Fulrad had rebuilt it, and in the ninth century Abbot Hilduin had added an eastern outer crypt to accommodate more relics and pilgrims. Hilduin also composed the saint's official biography, conflating him with two other Dionysius figures: the Areopagite mentioned in the Acts of the Apostles, and a later mystic known as the Pseudo-Areopagite, whose writings were now attributed to St Denis. By the 1120s, when Suger began to consider his own remodelling of the church, the abbey was hung about in a miasma of history, miracle, and legend, which was exploited to the full. As later at Magdeburg (see **12**), Suger's building both preserved earlier work and referred to its illustrious predecessors.[16]

The new crypt [**127**] enveloped the earlier crypts: Hilduin's had been built off axis to Fulrad's, and the twelfth-century axis compromised between them. The main elevation of the upper church probably had only two storeys, following local, but also earlier, tradition, and other consciously retrograde forms included the columns in the choir and the great western block. Just as the Carolingian church had reused Merovingian columns and capitals, so did Suger's; in other places foliage was cut to resemble Merovingian work. The final church, begun in 1231 (see **9**), respected Suger's additions, particularly around the sanctuary, where the preservation of the ambulatory required the shoring up of the arcade while new piers were inserted. Suger brought the shrine of St Denis and his two companions, Rusticus and

127

Saint-Denis Abbey church, detail of the crypt, looking north

The twelfth-century crypt was constructed around and eastwards of the two earlier ones. This view shows the junction of Abbot Hilduin's outer crypt (on the left) with Suger's crypt (on the right). The solid, columnar twelfth-century piers have capitals with a shallow foliate motif that recalls the much earlier work further west. Suger's sculptors also modified the ancient capitals and supplied others in their style.

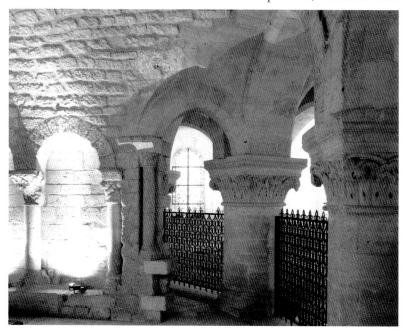

Eleutherius, from the crypt to a site behind the high altar, but, in anticipation of the arrangement at Canterbury, he placed them directly above their former tomb in the crypt, thus expressing continuity with the original burial in both time and space.

Prague Cathedral

Saint-Denis was reconfigured as the shrine of the patron saint of France and keeper of the oriflamme, the French battle standard. In the thirteenth-century rebuilding it became the official burial place of the French kings, Louis IX gathering his predecessors' remains into one spot in what amounted to a cult of ancestors. Rulers had established family burial places from an early date, although changing political realities might force later generations to choose a new mausoleum somewhere else: the early kings of France were not all buried at Saint-Denis, and the succession of Plantagenet tombs at Fontevrault Abbey was halted when the French took Anjou. Royal burials influenced one another: the Hohenstaufen tombs in Palermo, which are made of re-used Roman imperial porphyry, were imitated from the late thirteenth century by the Aragonese conquerors of Sicily, who ordered similarly grandiose tombs for themselves in the Cistercian abbey of Santes Creus in Catalonia. But Louis IX's action was more than a pious duty or a statement of grandeur. It sought to affirm his right to power through identification with his ancestors. Ancestor cults were often associated with new building. Pope Urban IV founded a collegiate church on the site of his father's house and his own birthplace at Troyes in Champagne, dedicating it to his own patron saint, Urbain [**128**]. Urban himself was buried in Perugia. Henry III, however, rebuilt the choir of Westminster Abbey as a shrine church for his sainted predecessor, Edward the Confessor, and was buried in the church. A canonized forebear increased the successor's claim to sanctified kingship, and Philip IV of France was to exploit the cult of Louis IX. Ladislas Łokietek of Poland was not canonized, but Kasimir the Great, as well as founding Wiślica church, honoured his father by promoting Ladislas's patron saint in dedications of churches in other places associated with Łokietek.[17] Kasimir also promoted the cult of St Stanislaw, the patron saint of Poland. But for Henry III and Emperor Charles IV the sainted forebear was also the patron saint of the country.

Bohemian national consciousness—or at least a sense of difference—developed early, and by the fourteenth century Wenceslas (Vaclav) I (*reg.* 921–9) was already established as the patron saint of Bohemia. He was buried in the cathedral of St Vitus in Prague Castle, and Charles included both saints in his cult of sacred kingship: they appear with him in the complex iconography of the tower of the Old

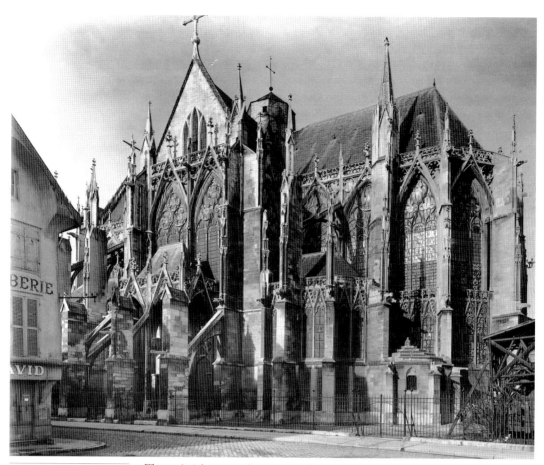

128

Troyes, France, collegiate church of Saint-Urbain, exterior from the south-east

Pope Urban IV founded the church in 1262, and the work continued slowly, to be completed in the nineteenth century. The choir, with its apparently thin structure and expanses of glass, and tracery covering windows, walls, and empty air, exploits the reliquary-like qualities of Rayonnant. The exterior, a concoction of pinnacles, gables, and openwork balustrades, develops the broken silhouette first explored at Saint-Nicaise, Reims, and on the south transept of Notre-Dame, Paris.

Town bridge, on the route of the coronation procession from the old palace to the castle, and their shrines, together with the tombs of Charles's Přemyslid ancestors, dictate significant aspects of the cathedral's design. Underneath the present building lie the ghosts of two predecessors, the late eleventh-century basilica of SS Wenceslas, Vitus, and Adalbert, and the tenth-century rotunda of St Vitus [**129**]. The rotunda was begun under Wenceslas I, a limestone building with four apses projecting from its circular core. The east apse housed the tomb of St Vitus, and in the south apse Wenceslas was buried 'among the saints', the analogy with Constantine being particularly apt in this instance, because his tomb was next to an altar of the Apostles, which was the dedication of Constantine's burial church in Constantinople. The south apse was retained in the later basilica as a chapel projecting from the regular line of the south aisle. The huge new cathedral [**130**] built for Charles IV was set out north and east of the old basilica, which lies beneath the crossing, south transept, and south tower of the present church. The south façade is a magnificent ensemble of sculpture, tracery, vaulting, and mosaic that marks the official entrance to the cathedral (for a detail see **22**), and acts as a vestibule to the

129

Prague Cathedral, superimposed plans of successive buildings

The original rotunda with four apses underlies its two successors. The Romanesque cathedral incorporated the south apse with the tomb of St Wenceslas as a projecting chapel on its south side. The fourteenth-century choir and south transept were built around and eastwards of the Romanesque cathedral, with the chapel of St Wenceslas in the same position. The nave was not built until the nineteenth century.

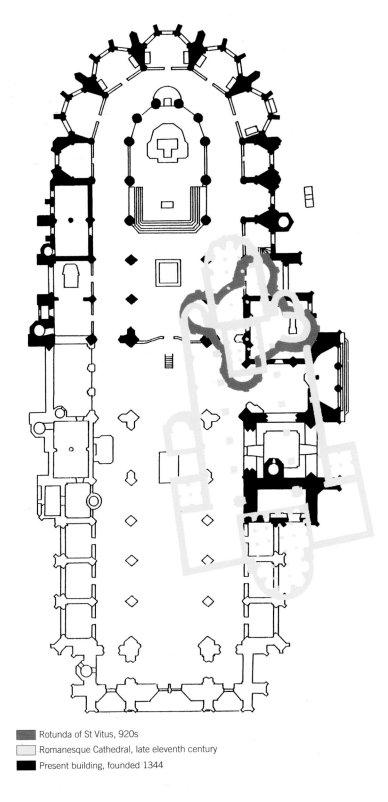

130

Prague Cathedral, interior of choir, looking east

The cathedral represented the most complete idea in central Europe of the French great church. The ambulatory and radiating chapels were built by Matthew of Arras, but Peter Parler, who arrived in 1356, was responsible for the zigzag line of the triforium, the inventive window tracery, and patterned vaults over the choir and in flanking chapels. The high vault design plays on intersecting parallel lines.

■ Rotunda of St Vitus, 920s
□ Romanesque Cathedral, late eleventh century
■ Present building, founded 1344

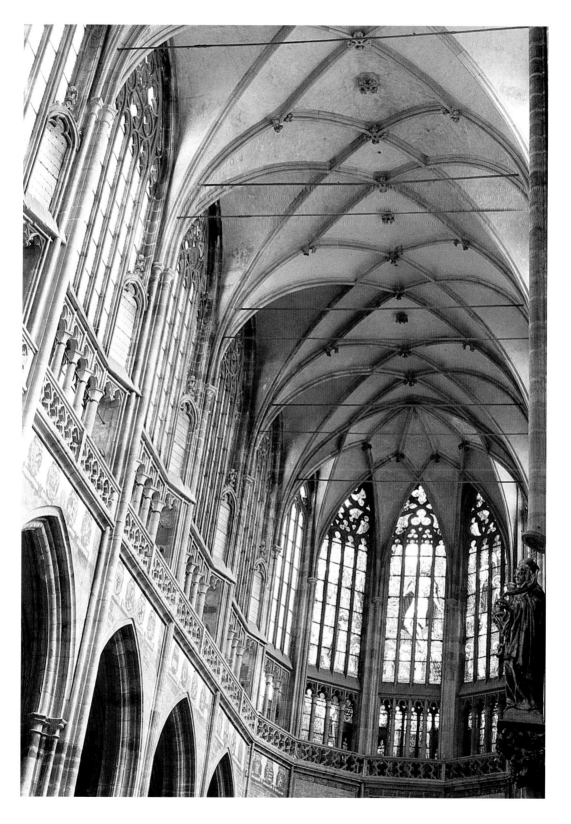

Wenceslas chapel in the angle with the choir aisle. The Wenceslas chapel [**131**] houses the saint's shrine. It is sited directly over his original burial place, a square room surmounted by one of Peter Parler's cross-parallel vaults, its dado decorated with amethyst mosaic, gilding, and paint similar to the work at Karlstein—an evocation of precious metal and a metaphor for the Heavenly Jerusalem.[18] Charles's Přemyslid ancestors were moved to new tombs in the radiating chapels of the choir, and the shrine of St Vitus translated to the ambulatory behind the high altar. The modern style of the choir, enhanced by Parler's inventive genius, and lit by the radiance that enters through the triforium, which breaks forward into space like a crown of light,

deliberately contrasts with the enclosed, sacred gloom of the Wenceslas chapel. Where St Wenceslas maintains the link with the past by lying near to his original burial place, the patron saint and the ancestors celebrate amid new beginnings.

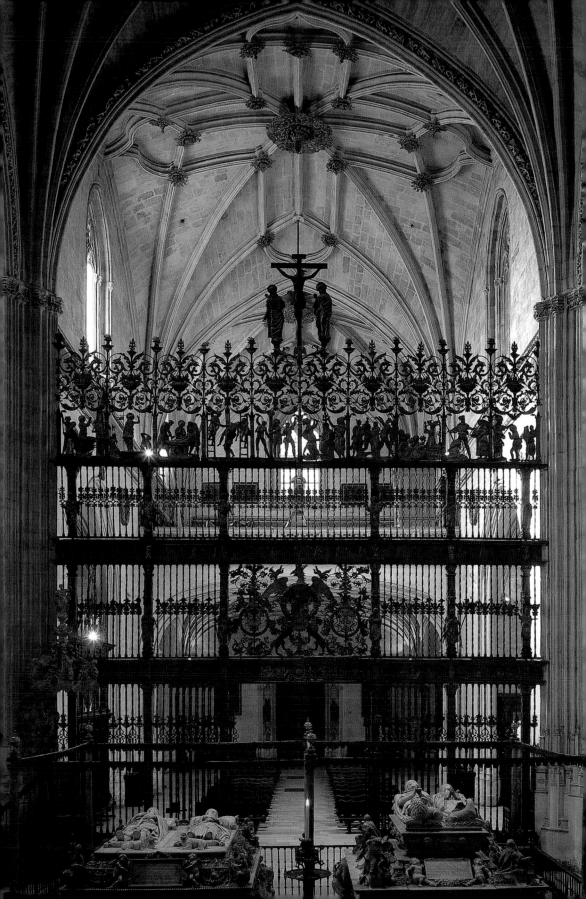

The Future that Arrives

7

By 1500, for more than three and a half centuries the people of Christendom had created types of building and styles of architecture that served the religious, cultural, and political aspirations not solely of the ruling classes but of whole communities. It was not only lay and ecclesiastical leaders who led taste and devised buildings, but such lesser patrons as friars, minor lords, parish priests, and merchants. Cultural expressions were not uniform, and some were more assertive than others, hence the period of strong French influence in the twelfth and thirteenth centuries, and the easily detectable 'foreign' forms that appeared in unexpected places. Religious or political motives are not always apparent. The French style of the abbey churches built after 1266 by Charles I of Anjou near Naples seem deliberately to assert the realities of French power; yet for Charles's courtiers, who founded most of the new architecture in the region, a consciously French style may have been less in their minds than the desire to have churches built in a familiar manner.[1]

Nevertheless, on the geopolitical margins Gothic identified the culture. After the fall of Acre in 1291 Cyprus became the foremost bastion of western Christianity and trade in the eastern Mediterranean, but it was under serious threat from Muslim expansion, particularly after the Ottomans seized Constantinople in 1453. The first Lusignan rulers and their French ecclesiastical hierarchy had built in French Gothic styles partly mediated through the Holy Land.[2] Church architecture continued to reflect the dominant Latin power until the fifteenth century, when Venice was effectively ruling in the island, and Venetian decorative motifs appeared on buildings from the last phases of Bellapais Abbey to small village churches. Meanwhile, even as some Latins converted to Orthodoxy, Greek churches had succumbed to western stylistic influences. What appears nowhere is any sign of Muslim influence. Yet, elsewhere the Venetians had reacted positively to their experience of Islamic art, which they had acquired through their extensive trading activities in the east. In Acre and other Levantine towns Venetian merchants lived like the local Muslims, in fortified, enclosed buildings round central courtyards. To Venice they took back Islamic motifs that were

132
Granada, Spain, Capilla Real, interior, looking west

When in 1492 the Catholic monarchs conquered Granada it was dominated by the Alhambra Palace of their Nasrid predecessors. They began to transform the lower town into a Christian city, one of the first foundations being the royal burial chapel in the city centre. The master mason Enrique Egas was brought from Toledo. Begun in 1505, the two-bay chapel has looping vaults and multiple fine mouldings, enriched by floriated ornament.

Segovia Cathedral, Spain, south aisle of the nave, looking east

The former cathedral was destroyed in 1521, and the present building is among the last large-scale cathedral foundations in medieval Spain. Designed from 1522 by Juan Gil de Hontañón, its details resemble his work at Salamanca, although its dimensions are modelled on Seville Cathedral. The massive piers with tiny capitals and prismatic bases, the sharply defined mouldings, and looping vaults are typical of the period.

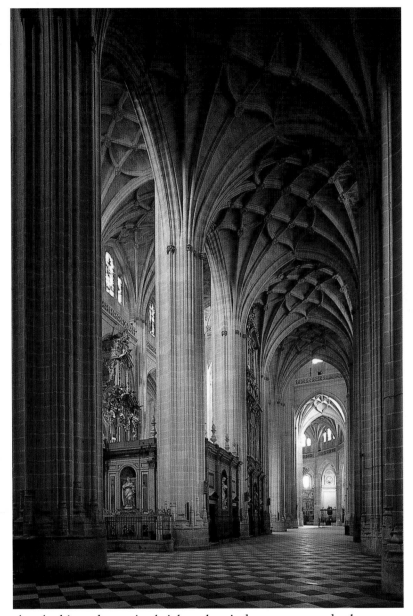

absorbed into decorative brickwork, window tracery, and other ornament (see **68**), in a manner paralleled only in *Mudéjar* Spain.[3] But in Cyprus and also in Crete, where Ottoman invasion was now imminent, the Venetians abjured all references to Islam. Even the decorative details brought from Venice had no Islamic connotations. What was necessary in a Muslim area, and acceptable in the secure confines of Venice itself, was taboo where cultural identity was a daily preoccupation.

Similar attitudes can be seen in southern Spain after the Catholic Monarchs, Ferdinand and Isabella, drove the Nasrid rulers out of

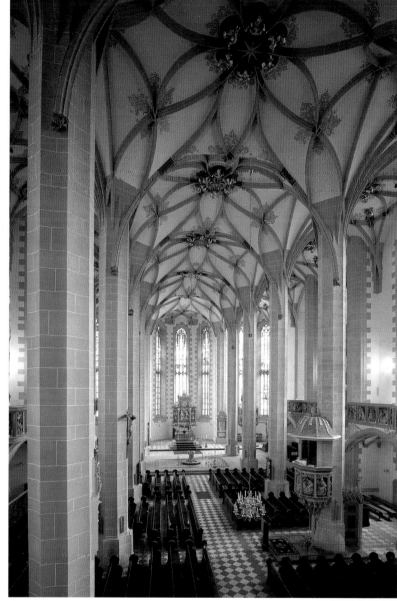

Unlike Segovia (see **133**),
where the vault bays are
separated by heavy transverse
arches, the looping ribs run
without interruption across the
shallow vault surface. The
third master mason, Jakob
Haylmann, was a pupil of
Benedikt Ried, and these
vaults, with their star pattern
and cut-off ribs, resemble
those of St Barbara, Kutná
Hora. The cut-off ribs are a
visual comment on the ribs'
structural and decorative
functions.

Granada in 1492. Not only was Granada Cathedral—like that of
Seville—founded on the site of the destroyed main mosque, but the
monarchs relocated their burial place from S. Juan de los Reyes in
Toledo to a chapel in Granada [**132**]. The Capilla Real off the cathe-
dral was a celebration of flower-like, looping vaults and elaborate
mouldings, with no hint of the Islamic details found in *Mudéjar* work.
The victory of Christianity was felt and continued to be felt, through-
out sixteenth-century Castile, with new cathedrals at Salamanca and
Segovia [**133**], huge, vaulted basilicas based on that of Seville, which
itself received a new net vault for its rebuilt crossing tower in 1513.

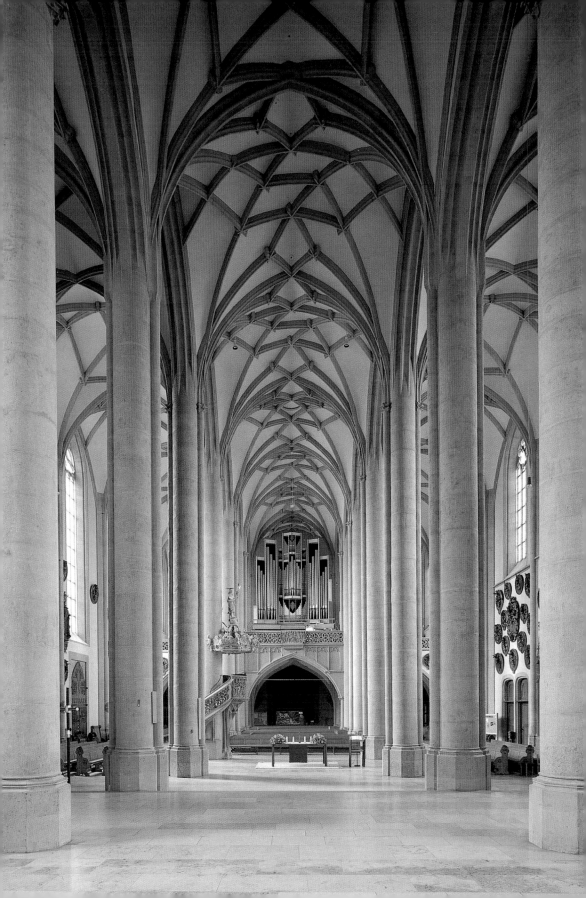

135

Nördlingen, Germany, St Georg's church, nave interior, looking west

The parish church dominates the small, walled Imperial city in Bavaria. Begun in 1427 and financed mainly by the townspeople, it is a columnar hall church, relatively austere in character except for its net vaults, designed by Stephan Weyrer and completed in 1512. The choir pattern differs from the lozenge design in the nave. The intersecting springers and cut-off ribs are probably derived from Burkhard Engelberg, the leading mason in Augsburg c.1500.

136

Tomar, Portugal, west window of the chapter house, monastery of the Knights of Christ

A new rectangular choir with chapter house beneath was added to the twelfth-century circular church from 1510, under the direction of Diogo de Arruda, who had probably been trained at Batalha Abbey. Tomar is a showcase of the royal iconography of King Manuel I, richly carved with sculptured allusions to Portuguese history and Manuel's vision of his kingship. References to the biblical Tree of Jesse symbolize the Tree of Life.

Vaults and ornament are the unifying elements in an otherwise bewildering variety of structures. The lightweight and luminous hall churches built in a region stretching from Austria through the prosperous mining towns of Bohemia and Saxony contrast strongly with the heavy darkness of the Spanish basilicas. Yet like them they have looping vaults in flower and star patterns twisting upwards from piers and wall supports. These are encapsulated in the work of Benedikt Ried, in the Vladislav Hall in Prague Castle (see **4**) and such churches as St Barbara, Kutná Hora, where he became master mason in 1512. Kutná Hora has a flattened vault surface, akin to those used for net vaults in fourteenth-century England, which was used in several churches in Saxony, for example St Anne at Annaberg [**134**], where the shallow curve helps to create an impression of broad spaciousness. In the parish church of Ingolstadt in Swabia (see **44e**) the loops combine with flying ribs carved to resemble branches of wood—*Astwerk*—which had also become popular on such liturgical furnishings as fonts, sacrament houses, and pulpits. Net vaults were built at Holy Cross, Schwäbisch Gmünd and St Georg, Nördlingen [**135**], from the 1490s, completed at Gmünd only in 1521. Heavily stylized plant motifs reached their apogee in buildings as far apart as Henry VII's chapel in Westminster Abbey, c.1509, and the monastery of the Knights of Christ at Tomar [**136**] and other Portuguese Manueline buildings. Reflecting the greater emphasis on secular values in society,

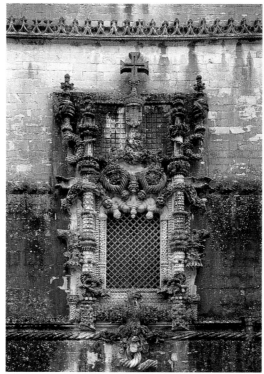

heraldic shields and rebuses (punning visual references to a patron's name) were incorporated into ornamental schemes as a matter of course.

Church plans and structural members were, however, no more than variations of established forms. But secular buildings were beginning to go their own way again, often free from such characteristics of church architecture as pointed windows that they had acquired. The logical consequences of timber construction had begun to assert themselves and although domestic window- and door-frames might be carved with traditional mouldings, arches were either flattened into the shallow, four-centred shape or dropped altogether [**137**]. Only in the hall, still the symbolic heart of the house, were there arched windows with elaborate tracery, and spectacular vaulted or beamed roofs. In other rooms flat ceilings gave greater warmth and more usable space, and from the fourteenth century rectangular windows followed the posts and beams of timber-framed construction. From about 1400 rectangular windows appeared in masonry façades, as at La Ferté-Milon and Ca' d'Oro (see **109** and **68**). The exterior window-frames of the Vladislav hall are rectangular despite the deep arches created by the vault. Rooflines were also changing, to give new exterior profiles. The tower of Belém [**138**], which marks the maritime approaches to Lisbon, is equipped with machicolations, crenellations, and turrets; but the crenellations around the top have small pyramidal caps, while the turrets are crowned by miniature melon domes, details that both play on the idea of military strength and belie it at the same time. For many years the roof crests of houses had been embellished with glazed ceramics in the form of grotesque figures, but decoration was now intensified. Before 1525 the merchant and banker Jakob Fugger II remodelled three houses in the Weinmarkt at Augsburg in Swabia

137

Lavenham, England, a timber-framed shop-front, c.1500

Although arched forms were used in both wall frames and roofs, timber framing followed its own rules, and windows fitted the horizontal and vertical lines of the framing. The rectangular door- and window-frames demanded by humanist studies of ancient architecture thus already fitted naturally into domestic buildings. In towns upper storeys were frequently jettied out, to make more room without impinging on the street space.

Belém Tower, Portugal
The site of Belém was originally an island in the river Tagus. The tower, begun in 1514, was designed by Francisco de Arruda, brother of Diogo (see **136**). Although it has gun emplacements in the lower storeys, it was built primarily for show, with elegant decorated balconies. The cornices are thick, Manueline rope mouldings and the crenellations are decorated with shields of arms of the Knights of Christ.

[**139**]. Since destroyed, they are known from illustrations to have had on their roofs a row of small turrets with a variety of cappings, including the type of squashed dome known as an Italian bonnet. Nonsuch Palace, Henry VIII's hunting lodge in Surrey built from 1538, had similar domes over the corner towers of the inner court, the roofs being further enlivened with tall brick chimney-pots.

But Nonsuch had other decorations in new forms: applied stucco panels and gilded slate made by an Italian craftsman, Nicholas Bellin of Modena, adorned with designs drawing on a repertoire of motifs that looked back to classical art.[4] This was a response by a northern patron to the revival of the 'antique' that had been begun by a group of humanist scholars and artists in Florence in the early fifteenth century, the rebirth or Renaissance of what they saw as their 'Italian' past, and its subsequent spread to north Italy and Rome. By the time Nonsuch was built these motifs had travelled beyond Italy, appearing in such grandiose architectural statements as the Colegio di S. Gregorio at

Augsburg, Germany, Fugger
houses in the Weinmarkt

The houses on the left were
built from *c.*1512 for Jakob
Fugger II who, with his
brothers, owned an immense
international mercantile and
banking business. Jakob also
built the Fugger chapel (see
141) and the Fuggerei
community houses in
Augsburg. Erected by the
workshop of Hans Hieber (see
147), the Weinmarkt houses
had painted decoration on
their façades as well as the
ornate turrets on their roofs.

Valladolid in Spain [**140**], or small-scale pieces like the 'Tulip' pulpit,
made 1508–10, in Freiberg Cathedral, Saxony, which is composed
entirely of branches and foliage but among the figures it supports is a
putto or winged cherub. In northern Europe 'antique' motifs were
often incorporated into schemes that were otherwise based on tradi-
tional designs. More striking are early sixteenth-century buildings that
use the classical orders or other classicizing architectural features.
Three in particular are outstanding, all burial chapels in central
Europe: that of Archbishop Bakócz at Esztergom in Hungary, the
Fugger chapel in St Anne, Augsburg, and the Sigismund chapel
attached to the cathedral on the Wawel in Kraków. The Fugger family

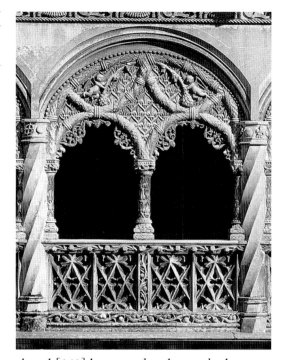

The Catholic Monarchs, Ferdinand of Aragon and Isabella of Castile, were married in Valladolid in 1469, and the city thereafter received many new buildings. The two-storey courtyard of the Colegio was built from 1487 by Juan Guas, who had been master mason of S. Juan de los Reyes in Toledo (see 25). The arcaded openings, with twisted columns and tracery balustrades, feature winged cherubs.

chapel [141] has round arches and a heavy, moulded cornice beneath the round-arched windows. The tombs in the west wall are encased by arches with classical pilasters, under a balustrade. Yet above these classicizing details floats a looping vault with cut-off ribs. The chapel built by King Sigismund of Poland from 1517, however, has no such hybrid characteristics (see **144**). It is a square building with a dome supported on a drum decorated with classical pilasters and circular windows. The substructure has rhomboid decorative panels, and the interior is adorned with classical swags, shell niches, and coffering in the dome. Consecrated in 1533, the Sigismund chapel is in a style that contemporaries in Kraków would have found wholly alien.

Maniera tedesca

Esztergom, Augsburg, and Kraków, and all the buildings that incorporated Italian motifs into their ornament, were as yet only hints of the stylistic change that was to engulf, if not entirely suppress, traditional styles by the beginning of the seventeenth century. The profound effect of classicism on art arose from the humanist study of ancient texts that gave scholars a precedent and a vocabulary for devising theories of art and architecture. Reawakened interest in Vitruvius's treatise stimulated the humanists to revive the architectural treatise as a literary form. The best known, Leon Battista Alberti's *De Re Aedificatoria*, composed *c.*1452, is both a critique and a refinement of its Roman model. Alberti was an educated man, first and foremost a scholar, who

The Fuggers' burial chapel
occupies the west bay of the
monastery church. It was
commissioned by Jakob
Fugger from c.1510, and was
probably built by Hans
Hieber's workshop (see **147**).
Despite the absence of direct
Italian involvement, the
elevation and tombs on the
west wall are in a classicizing
style based on 'antique' forms
although the ceilings are
vaulted.

promoted the classical orders and ancient forms as an ideal of beauty. It was Filarete (Antonio Averlino) who, in about 1460, converted the desire to revive the Italian past into an attack on imported styles: 'Therefore, I advise everyone to abandon the modern style and not be advised by those masters who use this crude system. May he who found it be cursed! I believe that none other than barbarians brought it to Italy.'[5] Filarete enjoyed several digs at forms derived from 'the Germans and the French'. It was he and a small group of fellow practitioners who converted what had been accepted as *modo franciae* into the despised *maniera tedesca*.

Yet *maniera tedesca* was not discarded immediately. Filarete had his own reasons for his intemperate outbursts, and in practice, classical was not placed in opposition to Gothic in the crude way suggested by his words and much subsequent scholarship. The Renaissance of the fifteenth century was the latest in a series of classical revivals that had occurred every so often since late antiquity. It was probably the Carolingian classical revival of the late eighth century that inspired the copying of the Vitruvius manuscript in northern monastic libraries. These revivals were all attempts to return to the authenticity not of the classical past but of the early Christian era. Each drew inspiration from ancient Rome. Abbot Suger of Saint-Denis was one of several twelfth-century churchmen who specifically recalled Rome in building designs: foliage capitals have the volutes and acanthus leaves, however debased they seem to us, of their Corinthian forebears, and the choice of columns in preference to square or cruciform piers was deliberate. These men would have been angered by suggestions that they were barbarians or breaking with the classical heritage. Brunelleschi incorporated what he thought were classicizing motifs in earlier Florentine buildings into his own designs to emphasize the connection to early Christianity. In the fifteenth century the first signs of interest in ancient Rome come from Alberti, and even his circle of humanists was concerned to reconcile pagan antiquity with the Christian tradition.

Moreover in Italy various kinds of cross vaulting continued in use, since they were justified by their appearance in Roman buildings. Alberti, who was possibly an adviser to Pope Nicholas V (*reg.* 1447–55) in the restoration of Rome after a century and a half of papal absence and concomitant neglect, positively recommended groin vaulting for churches. At this time several vaulted churches were built in Rome, and S. Maria sopra Minerva was rib-vaulted for the first time in its history precisely because cross vaults in Rome's ancient buildings justified their use now. When Pope Pius II (*reg.* 1458–64) transformed his native village of Corsignano into the 'ideal' Renaissance city of Pienza, he set the cathedral [**142**] among buildings designed in Tuscan revival style round a central square: but behind the façade in the form of a

Pienza, Italy, interior of the cathedral

Built by Bernardo Rossellino 1460–2, the interior contrasts sharply with the classical façades of the cathedral and the adjacent Piccolomini palace. The only concessions inside are the entablatures below the vault springers, the round arches of the arcade, and round-headed windows, although the latter are filled with tracery. The piers are cruciform and the vaults cross-ribbed. The cathedral stands on a north–south axis, hence the radiant light that suffuses its liturgical east end.

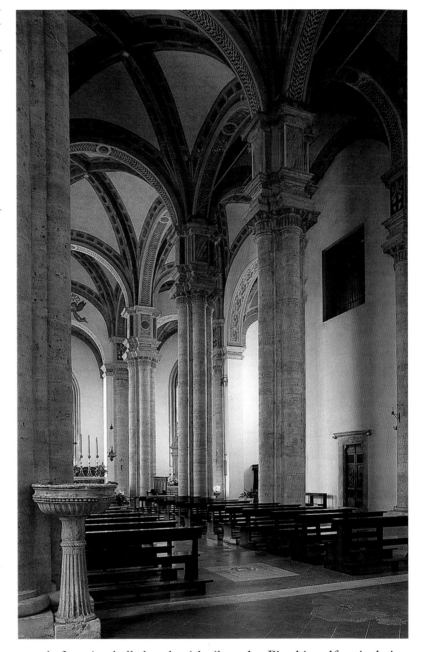

temple front is a hall church with rib vaults. Pius himself, articulating traditional ideas about light as a metaphor for God, wanted a light-filled church on the northern model. During his travels in north Europe he had admired York Minster for the brilliance of its light, and his memoirs state that the church of Pienza 'was according to the direction of Pius who had seen the plan among the Germans in Austria'.[6] Such gigantic vaulted structures as Milan Cathedral and S. Petronio in Bologna [143],[7] which had been begun before 1400,

continued in building into the sixteenth century and beyond, and rib vaults remained generally popular. In Florence Brunelleschi may have used a classicizing style in such buildings as S. Lorenzo, but the profile of the cathedral's dome was influenced not by ancient domes but by the twelfth- and thirteenth-century examples at Pisa and Siena. They also influenced the dome at the pilgrimage church of Loreto (begun 1432), and plans to build one at S. Petronio.

From about 1450, after its spread from Florence, the classical revival was essentially princely and court-led, although among the princes should be included the mercantile Fuggers of Augsburg, whose position as the most prominent banking and trading house in Europe gave them equivalent wealth and status. The revival spread last within Italy, taking on a different character according to the tastes of the patrons. Urbino followed the austerity of Florence but in their buildings in Milan and Pavia the Sforzas preferred the lush and ornamental. The French invasion of north Italy in 1494 brought the art of Milan and Venice to the notice of northern princely patrons.

143

Bologna, Italy, S. Petronio's church, interior, looking east

Dedicated to the city's patron saint and legendary defender of communal liberty, the church was begun by the commune in 1390 beside the main square. The dimensions of the nave and aisles were based on Florence Cathedral, which also inspired the pier forms. As the centuries passed and the design was revised its massive scale increased. The present nave vaults were built 6 m higher than before in the mid-seventeenth century.

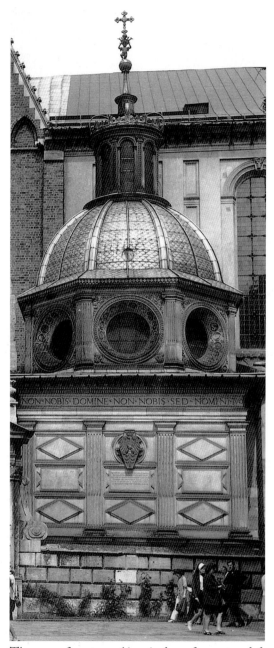

The chapel was founded on
the south side of the cathedral
in 1519 by King Sigismund I.
He brought in craftsmen from
Tuscany, headed by
Bartolomeo Berrecci, to create
a classical, domed cube,
decorated inside and out with
antique ornament and defined
by the classical orders. The
chapel's function as a burial
chapel for Sigismund and his
first wife shows how the new
formal language served
traditional purposes.

The use of rectangular window-frames and depressed arches that had
long been a feature of northern architecture meant that *maniera
tedesca*, in its homelands at least, was already going some way to meet
the classical revival. Copies of Alberti's and Filarete's treatises were
made in Florence for Mathias Corvinus, king of Hungary (*reg.*
1458–90), but northern patrons acquired their actual buildings in two
ways. Some, the Fuggers for example, relied on verbal description,

pattern books, and the recent medium of prints to convey their ideas to local masons. Others, such as Sigismund at Kraków, brought in Italian craftsmen: at Kraków, his architect, Bartolomeo Berrecci, created a wholly Italianate building [144], not only in style, but in his use of new materials, such as copper for the dome. Yet in many buildings of these years, even where Italian craftsmen are known to have worked, local tradition remained strong. Nonsuch Palace, for all its antique decoration, was a double-courtyard house, with stacks of individual lodgings. The Italianate decoration added by Cardinal Amboise to the palace of the archbishops of Rouen at Gaillon in Normandy was applied to an earlier, twin-towered gatehouse of familiar design [145]. Therefore, wherever princely patrons showed

145

Gaillon, France, entrance gate to the archbishops' palace

The entrance was built by Cardinal d'Estouteville, Archbishop of Rouen, in the 1450s, but the decoration was added by Cardinal-archbishop Georges d'Amboise from about 1508. The Cardinal had spent time in Milan, and introduced both Italian craftsmen and motifs to Normandy: Gaillon bears some of the earliest ornament in the new classical style in France. Amboise was also responsible for building work at Rouen Cathedral.

off their classical education by grafting Italianate motifs on to traditional buildings it is scarcely surprising that among the general population acceptance of the classical orders and other Italianate forms was neither rapid nor wholehearted. As we have seen, rib vaults were not seen as anti-classical in themselves: in Augsburg the Fuggers saw no inconsistency between the classical elevation and the rib vault of their burial chapel. The choir of Saint-Pierre in Caen [146], begun in 1528, combines rib vaults, radiating chapels, flying buttresses, and traceried windows, with round heads to the windows, classical scrolls hung from the vault ribs, and pinnacles in the form of candelabra derived from north Italy.

The decorative scheme of S. Giovanni Evangelista in Parma warns how careful we should be in our presumptions about the perception and interpretation of styles: the building in which Antonio Correggio painted his illusionistic frescoes in the 1520s was built between 1489 and 1510 as a rib-vaulted, brick basilica in the north Italian tradition. Contemporary with Correggio's paintings is the model made by the mason Hans Hieber of the proposed pilgrimage church, the Schöne

146

Caen, France, Saint-Pierre, interior of the south-east ambulatory

The east end was rebuilt between 1528 and 1545 by Hector Sohier. The piers, capitals, prismatic bases, and vault ribs are as traditional as the plan of ambulatory and radiating chapels, but the ribs are festooned with Italianate stalactite ornament. The exterior has flying buttresses, gargoyles, and pinnacles—the latter in the form of candelabra—and antique swags decorate spandrels and parapets.

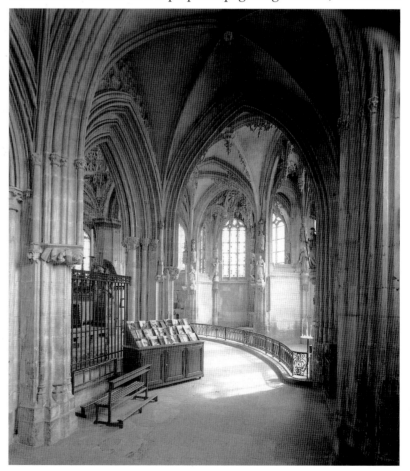

147

147
Regensburg, Germany, wooden model of Zur Schöne Maria church

The model was made c.1519 by Hans Hieber, a mason from Augsburg and pupil of Burkhard Engelberg, who had made a model for the tower of Bern Cathedral. The parish church was on the site of the demolished synagogue, attracting pilgrimage after a workman involved in the destruction survived his injuries. The status of the model is unclear since Hieber died in 1521 and work continued on very different lines.

Maria, in Regensburg [**147**]. This combined a hexagonal nave with a single-aisled chancel, flanked by towers and chapels, and ending in a polygonal apse. The hexagon, a centralized design in the tradition of churches dedicated to the Virgin, was to be vaulted from a central pier, like a chapter house. To us, the mixture of traditional and novel forms, as also at Caen or Parma—here a vault, window tracery, and intersecting ogees combined with a classical balustrade and Italian bonnet domes—suggests transition, of old giving way to new. Whether Hieber or his patron saw it that way is another matter. To them the new forms may not have suggested that the old should be discarded.

The future that arrives

The title of this book tacitly accepts the idea that medieval architecture is a distinct phase in architectural history. The idea of a middle age

sandwiched between ancient and modern times was invented in the Renaissance. Indeed, the whole notion of rebirth or revival is predicated upon a period of aberrant difference. The distinct identity of the medieval period was much reinforced by the great nineteenth-century architects—Viollet-le-Duc, Scott, Mocker, and Reichensperger—who imposed their vision of the Middle Ages on the buildings that they restored and in their influential writings. We have inherited this vision in churches that were effectively reconstructed, such as Saint-Denis or Notre-Dame in Paris, and fortifications that received the same treatment at Carcassonne, Pierrefonds, and even in the altered rooflines at Karlstein (see **79**). Conscientious and perceptive though these men were, like the humanists they invented a medieval period to suit their own day, just as we are refashioning it to suit ours. But our attitudes to style have been ossified by our predecessors' enthusiasm for defining it through taxonomy and comparison. Stylistic analysis encompasses difference. This may help with dating a building, but it obscures underlying continuities. An acute difficulty arises in periods of stylistic change, such as the twelfth century or even more the sixteenth, when the political and religious events can all too easily be interpreted as agents of that change. The discovery of America and trade routes round Africa in the late fifteenth century was followed by the Reformation and religious wars, which undermined people's profoundly held habits and beliefs. Such upheavals seem to insist on endings and new beginnings. Yet despite years of unimagined disruption, and apparent refashioning of both political and religious attitudes, demand for display, for symbolic representation, and for salvation continued as before. Changes of style were not accompanied by changes in underlying attitudes.

The idea of a medieval period, with its own fixed time limits, has inspired various strands of architectural writing: earlier scholars, notably Gerstenberg and Frankl, saw all medieval architecture as tending towards a fixed, known end, in their case the sixteenth-century hall church as exemplified at Annaberg.[8] In this reading, all previous Gothic is a prelude to a predetermined outcome. Others interpret architectural events in the sixteenth century as the last gasp of a dying style, since the survival of medieval styles in a newly modern world is by implication an anomaly. Scholars writing from the classicist standpoint see non-classical buildings almost as hangers-on, still medieval in an otherwise rational world.[9] A church such as Saint-Pierre at Caen is difficult to place: flying buttresses are associated with Gothic, yet here they are covered in Renaissance ornament. Like the Fugger chapel in Augsburg, Saint-Pierre seems to straddle two worlds. Retrospective knowledge of 'the future that arrives' emphasizes emerging styles at the expense of those that were to be superseded.[10] Yet no one at the time anticipated what was coming.

A liberal art

What, then, caused this style of architecture eventually to be phased out when it showed no signs of exhaustion and had suited everyone's needs for so long? One answer is evidently humanist powers of persuasion: that classicism reflected mankind's return to rationality after a thousand years of barbarism. But Gothic had begun and remained essentially a style for churches. Neither the humanists nor the reformers, anticlerical though the latter may have been, were anti-Christian, but the humanist belief in reason accorded equal validity to the secular values that had already become manifest in grand houses and the rebuses and coats of arms that displayed the identity of the patron, whether lay or ecclesiastical, on both churches and secular buildings. Even Jesus Christ had been brought into the world of the self, with the *arma Christi*, heraldic devices of the lance and nails associated with the Crucifixion. Civic architecture gained special significance: in Alberti's discussion of building types the church, although for him the highest form of building, took its place among the villas and public buildings. Builders were increasingly occupied with fortifications and secular works: where smaller houses were following their own stylistic route, larger ones had been 'Gothic' superficially at best, and now patrons were demanding a classicizing rather than Gothic surface. From the 1530s this was all exacerbated by the Reformation, since in areas that became Protestant whole categories of churches were no longer built: no monasteries, friaries, chantry and collegiate churches, nor cathedrals. Liturgical furnishings were banned, except for the plainest altars and pulpits for preaching. Yet large areas of Europe remained Roman Catholic, and such explanations are not sufficient in themselves to account for what happened.

The debates at Milan in the late fourteenth century were more than locally significant, for their inquiry into the geometrical basis of building anticipated what would happen in the following centuries. The urge to change the appearance of architecture brought its designers under scrutiny, and master masons became the main victims of the results of humanist scholarship. Humanist mathematical studies were to destroy the mystique of constructive geometry and with it the master mason's claim to be the sole arbiter of building design.[11] Mathematicians had rediscovered arithmetical calculations that could bypass the approximations used in constructive geometry and base ratios in whole rather than irrational numbers. The proportions in use remained essentially the same, but Alberti saw proportion as an end in itself, an essential aspect of beauty and *decorum*, and devised fixed rules to relate the proportions of parts of a building to the whole. Rules of proportion inherent to a building's beauty were a world away from

Not all medieval buildings were intended to be permanent. Timber-framed structures—hunting lodges and pavilions—were dismantled and rebuilt on new sites as needed. As large households moved from one estate to another, carpenters and tent-makers were kept busy erecting temporary lodgings. They were also required to produce buildings made of canvas and timber for festive occasions. Such were the representations of Heaven and the castles built over the processional route of Queen Isabella's Entry into Paris (see p. 166), and the stage scenery for the play of the Trojan War that was presented at the dinner. For this were needed a wooden castle, a ship, and a movable pavilion. The illustration shows an earlier celebration, in 1378, when Charles V of France entertained his uncle, Emperor Charles IV, in the Grand' Salle of the Palace to dinner and a play presenting the heroic Crusader story of Godefroy de Bouillon's conquest of Jerusalem. The city, representing both the actual and the Heavenly Jerusalem, is a wooden castle with battlements and a corner turret, erected at one side of the dais.

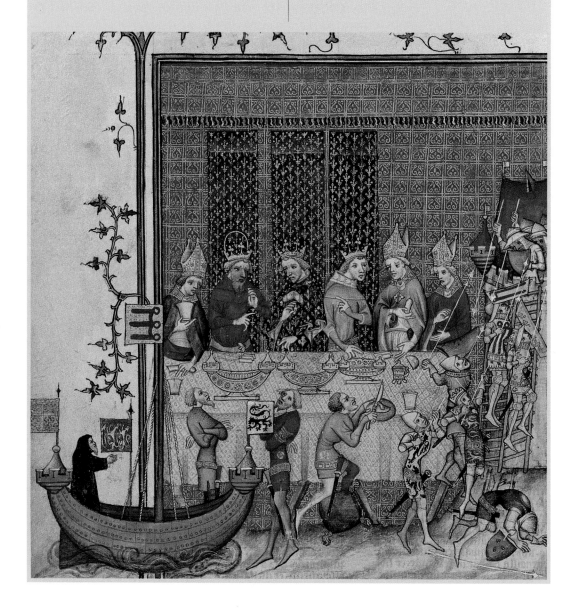

proportions that ensured structural stability. Alberti indeed placed beauty ahead of stability. Questions of aesthetics were barely raised in discussions of medieval construction. Comments on 'the right measure' that occur, for example, at Siena over the proposed new fourteenth-century cathedral, do seem to have concerned what was deemed appropriate, but the proportional systems of constructive geometry were not followed primarily for aesthetic reasons. There was an unbridgeable gulf between the scholarly tradition and the practicalities of the building site.[12] Roriczer's design booklets, written for a humanist patron in Germany and probably in response to Alberti's treatise, address method, not proportional rules, and while he may have been demonstrating that the method had as much classical legitimacy as Alberti's, he did not take up the aesthetic issues that are so important in Alberti's theory. Nor, many decades later, did Rodrigo Gil de Hontañón, master mason at Salamanca Cathedral in the 1540s, seem to grasp this point. In his surviving notes towards a treatise on architecture, his sections on proportion use traditional geometry for setting out vaults, and new arithmetical formulae for building a semicircular arch in the classical manner,[13] but, like Roriczer, he is concerned only with method. Alberti, however, brought proportion to the notice of an educated public outside the building trade but in a position to influence it. Such architectural writers addressed their work primarily to patrons and introduced them to the idea that the person who designed the building need not know how to build it. Thus, with scholars supplying designs that others were expected to execute, the position of the master mason was steadily downgraded.

In practice, the links between constructive geometry and design and between design and building did not break before the sixteenth century, although by 1500 a contract for Martin de Chambiges, master mason of Beauvais Cathedral, distinguished between Martin, the *architecte* who had produced a design, and the *massons* who were to build it.[14] In the 1570s Philip II of Spain employed as his official architect Juan de Herrera, who had no practical training in either building or design, but yet succeeded in imposing on Spain a style of architecture that wholly rejected non-classical details. What had once been the work of the intellect and the hand was now work only of the intellect: educated men could claim architecture unequivocally for the liberal arts. Practitioners of the mechanical art of building, which was all that master masons were now required to do, had inferior status. It is no accident that from now on we can begin to construct architects' careers. Although many buildings of these years are still 'anonymous', the architect was becoming an acknowledged and recorded part of the design process. In France architects connected with the court even produced instruction books for masons: Sebastiano Serlio, who worked for various courtly patrons in the 1540s, turned his architectural

knowledge into a treatise that was both illustrated and printed. His book was highly influential, not only on patrons but on craftsmen, who could use the illustrations as models. A successor to Serlio, Philibert de L'Orme, also produced illustrated books with the purpose of instructing masons. With architectural treatises directed not at patrons but at themselves, the masters' humiliation was complete. Although the mason-designer continued to build for lesser patrons well into the seventeenth century, and both workshop structures and building techniques went on as before, such attitudes prevailed in court circles and this court-led culture, with its power of patronage, opened up a gap that has never been closed, between the architect who cannot build and the builder who is not accepted as a designer. By 1600 the men who were actually designing prestige buildings did not see Gothic as a living style.[15]

The classical revival destroyed more than time-honoured traditions of design. Its success ended a phenomenon that Europe would not see again until the development of new materials and techniques in the nineteenth century and more especially in the late twentieth: a truly original, inventive style of architecture. A revival merely reworks existing forms. Medieval vaulting, rooted though it was in the Roman past, was structurally revolutionary, and for four hundred years masons were able to create ever more imaginative variations on it. It was only from the nineteenth century, with the use of iron and later steel and glass, that architects designed structures as ingenious and imaginative as those of the Middle Ages.

Notes

Part I

Introduction

1. D. Gillerman, *Enguerran de Marigny and the Church of Notre-Dame at Ecouis* (University Park, PA, 1994).

Chapter 1. 'What we now vulgarly call the Gothic'

1. As in, for example, G. Duby, *The Age of Cathedrals. Art and Society, 980–1420* (Chicago, 1981).
2. D. Gillerman, 'S. Fortunato in Todi: Why the Hall Church?', *Journal of the Society of Architectural Historians*, 48 (1989), 158–71; M. Trachtenberg, 'Gothic/Italian Gothic: Toward a Redefinition', *Journal of the Society of Architectural Historians*, 50 (1991), 22–37; E. B. Smith, 'Ars Mechanica: Gothic Structure in Italy', in L. T. Courtenay (ed.), *The Engineering of Medieval Cathedrals* (Aldershot, 1997), 219–33.
3. C. Wren yr, *Parentalia* (London, 1750; repr., Farnborough, 1965), 306.
4. P. Frankl, *The Gothic. Literary Sources and Interpretations through Eight Centuries* (Princeton, 1960).
5. L. Grodecki, *Gothic Architecture* (Eng. trans., London, 1979), 56; P. Frankl, 'The Crazy Vaults of Lincoln Cathedral', *Art Bulletin*, 44 (1953), 95–107; N. Pevsner and P. Metcalf, *The Cathedrals of England: Midland, Eastern and Northern England* (Harmondsworth, 1985), 20.
6. A. Klukas, 'Durham Cathedral in the Gothic Era: Liturgy, Design, Ornament', in V. Raguin, K. Brush, and P. Draper (eds), *Artistic Integration in Gothic Buildings* (Toronto, Buffalo, London, 1995), 69–83.
7. P. Draper, 'Interpreting the Architecture of Wells Cathedral', in Raguin, Brush, and Draper, *Artistic Integration*, 114–30.
8. G. Clarke and P. Crossley (eds), *Architecture and Language. Constructing Identity in European Architecture*

c.1000–c.1650 (Cambridge, 2000).
9. *Abbot Suger on the Abbey Church of St.-Denis and its Art Treasures*, ed. E. Panofsky (2nd edn, G. Panofsky-Soergel, Princeton, 1979); P. Kidson, 'Panofsky, Suger and St Denis', *Journal of the Warburg and Courtauld Institutes*, 50 (1987), 1–17; L. Grant, *Abbot Suger of St-Denis. Church and State in Twelfth-century France* (London, 1998), 33–6, 238–74.
10. J. Michler, 'La Cathédrale Notre Dame de Chartres: reconstitution de la polychromie originale de l'intérieur', *Bulletin Monumental*, 147 (1989), 117–31; N. Nussbaum, *German Gothic Church Architecture* (New Haven and London, 2000), 82.
11. T. Frisch, *Gothic Art 1140–c.1450. Sources and Documents* (repr., Toronto, 1997), 56.
12. D. Kimpel, 'La Sociogenèse de l'architecture moderne', in X. Barral y Altet (ed.), *Artistes, artisans et production artistique au Moyen Age*, i, *Les Hommes*, Colloque International CNRS, Rennes, 1983 (Paris, 1986), 135–49.
13. H. Colvin (ed.), *The History of the King's Works*, i and ii, *The Middle Ages* (London, 1963), i, 288.

Chapter 2. Structure and Design

1. A. Seeliger-Zeiss, *Lorenz Lechler von Heidelberg und Sein Umkreis* (Heidelberg, 1967).
2. E. E. Viollet-le-Duc, *Dictionnaire raisonné de l'architecture française du XIe au XVIe siècle* (Paris, 1844–68), i, 203; R. Mainstone, 'Structural Analysis, Structural Insights and Historical Interpretation', *Journal of the Society of Architectural Historians*, 56 (1997), 316–40.
3. L. T. Courtenay, 'Scale and Scantling: Technological Issues in Large-Scale Timberwork of the High Middle Ages', in E. B. Smith and M. Wolfe (eds), *Technology and Resource Use in Medieval Europe: Cathedrals, Mills and Mines* (Aldershot, 1997), 62.
4. L. T. Courtenay and R. Mark, 'The

Westminster Hall Roof: A Historiographic and Structural Study', *Journal of the Society of Architectural Historians*, 46 (1987), 374–93; G. Waddell, 'The Design of the Westminster Hall Roof', *Architectural History*, 42 (1999), 47–67.

5. J. Ackerman, '"Ars sine scientia nihil est". Gothic Theory of Architecture at the Cathedral of Milan', *Art Bulletin*, 31 (1949), 100.

6. P. Abraham, *Viollet-le-Duc et le rationalisme médiéval* (Paris, 1934).

7. *Abbot Suger on the Abbey Church of St.-Denis and its Art Treasures*, ed. E. Panofsky (2nd edn, G. Panofsky-Soergel, Princeton, 1979), 109.

8. J. Heyman, *Arches, Vaults and Buttresses. Masonry Structures and their Engineering* (Aldershot, 1996), 104–6; R. Mark, 'Model Analysis of Gothic Structure', *Journal of the Society of Architectural Historians*, 27 (1968), 48; E. T. Morris, R. G. Black, and S. O. Tobriner, 'Report on the Application of Finite Element Analysis to Historic Structures. Westminster Hall, London', *Journal of the Society of Architectural Historians*, 54 (1995), 336–41; Mainstone, 'Structural Analysis'.

9. J. James, 'Evidence for Flying Buttresses before 1180', *Journal of the Society of Architectural Historians*, 51 (1992), 261–87; S. Murray, 'Notre-Dame of Paris and the Anticipation of Gothic', *Art Bulletin*, 80 (1998), 229–53.

10. W. Leedy, *Fan Vaulting. A Study of Form, Technology and Meaning* (London, 1980), 6.

11. L. R. Shelby, *Gothic Design Techniques. The Fifteenth-Century Design Booklets of Mathes Roriczer and Hanns Schmuttermayer* (London and Amsterdam, 1986), 47 (Shelby's translation).

12. P. Crossley, 'The Man from Inner Space: Architecture and Meditation in the Choir of St Laurence in Nuremberg', in G. Owen-Crocker and T. Graham (eds), *Medieval Art: Recent Perspectives. A Memorial Tribute to C. R. Dodwell* (Manchester, 1998), 166–7; P. Kidson, 'Panofsky, Suger and St Denis', *Journal of the Warburg and Courtauld Institutes*, 50 (1987), 1–17.

13. E. Whitney, 'Paradise Restored. The Mechanical Arts from Antiquity through the Thirteenth Century', *Transactions of the American Philosophical Society*, 80 (1990), 120.

14. P. Kidson, 'Architectural proportion', in J. Turner (ed.), *Grove Dictionary of Art* (London, 1996), 2, 346; L. R. Shelby, 'The Geometrical Knowledge of Medieval Master Masons', *Speculum*, 47 (1972), 395–421; L. R. Shelby and R. Mark, 'Late Gothic

Structural Design in the "Instructions" of Lorenz Lechler', *Architectura*, 9 (1979), 113–31. For specific applications see F. Toker, 'Gothic Architecture by Remote Control: An Illustrated Contract of 1340', *Art Bulletin*, 46 (1985), 67–95.

15. V. Mortet and P. Deschamps, *Receuil des textes relatifs à l'histoire de l'architecture et à la condition des architectes en France au moyen âge*, 2 vols (Paris, 1911–28), ii, 277 and n. 8.

16. L. Neagley, *Disciplined Exuberance. The Parish Church of Saint-Maclou and Late Gothic Architecture in Rouen* (University Park, PA, 1998), 10.

17. M. T. Davis, 'Splendor and Peril: The Cathedral of Paris, 1290–1350', *Art Bulletin*, 75 (1998), 35.

18. S. Harrison and P. Barker, 'Byland Abbey, North Yorkshire: The West Front and Rose Window Reconstructed', *Journal of the British Archaeological Association*, 140 (1987), 142 and fig. 4; W. Schöller, 'Ritzzeichnungen. Ein Beitrag zur Geschichte der Architekturzeichnung im Mittelalter', *Architectura*, 19 (1989), 36–61, includes a catalogue of incised drawings.

19. C. F. Barnes, *Villard de Honnecourt, The Artist and His Drawings, A Critical Biography* (Boston, 1982); T. Bowie, *The Sketchbook of Villard de Honnecourt* (Bloomington, 1958); C. F. Barnes, Jr, 'Le Problème Villard de Honnecourt', in *Les Bâtisseurs des cathédrales gothiques* (exhibition catalogue, ed. R. Recht, Strasbourg, 1989), 209–23.

Chapter 3. Patron and Builder

1. M. Haines, 'Brunelleschi and Bureaucracy: The Tradition of Public Patronage at the Florentine Cathedral', *I Tatti Studies: Essays in the Renaissance*, 3 (1989), 89–125.

2. P. Kidson, 'Panofsky, Suger and St Denis', *Journal of the Warburg and Courtauld Institutes*, 50 (1987), 1–17; L. Grant, 'Naming of Parts: Describing Architecture in the High Middle Ages', in G. Clarke and P. Crossley (eds), *Architecture and Language. Constructing Identity in European Architecture c.1000–c.1650* (Cambridge, 2000), 46–57.

3. F.-A. Constantini, 'Les artistes de la Chaise-Dieu (1344–1352) d'après l'étude de la comptabilité pontificale', *Revue de l'art*, 110 (1995), 44–55.

4. H. Labande, *Le Palais des Papes et les Monuments d'Avignon au XIVe siècle*, 2 vols (Marseille, 1925); D. Vingtain, *Avignon, le Palais des Papes* (La-Pierre-qui-Vire, 1998); J. Gardner, *The Tomb and the Tiara. Curial Tomb Sculpture in Rome and Avignon in the*

Later Middle Ages (Oxford, 1992), 143–4; A. Erlande-Brandenburg, 'L'Abbatiale de la Chaise-Dieu', *Congrès Archéologique de France*, Velay (1975), 720–55.

5. C. Bruzelius, 'Il Gran Rifiuto. French Gothic in Central and Southern Italy in the Last Quarter of the Thirteenth Century', in G. Clarke and P. Crossley (eds), *Architecture and Language. Constructing Identity in European Architecture c.1000–c.1650* (Cambridge, 2000), 36–45.

6. C. Bruzelius, *The 13th-Century Church at St-Denis* (New Haven and London, 1985).

7. P. Crossley, *Gothic Architecture in the Reign of King Kasimir the Great* (Kraków, 1985), 220–30.

8. T. Howard, *The Architectural History of Venice* (London, 1980), 69–74.

9. R. Sundt, '*Mediocres domos et humiles habeant fratres nostri*: Dominican Legislation on Architecture and Architectural Decoration in the 13th Century', *Journal of the Society of Architectural Historians*, 46 (1987), 394–407; C. Norton and D. Park (eds), *Cistercian Art and Architecture in the British Isles* (Cambridge 1986), 317–93.

10. T. Cocke and P. Kidson, *Salisbury Cathedral. Perspectives on the Architectural History* (London, 1993), 50–2; P. Draper, 'Salisbury Cathedral: Paradigm or Maverick?' in L. Keen and T. Cocke (eds), *Medieval Art and Architecture at Salisbury Cathedral*, British Archaeological Association Conference Transactions, 17 (1996), 21–31.

11. J. S. Alexander, 'Masons' Marks and Stone Bonding', in T. Tatton-Brown and J. Munby (eds), *The Archaeology of Cathedrals*, Oxford Committee for Archaeology, Monograph 42 (Oxford, 1996), 219–36.

12. W. Cahn, 'Architectural Draftsmanship in Twelfth-Century Paris: The Illustrations of Richard of St Victor's Commentary on Ezekiel's Temple Vision', *Gesta*, 15 (1976), 247–54.

13. D. Kimpel, 'Le développement de la taille en série dans l'architecture médiévale et son rôle dans l'histoire économique', *Bulletin Monumental*, 135 (1977), 192–222.

14. T. Frisch, *Gothic Art 1140–c.1450. Sources and Documents* (repr. Toronto, 1997), 55.

15. J. Ackerman, '"Ars sine scientia nihil est". Gothic Theory of Architecture at the Cathedral of Milan', *Art Bulletin*, 31 (1949), 100.

16. D. Kimpel, 'La Sociogenèse de l'architecture moderne', in X. Barral y Altet (ed.), *Artistes, artisans et production artistique au Moyen Age*, i, *Les Hommes*, Colloque International CNRS, Rennes, 1983 (Paris, 1986), 135–49.

17. C. Brooks, *The Gothic Revival* (London, 1999), 264–5.

18. A. Erskine, *The Accounts of the Fabric of Exeter Cathedral, 1279–1353*, Devon and Cornwall Record Society, New Series, 24 (1981), 26 (1983); N. Coldstream, 'The Great Rebuilding *circa* 1270–1390', in M. Swanton (ed.), *Exeter Cathedral. A Celebration* (Exeter, 1991), 47–59.

19. J. Allan and B. Jupp, 'Recent Observations in the South Tower of Exeter Cathedral', *Proceedings of the Devon Archaeological Society*, 39 (1981), 141–54.

20. R. Goy, *The House of Gold. Building a Palace in Medieval Venice* (Cambridge, 1992); P. Hills, *Venetian Colour* (New Haven and London, 1999), 68–74.

21. Goy, *House of Gold*, 156.

22. F. van Tyghem, *Het Stadhuis van Ghent: Voorgeschiedenis, bouwgeschiedenis, restauraties, beschrijving, stijlanalyse*, 2 vols (Brussels, 1978); K. J. Phillip, 'L'Hotel de ville de Gand. Le gotique commercial du Brabant', in F. Aceto and others, *Chantiers Médiévaux* (Paris, 1996), 327–53.

Part II

Introduction

1. B. Brenk, 'The Sainte-Chapelle as a Capetian Political Program', in V. Raguin, K. Brush, and P. Draper (eds), *Artistic Integration in Gothic Buildings* (Toronto, Buffalo, London, 1995), 195–213.

2. P. Crossley, *Gothic Architecture in the Reign of King Kasimir the Great* (Kraków, 1985), 217–18.

3. M. W. Thompson, *The Rise of the Castle* (Cambridge, 1991), 23.

Chapter 4. Architectural Space

1. M. C. Miller, 'From Episcopal to Communal Palaces: Palaces and Power in Northern Italy 1000–1250', *Journal of the Society of Architectural Historians*, 54 (1995), 175–85.

2. S. Murray, *Notre-Dame, Cathedral of Amiens. The Power of Change in Gothic* (Cambridge, 1996), 50–1; R. Branner, *The Cathedral of Bourges and its Place in Gothic Architecture* (rev. edn, S. Prager-Branner, New York, 1989), 15–18.

3. C. Barron, 'The Parish Fraternities of Medieval London', in C. Barron and C. Harper-Bill (eds), *The Church in Pre-Reformation Society: Essays in Honour of F. R. H. Du Boulay* (Woodbridge, 1985), 25; B. Abou el-Haj, 'The Urban Setting for Late Medieval Church Building: Reims and its

Cathedral between 1210 and 1240', *Art History*, 11 (1988), 17–41.

4. *The Art of Invention. Leonardo and Renaissance Engineers* (exhibition catalogue, ed. P. Galluzzo, Eng. trans., Florence, 1999), 120–1.

5. R. Brentano, *Rome before Avignon* (Berkeley and Los Angeles, 1974; reissued 1990), 16–17.

6. N. Coldstream, *Nicosia—Gothic City to Venetian Fortress*, Annual Lectures of the Leventis Municipal Museum of Nicosia, 3 (Nicosia, 1993), 9.

7. A. Randolph, 'The Bastides of South-west France', *Art Bulletin*, 76 (1995), 290–307.

8. D. Friedman, *Florentine New Towns. Urban Design in the Late Middle Ages* (Cambridge, MA, and London, 1988).

9. M. Trachtenberg, 'What Brunelleschi Saw: Monument and Site at the Palazzo Vecchio in Florence', *Journal of the Society of Architectural Historians*, 47 (1988), 14–44.

10. D. Pringle, 'A Group of Medieval Towers in Tuscania', *Papers of the British School at Rome*, 42 (1974), 179–223.

11. A. Kettle, 'City and Close: Lichfield in the Century before the Reformation', in Barron and Harper-Bill, *The Church in Pre-Reformation Society*, 158–69.

12. G. Coppack, 'The Outer Courts of Fountains and Rievaulx Abbeys: The Interface between Estate and Monastery', in L. Pressouyre (ed.), *L'Espace cistercien* (Paris, 1994), 415–25; P. Fergusson and S. Harrison, *Rievaulx Abbey. Community, Architecture, History* (New Haven and London, 1999); R. Gilchrist, 'Community and self: perceptions and use of space in medieval monasteries', *Scottish Archaeological Review*, 6 (1989), 55–64; G. Fairclough, 'Meaningful constructions—spatial and functional analysis of medieval buildings', *Antiquity*, 66 (1992), 348–66; S. Bonde, E. Boyden, and C. Maines, 'Centrality and Community: Liturgy and Gothic Chapter Room Design at the Augustinian Abbey of St-Jean-des-Vignes, Soissons', *Gesta*, 29 (1990), 189–213.

13. M. T. Davis, 'Desespoir, Esperance and Douce France: The New Palace, Paris and the Royal State', *Fauvel Studies* (1997), 187–213.

14. For Glimmingehus, see R. Olsen, 'Danish Manor Houses of the Late Middle Ages', in T. Hoekstra, H. Janssen, and I. Moerman (eds), *Liber Castellorum* (Zutphen, 1981), 154–63.

15. B. Tuchman, *The Ties that Bound. Peasant Families in Medieval England* (Oxford, 1986), Chapter 6.

16. J. E. Jung, 'Beyond the Barrier: The Unifying Role of the Choir Screen in Gothic Churches', *Art Bulletin*, 82 (2000), 622–57.

17. Friedman, *Florentine New Towns*, 188.

18. M. Whiteley, 'Deux escaliers royaux du XIVe siècle: les "Grands Degrez" du Palais de la Cité et la "Grande Viz" du Louvre', *Bulletin Monumental*, 147 (1989), 133–42; M. Whiteley, '"La Grande Viz". Its development in France from the mid fourteenth to the mid fifteenth centuries', in *L'Escalier dans l'architecture de la Renaissance*, Actes du Colloque, Tours 1979 (Paris, 1985), 15–20.

19. B. Brenk, 'The Sainte-Chapelle as a Capetian Political Program', in V. Raguin, K. Brush, and P. Draper (eds), *Artistic Integration in Gothic Buildings* (Toronto, Buffalo, London, 1995), 195–213.

20. R. Kroos, 'Liturgische Quellen zum Kölner Dom', *Kölner Domblatt*, new series, 44/5 (1979/80), 35–202.

21. R. Pfaff, *New Liturgical Feasts in Later Medieval England* (Oxford, 1970).

22. M. Rubin, *Corpus Christi. The Eucharist in Late Medieval Culture* (Cambridge, 1991), 243–70.

23. A. Klukas, 'The Liber Ruber and the Rebuilding of the East End at Wells', in N. Coldstream and P. Draper (eds), *Medieval Art and Architecture at Wells and Glastonbury*, British Archaeological Association Conference Transactions, 4 (1981), 30–5; P. Blum, 'Liturgical Influences on the Design of the West Front at Wells and Salisbury', *Gesta*, 27 (1986), 145–50; P. Tudor-Craig, 'Bishop Grandisson's Provision for Music and Ceremony', in M. Swanton (ed.), *Exeter Cathedral. A Celebration* (Exeter, 1991), 137–43.

Chapter 5. Symbolic Architecture: Representation and Association

1. William Durandus, *The Symbolism of Churches and Church Ornaments*, ed. J. M. Neale and B. Webb (Leeds, 1843).

2. H. Sedlmayr, *Die Entstehung der Kathedrale* (Zurich, 1950); O. Von Simson, *The Gothic Cathedral* (New York, 1956).

3. W. Dynes, 'The Medieval Cloister as Portico of Solomon', *Gesta*, 12 (1973), 61–9.

4. Durandus, *Symbolism of Churches*, 29–30.

5. V. Raguin, K. Brush, and P. Draper (eds), *Artistic Integration in Gothic Buildings* (Toronto, Buffalo, London, 1995), passim.

6. H. Meek, *The Synagogue* (London, 1995), 88.

7. Durandus, *Symbolism of Churches*, 10–11; L. H. Stookey, 'The Gothic Cathedral as the Heavenly Jerusalem, Liturgical and Theological Sources', *Gesta* 8 (1969), 35–41; R. Suckale, 'La Théorie de l'architecture au

temps des cathédrales', in *Les Bâtisseurs des cathédrales gothiques* (exhibition catalogue, ed. R. Recht, Strasbourg, 1989), 41–50.

8. P. Crossley, 'The Man from Inner Space: Architecture and Meditation in the Choir of St Laurence in Nuremberg', in G. Owen-Crocker and T. Graham (eds), *Medieval Art: Recent Perspectives. A Memorial Tribute to C. R. Dodwell* (Manchester, 1998), 166–72.

9. R. Branner, *St Louis and the Court Style in Gothic Architecture* (London, 1965), 56.

10. P. Tudor-Craig, 'Richard III's Triumphant Entry into York, August 29th, 1483', in R. Horrox (ed.), *Richard III and the North*, Studies in Regional and Local History, 6 (Hull, 1986), 108–16.

11. M. Biddle, *The Tomb of Christ* (Stroud, 1999).

12. L. Devliegher, *Les Maisons à Bruges* (Lannoo, Tielt, Amsterdam, 1975), 281–2.

13. F. Woodman, *The Architectural History of Canterbury Cathedral* (London, 1981), 124–5; P. Kidson, 'St Hugh's Choir', in T. A. Heslop and V. Sekules (eds), *Medieval Art and Architecture at Lincoln Cathedral*, British Archaeological Association Conference Transactions, 8 (1986), 29–42.

14. M. T. Davis, 'Splendor and Peril: The Cathedral of Paris, 1290–1350', *Art Bulletin*, 80 (1998), 52.

15. J. Froissart, *The Chronicles of England, France and Spain*, ed. H. P. Dunster (London, 1906), 460–2.

16. J. Mesqui, *Les Demeures seigneuriales*, vol. 2 of *Ile de France gothique*, ed. A. Prache (Paris, 1988), 12–14.

17. A. J. Taylor, *The Welsh Castles of Edward I* (London, 1986); C. Platt, *The Castle in Medieval England and Wales* (London, 1982), Chapter 7; M. W. Thompson, *The Rise of the Castle* (Cambridge, 1991); R. Morris, 'The Architecture of Arthurian Enthusiasm: Castle Symbolism in the Reigns of Edward I and His Successors', in M. Strickland (ed.), *Arms, Chivalry and Warfare in Medieval Britain*, Harlaxton Medieval Studies, 7 (Stamford, 1998), 63–81.

18. T. A. Heslop, 'Orford Castle: Nostalgia and Sophisticated Living', *Architectural History*, 34 (1991), 36–58.

19. J. Gardner, 'An Introduction to the Iconography of the Medieval Italian City Gate', *Dumbarton Oaks Papers*, 41 (1987), 199–213.

20. M. C. Miller, 'From Episcopal to Communal Palaces: Palaces and Power in Northern Italy 1000–1250', *Journal of the Society of Architectural Historians*, 54 (1995), 175–85.

Chapter 6. Innovation and Commemoration

1. M. T. Davis, 'Splendor and Peril: The Cathedral of Paris, 1290–1350', *Art Bulletin*, 80 (1998), 58.

2. P. Fergusson and S. Harrison, *Rievaulx Abbey. Community, Architecture, History* (New Haven and London, 1999), 167–9.

3. M. Clanchy, *From Memory to Written Record* (London, 1979).

4. D. Abulafia, *Frederick II* (London, 1988), 280–9; see also J. Caskey, 'Steam and *Sanitas* in the Domestic Realm: Baths and Bathing in Southern Italy in the Middle Ages', *Journal of the Society of Architectural Historians*, 58 (1999), 170–95.

5. J. Bossy, 'The Mass as a Social Institution', *Past and Present*, 100 (1983), 29–61.

6. R. Mackenney, *Tradesmen and Traders: The World of the Guilds in Venice and Europe c.1250–1650* (Beckenham, 1987), 47.

7. E. M. Kavaler, 'Renaissance Gothic in the Netherlands: The Uses of Ornament', *Art Bulletin*, 82 (2000), 226–51.

8. W. H. Knowles, 'The Priory Church of St. Mary and St. Oswin, Tynemouth, Northumberland', *Archaeological Journal*, 67 (1910), 4.

9. J. Cannon and A. Vauchez, *Margherita of Cortona and the Lorenzetti. Sienese Art and the Cult of a Holy Woman in Medieval Tuscany* (University Park, PA, 1999).

10. Gervase of Canterbury on 'The Burning and Repair of the Church of Canterbury', in R. Willis, *The Architectural History of Canterbury Cathedral* (London, 1845, repr. in R. Willis, *The Architectural History of Some Cathedrals*, Chicheley, 1972, vol. i), 32–62; P. Draper, 'Interpretations of the Rebuilding of Canterbury Cathedral, 1174–1186', *Journal of the Society of Architectural Historians*, 56 (1997), 184–203.

11. P. Kidson, 'Gervase, Becket, and William of Sens', *Speculum*, 68 (1993), 969–91.

12. P. Crossley, 'The Architecture of Queenship: Royal Saints, Female Dynasties and the Spread of Gothic Architecture in Central Europe', in A. Duggan (ed.), *Queens and Queenship in Medieval Europe* (Woodbridge, 1997), 263–300.

13. M. Biddle, *The Tomb of Christ* (Stroud, 1999).

14. P. Kurmann and R. Kurmann-Schwartz, 'Chartres Cathedral as a Work of Artistic Integration', in V. Raguin, K. Brush, and P. Draper (eds), *Artistic Integration in Gothic Buildings* (Toronto, Buffalo, London, 1995), 131–52; J. Henriet, 'Le Chœur de Saint-

Mathurin de Larchant et Notre-Dame de Paris', *Bulletin Monumental*, 134 (1976), 289–307.

15. R. Merlet, 'Le Puits des Saints-Forts et l'ancienne chapelle de Notre-Dame-sous-Terre', *Congrès Archéologique de France*, 67 (1901), 226–55; F. Cabrol and H. Leclercq, *Dictionnaire d'Archéologie Chrétienne*, iii (Paris, 1913), cols 1029–33.

16. E. Fernie, 'Suger's "completion" of Saint-Denis', in Raguin, Brush, and Draper, *Artistic Integration*, 84–91; W. Clark, '"The Recollection of the Past Is the Promise of the Future." Continuity and Contextuality: Saint-Denis, Merovingians, Capetians, and Paris', in Raguin, Brush, and Draper, *Artistic Integration*, 92–113; L. Grant, *Abbot Suger of St-Denis. Church and State in Twelfth-century France* (London, 1998), 238–48; C. Bruzelius, *The 13th-Century Church at St-Denis* (New Haven and London, 1985).

17. P. Crossley, *Gothic Architecture in the Reign of King Kasimir the Great* (Kraków, 1985), 211.

18. A. Timmermann, 'Architectural Vision in Albrecht von Scharfenberg's *Jüngere Titurel*—A Vision of Architecture', in G. Clarke and P. Crossley (eds), *Architecture and Language. Constructing Identity in European Architecture c.1000–c.1650* (Cambridge, 2000), 69–70.

Chapter 7. The Future that Arrives

1. C. Bruzelius, '*Ad modum franciae*: Charles of Anjou and Gothic Architecture in the Kingdom of Naples', *Journal of the Society of Architectural Historians*, 50 (1991), 402–20.

2. W. H. Plommer, 'The Cenacle on Mount Sion', in J. Folda (ed.), *Crusader Art in the Twelfth Century*, British Archaeological Reports (Oxford, 1982), 139–66.

3. D. Howard, *Venice and the East* (New Haven and London, 2000).

4. M. Biddle, 'Nicholas Bellin of Modena',

Journal of the British Archaeological Association, 3rd series, 29 (1966), 106–21.

5. Filarete, *Il trattato d'architettura*, ed. and trans. E. G. Holt, *A Documentary History of Art*, I (Garden City, NY, 1957), 248.

6. *Memoirs of a Renaissance Pope: The Commentaries of Pius II (An Abridgement)*, ed. L. C. Gabel (New York, 1959), 287.

7. G. Lorenzoni, 'L'architettura', in L. Bellosi and others (eds), *La basilica di S. Petronio in Bologna* (Bologna, 1983), i, 53–124.

8. K. Gerstenberg, *Deutsche Sondergotik* (Munich, 1913); P. Frankl, *Gothic Architecture* (Harmondsworth, 1962; rev. edn, P. Crossley, New Haven and London, 2001); J. Białostocki, 'Late Gothic: Disagreements about the Concept', *Journal of the British Archaeological Association*, 3rd series, 29 (1966), 76–105.

9. A. Blunt, *Art and Architecture in France, 1500–1700* (2nd edn, Harmondsworth, 1970); H. R. Hitchcock, *German Renaissance Architecture* (Princeton, 1981).

10. A.-M. Sankovitch, 'Structure/Ornament and the Modern Figuration of Architecture', *Art Bulletin*, 80 (1998), 687–717; the phrase is taken from p. 698.

11. P. Kidson, 'Architectural proportion', in J. Turner (ed.), *Grove Dictionary of Art* (London, 1996), 2, 346.

12. R. Suckale, 'La Théorie de l'architecture au temps des cathédrales', in *Les Bâtisseurs des cathédrales gothiques* (exhibition catalogue, ed. R. Recht, Strasbourg, 1989), 41–50.

13. S. Sanabria, 'The Mechanization of Design in the 16th Century: The Structural Formulae of Rodrigo Gil de Hontañón', *Journal of the Society of Architectural Historians*, 41 (1982), 281–93.

14. S. Murray, *Beauvais Cathedral. Architecture of Transcendence* (Princeton, 1989), 128, n. 44.

15. N. Nussbaum, *German Gothic Church Architecture* (New Haven and London, 2000), 226.

Further Reading

General

D. Abulafia, *The Western Mediterranean Kingdoms 1200–1500* (London and New York, 1997).

M. Barber, *The Two Cities. Medieval Europe, 1050–1320* (London and New York, 1992).

R. Bartlett, *The Making of Europe: Conquest, Colonization and Cultural Change 950–1350* (London, 1993).

E. Christiansen, *The Northern Crusades. The Baltic and the Catholic Frontier 1100–1525* (2nd edn, London, 1997).

F. L. Cross (ed.), *The Oxford Dictionary of the Christian Church* (3rd edn, E. A. Livingstone, Oxford, 1997).

G. Holmes (ed.), *The Oxford Illustrated History of Medieval Europe* (Oxford, 1988).

A. Mackay with D. Ditchburn, *Atlas of Medieval Europe* (London and New York, 1997).

N. Saul (ed.), *The Oxford Illustrated History of Medieval England* (rev. edn, Oxford, 2000).

R. N. Swanson, *Religion and Devotion in Europe c.1215–c.1500* (Cambridge, 1995).

Medieval art and architecture

Age of Chivalry: Art in Plantagenet England 1200–1400 (exhibition catalogue, ed. J. Alexander and P. Binski, London, 1987).

Die Parler und der schöne Stil 1350–1400. Europaïsche Kunst unter den Luxemburgern (exhibition catalogue, ed. A. Legner, 5 vols, Cologne, 1978).

P. Kidson, *The Medieval World* (London, 1967).

V. Sekules, *Medieval Art* (Oxford, 2001).

J. Turner (ed.), *Grove Dictionary of Art*, 34 vols (London, 1996).

Contemporary documents

T. Frisch, *Gothic Art, 1140–c.1450. Sources and Documents* (repr. Toronto, 1997).

E. G. Holt, *A Documentary History of Art*, i (Garden City, NY, 1957).

Chapter 1. 'What we now vulgarly call the Gothic'

General

J. Bony, *French Gothic Architecture of the Twelfth and Thirteenth Centuries* (Berkeley, 1983).

J. Bony, 'The Resistance to Chartres in Early Thirteenth-century Architecture', *Journal of the British Archaeological Association*, 3rd series, 20–1 (1957–8), 35–52.

R. Branner, *Gothic Architecture* (New York, 1961).

R. Calkins, *Medieval Architecture in Western Europe, AD300–AD1500* (New York and Oxford, 1998).

P. Frankl, *Gothic Architecture* (Harmondsworth, 1962, new edn, P. Crossley, New Haven and London, 2001).

L. Grodecki, *Gothic Architecture* (Eng. trans., London, 1979).

D. Kimpel and R. Suckale, *L'Architecture Gothique en France 1130–1270* (French transl., Paris, 1990).

C. Norton and D. Park (eds), *Cistercian Art and Architecture in the British Isles* (Cambridge, 1986).

N. Nussbaum, *German Gothic Church Architecture* (New Haven and London, 2000).

R. Pestell, 'The Design Sources for the Cathedrals of Chartres and Soissons', *Art History*, 4 (1981), 1–13.

C. Platt, *The Architecture of Medieval Britain* (New Haven and London, 1990).

A. Prache, *Cathedrals of Europe* (Ithaca, NY, 2000).

R. Sanfaçon, *L'Architecture Flamboyant en France* (Quebec, 1971).

R. Stalley, *Early Medieval Architecture* (Oxford, 1999).

W. Swaan, *The Late Middle Ages. Art and Architecture from 1350 to the Advent of the Renaissance* (London, 1977).

R. Toman (ed.), *The Art of Gothic* (Eng. trans., Cologne, 1998).

J. White, *Art and Architecture in Italy, 1250–1400* (rev. edn, Harmondsworth, 1987).

C. Wilson, *The Gothic Cathedral. The Architecture of the Great Church 1130–1530* (London, 1990).

Regional studies

T. S. R. Boase, *Castles and Churches of the Crusader Kingdoms* (London, 1967).

J. Bony, *The English Decorated Style. Gothic Architecture Transformed 1250–1350* (Oxford, 1979).

R. Branner, *Burgundian Gothic Architecture* (London, 1960).

R. Branner, *St Louis and the Court Style in Gothic Architecture* (London, 1965).

N. Coldstream, *The Decorated Style. Architecture and Ornament, 1240–1360* (London, 1994).

P. Crossley, *Gothic Architecture in the Reign of Kasimir the Great. Church Architecture in Lesser Poland, 1320–1380* (Kraków, 1985).

C. Enlart, *Gothic Art and the Renaissance in Cyprus* (Paris, 1899, ed. and trans. D. Hunt, London, 1987).

R. Fawcett, *Scottish Architecture from the Accession of the Stewarts to the Reformation* (Edinburgh, 1994).

J. Harvey, *The Cathedrals of Spain* (London, 1957).

J. Harvey, *The Perpendicular Style 1330–1485* (London, 1978).

L. Heydenreich, *Architecture in Italy, 1400–1500* (rev. edn P. Davies, Harmondsworth, 1996).

D. Howard, *The Architectural History of Venice* (London, 1980, repr. 1987).

P. Kidson, P. Murray, and P. Thompson, *A History of English Architecture* (rev. edn, Harmondsworth, 1979).

W. Leedy, *Fan Vaulting. A Study of Form, Technology and Meaning* (Berkeley, 1980).

V. Mencl, *Czech Architecture of the Luxemburg Period* (Prague, 1955).

N. Nussbaum, *German Gothic Church Architecture* (New Haven and London, 2000).

D. Pringle, *The Churches of the Crusader Kingdom of Jerusalem. A Corpus* (i, Cambridge, 1993; ii, Cambridge, 1998; iii, forthcoming).

R. C. Smith, *The Art of Portugal, 1500–1800* (London, 1968).

G. E. Street, *Some Account of Gothic Architecture in Spain*, ed. G. G. King, 2 vols (London, 1914)—still the best account of Spanish church architecture in English.

G. Webb, *Architecture in Britain: The Middle Ages* (2nd edn, Harmondsworth, 1965).

Castles

H. Kennedy, *Crusader Castles* (London, 1994).

L. Monreal y Tejada, *Medieval Castles of Spain* (Eng. trans., Cologne, 1999).

R. Muir, *Castles and Strongholds* (London, 1990).

Timber buildings

D. Buckton, *The Wooden Churches of Eastern Europe* (Cambridge, 1981).

C. Platt, *The English Medieval Town* (London, 1976).

'Timber Structure' and 'Vernacular Architecture', in J. Turner (ed.), *Grove Dictionary of Art* (London, 1996).

Historiography of the Gothic

G. Clarke and P. Crossley (eds), *Architecture and Language. Constructing Identity in European Architecture c.1000–c.1650* (Cambridge, 2000).

W. Dynes, 'Concept of Gothic', in P. Wiener (ed.), *Dictionary of the History of Ideas* (New York, 1973), vol 2, 366–74.

P. Frankl, *The Gothic. Literary Sources and Interpretation through Eight Centuries* (Princeton, 1960).

J. Givens, 'The Leaves of Southwell Revisited', in J. Alexander (ed.), *Southwell and Nottinghamshire. Medieval Art, Architecture and Industry*, British Archaeological Association Conference Transactions, 21 (1998), 60–5.

V. Raguin, K. Brush, and P. Draper (eds), *Artistic Integration in Gothic Buildings* (Toronto, Buffalo, London, 1995).

W. Sauerlaender, 'Style or Transition: The Fallacies of Classification Discussed in the Light of German Architecture 1190–1220', *Architectural History*, 30 (1987), 1–13.

Chapter 2. Structure and Design

N. Coldstream, *Masons and Sculptors* (London, 1991).

D. Friedman, *Florentine New Towns. Urban Design in the Late Middle Ages* (Cambridge, MA, and London, 1988).

J. Heyman, *The Stone Skeleton. Structural Engineering of Masonry Architecture* (Cambridge, 1995).

P. Kidson, *From Greek Temple to Gothic Cathedral: Religious Architecture in the Classical and Medieval Periods* (forthcoming).

P. Kidson, 'Architectural proportion', in J. Turner (ed.), *Grove Dictionary of Art* (London, 1996), 2, 346.

R. Mark (ed.), *Architectural Technology up to the Social Revolution* (Cambridge, MA, and London, 1993); see L. T. Courtenay, 'Timber Roofs and Spires', 182–231 and S. Bonde, C. Maines, and R. Richard, Jr, 'Soils and Foundations', 16–50.

L. R. Shelby, *Gothic Design Techniques. The Fifteenth-Century Design Booklets of Mathes Roriczer and Hanns Schmuttermayer* (London and Amsterdam, 1986).

E. B. Smith, 'Ars Mechanica: Gothic Structure in Italy', in L. T. Courtenay (ed.), *The Engineering of Medieval Cathedrals* (Aldershot, 1997), 219–33.

Chapter 3. Patron and Builder

J. Blair and N. Ramsay (eds), *English Medieval Industries* (London, 1991).

H. M. Colvin, *The History of the King's Works*, i and ii, *The Middle Ages* (London, 1963).

H. M. Colvin (ed.), *The Building Accounts of King Henry III* (Oxford, 1971).

S. Connell, *The Employment of Sculptors and Stonemasons in Venice in the Fifteenth Century* (New York, 1988)

J. H. Harvey, *English Medieval Architects* (rev. edn, Gloucester, 1984).

D. Knoop and G. P. Jones, *The Medieval Mason* (3rd edn, Manchester, 1967).

S. Kostoff (ed.), *The Architect. Chapters in the History of the Profession* (New York, 1977).

R. Mackenney, *Tradesmen and Traders: the World of the Guilds in Venice and Europe, c.1250–1650* (Beckenham, 1987).

S. Murray, *Building Troyes Cathedral* (Bloomington, 1987); selection of building accounts in Appendix B.

L. F. Salzman, *Building in England down to 1540* (Oxford, 1952, repr. 1975).

H. Swanson, *Medieval Artisans. An Urban Class in Medieval England* (Oxford, 1989).

Introduction to Part II

Medieval concepts of space and time
A. Crosby, *The Measure of Reality. Quantification and Western Society, 1250–1600* (Cambridge, 1997).

E. Edson, *Mapping Time and Space. How Medieval Mapmakers Viewed their World* (London, 1997).

Chapter 4. Architectural Space

C. Frugoni, *A Distant City. Images of Urban Experience in the Mediterranean World* (Princeton, 1991).

R. Krautheimer, *Rome. Profile of a City, 312–1308* (Princeton, 1980).

T. McNeill, *Castles in Ireland. Feudal Power in a Gaelic World* (London and New York, 1997).

D. Nicholas, *The Later Medieval City* (London and New York, 1997).

V. Raguin, K. Brush, and P. Draper (eds), *Artistic Integration in Gothic Buildings* (Toronto, Buffalo, London, 1995), especially B. Abou el-Haj, 'Artistic Integration Inside the Cathedral Precinct: Social Consensus Outside?', 214–35; R. Reynolds, 'Liturgy and the Monument', 57–68; A. Klukas, 'Durham

Cathedral in the Gothic Era: Liturgy, Design, Ornament', 69–83.

M. Rubin, *Corpus Christi. The Eucharist in Late Medieval Culture* (Cambridge, 1991).

M. Thompson, *The Decline of the Castle* (Cambridge, 1987).

M. Thompson, *The Rise of the Castle* (Cambridge, 1991).

C. Wilson, 'Rulers, Artificers and Shoppers: Richard II's Remodelling of Westminster Hall, 1393–99', in D. Gordon, L. Monnas, and C. Elam (eds), *The Regal Image of Richard II and the Wilton Diptych* (London, 1998), 33–59.

Chapter 5. Symbolic Architecture: Representation and Association

C. Coulson, 'Hierarchism in Conventual Crenellation: An Essay on the Sociology and Metaphysics of Medieval Fortification', *Medieval Archaeology*, 26 (1982), 69–100.

P. Crossley, 'Medieval Architecture and Meaning: The Limits of Iconography', *Burlington Magazine*, 130 (1988), 116–21.

P. Dixon and B. Lott, 'The Courtyard and Tower: Contexts and Symbols in the Development of Late Medieval Great Houses', *Journal of the British Archaeological Association*, 146 (1993), 93–101.

R. Krautheimer, 'Introduction to an "Iconography of Medieval Architecture"', *Journal of the Warburg and Courtauld Institutes*, 5 (1942), 1–33, repr. in R. Krautheimer, *Studies in Early Christian, Medieval and Renaissance Art* (New York and London, 1969).

R. Krautheimer, 'Sancta Maria Rotonda', in Krautheimer, *Studies in Early Christian, Medieval and Renaissance Art*, 107–14.

M. Thompson, *The Decline of the Castle* (Cambridge 1991).

M. Thompson, *The Rise of the Castle* (Cambridge, 1987).

Chapter 6. Innovation and Commemoration

C. F. Barnes, Jr, 'Cult of Carts', in J. Turner (ed.), *Grove Dictionary of Art* (London, 1996).

P. Gerson (ed.), *Abbot Suger and Saint-Denis* (New York, 1986).

L. Grant, *Abbot Suger of St-Denis. Church and State in Twelfth-Century France* (London, 1998).

G. Henderson, *Chartres* (London, 1968), 21–37.

J. van der Meulen, R. Hoyer, and D. Cole, *Chartres: Sources and Literary Interpretations. A Critical Bibliography* (Boston, 1989).

J. Sumption, *Pilgrimage. An Image of Medieval Religion* (London, 1975).

F. Woodman, *The Architectural History of Canterbury Cathedral* (London, 1981).

Chapter 7. The Future that Arrives

The difficulty of any discussion of the stylistic transition and overlap between both sixteenth-century Gothic and on fifteenth- and sixteenth-century Renaissance architecture is discussed by A. M. Sankovitch, 'Structure/Ornament and the Modern Figuration of Architecture', *Art Bulletin*, 80 (1998), 687–717. N. Nussbaum, *German Gothic Church Architecture* (New Haven and London, 2000), chapter VIII, has a useful account. L. B. Alberti, *On the Art of Building in Ten Books*, trans. J. Rykwert, N. Leach, and R. Tavernor (Cambridge, MA, 1988).

J. Białostocki, *The Art of the Renaissance in Eastern Europe* (London, 1976).
A. Blunt, *Art and Architecture in France 1500–1700* (2nd edn, Harmondsworth, 1970).
N. Cooper, *Houses of the Gentry 1480–1680* (New Haven and London, 1999).
H. R. Hitchcock, *German Renaissance Architecture* (Princeton, 1981).
D. Howard, *Venice and the East* (New Haven and London, 2000).
C. R. Mack, *Pienza. The Creation of a Renaissance City* (Ithaca, NY, and London, 1987).
L. Neagley, *Disciplined Exuberance. The Parish Church of Saint-Maclou and Late Gothic Architecture in Rouen* (University Park, PA, 1998).

Timeline
Museums and
Websites
List of Illustrations
Index

Architecture

1137	Work starts officially at Saint-Denis Abbey church
1163	Work starts at Notre-Dame, Paris
1174	Fire at Canterbury Cathedral. Rebuilding choir started soon after
c.1190	Soissons Cathedral south transept finished; rest of church begun
1190s	Esztergom castle and cathedral built
1194	Fire at Chartres Cathedral. New church begun soon after
1209	Work starts at Magdeburg Cathedral
1210	Fire at Reims Cathedral. New church begun soon after
1218	Foundation of Salisbury Cathedral
1220	Work starts at Amiens Cathedral nave
1222	Work starts at Burgos and Toledo Cathedrals
c.1227	Work starts at Trier, church of Our Lady
1228	Foundation of S. Francesco, Assisi
1230s	Reims Palimpsest, first known medieval architectural drawing
1230s	Villard de Honnecourt's *Portfolio*
1235	Foundation of St Elisabeth, Marburg
1236	Work starts on Ely Cathedral choir
1241–8	Building of Sainte Chapelle, Paris
1245	Henry III takes over patronage of Westminster Abbey
1248	Work starts at Cologne Cathedral
1256	Work starts on Angel choir, Lincoln Cathedral
1260s	Early designs for façade of Strasbourg Cathedral
1262	Foundation of Saint-Urbain, Troyes
1265–1302	Arnolfo di Cambio mason and sculptor in Siena, Rome, Florence
1277	Work starts on Edward I's castles in north Wales
1278–1309	James of St George master of the king's works in Wales and Scotland
1289	Work starts at the Palais in Paris

Politics/religion

1150–1200	Rapid expansion of Cistercian monastic order
1170	Murder of Thomas Becket at Canterbury
1180–1223	Philip II Augustus, king of France
1187	Battle of Hattin, crusaders lose Jerusalem
1191	Lusignan rule begins in Cyprus
1198–1216	Pope Innocent III
1204	Venetians and crusaders sack Constantinople
1210–29	Albigensian crusade against Cathar heresy in southern France
1212	Victory of Alfonso VIII, king of Castile over the Almohads at Las Navas de Tolosa
1215–50	Emperor Frederick II Hohenstaufen
1215	Fourth Lateran Council; doctrine of Transubstantiation defined
1216–72	Henry III, king of England
1220/21	Inauguration of Dominican order of friars
1223	Papal confirmation of Franciscan order of friars
1226–70	Louis IX (St Louis), king of France
1230	Unification of León and Castile
1231	Teutonic knights established in Baltic territories east of river Vistula
1248	Castilian conquest of Seville
1250s onwards	Lübeck begins to dominate Hanseatic League
1252–84	Alfonso X, king of Castile
1261–4	Pope Urban IV
1264	Institution of Feast of Corpus Christi
1268	Angevin rule begins in Naples and Sicily
1272–1307	Edward I, king of England
1273	Rudolf I of Habsburg elected Emperor
1277	Genoa sends first of annual galley fleets to Bruges
1282	'Sicilian Vespers': Aragonese rule begins in Sicily
1285–1314	Philip IV, king of France

1200

Architecture

Politics/religion

1290 Angevin rule begins in Hungary
1291 Acre falls to Mamluks

1300

1293 Foundation of the hospital, Tonnerre
1296 Work starts at Florence Cathedral
1309–14 Building of Bellver Castle, Palma de Mallorca

1309–77 Papacy at Avignon
1310 Luxembourg rule begins in Bohemia

1316–42 Thomas of Witney master mason of Exeter Cathedral

1328 Valois rule begins in France
1333–70 Kasimir III the Great, king of Poland

1334 Work starts at papal palace, Avignon

1337–1435
Hundred Years' War between France and England
1342–52 Pope Clement VI

1346–70 Charles of Luxembourg, king of Bohemia; Emperor 1355
1347 Black Death arrives in Europe, first of several visitations

1344 Work starts at Prague Cathedral

1348 Foundation of Karlstein and Prague University
1351 Work starts at Holy Cross, Schwäbisch Gmünd
1356 Peter Parler called to Prague. Parler family subsequently work at Prague, Freiburg, and Strasbourg

1358–65 Rudolf IV of Habsburg, duke of Austria

1359 Foundation of nave of St Stephen's, Vienna
1361 Work starts on choir, St Sebaldus Nuremberg

1364–80 Charles V, king of France
1369–1477
Floruit of the Duchy of Burgundy under the Valois dukes
1370 Union of Poland and Hungary

1377–1534
Keldermans family of masons and sculptors based in Mechelen

1378–1417
Great Schism in the papacy
1385 Portuguese victory over Castile at Aljubarotta. Start of Avis rule: João I, d. 1433

1386 Work starts at Milan Cathedral
1389–1432
Hans von Burghausen master mason in Bavaria, Salzburg
1390 Work starts at S. Petronio, Bologna
1390s The Milan Expertise
1390s Adaptation of Westminster Hall by master carpenter, Hugh Herland
1392–1493
Ensinger family master masons in south Germany and Switzerland
1394 St Maria am Gestade, Vienna, built by Michael of Wiener Neustadt
1395–1428
Hinrich Brunsberg master mason in Baltic towns

1386 Union of Poland and Lithuania. Lithuania converted to Christianity. Jagiellon rule begins in Poland and Hungary

1400

1402 Foundation of Seville Cathedral nave

1414–17 Council of Konstanz resolves papal schism

1415–95 Roriczer family of master masons work at Regensburg
1418–55 Hans Puchspaum mason at Ulm, master at Vienna
1422 Work starts at Ca' d'Oro, Venice

1422–61 Henry VI, king of England
1433–48 Duarte, king of Portugal

1435 Hans Böblinger's *Leaf-Pattern Book*. Böblinger family masons at Ulm and Esslingen to 1511

Architecture

1436–99 Eseler family master masons in Bavaria and Swabia
1439 Work starts on choir, St Lorenz Nuremberg
1439–75 Peter von Pusica master mason at Wiener Neustadt

1448 Foundation of Coca Castle
1449–1542
Colonia family from Germany master masons at Burgos and Valladolid
1453 Juan Guas master mason in Spain
1456–80 Arnold von Westfalen master mason at Dresden and Meissen
1459 The Regensburg Ordinances
1461 Antonio Averlino (Filarete) writes *Trattato de Architettura*
1468 Work starts at Munich, church of Our Lady, under Jörg von Halsbach
1476 Foundation of S. Juan de los Reyes, Toledo
1477–1512
Burkhard Engelberg master mason at Augsburg and elsewhere
1480–1534
Enrique Egas master mason in Toledo and Andalusia
1480–1534
Benedikt Ried master mason in Prague and Bohemia
1485 Leon Battista Alberti's *De Re Aedificatoria* published
1486 Mathes Roriczer's *Booklet on Pinnacle Correctitude* published
late 1480s
Hanns Schmuttermayer writes *Booklet on Pinnacles*
1486–1563
Siloë family master masons in Burgos and Andalusia

1508–63 Arruda family master masons in Portugal

1513 Work starts at St Nicholas da Tolentino, Brou
1516 Lorenz Lechler writes his *Instructions* for his son Moritz
1516/17 Work starts at Ghent Town Hall
1517 Work starts at Sigismund chapel, Kraków
1528 Work starts at Saint-Pierre, Caen

Politics/religion

1440–93 Frederick III, Habsburg Emperor
1442/3 Alfonso V, king of Aragon, gains Naples
1447–55 Pope Nicholas V

1453 Constantinople falls to Ottoman Turks

1458–64 Pope Pius II

1469 Marriage of Ferdinand of Aragon to Isabella of Castile

1479 Union of Aragon and Castile

1487 Bartholomew Diaz (Portugal) rounds Cape of Good Hope
1492 Christopher Columbus sails to New World. Victory of Ferdinand and Isabella, the Catholic monarchs, over Nasrid rulers in Granada
1494 France invades north Italy
1495–1521
Manuel I, king of Portugal
1497 Vasco da Gama (Portugal) sails to India via Cape of Good Hope
1506–48 Sigismund I Jagiellon, king of Poland

1516 Charles of Habsburg, king of Spain; Emperor Charles V 1530–56, d. 1558

1530 Confession of Augsburg, start of Reformation in Germany
1536–9 Dissolution of the monasteries in England
1571 Cyprus conquered by Ottomans

1500

General websites

www.fotomr.unimarburg.de
Extensive picture library of German monuments
with on-line index at
http://bildindex.de/intro.htm

www.thais.it
Picture library of Italian sculpture and
architecture.

http://www.pitt.edu/~medart/
Images of medieval art and architecture

http://www.learn.columbia.edu/Mcahweb/Amiens.html
Amiens Cathedral website

http://jefferson.village.virginia.edu/salisbury/guide/links.html
Website with links to views of Salisbury
Cathedral, Westminster Abbey, Durham
Cathedral and Castle, churches and buildings in
Suffolk, Amiens Cathedral, Notre-Dame de
Paris, images of Medieval art and architecture,
Medieval English towns, The Labyrinth: Sources
for Medieval Studies, ORB: The Online
Reference Book for Medieval Studies, The
Grove Dictionary of Art.

General Medieval documents can be found at

http://www.fordham.edu/halsall/sbook.html

http://www.avista.org/afj.html
AVISTA

http://www.medievalacademy.org/
Medieval Academy of America

Gallery/Museum	Website

England

British Library
96 Euston Road
London NW1 2DB
One of the world's best collections of medieval
manuscripts, charters, seals, and maps.

www.bl.uk

British Museum
Great Russell Street
London WC1B 3DG
Major collection of European medieval art,
some sculpture, mainly metalwork, jewellery,
ivories.

www.british-museum.ac.uk

Victoria and Albert Museum
Cromwell Road
South Kensington
London SW7 2RL
Includes significant collection of church art and
domestic arts, major pieces displayed in
medieval 'treasury'; many more, such as stained
glass, metalwork, ironwork, and textiles in the
relevant departments of the museum for those
media.

www.vam.ac.uk

Scotland

Burrell Collection
Pollock Country Park
Glasgow G43 1AT
Important collections of tapestries and stained
glass.

www.clyde-valley.com/glasgow/burrell.htmil

Austria

Kunsthistorisches Museum
Maria-Theresien-Platz
1010 Vienna
One of the most important collections of
medieval art in Europe.

www.khm.at

France

**Musée Nationale de Moyen-Age—Thermes de
Cluny**
6 Place Painlevé
75005 Paris
One of the world's best comprehensive medieval
art collections.

www.musexpo.com/france/cluny

Germany

Diocezanmuseum St Ulrich
Domplatz 2
D 93047 Regensburg
Good collection of Church art, reliquaries, and
textiles from the eleventh century onwards.

www.regensburg.de

Italy

Museo Civico Medievale
Palazzo Ghislardi-Fava
Via Manzoni 4
40121 Bologna
Contains medieval church art and secular art
from Emilia Romagna area.

www.comune.bologna.it/iperbole/MuseiCivici

Museo Nazionale del Bargello
Via del Proconsolo 4
Florence
Contains important collection of medieval
sculpture, including the Carrand Collection of
ivories and metalwork.

www.sbas.firenze.it/bargello/index.html

Gallery/Museum	Website
The Netherlands	

The Netherlands

Rijksmuseum
Stadhouderskade 42
1071 ZD
Amsterdam
and:
PO Box 74888
1070DN
Amsterdam
Contains collections of medieval painting,
sculpture, applied arts, and furniture.

www.rijksmuseum.nl

USA

The Cloisters
Fort Tryon Park
New York
NY 10046
Impressive branch museum of the Metropolitan
situated in four acres at Fort Tryon, Manhattan.
Based around five reconstructed twelfth-
century cloisters from Spain and southern
France. Wide-ranging collection of medieval art
in Europe.

*www.metmuseum.org/collections/department.a
sp?dep=7*

National Gallery of Art
6th Street and Constitution Avenue, NW
Washington, DC 20565
Collection of church treasures includes chalice
of Abbot Suger and mainly Limoges enamels.

www.nga.gov

List of Illustrations

The publisher and author would like to thank the following individuals and institutions who have kindly given permission to reproduce the illustrations listed below.

1. The Sainte Chapelle, Paris, interior, looking east. Photo A. F. Kersting, London.
2. Hospital of Notre-Dame de Fontenilles, Tonnerre, France, interior, looking east. Photo Achim Bednorz, Cologne.
3. Former Cathedral (now Lala Mustafa Mosque) of Famagusta, Cyprus, from the west. Photo A. F. Kersting, London.
4. Vladislav Hall in Prague Castle, Czech Republic, interior, looking east. Photo Markus Hilbich, Berlin.
5. Chartres Cathedral, France, interior, looking east. Photo A. F. Kersting, London.
6. Cressing Temple, England, the Wheat Barn, interior. Essex County Council.
7. Orvieto Cathedral, Italy, interior, looking west. Photo The Conway Library, Courtauld Institute of Art, University of London.
8. Section of the nave of Amiens Cathedral, with architectural features identified (after Viollet-le-Duc).
9. Saint-Denis, former abbey church, interior, looking east. Photo Bridgeman Art Library, London/Giraudon, Paris.
10. Church plans.
11. Dore Abbey, England, choir interior, looking east. Photo A. F. Kersting, London.
12. Magdeburg Cathedral, Germany, interior, looking east. Photo Helga Schmidt-Glassner/Callwey Verlag, Munich.
13. Tracery patterns.
14. Vault patterns. Vault diagram, after N. Pevsner, *Buildings of England* (London: Penguin Books); (c), (d), (e), (f) after C. Wilson, *The Gothic Cathedral* (London: Thames & Hudson, 1990), fig. 172; (g), (h), (i) after L. Grodecki, *Gothic Architecture* (London: Faber, 1986); (k), (l) after P. Crossley, 'Wells, the West Country and Central European Late Gothic', in *Transactions of the British Archaeological Association Conference*, IV (1981), p. 19, B, (i) after Robert Willis.
15. Lincoln Cathedral, England, nave, looking east. Photo A. F. Kersting, London.
16. Cologne Cathedral, Germany, exterior of choir. Photo Bildarchiv Foto Marburg.
17. León Cathedral, Spain, north elevation of choir. Photo A. F. Kersting, London.
18. Barcelona, Spain, interior of S. Maria del Mar. Photo Institut Amatller d'Art Hispànic, Barcelona.
19. Nuremberg, Germany, interior of the choir of St Lorenz. Photo Achim Bednorz, Cologne.
20. Toledo, Spain, *artesonado* ceiling of El Tránsito synagogue. Photo Institut Amatller d'Art Hispànic, Barcelona.
21. Oppenheim, Germany, south façade of St Catherine. Photo Achim Bednorz, Cologne.
22. Prague Cathedral, detail of south transept. Photo Paul Prokop, Prague.
23. Tangermünde town hall, Germany, façade. © Könemann GmbH/photo Achim Bednorz, Cologne.
24. Soběslav church, Czech Republic, detail of cell vault. Photo Werner Neumeister, Munich.
25. Toledo, Spain, cloister of S. Juan de los Reyes. Photo Institut Amatller d'Art Hispànic, Barcelona.
26. Rouen, France, Saint-Maclou, from the west. Photo Bildarchiv Foto Marburg.
27. Westminster Hall, England, interior, looking south. Photo A. F. Kersting.
28. Model of the timber frame above the nave vaults of Notre-Dame, Paris. Photo Centre des Monuments Nationaux, Paris.
29. Exposed vault ribs at Ourscamp Abbey, France. Photo Centre des Monuments Nationaux, Paris.
30. Vault webs at Waverley Abbey, England. Photo The Conway Library, Courtauld Institute of Art, University of London.
31. Flying buttresses of Bourges Cathedral, France. © Könemann GmbH/photo Achim Bednorz, Cologne.

32. Mantes-la-Jolie, France, interior of Notre-Dame, looking east. Photo James Austin, Cambridge.

33. Florence, Italy, interior of S. Maria Novella, looking east. © Könemann GmbH/photo Achim Bednorz, Cologne.

34. Peterborough Cathedral, England, retrochoir, looking south. Photo A. F. Kersting, London.

35. The technique of vault projection. After A. Legner, ed., *Die Parler und die Schöne Stil* (Cologne: Museen der Stadt Köln, 1978), vol. 3, p. 18.

36. Setting out the choir of St Lorenz, Nuremberg. After Paul Crossley in G. R. Owen-Crocker and T. Graham, *Medieval Art: Recent Perspectives* (Manchester University Press, 1998), p. 167.

37. The derivation of some proportional ratios from polygons using constructive geometry. Drawing after Susan Bird.

38. Mathes Roriczer's prescription for designing a pinnacle by rotated squares, after his *Buchlein von der Fialen Gerechtigkeit* (Regensburg, 1486).

39. Muckross Friary. Setting out the plan by constructive geometry. After Roger Stalley in E. Fernie and P. Crossley (eds), *Medieval Architecture and its Intellectual Context* (London: Hambledon Press, 1990), p. 192.

40. Rotated squares from the Notebook of Master W. G. Städelsches Kunstinstitut, Frankfurt.

41. Allegory of Geometry from the *Hortus Deliciarum*, engraved copy, nineteenth century.

42. God as Architect of the Universe. Bodleian Library (MS Bodley 270b, f. iv), University of Oxford.

43. *Leaf-Pattern Book* of Hans von Böblingen. Bayerisches Nationalmuseum (inv. 3604, Laubhauerbüchlein, f. 1), Munich.

44. Foliage sculpture: (a) crocket, south transept of Laon Cathedral, France, 1170s; (b) stiff leaf, nave of West Walton parish church, Norfolk, c.1240. Photo Pamela Tudor-Craig; (c) naturalistic, transept of former cathedral of Toul, France, 1280s; (d) seaweed, nave of former cathedral of Toul, France, late fourteenth century; (e) *Astwerk*, west chapel of Ingolstadt parish church, Swabia, c.1520. Photos The Conway Library, Courtauld Institute of Art, University of London.

45. Drawing of the buttresses and a plan for a tower at Prague Cathedral. Ink on parchment, 132 × 52.5 cm. Akademie der bildenden Künste (Kupferstichkabinett, inv. 16.821), Vienna.

46. Drawing by Matthäus Böblinger for the west tower of Ulm Minster, c.1477. Münsterbauamt Ulm.

47. Ulm Minster, Germany, from the south-west. Photo Bildarchiv Foto Marburg.

48. Incised drawing at Clermont-Ferrand Cathedral, France. After Wolfgang Schöller, from R. Recht, ed., *Les Batisseurs des cathédrales gothiques* (Editions les Musées de la Ville de Strasbourg, 1989).

49. The tracing floor of York Minster. From the *Friends of York Minster Annual Report* for 1968. By kind permission of the Dean and Chapter of York.

50. York Minster, England, choir aisle window. Photo English Heritage/© Crown Copyright NMR.

51. A building site in the fifteenth century, miniature from the *Chronicles of Hainault*. Bibliothèque Royale de Belgique (MS 9243, f. 106v), Brussels.

52. Florence, Italy, Cathedral and bell tower from the south. Photo Scala, Florence.

53. Saint-Denis, choir chapels of the former abbey church. Photo The Conway Library, Courtauld Institute of Art, University of London.

54. Avignon, France, Audience Hall of the Palace of the Popes. Photo Thomson/The Conway Library, Courtauld Institute of Art, University of London.

55. Benedictine abbey church of La Chaise-Dieu, France, nave, looking east. Photo Achim Bednorz, Cologne.

56. Wiślica, Poland. Collegiate church of St Mary, interior, looking east. Photo The Conway Library, Courtauld Institute of Art, University of London.

57. Venice, Italy, SS Giovanni e Paolo, interior, looking east. Photo A. F. Kersting, London.

58. Sweetheart Abbey, interior, looking east. Photo Christopher Wilson, London.

59. Former Dominican chapel (now Jacobin church), Toulouse, France, interior, looking east. © Könemann GmbH/photo Achim Bednorz, Cologne.

60. Salisbury Cathedral, England, exterior from the north-east. Photo A. F. Kersting, London.

61. Soest, Germany, St Maria-zur-Wiese, interior, looking east. Photo Achim Bednorz, Cologne.

62. A masons' lodge, miniature from a manuscript, 1354, each folio 37 × 27 cm. Landesbibliothek (MS 472, f. 40v), Linz.

63. Burgos Cathedral, Spain, exterior from the north-west. Photo A. F. Kersting, London.

64. Strasbourg Cathedral, France, west façade.

Photo Centre des Monuments Nationaux, Paris.

65. Exeter Cathedral, England, exterior from the west. Photo A. F. Kersting, London.

66. Exeter Cathedral, choir interior, looking south-east. Photo Clive Hicks, London.

67. Timber conversion. Drawing after Lynn T. Courtenay in E. Bradford Smith and M. Wolfe (eds), *Technology and Resource use in Medieval Europe* (Aldershot: Ashgate, 1997), p. 19.

68. Ca' d'Oro, Venice, main façade. © Könemann GmbH/photo Achim Bednorz, Cologne.

69. Building phases of Ca' d'Oro, Venice. After R. Goy, *The House of Gold* (Cambridge University Press, 1992), p. 16.

70. Town Hall, Ghent, Belgium, façade on to Botermarkt. Photo Achim Bednorz, Cologne.

71. Corner turret, Ghent Town Hall. Photo Reynolds/The Conway Library, Courtauld Institute of Art, University of London.

72. The Palace of Paris. Miniature by the Limbourg brothers illustrating the month of June, from the *Très Riches Heures* of the Duke of Berry, c.1413–16. Musée Condé (MS 1284, f. 6v), Chantilly/photo Bridgeman Art Library, London/Giraudon, Paris.

73. Market square and former parish church, Freiburg-im-Breisgau, Germany. Photo Helga Schmidt-Glassner/Callwey Verlag, Munich.

74. Fifteenth-century view of Kraków, Poland, from H. Schedel, *Registrum hujus operis libri cronicarum in figuris* (Nuremberg, 1493). © The British Library, London.

75. The Pont Valentré, Cahors, France. Photo Achim Bednorz, Cologne.

76. Plan of Monpazier, France. Engraving by Th. Olivier after F. de Verneilh.

77. The Torre de Lavello, Tuscania, Italy. Photo Denys Pringle, Penarth, Wales.

78. Rievaulx abbey, Yorkshire, schematic plan of the precinct. After Caroline Atkins in P. Fergusson and S. Harrison, *Rievaulx Abbey. Community, Architecture, History* (New Haven and London: Yale University Press, 1998), p. 177, fig. 149. © Wellesley College, MA.

79. Karlstein castle, Czech Republic, painting, 1872, by Hugo Ullik. Photo Luboš Stiburek.

80. Plan of the Palace of Paris in the early fourteenth century. After P. Cherry in M. Whiteley, 'Deux escaliers royaux du XIV siècle' in *Bulletin Monumental*, 147 (Paris: Société Française d'Archéologie, 1989), p. 134, fig. 1.

81. The Llotja, Palma de Mallorca, interior. Photo Sumner/The Conway Library Art, Courtauld Institute of Art, University of London.

82. Glimmingehus, Skåne, Sweden. Photo Ivar Andersson/Antikvarisk-topografiska Arkivet, National Heritage Board, Stockholm.

83. Imaginary view of a Netherlandish town, c.1440, detail of a painting by a follower of Robert Campin, *The Virgin and Child before a Firescreen*. © The National Gallery (NG2609), London.

84. Old Court, Pembroke College, Cambridge. From D. Loggan, *Cantabrigia Illustrata sive omnium* (c.1690) © The British Library, London.

85. Albi Cathedral, France, choir screen, looking west. Photo Clive Hicks, London.

86. Chantry chapel screen, Cirencester church, England. Photo F. H. Crossley/The Conway Library, Courtauld Institute of Art, University of London.

87. Oratory of the Compagnia di Piazza, Scarperia, Italy. Reconstruction as in 1353. From D. Friedman, *Florentine New Towns* (Cambridge MA and London: MIT Press, 1988), p. 187, fig. 97.

88. St Davids, Wales, porch to the great hall, bishop's palace. Photo CADW: Welsh Historic Monuments, Cardiff. Crown Copyright.

89. *Les grands degrés*: stairs to the Galerie des Merciers, in the Palace of Paris. Detail from the *Retable de Parlement*. Musée du Louvre, Paris/photo J. G. Berizzi/Réunion des Musées Nationaux.

90. Choir of Aachen Cathedral, Germany, exterior from the south. Photo Achim Bednorz, Cologne.

91. Wells Cathedral, England, interior of the Lady chapel and retrochoir, looking north-east. Photo A. F. Kersting, London.

92. Prague, Old-New Synagogue, interior, looking east. Photo Matthew Weinreb, La Sauvetat, France.

93. Fifteenth-century view of Nuremberg. Detail of the Krell altarpiece, St Lorenz, Nuremberg. Photo Achim Bednorz, Cologne.

94. The Tomb of Christ in Konstanz Cathedral, Germany. Photo Achim Bednorz, Cologne.

95. Bruges, Belgium, Jerusalem church, exterior from the west. Photo Achim Bednorz, Cologne.

96. Salisbury Cathedral, chapter house interior. Watercolour by J. Buckler, 1810. Reproduced by kind permission of the Wiltshire Archaeological and Natural History Society, Devizes.

97. Ely Cathedral, England, interior of the octagon and lantern. Photo The Conway Library, Courtauld Institute of Art, University of London.
98. Trier, church of Our Lady, ground plan. From W. Götz, *Zentralbau und Zentraltendenz in der Gotischen Architektur* (Berlin: Gebr. Mann Verlag, 1968), fig. 30.
99. Trier, Germany, church of Our Lady, looking north-east. Photo Helga Schmidt-Glassner/Callwey Verlag, Munich.
100. Batalha Abbey, Portugal, the Capellas Imperfeitas, interior, looking north. © Könemann GmbH/photo Achim Bednorz, Cologne.
101. Burgos Cathedral, Spain, Capilla del Condestable, interior, looking east. © Könemann GmbH/photo Achim Bednorz, Cologne.
102. Meissen, Germany, staircase in Albrechtsburg Palace. © Könemann GmbH/photo Achim Bednorz, Cologne.
103. Blaubeuren, Germany, monastery church, interior, looking east. Photo Achim Bednorz, Cologne.
104. Milan Cathedral Italy, eastern apse, exterior. © Könemann GmbH/photo Achim Bednorz, Cologne.
105. Reliquary of the Holy Sepulchre. Cathedral Treasury, Pamplona.
106. Vienna Cathedral, Austria, exterior from the south-west. Photo Bildarchiv Foto Marburg.
107. Malbork Castle. Photo Florian Monheim, Meerbusch.
108. Caernarfon Castle, Wales, south curtain. Photo A. F. Kersting, London.
109. La Ferté-Milon, France, façade from the south. Photo Achim Bednorz, Cologne.
110. Coca Castle, Spain, exterior from the north-east. Photo Achim Bednorz, Cologne.
111. Siena, Italy, Palazzo Pubblico and the Campo. Photo Angelo Hornack Library, London.
112. Assisi, Italy, S. Francesco, interior of the upper church, looking east. Photo Scala, Florence.
113. Rievaulx Abbey, England, choir interior, looking east. Photo Clive Hicks, London.
114. Melrose Abbey, Scotland, presbytery and south transept from the south-east. Photo A. F. Kersting, London.
115. Wiener Neustadt, Austria, wall of shields on the castle entrance. Photo Markus Hilbich, Berlin.
116. Castel del Monte, Italy, entrance door. Photo Markus Bollen, Bensberg.

117. Herstmonceux Castle, England, façade. Photo A. F. Kersting, London.
118. Venice, Scuola Vecchia della Misericordia, exterior. Photo The Conway Library, Courtauld Institute of Art, University of London.
119. Bourg-en-Bresse, France, priory church of St Nicholas of Tolentino, Brou, west front. Photo Achim Bednorz, Cologne.
120. Chantry chapel of Prior William Bird in Bath Abbey, England. Photo F. H. Crossley/The Conway Library, Courtauld Institute of Art, University of London.
121. Canterbury Cathedral, England, interior of choir and Trinity chapel, looking east. Photo Angelo Hornack Library, London.
122. Canterbury Cathedral, comparative plans of the choir. After Robert Willis.
123. Marburg, Germany, St Elisabeth's church, exterior from the south-east. Photo AKG, London.
124. Chartres Cathedral from the air. Photo Sonia Halliday Photographs, Weston Turville.
125. Larchant, France, church of Saint-Mathurin, interior of apse, looking east. Photo Achim Bednorz, Cologne.
126. Jean Tissendier, Bishop of Rieux-Volvestre, France, holding a model of a church. Polychrome stone (132.5 cm H). Musée des Augustins (inv. RA552), Toulouse.
127. Saint-Denis Abbey church, detail of the crypt, looking north. Photo The Conway Library, Courtauld Institute of Art, University of London.
128. Troyes, France, collegiate church of Saint-Urbain, exterior from the south-east. Photo Bildarchiv Foto Marburg.
129. Prague Cathedral, superimposed plans of successive buildings. After I. Hlobil and K. Benešovská, *Petr Parléř, Svatovítská katedrála 1356–1399*, exhib. cat. (Prague: Správa Pražského hradu, 1999), fig. III.
130. Prague Cathedral, interior of choir, looking east. Photo Clive Hicks, London.
131. Prague Cathedral, chapel of St Wenceslas, interior, looking north-east. Photo Jiří Kopřiva, Prague.
132. Granada, Spain, Capilla Real, interior looking west. © Könemann GmbH/photo Achim Bednorz, Cologne.
133. Segovia Cathedral, Spain, south aisle of the nave, looking east. Photo Achim Bednorz, Cologne.
134. Annaberg, Germany, interior of St Anne's church, looking east. Photo Achim Bednorz, Cologne.

135. Nördlingen, Germany, St Georg's church, nave interior, looking west. Photo Achim Bednorz, Cologne.

136. Tomar, Portugal, west window of the chapter house, monastery of the Knights of Christ. © Könemann GmbH/photo Achim Bednorz, Cologne.

137. Lavenham, England, a timber-framed shop-front, c.1500. Photo Clive Hicks, London.

138. Belém Tower, Portugal. © Könemann GmbH/photo Achim Bednorz, Cologne.

139. Augsburg, Germany, Fugger houses in the Weinmarkt. Engraving after Hans Tirol, mid-sixteenth century. Städtisches Kunstsammlungen (inv CT 1574), Augsburg.

140. Valladolid, Spain, detail of the courtyard of the Colegio di S. Gregorio. © Könemann GmbH/photo Achim Bednorz, Cologne.

141. Augsburg, St Anne's Carmelite church, the Fugger chapel, looking west. Photo Werner Neumeister, Munich.

142. Pienza, Italy, interior of the cathedral. © Könemann GmbH/photo Achim Bednorz, Cologne.

143. Bologna, Italy, S. Petronio's church, interior looking east. © Könemann GmbH/photo Achim Bednorz, Cologne.

144. Kraków, the Sigismund chapel on the cathedral on the Wawel. Photo Bildarchiv Foto Marburg.

145. Gaillon, France, entrance gate to the archbishops' palace. Photo The Conway Library, Courtauld Institute of Art, University of London.

146. Caen, France, Saint-Pierre, interior of the south-east ambulatory. Photo The Conway Library, Courtauld Institute of Art, University of London.

147. Regensburg, Germany, wooden model of Zur Schöne Maria church. Museum der Stadt Regensburg.

148. Reception for Emperor Charles IV in the Grand' Salle of the Palace, 1378. Miniature from the *Grandes Chroniques de France* of Charles V. Bibliothèque Nationale de France (MS fr. 2813, f. 473v), Paris.

The publisher and author apologize for any errors or omissions in the above list. If contacted they will be pleased to rectify these at the earliest opportunity.

Index